Empire, Espionage,
and the Quest
for the Color
of Desire

A Perfect
Red

AMY BUTLER
GREENFIELD

"Delightful, rollicking history. . . .
A fun read, well supported
by extensive research."
—*Los Angeles Times*

"Absorbing. . . . [An] intricate, fully researched and stylishingly written history of Europe's centuries-long clamor for cochineal, a dye capable of producing the 'brightest, strongest red the Old World had ever seen.'"
—*Publishers Weekly*

"In *A Perfect Red*, Greenfield does what the best historical authors do—she follows the thread of a story through history without missing a stitch. . . . Reading this purely factual account is a worthy endeavor, thanks to Greenfield's affable prose and to her ability to ensnarl us in many vivid details."
—*Cleveland Plain Dealer*

"Pirates! Kings! Beautiful ladies! Daring spies! . . . Greenfield combines the investigative prowess of a detective with the intellectual reasoning of an academician to create an eminently entertaining and educational read."
—*Booklist*

"Delightful, rollicking history. . . . A fun read, well supported by extensive research."
—*Los Angeles Times Book Review*

"Meticulously researched story that threads in and out of world history: ancient Mexico, Aztec marketplaces, Spanish conquistadors, the merchants of Venice, trade routes from the east, piracy on the high seas, and so on. . . . Color this well-researched read remarkable."
—*Knoxville News-Sentinel*

"This book is . . . the most colorful of stories, written with style and verve, and it carries the reader along effortlessly, over centuries and continents. It is a book that should not be missed. *A Perfect Red* is a perfect read."

—J. H. ELLIOTT,
author of *Imperial Spain 1469–1716*

"*A Perfect Red* is a marvelous book. . . . Through the tale of this tiny bug, Greenfield has written a dramatic, entertaining history of the world, from the Spanish conquistadors through the invention of synthetic dyes and beyond. Meticulously researched, this saga will enchant lovers of historical mysteries, fascinating characters, and world economics."

—MARK PENDERGRAST,
author of *Uncommon Grounds* and *Mirror Mirror*

"A smart blend of science and culture pleasing to readers of Mark Kurlansky, Philip Ball, among other interpreters of how the things of daily life, past and present, came to be."

—*Kirkus Reviews*

"The main action lies with a fascinating array of royals, traders, pirates, and entrepreneurs, all vying for the source of the most beautiful crimson ever known. Greenfield packs a dissertation's worth of history into her story without bogging down in the details. . . . Highly recommended."

—*Library Journal*

"An extraordinary epic. . . . I never thought a book about an insect could be so engaging!"

—*New York Post*

"Fascinating. . . . Greenfield has shown that the tiny insect that caused such a stir in Europe in the 1700s is still coloring our world. Her appreciation of its history shows clearly as she shares her delight with readers."

—*Virginia-Pilot*

"Amy Butler Greenfield . . . has mined the rich history of cochineal for wonderful stories about the biology of insects, the sociology of fashion, and the economics of colonialism."

—*Natural History* magazine

"Fluently written and thoroughly researched. . . . A good introduction not only to the history of red, but of microscopes, conquistadors, the eccentricities of Spanish kings, [and] the thieves of early Seville."

—VICTORIA FINLAY,
author of *Color: A Natural History of the Palette*

"*A Perfect Red* gives you a new respect for what you might have thought was just another color."

—*New York Times*

About the Author

AMY BUTLER GREENFIELD's grandfather and great-grandfather were dyers, and she has long been fascinated by the history of color. Born in Philadelphia, she grew up in the Adirondacks and graduated from Williams College. As a Marshall Scholar at Oxford, she studied imperial Spain and Renaissance Europe. She now lives with her husband near Boston.

A Perfect Red

Empire, Espionage, and the Quest for the Color of Desire

Amy Butler Greenfield

HARPER PERENNIAL

NEW YORK ● LONDON ● TORONTO ● SYDNEY

HARPER ● PERENNIAL

A hardcover edition of this book was published in 2005 by HarperCollins Publishers.

HarperCollins books may be purchased for educational, business, or sales promotional use. For information please write: Special Markets Department, HarperCollins Publishers, 10 East 53rd Street, New York, NY 10022.

First Harper Perennial edition published 2006.

Designed by Nancy B. Field

The Library of Congress has catalogued the hardcover edition as follows:
Greenfield, Amy Butler.
 A perfect red : empire, espionage, and the quest for the color of desire / Amy Butler Greenfield.—1st ed.
 p. cm.
 ISBN 0-06-052275-5 (acid-free paper)
 1. Cochineal—History. 2. Dyes and dyeing—Textile fibers—Europe—History. 3. Dyes and dyeing—Mexico—History.
 4. Cochineal insect. I. Title.

TP925.C63G74 2004
667'.26—dc22 2004042376

ISBN-10: 0-06-052276-3 (pbk.)
ISBN-13: 978-0-06-052276-6 (pbk.)

06 07 08 09 10 ❖/RRD 10 9 8 7 6 5 4 3 2 1

For my family,
at home and abroad

Contents

Illustrations follow page 164.

A Perfect Red

PROLOGUE

The Color of Desire

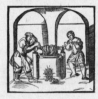 **HUMANS SEE THE WORLD IN A CASCADE** of color, with eyes that can distinguish any single shade from more than a million others. As a species, we prize color and attach great significance to it. Yet few colors mean as much to us as red. Proof of our attachment lies in many of the world's languages, English among them. We roll out the red carpet, catch crooks red-handed, and dread getting caught in red tape. We stop at red lights, ignore red herrings, and celebrate red-letter days. Depending on our political persuasions, we wave the red flag or fear the red in the bed. When hot rage overpowers us, we say we see red.

Many of these expressions are fairly modern, dating back less than three hundred years. Radical politics, for instance, have been called red only since the bloody European uprisings of 1848, while *red tape* is an eighteenth-century idiom that alluded to the red ribbons or "tapes" that tied together official documents in Great Britain. Yet red itself is a concept with much deeper

1

roots in the human psyche. Although many mammals have trouble perceiving red, the human eye is strongly sensitized to the color. An affinity for red seems almost hard-wired into us. Perhaps this explains why, in language after language, the word for red is an ancient one, older than any other color term save black and white. Before there was blue or yellow or green, there was red, the color of blood and fire.

Sacred to countless cultures, red has appealed to humans for time out of mind. Neanderthals buried their dead with red ochre, as did the Cro-Magnons, who painted cave walls with the same iron-rich ore. In ancient China, red was considered a lucky color, symbolic of prosperity and health. In the Arab world, it was sometimes construed as a sign of divine favor, sometimes as the mark of the damned—but above all as a male color, emblematic of heat and vitality. South of the Sahara, red was a color of high status, while in ancient Egypt it was the harbinger of danger, sacred to the trickster god Seth. Among the ancient Romans, red light was equated with divine fire. In primitive societies, the color has often been credited with magical powers, including the ability to exorcise demons, cure illness, and ward off the evil eye.

Throughout much of the world, red represents events and emotions at the core of the human condition: danger and courage, revolution and war, violence and sin, desire and passion, even life itself. No wonder our poets sing of it. "O, my luve's like a red, red rose," croons Robert Burns, while Tennyson warns us that Nature is "red in tooth and claw." "Friday I tasted life," wrote Emily Dickinson in 1866. "A circus passed the house—still I feel the red in my mind."

It is one thing, however, to assign meaning to a color, quite another to create the color itself. For thousands of years artists met with disappointment as they tried to reproduce the flaming scarlets and deep crimsons they saw in nature. The best red these artists knew was ochre, the Cro-Magnon's pigment, which produced a color that was muddied with orange and brown.

Sometime before the fifth century B.C., painters in Asia discovered that a far more satisfactory red could be made from the mineral cinnabar, or mercuric sulfide, a compound also known as vermilion and minium. Used to striking effect in Chinese scrolls and later on the frescoed walls of Pompeii, cinnabar did have several disadvantages: it was expensive, poisonous, and had a disconcerting propensity to turn black with exposure to light. Yet because it was by far the most brilliant red paint available, cinnabar continued to be used and celebrated for more than a thousand years.

If artists found it difficult to find a stable and vivid red, dyers faced an even greater challenge: their reds had to stand up to sunlight, sweat, and repeated washing. Because neither ochre nor cinnabar yielded a bright red when applied to cloth, dyers were forced to look elsewhere. Their quest was rather like alchemy: a secret art by which practitioners sought to transmute base materials—leaves, bark, blood, dirt, and even cow dung—into a gold mine of brilliant red dyes.

Unlike the alchemists, the dyers were successful—but only to a point. Although they learned to make russets and orange-reds cheaply and easily from plants, true red proved a much greater challenge. Before the invention of artificial dyes in the nineteenth century, it could be obtained only from exotic substances and secret techniques that few dyers ever mastered.

Elusive, expensive, and invested with powerful symbolism, red cloth became the prize possession of the wealthy and well-born. Kings wore red, and so did cardinals. Red robes clothed the shah of Persia, and in classical Rome red became so synonymous with status that the city's most powerful men were called *coccinati*: the ones who wear red.

It was big news, then, when Spain's conquistadors found the Aztecs selling an extraordinary red dyestuff in the great marketplace of Mexico in 1519. Calling the dyestuff *grana cochinilla*, or cochineal, the conquistadors shipped it back to Europe, where it produced the brightest, strongest red the Old World had ever seen.

According to the eminent English chemist Robert Boyle, cochineal yielded "a perfect Scarlet." A master dyer went farther and called it "the finest and best dye drug in the world." Cochineal became Europe's premier red dyestuff, and Spain made a fortune selling it to dyers around the globe.

As far as Europe was concerned, the only trouble with cochineal was that Spain controlled the supply. Indeed Spain guarded its monopoly so jealously that the dyestuff's very nature remained a mystery. Was cochineal animal, vegetable, or mineral? The best minds in Europe argued the point for more than two centuries.

Few, however, disputed the new dyestuff's value. In an age when textiles were a major source of wealth, cochineal was big business. Determined to break Spain's lucrative monopoly, other nations turned to espionage and piracy. In England, the Netherlands, and France, the search for cochineal soon took on the tone of a national crusade. Kings, haberdashers, scientists, pirates, and spies—all became caught up in the chase for the most desirable color on Earth.

The history of this mad race for cochineal is a window onto another world—a world in which red was rare and precious, a source of wealth and power for those who knew its secrets. To obtain it, men sacked ships, turned spy, and courted death.

This is their story.

ONE

The Dyer's Lot

FORTY MILES WEST OF FLORENCE, IN A fertile Tuscan valley not far from the Mediterranean Sea, lies the serene and sunlit city of Lucca. Known throughout the region for its trade in olive oil, flour, and wine, modern-day Lucca is not much more than a provincial market town, but its great piazzas, Romanesque churches, and medieval towers bear mute witness to a more illustrious past. Eight hundred years ago, Lucca was a power to be reckoned with: its luminous silks, dyed in jewel-like tones, were one of the wonders of the thirteenth century. No one on the Continent could equal them, though many tried. Sold only by Europe's most exclusive merchants, Lucchese silks included smooth taffetas, intricate damasks, and elaborate brocades figured with fleur-de-lis, griffins, dragons, peacocks, and even entire hunting scenes. All were fabrics fit for noblemen, princes, and kings.

Advantageously situated on a major road between Rome and northern Europe, Lucca enjoyed peace and prosperity for many years. Like most Tuscan towns, however, it had its share of long-

standing family feuds. These quarrels blazed into open warfare in 1300, intertwining with a larger struggle that was raging throughout much of Tuscany, forcing many people, including the poet Dante, to flee the region. A rich prize in a troubled land, Lucca found itself under frequent attack from both without and within. The violence culminated in 1314, when a band of Lucchese exiles joined a Pisan army and sacked the city, robbing, raping, and murdering their enemies.

Fearing for their lives, many of Lucca's dyers and silk workers fled to Venice, a neutral city a hundred miles away. The Council of Venice offered the refugees generous loans, but to no one's surprise there was a catch to the deal; the Venetians, after all, hadn't created an empire out of their swampy archipelago by giving their money away. Eager to learn the secrets of Lucchese silks, they required the refugees to repay the loans, not in cash but in Lucchese goods and tools.

Destitute, many refugees accepted these terms. In doing so, however, they betrayed their city and put their own lives in peril. They would spend the rest of their days with a bounty on their heads, because Lucca's guild laws prescribed death for any Lucchese practicing the silk trade outside the city. According to statute, the men were to be strangled, the women burned.

Lucca's draconian guild laws were a sign of the times, for textiles were a matter of life and death in Renaissance Europe. In many ways, they were to the Renaissance what computing and biotech are to our own time: a high-stakes industry rife with intense rivalries and cutthroat competition—an industry with the power to transform society.

 With textiles, the transformation began in medieval times and accelerated after 1350. Aristocrats who survived the Black Death had inheritances to spend, and rising merchants and lawyers were eager to ape their fashionable ways. As each tried to outdo the other, they insisted on wardrobes far larger and fancier than their grandparents had known; their houses, too, were more

extravagantly furnished. People of lesser station were also buying cloth at market stalls and clothier's shops—and buying more of it as the decades wore on. Bolt by bolt, their purchases helped fuel the rise of Europe.

Like the spice trade, the textile industry created new markets and trade networks, but its importance did not end there. Spices were usually grown and processed in the Far East, but textiles were something Europeans could produce for themselves, and for this reason their impact on Europe was more profound. Textiles spurred the invention of new technologies—new types of spinning machines, new methods for bleaching—and shaped the very pattern of work itself.

By the fifteenth century, hundreds of thousands of Europeans, from humble shepherds to great merchants, made a living from textiles, and many a nobleman depended on the wealth they created. Because each step in the cloth-making process was handled by different craftsmen, more than a dozen people could be involved in fashioning a single piece of fabric. The silk workers of Lucca, for example, included in their ranks a host of specialized workers: reelers to unwrap the cocoons, throwers to twist the thread, boilers to clean it, dyers to color it, and warpers and weavers to turn the thread into cloth.

Wool, the most common fiber in Europe, required even more specialization. After shepherds raised the sheep and shearers fleeced them, washers cleaned the raw wool and carders pulled the fibers apart with bristles. Spinners spun those fibers into yarn with distaffs and spindles and passed the yarn to the weavers, who wove it into cloth. Wool cloth then had to be "finished," a process that involved fullers or "walkers" who washed the fabric in troughs of water treated with fuller's earth, a mineral compound that promoted absorption. (Many walkers trampled the mixture into the cloth with their bare feet, but prosperous fullers kept their boots on and used a millwheel and hammers instead.) The soaking-wet cloth was then hung out on wooden

frames called tenters; tenterhooks held the fabric fast and
stretched it to the right dimensions as it dried. While still damp,
the cloth could be brushed and sheared several times for a finer,
softer nap. The fabric was then handed to the dyers. Although
dyers usually worked with finished cloth, sometimes they treated
the unspun wool instead, a costly practice that yielded the most
intense and enduring colors and gave us the expression "dyed in
the wool."

No matter what fiber was used, the textile industry required
immense amounts of skilled labor, which is why textiles were a
lifeline for many communities. A thriving cloth business meant
jobs, and jobs meant coins in the purse and food on the table. If
the business faltered or failed, people went hungry and lost their
homes. If worse came to worst, they starved on the streets—an
eventuality that was no mere figure of speech to the people of
Renaissance Europe. During the Great Famine of 1315–1317,
when crops across Europe failed for two years running, people
died by the thousands. Many other famines followed during the
rest of that grim century, and for generations afterward the suf-
fering remained vivid in European memory, inspiring dozens of
folktales—the Renaissance equivalent of the urban legend—that
told harrowing stories of people who ate their dogs, their shoes,
and even their children before they succumbed to starvation.

Weavers, dyers, and other cloth workers lived in constant
fear of such an end, for the textile industry was a crowded and
competitive field. Those who produced low-grade cloth faced the
most competition, made the smallest profits, and were most
likely to lose their jobs when business contracted, as it periodi-
cally did. Those who knew the secrets of making fine cloth were,
as a rule, much better off. They had fewer rivals and made most
of their sales to the wealthy elite, who could afford to pay a high
price for their luxuries, even during hard times.

As it was with workers, so it was with countries. England,
which primarily exported raw wool and plain cloth, was considered

a backward place in late medieval times; its leaders were desperate for the kind of success enjoyed by more exemplary industries across the Channel, where Holland was famous for its high-quality linen and Flanders for its woolens. These nations, in turn, envied Italy, where cities like Lucca and Venice produced exquisite satins, brocades, and velvets in a multitude of rich hues. Wealthy Europeans were willing to pay astronomical prices for these dazzling Italian textiles, which they wore as badges of rank, not least because of their color.

Today dressing for success often means donning gray and black suits, beige blouses, and black pinstripes; subdued colors are considered classy. To the people of Renaissance Europe, however, such thinking would have seemed entirely backward. In their day, gray and beige were the colors of poverty: only the poorest of the poor—and lowly priests, monks, and nuns—wore such undistinguished garb. More prosperous peasants, craftsmen, and other middling folk dressed in muted clothing colored with cheap, domestic dyes. Although such dyes could sometimes yield strong blues, yellows, oranges, and greens, the fabrics tended to fade quickly, especially if the wearer worked outdoors.* The most brilliant, intense, and lasting colors came from imported dyestuffs that only the rich could afford. Bright clothing was therefore a mark of high status, a code for power that even the illiterate could read at a glance.

The association of color and rank was reinforced by sumptuary laws that decreed what each level of society was allowed to eat, drink, and wear. Passed by medieval rulers who wished to

*Peasants sometimes appear brightly dressed in medieval and Renaissance works of art, such as the duc de Berry's lavish *Très Riches Heures*. This is less a reflection of peasant wardrobes than of the fact that wealthy patrons could afford precious pigments and expected their artists to use them. Although some people in the lower ranks may have worn colorful clothes from time to time, particularly for special occasions, most of the vivid hues commonly worn by the wealthy were beyond their reach.

discourage vanity and extravagance in their subjects—an aim that met with the full approval of the Church—these codes of consumption also ensured that no one ever looked grander than the monarch himself. To this end, sumptuary laws regulated all kinds of apparel. In Nuremberg, such laws forbade ordinary men from wearing gold lace, velvet, pearls, ermine, and weasel fur. Farther south, in Siena, veils, trains, and platform shoes were tightly regulated. In England, fourteenth-century yeomen and artisans could not wear silk, rings, jewels, or buttons—buttons being new to Europe and extremely fashionable at the time. Yeomen could, however, wear cat fur without penalty.

Many sumptuary laws also concerned themselves with color, reserving bright fabrics for aristocrats and the well-to-do. One of the earliest of these regulations dates back to the eighth century, when Charlemagne ordered peasants to clothe themselves in black and gray, a dress code similar to that of fifteenth-century Florence, where female slaves were restricted to coarse woolens and expressly forbidden to wear "coats or dresses or sleeves of any kind in any bright colors." In many parts of medieval Europe only aristocrats were entitled to wear scarlet cloth; some types of purple fabric were also restricted. On the whole, however, color was most effectively regulated by the many laws that severely limited what middling and poorer people could spend on their clothes; on such restricted budgets, expensively dyed cloth was out of the question.

As the centuries passed and bright fabrics became more widely available, it became more difficult to prevent people from dressing above their station. In 1583, a curmudgeonly Elizabethan commentator complained that "now there is such a confuse mingle mangle of apparel . . . that it is verie hard to knowe who is noble, who is worshipfull, who is a gentleman, who is not." It seems likely, however, that such confusion was largely confined to prosperous members of the middling and upper ranks: peasants simply could not afford the best and brightest fabrics. According to another

Elizabethan writer, they dressed instead in a dull tweed called medley and "*graye* and *russet*, never dy'de."

Aristocrats, on the other hand, were a colorful lot, especially in the fifteenth and early sixteenth centuries. Although a few played against type and wore black—fine, deep-dyed black cloth was both dramatic and expensive—most reveled in gaudy display. Flashy cloth-of-gold, fashioned with twisted filaments of the precious metal, was reserved for royalty, but richly colored damasks and silks delighted all the nobility. Throughout Europe, courtiers favored luminous garments decorated with spangles, ribbons, and beads. In Italy, the sons of noblemen wore multicolored hose with contrasting doublets and capes, a fashion that spread to much of the Continent. Slashed sleeves and breeches in a kaleidoscope of colors were all the rage, as were luxurious velvet fabrics in polychrome stripes. Nor were rulers immune to the craze; Henry VIII prided himself on a spectacular wardrobe that included a green velvet gown, a purple tinsel cloak, and bright blue and red doublets.

Those who could cater to this rage for color were assured of plentiful jobs and handsome profits. But the production of bright cloth was no easy road to riches, for dyeing was a difficult and dangerous art—no fit job for the faint of heart.

DURING THE RENAISSANCE, DYERS HAD TO SPEND many years apprenticed to a master, learning their trade. Their days were long, often beginning before dawn and ending after sunset, and the work was both exacting and exhausting.

"The dier . . . in smoke, and heate doth toile, / Mennes fickle mindes to please," runs a sixteenth-century poem. The accompanying illustration shows a well-muscled dyer, shirtsleeves rolled up, hoisting wet cloth from a bricked-in cauldron. Steam and smoke fill the room, a potent reminder of how hazardous the job was. Each day, dyers and their apprentices worked with fiery fur-

naces, boiling water, corrosive acids, poisonous salts, and fuming vats. Accidents were common.

Amid these dangers, apprentice dyers attempted to master the mysteries of the trade, of which there were many (see fig. 1). Before the invention of artificial dyes in the mid-nineteenth century, most dyes came from plants, and there was no rhyme or reason to the colors they yielded. Green woad produced a blue dye, purple loosestrife a brown one. Red blossoms might turn cloth orange or yellow—if, that is, they produced any lasting color at all. To make matters even more complicated, the dye in some plants was found in their flowers, while others had it in their leaves or roots. Nor was the amount of dye consistent; it depended instead on a variety of factors, including where the plant was grown, when it was harvested, and how soon it was used.

And the secrets of dyeing did not end there. Apprentice dyers soon learned that a few dyes were naturally fast, holding their color through years of wear and washing. Most, however, required the addition of chemical binding agents such as tannin, cream of tartar, alum, iron, and chrome—known as "mordants" because they helped dyes "bite" into the cloth. Mordants, while necessary, were a challenge to master, especially as each produced different colors from the same dyestuff. The temperature of the dyebath—the mixture of water, dyestuffs, and other ingredients—was often crucial to the color, as was the amount of time the cloth remained in the dyepot. Even the dyepot itself could affect the color of the cloth, if its metal reacted with the dye.

Nor were dyepots the only tools that dyers needed. The high-tech specialists of their day, they often possessed a dizzying array of equipment. In 1394, when two Tuscan dyers fell into debt and their shop was inventoried, the list ran to nearly a hundred items, including vats, washboards, winches, scales, tubs, shovels, and "a small sieve for fishing the wool out of the boilers." All told, their equipment was worth over 400 gold florins, with dyestuffs and mordants adding another 200 florins to the total.

In an age when 20 florins sufficed to buy a small farm, this was a substantial sum, which may explain why the dyers were in debt in the first place. Such investment, however, was necessary for those who wished to excel in the business.

Succeeding despite the many complications of their craft, the best dyers were part artist and part scientist, at a time when art and science were not yet regarded as divisible realms. Like modern scientists, they engaged in methodical experimentation and set great store by their ability to reproduce results. They also developed accurate testing techniques to check the quality of their raw ingredients and to detect fraud among their fellow dyers. Yet their science was necessarily imprecise. Lacking thermometers and stopwatches, they spoke of dyepots that seethed or boiled, or of holding cloth under the water for "a space of three paternosters." To judge when a cloth was colored to perfection, dyers relied less on exact formulas than on training, experience, and keen artistic instinct.

ALTHOUGH THE BEST DYERS PRODUCED COLORS OF such rare beauty that people would pay a king's ransom to possess them, dyers themselves ranked very low on the social ladder. From ancient times, people had regarded them with suspicion and distaste. "The finger of a dyer has the smell of rotten fish," sniffed the author of an ancient Egyptian papyrus. "His eyes are red from fatigue." In India, dyers were considered unclean.

Because dyers changed the outward appearance of objects, the ancient Greeks regarded them as dabblers in deception, a shifty-eyed lot who had to be kept under close watch. The Greek word *dolon*, "to dye," had a second meaning: "to deceive," and the uncompromising Spartans considered dyers such tricksters that they forbade them to dwell within the city.

Under the Romans, dyers fared better. Highly organized and

politically active, they were believed to enjoy the protection of Minerva, the goddess of wisdom. Nevertheless, few people wished to be their neighbors. Dyers made frequent use of noxious chemicals, including urine, which was both a bleaching agent and a key ingredient in blue dye. Not surprisingly, the dyeing district of any city could be found by smell alone.

After Rome fell, dyers in Europe lost both status and skill. During the turmoil of the Dark Ages, the art might have died out altogether had it not been for a few dedicated practitioners and patrons. Important, too, were the monks and nuns who wrote treatises on dyeing. Intent on preserving paint recipes for their illuminated missals and codices, they recorded many secrets of color for posterity.

European interest in dyeing rekindled with the Crusades. Christian soldiers who traveled to the East marveled at the brilliant colors and luxurious feel of Arab fabrics, and many brought samples home as souvenirs, gifts, and articles of trade. In Spain and Sicily, Arabic dyeing manuals were translated into Latin, and rulers of both kingdoms sought to encourage high-quality cloth making. It was during this period that Lucca's rise to fame began, with the arrival of Jewish textile workers in the eleventh century, who came to the city by way of southern Italy and Sicily. They brought with them the secrets of dyed silk, an art that was far more advanced in their eastern homelands than in Europe.

If by the eleventh century Europeans were starting to show a new respect for the dyers' craft, they nevertheless continued to despise dyers themselves. Church leaders, who had no great liking for tradesmen of any description, considered dyers especially disreputable because they had contact with so many foul and unclean substances. Delicate ladies scorned them for their stained fingernails; according to the thirteenth-century grammarian John Garland, the only reason any lady ever married a dyer was for money. Dyers' odorous workshops and their habit of dumping their stinking vats into nearby streams made enemies of

just about everyone. In twelfth-century England, they were held in such low esteem that merchant companies expelled any members caught practicing the art.

Attitudes toward dyers began to change in the thirteenth century. The European market for fine textiles was expanding, and skilled textile workers found themselves in demand. The competition for dyers was especially fierce, since their work was so complicated and since they added so much value to the cloth. Edward III did his best to woo Flemish dyers to England, and many cities, including Volterra and Siena, offered assistance to foreign master dyers who agreed to set up shop within their walls. As the experience of the Lucchese in Venice suggests, poaching experienced dyers was a well-trodden path to success in the textile business; whenever disaster struck a dyeing center, other cities hoped to profit from their rival's misfortune and attract the fleeing craftsmen.

Like many other medieval artisans, dyers took advantage of their new power and organized themselves into guilds, or trade associations. Each of these guilds attempted to regulate the profession for the benefit of its most skilled members. Their chief aim was to prevent rivals from driving prices and quality down, and to this end they established working hours, conditions, and wages, all of which differed from city to city. To keep competition down, they also set up systems of apprenticeship which limited entry into the profession.

In some regions, dyers had trouble establishing their own guilds, ending up instead as minor members of more powerful guilds run by wool merchants or weavers, who often ruled with an iron hand. One of the most infamous of these guilds, the Arte di Calimala in Florence, burned any cloth not dyed to standard and fined the dyer. If the dyer could not pay the fine—and many dyers had little cash to spare—the Arte di Calimala chopped off one of his hands instead.

Needless to say, dyers preferred to form their own guilds

wherever they could. In Venice, Lucca, and many other medieval cities, such guilds prospered and helped raise members to new heights of respectability. In London, the dyers' guild was even allowed the rare privilege of keeping swans on the Thames, a privilege once reserved solely for royalty.

Over time, dyers' guilds became quite specialized. Dyers who worked with different fabrics often belonged to different guilds, as did dyers who worked in different colors. Blue, black, and green were one common range, and red, violet, and yellow another. A dyer caught using colors outside his chosen specialty could be fined and thrown out of his guild.

Depending on the dyestuffs they employed, dyers were also categorized—at least in some regions—as either plain dyers or high dyers. Plain dyers, known as *schwarzfärber* in Germany, *teinturiers en petit teint* in France, and *tintori d'arte minore* in Italy, were by far the largest group. Their dyes used comparatively inexpensive ingredients, usually in simple recipes, though *simple* was a relative term. In some cities, the apprenticeship of plain dyers lasted three years, followed by at least five years' practice as a journeyman working in a licensed master's shop. Guilds allowed only so many of these journeymen to attain the rank of master, and to achieve that status each candidate had to pass rigorous tests. One such examination required a "master-piece" of forty-eight yards of linen dyed blue, along with several pounds of woolen thread dyed in blue and green.

High dyers specialized in fine fabrics and rare and expensive dyes. Called *schönfärber* in Germany, *teinturiers en bon teint* in France, and *tintori d'arte maggiore* in Italy, they were far less numerous than the plain dyers, in part because their apprenticeship could last twice as long. Independent masters of the art, they did not always form guilds, although some knew one another personally. When they did band together, they often specialized in a single color. Scarlet dyers, for example, formed their own guilds in Venice, Genoa, Marseilles, and several other cities.

Whatever its specialty, every dyers' guild was in a sense a secret society, guarding the mysteries of its art from outsiders. Members who violated the rule of secrecy were punished, expelled from the guild, and—if the offense was grave—outlawed from the city. Guilds also established standards for their members, discouraged them from taking shortcuts, and prohibited the substitution of cheap ingredients for expensive ones. In this, the dyers' guilds could be quite as ruthless as the Arte di Calimala; for example, the statutes of the dyers' guild of Lucca, recorded in 1255, decreed that any member who used cheap red dyestuffs—thereby compromising the city's excellent reputation for quality goods—would be fined one hundred lire or else lose his right hand.

That this regulation concerned red dye is no coincidence. Although Lucca was not the only European city that made red cloth, its scarlet silk was famous. The techniques for making this fabric were therefore among the most valuable secrets the Lucchese possessed—as the canny Venetians well knew when they drove their hard bargain with Lucca's refugees.

Others were also eager to learn those secrets, for red was the most desirable color in Europe, and any who mastered its mysteries stood to make a fortune. Like the Venetians, the citizens of Milan, Florence, Bologna, Pisa, and other cities north of the Alps also welcomed Lucca's dyers and learned the secrets of Lucchese scarlet. But the quest for the perfect red did not end there. Instead, each city sought to improve upon Lucca's methods and on their own craft secrets, searching for a red more desirable than any other. The result was a world of fierce rivalries that pitted country against country, city against city, and dyer against dyer, in a struggle that would ultimately encompass the entire globe.

TWO

The Color of the Sun

ON FEBRUARY 8, 1587, THREE HUNDRED people gathered in the great hall of England's Fotheringhay Castle to see a queen beheaded. Mary, Queen of Scots had been caught plotting a rebellion against Elizabeth I, her cousin, and after much delay she had finally been sentenced to death for treason. Guests lucky enough to have received an invitation to the gory event took their places around a hastily erected stage draped in black velvet. Everyone fell silent as the prisoner was led into the room.

Tall and graceful, Mary had a reputation for beauty and a flair for drama. That morning she was dressed like an elegant nun, with a long black satin gown embroidered in black velvet, and two rosaries—symbols of the faith she hoped to restore to Protestant Britain—strung from her waist. A long white veil covered her auburn hair. But when she mounted the stage and took off her robes, all semblance of the convent disappeared, for underneath her black and white she was wearing a dark red velvet

petticoat and a dark red satin bodice. It was in this garb that she approached her masked executioners.

To the assembled crowd, the queen's colorful apparel spoke of far more than the bloody end that was about to follow. In Tudor England, and indeed throughout Europe, red was the color of martyrdom, courage, and royal blood—a bold choice for a condemned traitor to wear to her execution. But wear it Mary did, and her silent act of defiance gave her dignity even as she met her end on the block.

Rich in meaning, red was a color of great power and prestige in Renaissance Europe. Although all colors were thought to have symbolic value—according to one popular guide, green stood for love and joy, while turquoise was a sure sign of jealousy—none could match red for breadth and importance. Its many meanings were derived from a variety of sources, including ancient Hebrew culture.

In Jewish tradition, red was a color of enormous significance and complexity. It not only stood for man—in Hebrew, *Adam* means "red"—but also represented the deity, in the form of the burning bush. Bright red, too, was the color of blood sacrifice, as well as a symbol of the very sin for which the sacrifice was supposed to atone. "Though your sins be as scarlet, they shall be white as snow," runs verse 1:18 of Isaiah. Red had other connotations that concerned wealth, war, and erotic love: in Hebrew texts red clothing is often worn by rich men, and also by valiant soldiers; in the Song of Solomon the beloved's lips are compared with a "thread of scarlet." Like many other cultures, the ancient Jews also associated red with the quintessential act of shame and self-betrayal, the blush. This intricate and sometimes contradictory web of meaning was part of the rich inheritance of Renaissance Europeans, most of whom came to it by way of the Christian Bible.

Renaissance beliefs about red were also strongly influenced by classical culture. Like the Jews, the ancient Greeks and Romans

regarded red as a divine color, and they used it prominently in classical weddings, burials, and other sacred rites. Statues of Roman gods were sometimes painted red, and some sacred temples had red interiors. In classical times, red also evoked the greatest of the heavenly bodies, the sun, which artists depicted as a glowing red disk with white, reddish yellow, and gold rays.

War, too, was another meaning of red that the Greeks and Romans seem to have had in common with the Jews. The Greek historian Xenophon wrote that the bellicose Spartans considered red cloaks "most suitable for war," perhaps because the color hid bloodstains and made them appear invincible. Later, much of Rome's power derived from its scarlet legions. Throughout the Roman Empire, the red tunic signified a man who had taken the soldier's oath and no longer lived under normal laws; at his commander's order, he could kill without fear of punishment.

Within civilian society, red benefited from its association with imperial purple, the most precious dyestuff in the ancient world. Made with the ink of the Murex snail, imperial "purple" was in fact a range of colors that included deep scarlets and crimsons as well as shades of amethyst and violet. To people of classical times, the intensity and luster of the color mattered as much as, if not more than, the actual hue. Dyers had to crush thousands of snails to extract enough imperial purple for a single garment, making it a fabulously expensive dye. In the fourth century, under the emperor Diocletian, a pound of the best imperial purple cloth was worth 50,000 *denarii*, which meant it was literally worth its weight in gold. Less expensive imperial purples cost 16,000 *denarii* per pound, still an enormous sum in an age when stoneworkers earned only 50 *denarii* a day.

Largely due to its expense, imperial purple became one of the preeminent symbols of power and prestige in the classical world. "The official rods and axes of Rome clear it a path," wrote the first-century scholar Pliny in his *Natural History*. "It is called in to secure the favor of the gods, and it adds radiance to every gar-

ment." On holidays and feast days, only senators and other great leaders were allowed to wear imperial purple cloth; under Caligula and Nero and the fourth-century emperors, its use was restricted to the imperial family. Despite such restrictions, the evidence suggests that many elite Romans used imperial purple—or at least some shades of it—for less ceremonial purposes. Pliny noted that one double-dyed variety was used "for covering dining-couches."

Fashions in imperial purple changed with the times. In the early first century, wealthy Romans preferred purples that tilted toward red, but fifty years later the most desirable shade was a mixture of scarlet and purple-black dyes that produced what Pliny described as "the color of congealed blood, blackish at first glance but gleaming when held up to the light." But even when these dark purples were in the ascendant, scarlet and crimson remained prestigious colors in ancient Rome. Though frequently made with dyestuffs other than snails, their close connection with the imperial hue gave them additional luster and value. Romans were especially impressed by scarlets from Persia and points farther east, which apparently surpassed what their own dyers could achieve.

After Rome fell, red remained a color of great significance throughout the old empire. In many European legends and folktales, it was considered a sign of otherworldly power, and in time it would become an iconic element in many fairy tales, from Red Riding Hood's bright cloak to Snow White's poisoned red apple. In many communities, red hair was thought to indicate a special connection to the spirit world, while red thread was said to ward off witches. Wealthy children were given red coral necklaces to guard them from illness, and red cloth was said to prevent sore throats and smallpox.

These superstitions probably owed more to Druid beliefs and local traditions than to Roman notions of red as a mystical and powerful color. Even the fact that writers from Iceland to Italy

celebrated red as a symbol of ferocity and courage did not necessarily have much to do with distant memories of Roman legions; it may have sprung instead from the nearly universal association of red with blood and the bloody deeds of war.

Other European ideas about red, however, were clearly a direct inheritance from the classical world, and nowhere was this more true than in that most Roman of institutions, the Church. From the late 1100s, the Church adopted red as a symbol of its authority, taking a red cross on a white shield as its emblem. By decree, red also became the Church's official symbol for Pentecostal fire and the blood of Christ. Informally, too, the color had other associations with key Christian concepts, particularly Christian martyrdom, the Crucifixion, and Christian charity. Medieval artists depicted the Virgin Mary in red robes as well as blue ones, and Crusader shields were often emblazoned with red crosses.

As the Church patriarchs were no doubt aware, however, red was a double-edged sword. The color of hellfire, it could symbolize the satanic as well as the divine, a legacy that went back at least as far as the ancient Hebrews, and probably much farther. As anyone who read the Old Testament knew, sin itself was scarlet—which may explain why some cities required courtesans and prostitutes to wear a red scarf, gown, or badge, and why small red badges were occasionally assigned to Jews and other outcasts as well. Red's association with sin was further underscored by the indelible imagery of the New Testament. In the Book of Revelation, the Antichrist is portrayed as a "great red dragon" cavorting in the depraved company of the Scarlet Woman, the Whore of Babylon, who is "drunken with the blood of the saints, and with the blood of the martyrs."

These texts notwithstanding, the pope decreed in 1295 that cardinals would henceforth wear "red" robes—actually a reddish shade of imperial purple—which Church officials obtained at great expense from Byzantine Constantinople, by then the sole

source of the old Roman dye. This source dried up completely when Constantinople fell to the Turks in 1453; the secret of imperial purple perished in the chaos. Soon afterward, the Church switched to a red European dye made partly with alum, a key mordant for many Renaissance dyes.* From then on its cardinals dressed in scarlet robes—a fact which militant Protestants later construed as proof positive that the Catholic Church was Revelation's Scarlet Woman and the pope the Antichrist.

For most Europeans, however, the new "cardinal purple" was simply a visible sign of the pope's temporal and spiritual power. For them, red had long since become the color of kings, in part because imperial purple was so scarce in medieval Europe that most monarchs had trouble obtaining it. During the centuries between the fall of Rome and the fall of Constantinople, only the Byzantine emperors and the very highest echelons of the Church hierarchy had anything like a satisfactory supply of the dye. Although some European monarchs resorted to cheaper, plant-based purples, these were not always easily distinguishable from the berry-colored garments worn by craftsmen and peasants. Red cloth, which was far too expensive for commoners, was much more distinctive, and it had the additional attraction of being identified with the kingly virtues of valor and success in war. According to medieval writers, red also represented fire, "the most noble of the four elements." Throughout Europe, red was held to be a symbol of royal status from the Dark Ages onward, a choice color not only for fabrics but for coats of arms as well.

For monarchs, the preferred reds were *scarlet* and *crimson*— but what exactly these terms meant in medieval and Renaissance times is now a matter of some debate. Color is a notoriously sub-

*For centuries Europeans had been forced to import most of their alum supply from the Middle East, but in 1460 the pope's nephew had discovered enormous deposits of alum in papal territories in Tolfa, Italy. The discovery greatly enriched the Church and helped make its cardinals brighter than ever.

jective concept; even on an individual level, there are biological and cognitive differences in how people view, process, and label various colors. We do not, for example, all see the same red the same way. Over time, too, the names of colors alter and bend, becoming now darker, now lighter, now grayer, now brighter. Thus the meaning of a word like *scarlet* can vary from place to place, from century to century, and even from person to person.

Even so, it is possible to make a few generalizations about what *scarlet* and *crimson* signified during the medieval and Renaissance periods. As in the classical world, these words did not necessarily describe the hue of an object, the way they do today. To textile workers and merchants, they instead often signified the use of particular types of red dyestuffs and fabrics. *Scarlet,* for example, almost always referred to high-quality woolens made with certain insect-based red dyestuffs. Sometimes these woolens were dyed with other colors as well to produce mulberrys, grays, blacks, and even greens—and in some places, these too were known in the trade as *scarlets*. Outside the cloth business, however, the words *crimson* and *scarlet* were used more generally to indicate the sort of rich, saturated, luminous reds that had appealed to Europeans since Roman times. The exact color associated with each word varied over time, but *crimson* most often meant a red that tended toward purple, while *scarlet* suggested a somewhat brighter hue.

Though not as rare as imperial purple, scarlet and crimson dyes were nevertheless costly, and early European rulers could not afford to be lavish with them. Yet a touch of these colors was often enough to prove one's royal bona fides: Charlemagne, for example, was said to have worn scarlet leather shoes when he was crowned emperor in Rome. Later monarchs, who had better access to fine red dyes, proclaimed their majesty by dressing in the much-desired colors from head to toe. Among the many rulers who followed this fashion were Richard II of England, who went to his coronation in crimson shoes, hose, and gown, and King Ferdinand of Spain, who had

himself painted in scarlet robes that exactly matched those of the
Virgin Mary hovering above him.

To enhance the overall glory of the monarch, those who dis-
pensed justice in his name were also allowed to wear scarlet and
crimson. In Scotland, judges on the King's Bench sat in scarlet-
robed glory, as did their counterparts in the Holy Roman Empire
and on England's Court of Common Pleas. On official occasions,
peers in English Parliament also wore scarlet. In France, mean-
while, royal magistrates were entitled to wear scarlet gowns, while
the king's chancellor dressed in crimson. In Venice and Florence,
scarlet and crimson gowns were part of the official costumes for
many high government posts.

Not to be outdone by the lawyers and councillors, royal
courtiers at times wore scarlet and crimson cloth, too, something
few commoners could afford to do. In the fifteenth-century
wardrobe accounts of England's Henry VI, even the cheapest
scarlet cloth cost nine shillings five pence a yard, more than a
month's wages for a master mason, let alone a common laborer;
the most expensive red cloth cost twice as much. In Flanders,
and elsewhere in Europe, prices were similar.

For those who could afford such outrageous sums, the
expense of fine red cloth only added to its desirability. In fabu-
lously wealthy Venice, rich young aristocrats gloried in their scar-
let wool gowns, while those who wore the best crimson silks were
said to dress *a modo principe*, "in the way of a prince." Elsewhere
in Italy, the men of elite clans like the Medici, the d'Estes, and
the Farneses wore luxurious scarlet and crimson gowns as a mat-
ter of course, or so the work of Renaissance artists like Domenico
Ghirlandaio and Giovanni da Oriolo would suggest. Sumptuous
red fabrics were worn by elite women, too, including Lucrezia
Panciatichi, who married into a wealthy family of Florentine dig
nitaries in the early 1500s. In a portrait by Agnolo Bronzino, she
sits serenely in a magnificent red dress, with sleeves that are an
ecstasy of crimson and shirred scarlet silk (see fig. 2).

Some aristocratic families even carried the majesty of red beyond the grave, commissioning posthumous portraits that depicted their ancestors clothed in expensive red fabric. The most spectacular of these after-the-fact portraits, painted by Jacopo da Pontormo in the early sixteenth century, depicts the melancholy figure of Cosimo de' Medici swathed in luminous scarlet (see fig. 3). (What Cosimo himself would have thought about this memorial is hard to say. As a hardheaded banker who ruled Florence with great skill in the mid-1400s, he had commented skeptically that "a gentleman can be made with two yards of red cloth.")

Aristocrats embraced the color red in other ways, too. Some highborn families covered their walls in tapestries shot through with red silks—a form of art that was far more expensive than painting and at the time far more desirable. In many hangings, red-garbed lords and ladies danced, hunted, and struggled against a multicolored backdrop; in others, like the fifteenth-century *Lady and the Unicorn* tapestries made for the French nobleman Jean Le Viste, the millefleur background was itself a glowing medley of scarlet and crimson. Nor were tapestries the only source of red ornamentation available to the elite. Sumptuous red rugs, often imported from the East, lined their floors and topped their tables. Their chapels and churches glowed with red stained glass, and on their fingers they wore rings made with rubies and other red gems, believed to protect the wearer from evil and cure diseases of the blood. Their books, too, were often bound in red cloth or red leather casings. Federigo, duke of Urbino, who commissioned a lavish library of Latin books in the fifteenth century, was said to have given "every writer a worthy finish by binding his work in scarlet and silver."

If the patrician class enjoyed the color red so, too, did wealthy people in the rising middle classes, albeit in a more limited fashion. Merchants, lawyers, and well-to-do artists sometimes wore scarlet and crimson garments, even though in certain cases this meant they flouted sumptuary law. In Chaucer's

Canterbury Tales, the exuberant Wife of Bath declares that moths and mites never had a chance to destroy her "gayest scarlet dress" because she "wore it every day." Among upwardly mobile Renaissance men, scarlet caps and hats were a popular fashion accessory. Some men even took to wearing scarlet turbans, as depicted in a fifteenth-century portrait by Jan van Eyck (see fig. 4). Admittedly, the flamboyant turban sits oddly above the sober features of van Eyck's wary subject (who may be the artist himself). But for Renaissance merchants and artists, the scarlet turban was an effective form of self-advertisement—exotic proof of success in international markets and of their access to the most coveted red dyes.

Deep, rich reds were also popular among peasants and small farmers, but both legal strictures and the prohibitive cost ensured that they rarely had a chance to wear them. At best, peasants could afford only the cheaper orange-red and russet dyes. Even these, if too bright, could bring them into conflict with sumptuary laws and local customs. Such laws were a sore point, at least in parts of Germany, where during a revolt in 1525 peasants demanded, among many other things, the right to wear red.

From the vantage point of our own time, when red is everywhere, it can be hard to comprehend such longing. But to the people of Renaissance Europe, the desire was real—and growing. As Europeans continued to prosper, their hunger for the color increased. The fact that vivid red cloth remained rare only whetted their appetites all the more.

RED CLOTH WAS RARE CHIEFLY BECAUSE RED dyestuffs were so scarce. Only a handful of natural substances produced red dye, and some of them—including the vegetable dye henna—did not work well on cloth. Others were difficult to transport and were costly or complicated to use.

Even the most popular red dyestuff in Europe, madder, had serious drawbacks. One of the oldest dyestuffs known to humankind, madder had been used in ancient Egypt and China and was probably the source of the red worn by Greek and Roman warriors. Derived from the roots of plants in the prolific Rubiaceae family, it was a fast, strong, and relatively inexpensive dyestuff that many Europeans could grow for themselves. Yet to derive a good red from madder required great precision and a certain amount of luck, because madder roots varied greatly in quality, and their dye was sensitive to both alkalinity and temperature. Most madder reds tended toward orange, and dyers often ended up with corals, russets, and brick reds, some of which could be made more cheaply and easily with other plant dyes.

The only dyers who knew how to consistently derive a rich red dye from madder lived in the Ottoman Empire, India, and other Eastern countries. Called "Turkey red" by Europeans, this dye worked best on cotton, a fiber that was relatively rare in Renaissance Europe. The intricate process involved more than a dozen steps, which took three or four months to complete. Rancid olive oil, cow dung, and blood were used at various stages along the way. Despite the unsavory ingredient list, European dyers were desperate to learn the technique, but due to the sheer complexity of the process and the Eastern dyers' understandable desire to conceal their methods, they met with no success until the eighteenth century. In the meantime, madder's orange-red was glory enough for many Europeans, especially those in the lower and middling ranks.

For grander folk, however, only the striking and more prestigious hues of scarlet and crimson would do. To satisfy the patrician desire for these colors, dyers turned to costly substances such as brazilwood, the common name for a group of dense tropical hardwoods found in the East. Brazilwood yielded deep crimson and purple dyes, which usually faded with disappointing rapidity to a dowdy pinkish brown. For this reason, "disceytfull brasell"

was often castigated as a "fauls colour"; it also had a tendency to stiffen cloth. But the rarity of good red dyestuffs ensured that brazilwood remained valuable. When new varieties were found in South America, the entire region was triumphantly christened Brazil.

Another important red dyestuff was archil, or orchil, a dye made from lichens found on coastal rocks. Well known in classical times, it persisted in the Middle East for many centuries. In 1300, a Florentine merchant rediscovered the formula and consequently did a booming business exporting red cloth. Like brazilwood, however, archil tended to fade, a serious disadvantage for many buyers.

A red dyestuff that offered even more challenges to European dyers was lac, the source of both lacquer and shellac. Native to India and Southeast Asia, lac was made from the insect *Laccifer lacca*, which secreted a sticky resin on tree twigs. The resin, collected with the bugs still inside it, produced fiery reds on wood. The color it imparted to textiles, however, was not always so desirable. European dyers found the expensive, gummy substance hard to work with and used it primarily for dyeing leather.

Dyers who were disappointed with brazilwood, archil, and lac turned to another set of red dyestuffs, which produced the most vivid and lasting colors of all: oak-kermes, St. John's blood, and Armenian red. All three were derived from parasitic insects related to lac, and all of them worked best on animal fibers such as wool and silk, rather than on plant fibers like cotton and linen.

Oak-kermes had been a valuable source of dye since ancient times. In the days of the Roman Empire, Spain was a key supplier, paying half its substantial tribute in the dyestuff. Found in hot, dry regions along the Mediterranean shore and in the Middle East, oak-kermes lived on the leaves and branches of Mediterranean oak trees and was usually collected in the spring. Although there were several species of the insect, the variety that produced the best color, and was consequently the most valued,

was *Kermes vermilio*. Killed with vinegar and steam, the insects were dried, crushed, packed for market, and sold to discriminating dyers throughout the Mediterranean world and beyond.

St. John's blood was a popular name for the insect *Porphyrophora polonica*. Later called Polish cochineal, it sometimes served as payment for tithes and rents in the regions where it was grown: eastern Europe, Russia, and Asia Minor. Eastern Europeans traditionally harvested the insects in June and July, starting on the feast day of St. John—hence the name. Unlike oak-kermes, which grew out in the open, St. John's blood flourished underground on the roots of the scleranth plant, which made collecting it a burdensome process. Since each plant harbored only about forty of the minuscule insects, thousands of plants had to be uprooted, cleaned, and stripped to produce a marketable amount of the dyestuff. Though the grassy bushes were replanted again, they often withered away, so new ones were always needed—adding to the expense of what was already a very costly dyestuff. Yet its red was undeniably brilliant, and many dyers valued it even more highly than that of oak-kermes.

Dyers also put a premium on Armenian red, which was made from the insect *Porphyrophora hameli*, a parasite on the roots and stems of certain grasses in Armenia, Azerbaijan, Georgia, Turkey, and Iran. Like St. John's blood, Armenian red was difficult to harvest. The insects obligingly surfaced from their underground hideout each autumn, but they did so only briefly, and collectors could easily confuse them with other insects that yielded no color at all. When the right insects were caught, killed, and processed, however, the product was extremely valuable. First mentioned in the eighth century BC, Armenian red was highly prized by the Assyrians and the Persians, despite the insects' high fat content, which made the dyeing process more difficult. In medieval Europe, many considered it the finest red dyestuff of all.

Modern chemists have demonstrated that the coloring power of these insect dyestuffs comes from three closely related dye

molecules. Even today, experts have trouble telling the dyes apart by eye alone, and they rely on chemical tests to differentiate them. In Renaissance times, the dyes seemed so similar that many Europeans used the same name for them all. To some, they were *grain*, a term that dated back to Roman times, when *granum*, meaning "kernel" or "seed," was the chief name for oak-kermes. The term suggested the tiny dried insects were actually berries, a classical notion that persisted in Renaissance Europe.* Other Europeans called them *vermilion*, after the Latin word *vermiculum*, meaning "little worm"—a term which reflected another classical idea about the dyestuffs' true nature.

By the fourteenth century, Europeans had discovered yet another word to describe these dyestuffs: *kermes*, a term borrowed from *kirmiz*, the Arabic word for the insect reds. (The same word gave rise to the term *crimson*.) Like *vermilion*, *kirmiz* meant "worm," though it is unlikely that most Europeans were aware of this. First used to describe eastern imports of Armenian red and St. John's blood, *kermes* became a common word for all three insect dyes by the sixteenth century.

The kermes reds were sometimes used in conjunction with less expensive dyestuffs to create blacks, violets, and other colors, but they were generally most valuable when used to dye textiles a deep scarlet or crimson. Considered the noblest of dyes, they had a price to match, as two price lists from Renaissance Florence demonstrate. At one Florentine dyeshop, "kermes" dye cost nearly twice as much as green dye and over three times as much as yellow or light blue. At the other dyeshop, the price differential was even more extreme: it cost ten times more to dye fabric an intense red *scarlatto* than to dye it sky blue.

Always valuable, the kermes reds were worth more in some

*This meaning of *grain* is now considered archaic, but it left its mark on the language. The word *ingrained* comes from the expression to dye "in grain" and reflects one of the insect dyes' best qualities, their fastness.

hands than others. The skilled dyers of Venice, in particular, were known for their ability to create gorgeous red dyes. A great maritime power, Venice had controlled the bulk of Europe's trade with the East for centuries, dealing not only in silks, spices, slaves, and precious metals, but also in kermes and other products useful for high-quality dyeing. This mastery, and the wealth that went with it, inspired the city's dyers—including refugee craftsmen like the Lucchese, and their descendents—to create a variety of striking red dyes. The deepest and most resplendent reds, collectively known throughout Europe as "Venetian scarlet," were the envy of all who saw them. Throughout Europe, dyers tried to imitate these reds without success, perhaps because no one thought to add arsenic, an ingredient used by the Venetians to heighten the brilliancy of their dyes.

The dyers of Venice became wealthy and powerful, in part because they shrouded the techniques of Venetian scarlet in mystery. Besides enforcing the usual guild penalties against those who violated the rule of secrecy, they spread eerie stories designed to discourage people from hanging around their dyeworks. Eventually, the tales took on a life of their own. According to some accounts, a white ghost haunted the dyeing district. Other stories spoke of a specter in a black cape and wide-brimmed hat who, with an otherworldly lantern in hand, hunted down anyone foolish enough to approach the dyeworks after dark.

Such stories helped preserve the secrets of Venetian scarlet for many years, but by the beginning of the sixteenth century Venice's supremacy as a dyeing center was under threat. The Turkish victory at Constantinople in 1453 had disrupted many of Venice's trading relationships with Eastern merchants, and the continued growth of the Ottoman Empire was a worry to many Venetian traders. Even worse, from the Venetian point of view, was the Portuguese discovery of a new sea route around Africa to the Indies. With this discovery, and Spain's subsequent discovery

of the Americas, the axis of European trade started to shift toward the Iberian Peninsula—and away from Venice. Perhaps the last straw was when a rumor reached Venice that Spain's conquistadors had found a spectacular red dye in the New World, a dye as vivid as any Venetian scarlet.

Was the rumor true? Venice—and all Europe—waited to find out.

THREE

An Ancient Art

 RUMORS ABOUT AMERICA ABOUNDED IN sixteenth-century Europe. Spain was said to have found China, Arcadia, even Paradise itself—a place where people lived in harmony without need of money, politics, or law. According to some stories, the inhabitants of America spoke ancient Hebrew. According to other stories, they were the descendants of Visigoth kings. Other tales spoke of precious metals glittering on beaches, fountains of eternal youth, and seven golden cities with riches beyond compare.

Europeans lured to the New World by such tales were doomed to disappointment. Yet not all the rumors about America were false. Indeed some were absolutely true, including the story about the spectacular red dye. Derived from the cochineal insect, it was central to the life and culture of the peoples of ancient Mexico.

A close cousin to oak-kermes, St. John's blood, and Armenian red, cochineal belongs, as they do, to the scale family. Infamous among gardeners for their voracious appetites, scales have been known to devastate greenhouses and gardens in a matter of days.

Although the destruction they cause is enormous, most scale insects are quite small, and cochineal—genus *Dactylopius*—is no exception. A wild cochineal insect is one-third the size of a ladybug and ranges in color from silver-gray to red-black. Six of them could fit quite comfortably along the length of a paperclip, provided they didn't fall through the middle first.

While some scales will eat almost anything, cochineal has very decided tastes. It feeds off the round, spiny branches of cacti belonging to the *Opuntia* genera. Native to the Americas, these cacti are commonly known to many English speakers as nopals or prickly pears. When a cochineal nymph hatches, it gets straight to work, slipping its beaklike proboscis into the nopal and sucking out the juices.

For female cochineal insects, life doesn't hold much more than this. Wingless, they spend their lives attached to one spot, secreting a waxy white nest in which they feed, lay their eggs, and die. To anyone passing by, they look like so many bits of cotton fluff caught against the spiny cactus. Male insects, which are less common than females, live a more adventurous life, developing wings which allow them to fly as they search for mates. Their free-spirited existence, however, has its own drawbacks: as they age, their mouthparts atrophy, and they live only half as long as females do.

All cochineal insects are parasites, but it is the females who do the most damage, since they spend virtually their whole lives eating. Left to themselves, they will suck their hosts dry. Fortunately for the cacti, the insects have many predators. Numerous grubs, worms, ants, and other invertebrates are major enemies of *Dactylopius*, and birds, lizards, mice, and armadillos have also been known to eat or attack the insects. For these mobile predators, the motionless female cochineal is easy pickings. The female, however, has a secret weapon at her disposal: she produces carminic acid, a compound belonging to a class of chemicals called anthraquinones, which ants and a few other ani-

mals find distasteful. Armed with carminic acid, a female cochineal bug can hold her own against some would-be stalkers. Recent research suggests that the chemical may also protect her from internal parasites that plague other insects.

Carminic acid has another outstanding property that humans have appreciated for thousands of years: it is a powerful red dye. Pinch a female cochineal insect, and blood-red dye pours out. Apply the dye to mordanted cloth, and the fabric will remain red for centuries.

No one knows when humans began using cochineal to dye fabric, but archaeologists have found cochineal-saturated textiles that date back two thousand years. The oldest samples come from a great necropolis in Peru, leading some scholars to speculate that the Peruvians discovered cochineal dyeing and introduced it to Central America. Others argue that the peoples of ancient Mexico discovered the art first, or at any rate independently.

Wherever cochineal dyeing began, the evidence suggests that the cultivation of cochineal reached its apex in Mexico. As biologists have pointed out, animals that prey on domesticated cochineal are abundant in Mexico but relatively rare in Peru, indicating that Mexican cochineal and its predators have been coevolving for a much longer time than their Peruvian equivalents.

Tradition credits the people of the southern Mexican highlands—specifically the people of the overlapping regions of the Mixteca and Oaxaca—with the leading role in cochineal's development; neighboring groups may also have made a major contribution. In ancient times, the highland region boasted splendid cities and temples, but the vast majority of people there made their living as farmers, growing maize, beans, and squash, important crops in which they had exceptional expertise.* In addition, some highland

*Archaeologists have discovered evidence of squash and maize domestication in Oaxaca that dates back to 4000 to 8000 B.C., the earliest such evidence yet found in the Americas.

farmers cultivated cochineal, with striking results. Rather than collecting wild cochineal from the hills, they tended the insects carefully on their own farms, guarding them from predators. They also appear to have been the first to breed them for size and color.

Animal domestication was not a common phenomenon in ancient Mexico—primarily, it seems, because there were not many species in America suited to that kind of development. Mexicans did, however, show great skill in cultivating insects, including not only cochineal but another form of scale known as *Llaveia*, which produced a wax used in cosmetics, medicines, and the creation of pre-Columbian lacquer. They also seem to have worked closely with an American honeybee, with butterflies, and with various edible insects.

Of all these ventures, the cochineal regimen produced the most dramatic and far-reaching results. Over the centuries, the ancient Mexicans' efforts paid off: under their care, a new species of cochineal flourished, a species now known to scientists as *Dactylopius coccus*. The new insect was twice the size of the wild varieties and produced considerably more dye; it may also have yielded a slightly more vibrant red. There was, however, a trade-off. Unlike wild cochineal, whose cottonlike nest allowed it to survive freezing temperatures and altitudes over 8,000 feet, the domesticated insect had only a thin coat of powdery wax on its back, leaving it extremely vulnerable to the elements. When exposed to frost or to a sustained heatwave, *Dactylopius coccus* often died. Nor could it tolerate constant rain and high humidity. Indeed, it was so delicate that an ill-timed shower could do it in.

What *Dactylopius coccus* liked best was the climate where it had been bred: the warm, dry climate of the southern Mexican highlands, where temperatures generally hovered between fifty and eighty-five degrees Fahrenheit. Yet even the inhabitants of those highlands found it difficult to meet the insect's exacting requirements. Frosts, though rare in the highland valleys, were deadly, wiping out whole plantations of cochineal in a single

ght, and the summer rains were similarly destructive. Farmers learned to time their harvests carefully, gathering and processing the cochineal before the rains fell. While they waited out the stormy season, they kept a clutch of pregnant females, known as cochineal *madres*, safe and dry in a corner of their homes, thereby assuring themselves of next year's crop. Some farmers carried the *madres*—protected in baskets lined with palm leaves—twenty or thirty miles up into the mountains, where they passed the summer in drier conditions.

Even when the weather was ideal, cochineal insects required work and care. Farmers had to "seed" or place nests of cochineal eggs onto cactus joints and protect the young nymphs from predators. They also had to weed out any wild cochineal that appeared, in order to prevent them from overwhelming their less hardy cousins.

The cacti required attention, too. The preferred host was *Opuntia ficus-indica*, but other opuntias were sometimes used, and all were susceptible to frost and rot. If they were not kept very clean, they succumbed to one of the many pests and diseases that preyed on them. Because cochineal insects did best on young leaves, farmers had to frequently prune the cacti to promote new growth. They also had to propagate new cacti, which involved cutting off a cactus leaf cleanly at the joint, allowing the scar to heal, and then planting the leaf in the ground. Eighteen months to three years later, the new cactus could safely be seeded with cochineal.

After seeding, domesticated cochineal took three to four months to mature. Farmers could count on two or occasionally three harvests a year, substantially more than could be expected from oak-kermes, St. John's blood, and Armenian red. Nor was cochineal as onerous to collect as these Old World kermes reds. Still, harvesting cochineal was at best a tedious business, one that could last for days or weeks, depending on the size of the nopalry. Before it began, a white turkey was sacrificed to appease

Coqueela, the god in charge of cochineal. Then laborers took up sticks, quills, and brooms and flicked the female insects into a widemouthed bowl made of wood or clay. Perhaps because of concerns about rot and other infections, it was considered bad form to touch either the cochineal or the cactus directly with one's hand.

After harvesting, the insects were spread onto mats and dried in the sun for four or five days. To hurry the process along, farmers could place the insects in ovens or heat them in steam baths called *temazcalli*. In each case, the cochineal shriveled up and died, losing a third of its weight in the process. It took as many as 70,000 dried insects—and sometimes more—to make one pound of dye.

Raising cochineal was hard work, but the ancient Mexicans considered it well worth the effort. Long before the Conquest, farmers were able to sell their cochineal in many marketplaces, exchanging it for fish, maize, chile peppers, and salt. As commerce developed, certain merchants from the southern highlands became specialists in the rare dyestuff. The powerful merchants of the town of Nochixtlán, for instance, developed an extensive cochineal trade that reached as far south as present-day Nicaragua. Complex and sophisticated, these ancient trade networks flourished for centuries, reaching what may have been a high point under the rule of the Aztecs, a warrior society that controlled much of ancient Mexico in the fifteenth and early sixteenth centuries.

The Aztecs practiced human sacrifice, a fact that has rendered them infamous ever since. What is less well known is that their capital, Tenochtitlán, was one of the world's largest, cleanest, and most imposing cities in the early 1500s. Gifted poets and musicians, the Aztecs were also master craftsmen, especially when it came to textiles and dyes. Most remarkable was their skill in dyeing feathers, which they used in the thousands to cre-

ate elaborate cloaks, shields, and headdresses in a multitude of colorful designs. Much of this work was done by women, whose families prayed to the gods—according to Aztec accounts—that their daughters would be skillful in learning to "dye feathers in varied colors: azure, yellow, rose red, light blue, black."

Like other ancient Mexicans, the Aztecs prized bright colors, and for them red held special allure. Indeed, one of their words for red (*tlapalli*) was also the word for color in general. In common with some European cultures, the Aztecs believed that red was the color of the sun, and they further identified the color with rituals of blood, death, and sacrifice. Although they had several red dyestuffs at their disposal—including weak forms of madder and another plant called *achiote*, or anatto—cochineal produced the most vibrant colors and was valued above all others.

The Aztecs called cochineal *nocheztli*, or "blood of the nopal"—a significant name, for the nopal cactus was central to Aztec identity and culture. They collected staggering amounts of the dyestuff as tribute from the chief centers of production. By the time of the Conquest, some records indicate that they were demanding over one hundred bags of cochineal a year from villages in Oaxaca and the Mixteca region; modern estimates suggest this may have amounted to over nine tons of cochineal, or more than a billion insects. Another district paid part of its tribute in cochineal-dyed cloth, 1,800 lengths every year.

The Aztecs used their cochineal tribute in a variety of ways. Doctors mixed the ground dyestuff with vinegar and applied it to wounds; they also prescribed it to cure a multitude of head, heart, and stomach problems. Cooks used cochineal to color tamales and other foods. Women used it to color their necks, cheeks, hands, and breasts. Some prostitutes even stained their teeth with it.

Aztec dyers used cochineal in their textiles, usually with alum as a mordant to make the color stick. Like the other insect reds, cochineal combined best with the proteins found in animal

fibers, rather than with celluosic plant fibers. Feathers and rabbit fur came out of the dyebath glowing red. But Aztec dyers also obtained admirable, though paler, reds on cotton, too.

Aztec scribes illustrated their colorful histories and genealogies with cochineal, among other pigments, and craftsmen throughout ancient Mexico used cochineal to decorate their work. Pots, statues, baskets, jars, dancing poles, and even houses—all bore the stamp of the brilliant red dye.

Indeed, cochineal was everywhere in ancient Mexico. No wonder, then, that when the conquistadors arrived in 1519 the dyestuff provoked both their admiration and their envy. Many of these conquistadors were poor men themselves, for whom bright colors were a luxury. Even their leader, Hernán Cortés, had no great claim to wealth. Born to a family with noble pretensions but little money, Cortés had arrived in the New World in 1506, a scapegrace young man with little more than his sword and his clever tongue to recommend him.

In those early days Spain's American empire was limited to a few islands in the Caribbean. When Spain decided it was time to add Cuba to that list, Cortés joined the 1511 expedition and won the favor of Diego Velázquez, who became the island's governor. But Cortés's chance for lasting fame—and infamy—did not arrive until 1518, when his patron Velázquez put him in charge of an expedition to the mainland.

Although Spaniards had gone to the mainland before, no one had succeeded in establishing a settlement there—and a settlement was precisely what Velázquez wanted, for in European eyes it would give him a permanent legal claim to the territory. But Velázquez had no wish to endanger his life in an enemy land. Instead he preferred to remain safely in Cuba while Cortés served as his agent, under a commission that made it clear that Cortés could not act on his own but remained subject to Velázquez's authority.

Dreaming of glory, Cortés chafed at these restrictions, and soon after he arrived in Mexico he found a way to enlarge his remit. In a remarkably devious yet entirely legal maneuver, he established the army's beach encampment as an official Spanish municipality and christened it Villa Rica de la Vera Cruz (Rich Town of the True Cross), or Veracruz for short. He then persuaded the army to "elect" a town council of his own choosing— a council that promptly relieved him of Velázquez's commission and elected him captain of the army and chief justice of Veracruz. Under Spanish law, this election made Cortés his own man: he no longer had to bow to the wishes of Velázquez but instead derived his authority directly from Spain. And since Spain was three thousand miles away, Cortés was, for the time being, virtually a law unto himself.

Not everyone supported Cortés's bold move, but the new chief justice found it easy enough to silence his critics: any conquistador who opposed him was chained in irons. Velázquez, however, proved a far more powerful and implacable enemy. As Cortés began his ambitious campaign against the Aztecs, the Cuban governor sent an army after the renegade officer—an army which Cortés promptly defeated. But Velázquez refused to give up. Through his agents in Spain, he petitioned the king to condemn Cortés as a traitor. Cortés, meanwhile, composed his own letter to the king, in which he explained that far from being a traitor, he was conquering one of the world's great empires in the king's own name. Mexico, he wrote to his sovereign, was as rich as the land "from which Solomon is said to have taken the gold for the temple."

Cortés's description owed more to wishful thinking than to fact, for at the time he and his men had done little more than engage in a few skirmishes in humble villages along the Mexican coastline. But if the coastline villages did not live up to his billing, Tenochtitlán came far nearer the mark. Entering the city as guests of the Aztec ruler Montezuma, Cortés and his men learned that Tenochtitlán was the repository of a seemingly end-

less stream of tribute from the surrounding region. Left to their own devices as palace guests one day, Cortés and his men quietly pried open a door that led to Montezuma's secret coffers. "Cortés and some of his captains went in first," the conquistador Bernal Díaz del Castillo reported years later, "and they saw such a number of golden jewels and plates and disks . . . and other very great riches, that they were quite transported and did not know what to say about such wealth." As for himself, Díaz wrote, "I took it for certain that there could not be another such store of treasure in the whole world."

If Montezuma's secret vaults were full of treasure, so too were the marketplaces of Tenochtitlán, where merchants sold everything from furs and feathered cloaks to pottery, honey, salt, and slaves. To the conquistadors, it seemed the very stalls glittered with gold and silver, while dyes and pigments made the marketplace a kaleidoscope of color. "There are many sorts of spun cotton, in hanks of every color, and it seems like the silk market at Granada, except here is a much greater quantity," Cortés reported to the king. "They sell as many colors for painters as may be found in Spain, and all of excellent hues." Desperate for royal attention and favor, Cortés had every reason to exaggerate the splendors of the world he meant to conquer, but Bernal Díaz del Castillo's more disinterested account of events confirms that the conquistadors were amazed by the wealth of dyes available in Aztec Mexico. More than thirty years after the Conquest, Díaz del Castillo remembered how he had marveled at the immense amounts of cochineal for sale in the great market of Tlatelolco, a suburb of Tenochtitlán. Like the other conquistadors, he called the commodity *grana*, the Spanish word for the most precious red dyestuffs.

As proof of his good faith, Cortés sent several shipments of Mexican plunder to his sovereign. In late October 1519, the first ship reached Spain. On board were five Totonac Indians—three men and two women—whom the conquistadors had saved from

sacrifice, only to send them half a world away from home. Accompanying the Totonacs were hundreds of treasures: gold collars strung with golden bells and set with jewels, great wheels of gold and silver, a helmet full of gold dust, feathered cloaks, and painted books whose dazzling pages almost certainly glowed with the rare, exquisite reds of cochineal.

In Mexico, meanwhile, Cortés and his men were struggling to conquer the empire that was the source of all these treasures. In 1521, they finally brought the Aztecs to their knees, with the help of an outbreak of smallpox and an alliance with Tlaxcala, a cochineal-producing province that was home to the Aztecs' fiercest enemies. Victorious, the conquistadors and their Tlaxcalan allies burned the moated city of Tenochtitlán to the ground and slaughtered most of its inhabitants. Grieving Aztec poets composed their laments:

> *The houses are roofless now, and their walls*
> *are red with blood.*
>
> *Worms are swarming in the streets and plazas,*
> *and the walls are splattered with gore.*
> *The water has turned red, as if it were dyed,*
> *and when we drink it,*
> *it has the taste of brine.*

For the Aztecs, red had become the color of defeat. For the conquistadors, it was a promise of riches to come.

FOUR

The Emperor's New Dye

 WHEN CORTÉS'S FIRST SHIPMENT OF booty arrived in Spain, it caused a sensation. Confiscated at the dock by officials who disapproved of Cortés's grandiose schemes, it was sent to Valladolid, the seat of the Spanish court, at the command of the king, Charles V. The king also requested that the Totonac Indians who had accompanied the treasure be sent to Valladolid, too, and that they be dressed warmly in velvet coats, gold stockings, and scarlet cloaks, in a manner befitting high nobility.

It took many weeks for the Totonacs and the treasure to reach Valladolid, but on March 3, 1520, they were together presented to the Spanish court. From the few accounts of the event that survive, it is clear that the court was fascinated by the Indians, though one archbishop was appalled to see that "the bodies of the men were pierced and cut all over." The jewelry, featherwork, and painted books also attracted a great deal of comment. "If ever artists of this kind have touched genius, then

45

surely these natives are they," the renowned scholar Peter Martyr
wrote to the pope. "In my opinion, I have never seen anything
which for beauty could more delight the eye."

What mattered most, however, was what the king thought,
for it was the king whom Cortés wished to impress. Getting his
attention proved difficult. Although the conquest of Mexico
would eventually be recognized as a pivotal event in human his-
tory, for Charles V it was merely a sideshow.

Only twenty years old, Charles was already considered the
greatest monarch of his day. "He alone on earth is King of
Kings," a Spanish bishop averred, the "grandson and successor of
seventy and more Kings." An exaggeration, to be sure, and yet it
was true that Charles had a bloodline that few in Europe could
equal. Grandson and heir to Ferdinand and Isabella, the great
monarchs of Spain, he also claimed two other blue-blooded
grandparents: Mary of Burgundy, heiress to one of the richest
regions in Europe, and Emperor Maximilian I, who had consoli-
dated the Habsburg dynasty that would rule over much of central
Europe for another four hundred years.*

Thanks to these illustrious ancestors, young Charles claimed
nearly half of Europe as his birthright. Yet if family was the making
of Charles, it was also the source of great sorrow. Many had con-
sidered his parents' match felicitous—his Flemish father, Philip the
Fair, was said to be the handsomest man in Europe, and his mother,
Juana of Castile, was destined to inherit the crown of Spain—but
the marriage was a disastrous one. Unfaithful to his wife, Philip had
attempted to rule over her kingdom with a heavy hand, only to die
of a sudden fever when Charles was just six. Some claimed that
Juana had poisoned her philandering husband—an unlikely story,

*The emperor counted among his lesser achievements the establishment of
Vienna's Spanish Riding School and the Vienna Boys' Choir. His many descen-
dants in the House of Habsburg included Archduke Francis Ferdinand
(1863–1914), whose assassination set off World War I.

though it was certainly true that Philip, when alive, had driven his wife half-mad with jealousy.

After Philip's death, Juana descended even farther into madness and melancholia, a victim of the mental illnesses that plagued Iberia's inbred royal houses. Refusing to bury her husband's body, she accompanied it instead on a macabre funeral tour of Spain, during which she insisted on opening the casket again and again. The people of Spain began calling her Juana *la loca*—Juana the Mad. Soon afterward, she was confined for life in a castle in Tordesillas.

With his father dead and his mother locked away, Charles was raised by his paternal aunt, Margaret of Austria, regent of the Netherlands. In this, at least, he had a measure of good fortune, for Margaret was one of the most extraordinary women of her day. Energetic and witty, she was experienced in statecraft and diplomacy, and she made a good guardian to her nephew.

As Charles grew up under Margaret's care, it became clear that he had inherited his father's athletic grace but not his good looks. When he was a child, Charles's lower jaw jutted out to an abnormal degree, and by the time he reached manhood his jaw was so massive that he found it a strain to keep his mouth closed. Instead he often let it hang open, prompting a common laborer to say to him in 1518, "Lord, shut your mouth, the flies of this country are naughty." Charles would later do his best to disguise the fault with a beard and mustache, but the "Habsburg jaw" would dog his descendants for generations.

A shy child, Charles had a strong sense of duty and a great gift for music. Contemporaries reported that he was a remarkably good singer, and he enjoyed his lessons at the keyboard so much that it was hard to keep him away from the spinet. Despite the problems posed by his jaw, he also mastered the flute and several other instruments. Yet as his responsibilities mounted, Charles frequently had to set his music aside. Shortly before his fifteenth birthday, he became duke of Burgundy. At sixteen,

upon the death of his grandfather Ferdinand, he was proclaimed king of Spain. As Carlos I, he ruled in the name of his mad mother, still confined in Tordesillas.

Young and gifted, Charles was nevertheless a great disappointment to Spain. He would later prove himself an accomplished linguist—according to legend, he once claimed to speak French with his ambassadors, Italian with his women, German with his stable boys, and Spanish with God—but at sixteen he understood little Spanish and spoke even less. His closest advisers were men from Flanders, Burgundy, and other parts of northern Europe, and to Spain's dismay he appointed many of these northerners to positions of influence in his new dominion. His taste in art and entertainment also owed more to his northern European upbringing than to Spanish ideals, and Spain's austere court was shocked by what they saw as the young king's outlandish ways.

Spaniards soon concluded the king's heart was not truly with them—which was no more than the truth. Although Charles was determined to do his duty by his mother's country, he had his eye on a far greater prize: the Holy Roman Empire, a vast dominion that was, in Voltaire's famous phrase, "neither holy, nor Roman, nor an empire." (The misleading name originated with medieval Frankish and Germanic rulers who saw themselves as the guardians of Western Christianity and the inheritors of Roman imperial authority.) In Charles's day, the Holy Roman Empire was a loose agglomeration of territories that stretched across Europe; at its core were the German principalities.

Charles's grandfather Maximilian I had reigned over this disparate empire for many years, but the title was not hereditary, being instead decided by seven electors—three archbishops and four noblemen from central Europe. When Maximilian died in 1519, a fierce contest for the imperial Crown followed, with the king of France setting himself up as Charles's chief rival. Other monarchs, including England's Henry VIII and the king of

Hungary and Bohemia, showed some interest in the title, but careful negotiation—and outright bribery—ensured that Charles was chosen as his grandfather's successor. As Emperor Charles V, he controlled the largest European empire since the time of Charlemagne—a vast realm that included Spain, Austria, Germany, Switzerland, and the Netherlands, as well as parts of France, Czechoslovakia, and Italy.

Having gained his empire, nineteen-year-old Charles now had to maintain it. Although he showed considerable talent for statecraft and strategy, the task was a trying one, since his motley dominion was at all levels a deeply disjointed and contentious place.

Spain, for example, was merely a recent and uneasy alliance of the realms of Castile, Aragon, Valencia, Catalonia, and Navarre, each of which had different dialects, traditions, and laws. The other territories that made up Charles's empire were, if anything, even more divided. Together, they proved nearly impossible to govern.

Within a year of his election as emperor, Charles was facing a revolt back in Spain, as city after city sought greater independence from the Crown. It took him nearly two years to regain control of the country, and soon afterward another revolt began in Germany. Meanwhile France attacked the western border of his empire, and the Turks advanced on him in the east.

As if these troubles were not enough, Charles became deeply involved in the most divisive issue of his time: the Protestant Reformation. At the Diet of Worms in 1521, he confronted the rebel monk Martin Luther, whose theses attacking the Catholic Church and the pope's authority were causing a great stir. When Luther refused to recant, Charles condemned him as a dangerous heretic. Although he granted Luther safe-conduct from the meeting, the young emperor pledged to defend the Catholic faith throughout Europe, whatever the cost.

Preoccupied by his European commitments, Charles gave little thought to the Crown's territories in the New World. In the

spring of 1520, however, he made time to meet the Totonacs and see the treasure that Cortés had sent him. He was apparently much impressed by both. Concerned that the Totonacs were doing poorly in the northern Spanish winter, Charles sent them back to balmy Seville, instructing his officials to "try very hard to make them happy." There one Totonac died, and the others boarded a ship bound for Cuba; what became of them once they reached that island is not known. The fate of the treasure is likewise murky, though it is known that when Charles left Spain that spring he took some of the hoard with him.

For all that Charles approved of Cortés's treasure, he made no attempt to settle the conquistador's dispute with Velázquez. Busy with other matters of state, he left the affair in the hands of the Council of Castile, which concluded, in typical committee fashion, that more information was needed before a decision could be made. In the meantime, Cortés was allowed to continue with his conquest, and his success in that endeavor ultimately persuaded the emperor and his advisers to rule in his favor. Soon after the news of Tenochtitlán's fall reached Europe, Charles appointed Cortés to the position of captain-general and governor of New Spain—"New Spain" being the official Spanish name for the Mexican territory he had conquered. Velázquez, meanwhile, was reprimanded for his conduct and made the subject of an official inquiry.

Though Charles was wary of sycophants—he later advised his son to "take heed of flatterers as you would of fire"—he must have enjoyed the enhanced prestige that Cortés's conquest brought him. As Cortés himself noted, Charles was now emperor not just of one world but of two. No doubt this way of putting things pleased the ambitious young sovereign. At any rate, he enjoyed collecting maps of his new American possessions.

What pleased Charles most, however, was the money his new empire supplied, money that helped bolster his position in Europe. In 1520, the emperor used some of Cortés's treasure to help pay for the royal fleet. The following year he received another lucrative

consignment from Cortés that included gold tribute for the royal treasury. Other shipments of Mexican treasure continued to arrive at irregular intervals throughout the 1520s.

Welcome as these remittances were, they were nowhere near what Charles needed to meet his commitments in Europe. To defend his faith and to hold his empire together, Charles needed enormous amounts of money—money for soldiers, money for arms, money for bribes. He had already spent nearly one million gold florins to win the title of Holy Roman Emperor, much of it borrowed from the Fuggers, the wealthy German family who had bankrolled his grandfather Maximilian. Charles would only become more beholden to them over time, as his military ventures put him deeper and deeper into debt.

Always shorthanded, the young ruler worried incessantly about finding the money to fight the battles that would save his empire and, as he saw it, Christendom itself. "However much I scrape and save," he wrote, "it is often difficult for me to find the necessary means." Desperate for money, he raised taxes wherever he could, yet there was a limit to how much he could ask from his subjects without triggering yet another revolt. Increasing his returns from the Indies seemed a safer course, and it was for this reason that he became interested in cochineal.

No one knows how news of a new red dyestuff first reached the emperor. Perhaps the possibility dawned on him in Valladolid as he looked at the first shipment of painted books and dyed garments that Cortés had sent him. He may also have learned something of cochineal from the conquistadors who brought those treasures back to Spain. Or perhaps one of his advisers overheard a rumor about cochineal dyes and passed it on to him.

However the news about cochineal came to him, the hard-pressed emperor could not afford to ignore such a promising source of income. Red dye, after all, was worth a great deal of money. Exported from Mexico, a dyestuff like cochineal could be sold in Europe, producing income for Spain and for Charles

himself. Charles may also have hoped that the cochineal dyes would boost the Spanish textile industry, which produced some of the best raw wool in Europe but lagged behind the Italian states in the manufacture of high-quality cloth.

According to the sixteenth-century Spanish historian Antonio Herrera, Charles sent Cortés a letter about the dyestuff in 1523. After detailing his many expenses, and his great need of money, Charles explained that he had heard that *grana* was abundant in Mexico. He instructed Cortés to see if the dyestuff could be exported to Spain, where it could produce "a great profit for the royal purse." In December of the same year, a royal official taking up an appointment in New Spain was instructed to find out how much of the red dyestuff was being produced in his province and how Spain might profit from it.

Such profits must have seemed all but certain, for by the end of 1523 cochineal itself had reached Spain. No one knows whether dyers performed tests on it, but royal officials regarded the Mexican dyestuff as true *grana* from that point on. Charles must have been pleased: his hunch that cochineal would produce "a great profit" seemed on the verge of fulfillment. But the emperor's plans for the new dyestuff were about to go awry. To turn cochineal into a gold mine, Charles needed the cooperation of the conquistadors who had toppled Tenochtitlán—but that cooperation was not forthcoming.

FIVE

A Profitable Empire

 CHARLES V WAS NOT THE ONLY SPANIARD with empty pockets. The conquistadors, too, were desperate for anything that could turn a profit. Even those who had come to Mexico in the hope of serving their faith and their God were generally after more worldly rewards as well. Most conquistadors wanted glory; even more, they wanted wealth. Cortés, who was funding much of the venture from his own purse, was unable to pay them salaries, but in time-honored Spanish tradition he had promised them a share of the booty—and both Cortés and his men expected such booty to be substantial.

Much as the conquistadors admired cochineal, what excited them most was gold, a substance that Renaissance Europeans valued above all else. Mined in Nubia and along the Niger, the amount of gold that reached Europe came nowhere near meeting Renaissance needs, for the European economy, spurred in no small part by the textile industry, was expanding at a tremendous pace. Consequently gold's purchasing power began to rise at a

spectacular rate: by 1500 a gold coin was worth, in goods and services, roughly twice what it had been worth a century before.

Some Aztec gold, given as gifts or stolen as plunder, began trickling into the conquistadors' pockets even before the Conquest was fully accomplished, and Cortés and his men were convinced that this small stream would widen into a mighty river once Tenochtitlán itself was defeated, making them all as rich as Midas. But when the Aztec capital finally fell, the booty was far less than the conquistadors had expected. Surveying the small hoard of gold surrendered by the defeated Aztecs—a heap of armbands, helmets, and disks—Cortés was dismayed. "Is this all?" he is said to have asked.

It seemed it was. Rumor had it that fleeing Aztecs were hiding gold and jewels in their ragged clothes, but when Cortés ordered guards to search them at the city gates, very little treasure was found. Nor was there much of value in the smoking remains of the city's once-proud palaces and marketplaces. All told, the conquistadors' plunder from the Mexican campaign amounted to a little less than 200,000 pesos—considerably more than had been gained from Spain's previous expeditions in the Americas but far less than the conquistadors had expected.

The money dwindled quickly. Twenty percent of the gold and jewels—the customary royal fifth, or *quinto*, to which the Spanish monarch was entitled—went straight to Charles V. Cortés claimed one-fifth of the remainder, then bestowed special payments on various senior captains. Ordinary foot soldiers were left with less than fifty pesos each—not even enough to buy a new sword.

To make matters worse, many of these foot soldiers had incurred serious debts while fighting under Cortés. Because the expedition was a private venture, they were responsible for their own expenses; some supplies came free, but they were expected to pay for services provided by the blacksmiths, notaries, tailors, apothecaries, and surgeons who accompanied the expedition. By

the time Tenochtitlán was conquered, some conquistadors found that these bills outweighed their share of the plunder. Although Cortés's lieutenants ordered that such men be given two years to settle their accounts, the fact remained that many conquistadors had nothing to show for the danger and hardship they had endured except debts.

Bitterly disappointed, the conquistadors began to look askance at their leader. Soon graffiti appeared on the white walls of the palace that Cortés had claimed for himself in the garden city of Coyoacán. "How sad will my spirit be till Cortés has given back all the gold which he has taken," one conquistador wrote.

Ever an astute judge of events, Cortés was acutely aware of how tenuous his situation was. His claim to authority, though officially based on his tricky legal maneuvers in Veracruz, ultimately depended on the support of his men; but his men, deprived of any real reward for their conquest, were growing more angry and restless by the day. Desperate to prevent a mutiny, he granted them something they wanted almost as much as gold and treasure: rights to the labor and tribute of the people they had conquered.

The conquistadors called these grants *encomiendas*, a term rooted in the Reconquista, Catholic Castile's medieval struggle against Moorish Spain. During this centuries-long crusade— which finally ended in Castile's victory over Muslim Granada in 1492, mere months before Columbus set sail for America—it became common practice for Castilian knights to receive temporary jurisdiction over the people who lived in the villages they had captured from the Moors. Patterned after this medieval *encomienda* system, Cortés's grants were eventually awarded to about half the conquistadors who survived the battle for Tenochtitlán, with the greatest number going to those men who had been with Cortés since the first days of the Conquest.

In Mexico, as in Spain, the men who held *encomiendas* were called *encomenderos*, and the grants they received involved certain

limitations. For instance, they held their villages as vassals of their sovereign; they did not own the land outright. Nor did they own the people who lived in the village; unlike slaves, the inhabitants could not be bought and sold. Instead *encomenderos* were expected to convert their charges to the Catholic faith and to maintain order, and it was in exchange for fulfilling these duties that they were awarded labor and tribute rights from their villages.

Its Spanish origins notwithstanding, the *encomienda* system grafted well onto existing Aztec practice. Having destroyed the Aztec lords, the conquistadors simply took their place at the top of the tribute pyramid. To facilitate a smooth transistion and to avoid any disruption in the flow of tribute, they made only minimal changes to the Aztec system, even going so far as to model *encomienda* tribute quotas on what the Aztecs themselves had demanded.

Some Aztec tribute items, such as quetzal feathers, were of little value in the post-Conquest world. Others, however, were the sort of goods that Spaniards could readily appreciate, such as gold, slaves, pearls, honey, and eggs.

Cochineal, by rights, should have been in this second, more valuable group. Like most military men of the era, the conquistadors treasured red cloth as a symbol of courage under fire. Even in the frontier outposts of the New World they paid top dollar for fine fabrics colored with the best red dyes. In 1520, one Spanish merchant in the Americas triumphantly reported to his Sevillian partner that he had sold fourteen yards of scarlet wool for breeches, and "3 ⅓ yards of crimson satin, at 3 pesos cash. Consider what a price!"

In other ways, too, cochineal was an ideal tribute commodity, not least because it was ripe for exploitation by transatlantic markets. Red dye was in high demand in Europe, and dried cochineal was durable, easy to transport, and had a high value-to-weight ratio—important considerations for an item that had to be shipped over long distances.

Cochineal, in short, offered the conquistadors a magnificent

opportunity to enrich themselves. But it was an opportunity they failed to grasp. Not only did the conquistadors make no concerted effort to develop a transatlantic trade in the dyestuff, but some could not even be bothered to collect what cochineal tribute belonged to them. Although cochineal remained a valuable article of commerce in the Americas, in the 1520s and 1530s the trade seems to have been dominated by Indian merchants and buyers, not Spaniards. Meanwhile, cochineal remained virtually unknown in Europe.

Why did the conquistadors neglect cochineal so profoundly? To a large extent, the answer lies in the ambitions of the conquistadors themselves—ambitions that were shaped by an explosive and protracted struggle with their emperor over how the wealth of Mexico, including cochineal, should be developed. The struggle took decades to resolve, and before it was over many Spaniards, including Charles, were forced to confront crucial questions about the morality of empire itself. Was empire supposed to benefit the conquerors or the conquered? Was an emperor bound to protect the interests of all his subjects? And what were the limits of imperial power in the Renaissance world?

IF THE BATTLE BETWEEN CHARLES V AND THE conquistadors was about the nature of empire, the chief bone of contention was the *encomienda* system. Though long accepted in Spain, the system as practiced in the Americas was already under serious attack by the time Cortés introduced it to Mexico in 1522. Leading the charge were Dominican clerics, who had recently convinced Charles V and his advisers that *encomienda* grants were archaic, ill conceived, and immoral.

The Dominicans' fierce opposition to the *encomienda* system had its origins in bitter experience, for they had seen the system at work in the Spanish Caribbean in the early 1500s. In Spain,

encomenderos who abused their power could be brought to heel by the Crown, but in the faraway American islands no such limits applied. Far from the king's reach and crazy for gold, *encomenderos* forced the islands' native people to leave their families and search for the precious metals in rivers and streams. Others repeatedly tortured, starved, and raped the people in their charge, turning the sunny Caribbean into a charnel.

"Tell me, by what right of justice do you keep these Indians in such a cruel and horrible servitude?" an appalled Dominican priest asked his Hispaniola parishioners in 1511. "Are these not men? Have they not rational souls? Are you not bound to love them as you love yourselves?" It was a clarion call for justice and mercy, but the *encomenderos* ignored it. Eventually, however, word of what was happening in the Caribbean reached Spain, in part through the efforts of another Dominican, Bartolomé de Las Casas, who was the Indians' most dogged advocate. Returning from the Caribbean to Spain, Las Casas worked his way into the circle of Charles V's advisers and recounted the abuses of *encomienda* to the recently crowned king.

Charles V had a keen appetite for Caribbean gold, but he also took his role as defender of the faith seriously, and he was disturbed to hear that his Caribbean subjects were not converting the Indians but destroying them. A canny politician, he also took exception to the *encomenderos'* unbridled appetite for pomp and power, which he considered a threat to his own authority as king. Urged on by Las Casas, Charles and his advisers decided to outlaw *encomiendas* in 1520. Existing grants were to be phased out, and in the meantime no new ones would be given.

Despite Charles's good intentions, little changed in the Spanish colonies. Enforcement was weak, and greed kept its stranglehold on the Caribbean. But the decree against new *encomiendas* was still on the books when Cortés conquered Mexico.

Never one to let the law stand in his way, Cortés had no qualms about resorting to questionable practices to avoid a mutiny. But

when Charles learned about the distribution of *encomiendas* he was outraged. In 1523, he wrote to Cortés with the order that all Indians were "to live in liberty, as our vassals in Castile live, and if before the arrival of this letter you have given any Indians in *encomienda* to any Christians, you will remove them."

Cortés refused to comply, shrewdly arguing that rescinding the grants would plunge the country into chaos. "The majority of the Spaniards who come here are of low quality, violent, and vicious," he wrote; only the incentives of the *encomienda* system, directed by the firm hand of Cortés himself, could keep them in check. If the emperor instead followed the advice of Las Casas and delivered Mexico into the hands of unworldly priests, the work of conversion would be undone, the orderly collection of tribute would end, and the Crown would see little profit—spiritual or financial—from its American empire. Indeed, it might even be forced to withdraw from that empire altogether. Far better, Cortés argued, to keep *encomienda* and reform it from within.

Charles was not swayed, at least not at first. Yet the pragmatic force of Cortés's arguments could not be denied. *Encomienda* grants, once given, could not be easily taken away—and how else was Spain to pay the conquistadors and hold the territory it had gained? Conscious of his own empty coffers, Charles by 1526 had accepted the *encomienda* system as an unfortunate reality.

Charles did, however, resist Cortés's request that he confirm all *encomienda* rights in perpetuity to their owners and descendants. Consequently, the grants lasted only for a few years at a time throughout the 1520s. The effect of this shortsighted policy ran exactly counter to what Charles wanted to see in the Indies. With little incentive for learning how to maximize the long-term production of tribute, the *encomenderos* instead plundered their towns and villages for all they were worth, then squandered the takings on fine houses, fast horses, and high living.

What happened to the cochineal business during this Wild

West period is not entirely clear; swordsmen bent on booty do not make the best record keepers. But since cochineal was a commodity that required patience, market savvy, careful accounting, and serious investment from dealers, it would not have held much appeal for conquistadors on the make in the freebooting 1520s. Conquistadors who received cochineal as tribute had neither the skill nor the desire to market it themselves; instead, they probably sold it for quick cash to local indigenous dealers. Moreover, the evidence suggests that the conquistadors preferred collecting other tribute goods instead: commodities like corn or honey that they themselves could eat right away, or better yet gold, silver, and jewels, which had a luster all their own.

A case in point is Hernán Cortés himself, whose vast *encomienda* grants included villages in Oaxaca that had provided large amounts of cochineal tribute to the Aztec rulers. Cortés had a taste for rich scarlet trappings: he had directed the last siege of Tenochtitlán from a tent with a crimson canopy, and a 1529 inventory reveals him as the proud possessor of a doublet with scarlet velvet sleeves, a coverlet made with scarlet and olive-colored cloth, and various garments decorated with scarlet facings and embroidery. Yet it was not for the sake of the red dyestuff that he had claimed the Oaxacan villages. What Cortés wanted instead was gold, for Montezuma had told him that the villages were rich in the precious metal. Throughout much of the 1520s, Cortés received tribute worth 5,000 pesos a year from them, most of it apparently paid in river gold mined by the villages' Indians. In two letters from 1527, Cortés stresses the importance of the villages' gold tribute and his immediate need of it, but he says not one word about cochineal.

Cortés's situation was a uniquely favored one. As a rule, *encomenderos* had much more modest tribute entitlements, some of which were quickly depleted after a few years of shortsighted pillage. Yet even *encomenderos* who found themselves in serious financial distress were unlikely to devote themselves to the art of trading

in undervalued commodities like cochineal. Instead, like the soldiers they were, they joined expeditions bound for Honduras, Guatemala, Ecuador, and Panama, seeking once again to make their fortunes with their swords. It was still the age of Spanish conquest, an age that reached a dramatic climax with the conquest of Peru in the early 1530s, when Francisco Pizarro and a small band of Spaniards took advantage of an Incan civil war and became rich on Peruvian silver and gold.

Audacious though it was, Pizarro's venture nevertheless marked the end of an era. After Peru, most would-be conquerors encountered slim pickings, and many Spaniards began to think twice about risking their lives for such uncertain rewards. Some, indeed, had grown weary of conquest long before. In 1527, Maestre Baltasar, a barber-surgeon on campaign in Ecuador, wrote to his brother in Panama, "I wish to God, though it cost me a finger of each hand, that I could be there [with you] and settle accounts, since it would save my life and I would escape from great bad fortune, hunger, and hardship." He asked his brother to find a way to obtain his release because, as he explained, "I have done all I am obliged to, and am married, and they have held me by force for more than a year and a half."

Other conquistadors apparently shared Maestre Baltasar's sentiments. Disillusioned with conquest and often fearful for their lives, they did their best to be called back to established bases in Panama or Mexico. Some even returned home to Spain. Yet for most conquistadors, returning to Spain was an unattractive option. Many were dispossessed swordsmen, second sons of second sons, threadbare adventurers born into poverty, who could expect nothing in the way of patrimony back home. They were better off in America, especially if they owned *encomiendas*, however paltry, for there was always a chance that they could build their holdings into the kind of estates that would command respect even in Spain itself.

With these thoughts burning in their minds, by the 1530s

many conquistadors had begun to take a new look at how they
made money from their holdings. In this they were encouraged
by a sea change in Spanish imperial policy—a change that took
place soon after Cortés, the greatest conquistador of them all,
met his downfall.

In his letters to the emperor, Cortés signed himself fulsomely
as "Your Sacred Majesty's very humble servant and vassal who
kisses the Very Royal feet and hands of Your Highness." Yet
Charles had long had his doubts about Cortés's loyalty. Here,
after all, was a man who held an entire empire in his safekeep-
ing—a man, moreover, who had an alarming tendency to take
the law into his own hands. In 1526, Charles and his Council of
the Indies started to rein Cortés in, launching an inquiry into
Cortés's conduct as governor. Soon afterward, the council estab-
lished a royal court of appeals in Mexico City, which replaced
Cortés as the highest civil authority in New Spain.

Cortés emerged from the royal inquiry with his title as captain-
general of New Spain intact. Created a marquis at the emperor's
command, he not only held on to most of his *encomienda* grants but
was granted them in perpetuity, a privilege that no other
encomendero was offered. Nevertheless, his star was on the wane. He
lived for another two decades, dying in 1547, but his last years were
bitter ones, for he never enjoyed real political power again.
Overlooked by the emperor and his councillors, he was forced to
stand by as the court of appeals passed new laws that superseded his
own previous dictates. When the first viceroy of Mexico was
appointed in 1535, Cortés was not even considered for the post.

Cortés's close allies no doubt mourned his fall from power, but
for many Spaniards in America his loss was their gain—because
once Cortés was neutralized, Charles was at last willing to tolerate
a general expansion of *encomienda* rights. In the late 1520s and
1530s, *encomiendas* were first confirmed for life, then permitted to
pass to a conquistador's widow or child. Although further genera-

tions were not allowed to inherit, many *encomenderos* hoped this aspect of law would also change in time.

These adjustments in imperial policy gave the colony of New Spain a certain stability it had lacked in the wild years immediately after the Conquest. In the late 1530s, however, Charles had a change of heart. To some extent, the change was prompted by political concerns: he feared that the *encomenderos* were gaining in wealth and power at his expense. But he was also troubled by reports that Mexico's Indians were suffering under the *encomienda* system, and his worries on this score were amplified by many eminent Spanish scholars and clerics.

These Spaniards were right to be concerned, for a tragedy of staggering dimensions was overtaking Mexico's people. Exposed to Old World diseases like smallpox and measles, they were literally dying by the millions, and *encomendero* abuse increased the toll. In some districts, half the native population died in the quarter century after the Conquest; in others, the death rate exceeded 90 percent.

Such a holocaust, even today, is difficult to comprehend. In the 1530s, as the catastrophe was unfolding, few people grasped what was happening. Nevertheless, Charles and many other Spaniards were unsettled by the stories of death and abuse that reached them. Strongly influenced by Renaissance humanism— which had a large following in Spain—some scholars questioned whether Spaniards were doing right by the Indians. Others went farther and questioned the entire basis of Spanish rule in the Indies. "The Emperor is not the lord of the whole world," argued Friar Francisco de Vitoria, the popular chair of theology at the University of Salamanca. "And even if he were, he would not therefore be entitled to seize the provinces of the Indians, to put down their lords, to raise up new ones, and to levy taxes."

Charles V ordered his subordinates to "silence these friars," but he could not completely silence his own conscience. Although he

had no intention of giving up his American empire, he gradually became convinced that he had angered God by not taking his responsibilities to the Indians more seriously. Remarkably for a man in his august position, Charles was able to learn from his critics. In the early 1540s, he turned to Francisco de Vitoria for advice on Indian policy. He also consulted Bartolomé de Las Casas, who had remained the Indians' most tireless supporter for more than twenty years. Their opinions, along with a series of papal bulls that condemned Spain's Indian policy, led Charles and his advisers to rewrite the laws of the Indies in 1542. The Leyes Nuevas, or New Laws, essentially abolished the *encomienda* system.

Had the laws been enforced, they would doubtless have improved life for many Indians. But when angry Spanish colonists demanded that the Crown repeal the new code, Charles smelled revolt in the air and backed down, just as he had done with Cortés in the 1520s. The New Laws were scaled back, and the *encomienda* system became legal once again.*

There was, however, a Pyrrhic quality to the *encomendero* victory. While they had retained their right to Indian tribute, such tribute was falling fast, in direct consequence of the demographic catastrophe that had prompted Charles to enact the New Laws in the first place. Between the early 1520s and the late 1530s, some *encomenderos* had seen tribute receipts fall by half. As mortality rates continued to rise, others saw their villages effectively disappear from the map. Either way, most *encomenderos* soon realized that tribute collection, by itself, was no longer the high road to riches. To make the most of their two generations of possession, they needed to find other ways to develop their holdings for long-term profit.

*There were a few restrictions that remained even in the revised version of the New Laws; for one, *encomenderos* could no longer demand any kind of labor from their Indians; for another, their tribute quotas were now more strictly regulated. Yet the *encomenderos* had essentially won their case.

They refused, however, to consider raising cochineal. To Spaniards, this did not seem the pursuit of a gentleman, and to them gentility was everything.

To improve an *encomienda* was easier said than done, since technically the grants did not give *encomenderos* ownership of the land, merely the right to use it in certain ways. They could, however, build houses or mills on their holdings, or use the land for farming and grazing. Sometimes *encomenderos* or other Spaniards even managed to buy the land outright, creating an estate that could belong to their families forever—giving them additional incentive to forgo quick plunder for longer-term rewards.

Whether they owned their estates outright or only through *encomienda*, the conquistadors were slowly metamorphosing into businessmen. The difficulty lay in making their estates pay without compromising their status as gentlemen. By now, they considered themselves men of standing, *hidalgos* of some repute, and the fact that most had attained their position through conquest, not birthright, only made them more determined to adhere to Iberian codes of upper-class conduct. Like the grandees of Old Spain, they wished to avoid anything that smacked of manual labor. To them, the only acceptable occupations were mining, ranching, and estate agriculture—provided, of course, that Indians and servants did most of the dirty work.

What made these occupations acceptable to the conquistadors was, in part, their familiarity: they involved technologies, animals, and crops that the conquistadors had known in Spain, and that were regarded with a certain amount of respect in Europe.

Among agriculturalists, for example, the gentlemen who were most admired were those who owned large, prosperous

estates and produced wheat, sugarcane, grapes, flax, and other
European crops that Spaniards had introduced to Mexico. Men
who grew Indian crops were not regarded with the same respect,
which was one reason why cochineal production continued to
hold little appeal for Spaniards in the Americas. Consequently,
their ignorance of the dyestuff remained profound. The art of
cochineal cultivation was a complete mystery to them.

It was, moreover, a mystery few Spaniards cared to unravel.
The only way to learn about cochineal was to consult the Indians,
for cochineal was a crop with few Old World parallels; only the
other insect reds were in any way related, and their cultivation
was markedly different from that of cochineal, besides being vir-
tually unknown among Spaniards. But for most Spanish settlers,
consulting the Indians was out of the question. As a rule, they
avoided situations in which they would be the students, and the
Indians the masters. It is possible, too, that many Indians
rebuffed Spaniards who showed curiosity about cochineal. Like
their counterparts in Europe, Indians in the color trade were
probably reluctant to share their secrets with anyone outside their
own circle.

In any case, most conquistadors refrained from cultivating
the insect and from becoming seriously involved in its trade.
Even in districts where cochineal had been cultivated for cen-
turies, they preferred instead to raise sheep, cattle, or European
crops. In Oaxaca, for example, Cortés did not regularly collect
the cochineal tribute that his towns had provided since Aztec
times, and he never became involved in the cochineal business.
Instead he set some of his subjects in Oaxaca's cochineal districts
to raising Spanish wheat, cattle, and silkworms when their gold
ran out. And most of his entrepreneurial efforts were expended
on other districts, where he used Mexican and African slaves and
encomienda laborers to mine silver, grow sugarcane, and build
flour mills.

As far as the conquistadors were concerned, the Mexican

dyestuff could not compare with the glint of metal or the shaggy sides of a hundred thousand sheep. Ironically, the very qualities that made these Spaniards prize the color red—their delight in status and ceremony, their admiration for noble rank, and their sense of pride and dignity—had made it almost impossible for them to conceive of getting their hands dirty in the cochineal trade. Still less did they wish to produce the dyestuff for themselves.

For the most part, Charles and his counselors seem to have accepted this state of affairs. After their initial inquiries about cochineal in the early 1520s met with little response from the conquistadors, they let the matter drop. Although royal instructions given to Mexico's viceroys in the 1530s and 1540s addressed many agricultural and economic matters, they never mentioned cochineal.

Yet if cochineal seemed doomed to neglect from Spaniards, the Indian market for the dyestuff persisted. Supplied by *encomenderos* who wanted quick cash for tribute cochineal and by Indians who cultivated the dyestuff on their own account, Indian merchants adhered to their time-honored trade despite the devastating disruption of the Conquest and the outbreaks of disease that followed. Spanish records reveal only the barest outlines of this trade, but we know that Indian merchants sold cochineal in Mexico's marketplaces, and they probably continued to engage in long-distance trade, too.

At first, the majority of the Indian merchants' customers were most likely Indians themselves: not only painters, dyers, and cooks, but also petty traders who hawked small amounts of the dyestuff in tiny stalls or on the streets. Yet by the mid-1530s, more and more Spanish merchants were pouring into New Spain—and unlike the conquistadors, who were inspired largely by the feudal past, these merchants and their agents had a keen appreciation of the opportunities afforded by innovative commodities such as cochineal. By the early 1540s, and possibly a bit earlier, they were buying the dyestuff from Indian merchants and

sending small but regular consignments overseas to Europe. There, after a transatlantic journey of more than three thousand miles, the shriveled grains of cochineal—smaller than peppercorns, dry as blackened bone—were at last unloaded on the docks of the great Spanish port at Seville.

SIX

Cochineal on Trial

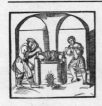 **FAMOUS FOR ITS FLOWERING ORANGE** trees and filthy streets, Seville had been Spain's official transatlantic port since 1503. By decree, all New World voyages started and ended at the city, and all American commodities—including cochineal—were unloaded and registered there.

That the Spanish Crown desired an official port was not surprising, for centralization made it easier for royal officials to regulate and tax the American trade. Seville, however, was an unlikely center of oceangoing commerce. Twenty leagues inland from the Mediterranean, it was centered on the muddy, shallow Guadalquivir, a river notorious for its sandbars. Yet Seville, for all its navigational failings, offered a number of significant advantages not found in other ports with deeper harbors and better access to the Atlantic. Not only was it well protected from pirates, but its location in the grain-rich region of Andalusia made it ideal for provisioning ships, and it boasted some of the most sophisticated markets in all Spain.

Sophistication, indeed, was a keynote of Sevillian life. "*Quien no ha visto Sevilla, no ha visto maravilla,*" Spaniards said. "He who has not seen Seville, has not seen a wonder." Captured from the Moors in 1248, the city was undoubtedly both Spanish and Catholic, yet everywhere it was marked by the complex imprint of five hundred years of Arab rule. Moorish tiles glorified the walls of the royal palace, Moorish fountains cooled the city's walled court-yards, and Moorish rhythms echoed in the region's anguished music. Even Seville's cathedral, seat of the Spanish Inquisition, owed much to Moorish influence, for its bell tower, the famous Giralda, had once been the minaret of Muslim Seville's great mosque.

After Seville was named Spain's official New World port, its cosmopolitan atmosphere became even more pronounced. Foreigners and Spaniards alike poured into the city, hoping to become involved in the greatest economic venture of their time. Dubbed the "new Babylonia," Seville became the decadent capital of a new golden age. In its streets and alongside its docks, trades-men, sailors, and soldiers of fortune mingled with vagabonds, pros-titutes, and assassins. Beggars roamed the city in inordinate num-bers, feigning disease or madness to earn their bread. The city also played host to a wide and varied brotherhood of thieves—including the *cortabolsas*, who stole purses; the *capeadores*, who stole cloaks; and the *devotos*, who (oddly enough) went after religious images.

But it was not only thieves who gave Seville its reputation for corruption. Its womenfolk, too, were a cause for concern, for as Sevillian men emigrated to the New World in droves, their wives, mothers, and sisters were left to manage affairs in their absence. Many of these women took advantage of their new freedom to make investments, buy property, and run businesses. By 1525, Seville was said to be a city "in the hands of women"—which the conventional considered a sure sign of moral decline. Yet the offenses of Seville's women paled beside those of its merchants. To the archbishop's indignation, they insisted on doing business in the

shadow of the city's cathedral; on rainy days they met in the nave of the cathedral itself. In 1598, they would move to a new building, built specifically for their trading, but until then the moneychangers remained in the temple, to the great consternation of the pious.

Even the pious, however, were drawn into the rhythms of Seville's commercial life— rhythms that were in large part controlled by the ebb and flow of traffic along the Guadalquivir. During the first half of the sixteenth century, there was no regular schedule of fleets, but each time a convoy of ships prepared for a voyage to the New World, the city hummed with activity. Shipwrights made repairs, captains searched for crew members, and merchants sent their agents scurrying to find provisions and cargoes for the journey. Salt cod, ship's biscuit, wine, oil, rope, gunpowder, ironware, paper, shoes, wax, cheese, bolts of cloth—stevedores loaded all these and more aboard the departing ships. Once the vessels had departed, the city's pulse returned to normal, only to quicken again when the ships returned from the New World, laden with exotic cargo.

Yet if Sevillians dreamed of New World treasure, the actual returns were disappointing during the early decades of empire. Although the conquistadors welcomed Spanish vessels and the goods they brought, they were not often inclined to restock the ships with marketable American commodities and send them back across the Atlantic. Even worse, from the merchants' point of view, was the conquistadors' habit of cannibalizing their ships. Because ship timber, iron fittings, and cannon were much in demand in the New World, many a Spanish vessel reached America only to be sold for scrap after it had arrived. Desperate for replacements, Sevillian merchants pressed clapped-out galleons into service. Overloaded and undermanned, they foundered at sea, producing staggering losses for all concerned. It was only in the 1540s that this shipping crisis eased, allowing the riches of America to freely pour into Seville.

Silver from newly discovered mines—especially the immense

and legendary mine at Potosí—made up the lion's share of the American riches that landed in Seville. But the Spanish colonies produced other exports, too, including sugar, pearls, indigo, hides, tallow, tobacco, and cochineal.

Tobacco, of course, was a somewhat puzzling commodity. New to Europe, it had no merchants who were expert in its qualities, nor did it have established routes of commerce; consequently it took time to achieve wide popularity. Cochineal, by contrast, seems to have been rapidly accepted by Seville's merchants, for their city had long been a center for the trade of kermes and other red dyestuffs. No doubt relying on the connections they had already developed in the business, they quickly put cochineal into the hands of Europe's dyers.

The first European dyers to work with cochineal were almost certainly Spanish, but if Spain's dyers had hoped to keep the new dyestuff to themselves, those hopes were soon dashed. Although cities like Segovia, Toledo, and Granada produced some fine fabrics, the Spanish textile industry was continually hampered by a lack of skilled workers. Trying to make the best of a bad situation, the Crown commandeered beggars and vagrants as wool shop workers, but the problem of skilled labor persisted, and prices for Spanish textiles remained high—a situation that would only worsen as inflation sent Spanish prices skyrocketing after 1550. Hamstrung by the labor shortage and by a national economy in crisis, Spanish cloth workers could make only limited use of cochineal. Instead, the merchants of Seville took to selling cochineal abroad, especially to Italians, who were always on the lookout for a new and promising red dyestuff.

To be sure, some dyers balked at buying an untried commodity. In 1543, for instance, the dyers' guild of Genoa scorned the new "mixture or composition that is called Indian kermes," ruling that it could not be used to dye silk. Yet many other dyers were eager to experiment with cochineal. Like the merchants of New

Spain, they understood the value of innovation; indeed, their cutthroat profession demanded it. In skillful hands, cochineal might yield profitable secrets, and no dyer wanted his rivals to steal a march on him. Across Italy, dyers quietly began to subject the "kermes and powder of Spain" to rigorous trials.

One of the earliest dyers to test cochineal's properties was a Tuscan by the name of Lapo da Diacceto, who applied cochineal dyes to silk in the early 1540s, with vivid and striking results. Similar experiments in Mexico in 1537 had failed to elicit much response from the conquistadors, but in Italy, where luxury textile production was considered a matter of the utmost state importance, the reaction was immediate and powerful. The most formidable man in Tuscany, Cosimo the Great—duke of Florence and head of the Medici family—became the dyer's sponsor. Da Diacceto continued with his experiments in secret, protected by the Medici name.

Outside the Medici domains, other Italian dyers were hot on his heels, including the Venetians. Since Venetian merchants dominated the trade in kermes reds, and since Venetian dyers were famous for the scarlet cloth made with those reds, the city had every reason to look askance at any dyestuff that might threaten the status quo. But Venetian merchants and dyers had not achieved their renown by ignoring new technologies. Having heard rumors of cochineal's great affinity for silk, they wished to see for themselves whether the American dyestuff could yield a color equal to their own Venetian scarlet.

In February 1543, an enterprising silk merchant and a distinguished citizen presented three samples of cochineal to the Venetian silk guild. Each sample had a different name—*uchimil-lia*, *cochimeia*, and *panucho*—possibly indicating slight variations in the place of origin. It was also true, however, that in 1543 cochineal was too new a commodity in Europe to have a settled name. Only later in the century would the term for the dyestuff

be firmly established as *grana cochinilla*, or cochineal.* Despite
the bewildering profusion of names, the two men attested that all
three kinds of *grana* had been "grown in the Indies of the
Emperor's Caesarian Majesty," Charles V. They wished the guild
to test them, "to see their good quality, if they are really kermes
or not."

Their request was straightforward enough, since it was stan-
dard practice for Venetian textile guilds—like top guilds else-
where—to examine and regulate new dyestuffs, new suppliers,
and new dyeing techniques. In the case of cochineal, however,
the silk guild acted with uncommon speed, perhaps because the
Mexican dyestuff was already regarded as a commodity of
unusual importance. That same day guild officials gave a master
dyer three skeins of silk, to be prepared for dyeing by the follow-
ing Monday, when the trial would officially commence. In the
meantime, they left the cochineal to soak and soften in three
basins of water, which were placed under lock and key in a cabi-
net in the guildhall.

Three days later, on Monday, February 12, the trial began. Six
master dyers—including the dyer who had prepared the three
skeins of silk—came to the guildhall, where they applied a different
sample of cochineal to each skein. Once the skeins dried, the dyers
compared them to a reel of the highest-quality crimson silk, dyed in
the traditional way. Cutting threads from each of the samples, they
placed them "over the fire," in order to more fully assess their char-
acteristics. When all this was done, the master dyers attested under
oath that the three cochineal samples had produced a dye as good
as the best traditional kermes reds.

*The exact origins of the term *cochinilla* remain a mystery. One sixteenth-century
Spaniard suggested that it was derived from the Latin word *coccus*, meaning
"scarlet dye"; other scholars have speculated that it comes from the Latin *coc-
cineus*, meaning "scarlet-colored." In Spanish, *cochinilla* literally means "little
pig," and the term is applied not only to cochineal itself but to a crustacean that
cochineal resembles, the woodlouse.

Their statements, filed in guild archives along with the dyed silk and cochineal samples, were based solely on what Venetian artisans and guild officials could see with the naked eye. Yet in the twentieth century, when it finally became possible to analyze the structure of the kermes and cochineal dyes at the molecular level, scientists would reach similar conclusions. To this day the exact composition of these highly complex dyes is disputed, but chemists agree that their primary dyeing agents are closely related. The color of oak-kermes, for example, is produced by kermesic and flavo-kermesic acids, both of which have a chemical structure similar to that of cochineal's chief ingredient, carminic acid; trace amounts of kermesic acid are found in cochineal dye, too. St. John's blood, which contains a mixture of kermesic and carminic acids, is an even closer match for cochineal. The closest match of all is Armenian red, whose chemical composition is almost identical with that of cochineal dye.

The fact that cochineal most closely resembles St. John's blood and Armenian red is important, for Renaissance dyers seem to have set special store by these reds. Their high carminic acid content seems to have produced deeper and more lustrous reds than those produced by kermesic acid, especially on silk, the most luxurious of all fibers.

But cochineal had three advantages that St. John's blood and Armenian red lacked. First, cochineal insects produced their carminic acid with far fewer lipids than did the plump little Armenian insects, whose fat melted in the dyepot and sometimes coated the threads of silk, preventing the fibers from fully absorbing the dye.* Second, cochineal could be more efficiently

*According to the German dye specialist Harald Böhmer, Armenian red insects contain up to 50 percent lipids, an unusually high figure that has produced some startling results in the laboratory. Having located and harvested some of the Armenian insects in 1990, he processed them by cooking them in a lab oven. "This brutal treatment," he wrote, "produced a pleasant odor of fresh roast throughout the department and down the hall."

produced than either St. John's blood or the Armenian dyestuff, and it could be harvested several times a year. Third—and most important—cochineal yielded a far more powerful dye than any of the Old World reds. Though roughly similar in cost, ounce for ounce it was ten times more potent than oak-kermes and St. John's blood. It produced up to thirty times as much dye per ounce as Armenian red—a fact which must surely have caused dyers to marvel.

Cochineal, in other words, was the closest thing Europe had ever seen to a perfect red. Besides producing striking scarlets and crimsons, it could be made to yield soft pinks and roses, which appeared very fragile but which were in fact very fast. Within a few years, top artisans in Venice, Milan, Florence, Lucca, and Antwerp were said to be using it daily, incorporating the dyestuff into new secret formulas which they applied to rich velvet, sleek satin, and crisp taffeta. Soon even the dyers of Genoa lost their distaste for the "Indian kermes." Worried that they were losing the business of customers who wanted cochineal, they legalized its use in 1550.

Not everyone, however, could be persuaded to join the cochineal camp. Some Frenchmen called on their compatriots to reject the dyestuff, arguing that it was a wasteful foreign luxury that depleted the country's store of bullion; they also worried it would destroy the market for French madder. In Venice, too, many merchants resisted the new commodity, fearing the damage it would do to the city's long-established trade in Old World kermes reds. Largely due to their opposition, the Venetian government forbade the use of cochineal on wool in the 1550s and 1560s. But such rules had little effect. To dyers, results meant far more than government rulings, and the results produced by cochineal were second to none.

By the 1570s, even the dyestuff's enemies were forced to admit that the cochineal business had become one of the most dynamic enterprises in Europe. Large stocks of cochineal could be found not only in Seville but in Rouen and Antwerp as well,

and lively markets also existed in dozens of other European cities, including Genoa, Florence, Marseilles, Nantes, and Lyon. Before the century was out, even Venice had capitulated to cochineal, and Venetian galleys laden with the dyestuff could be seen on the Adriatic. The amount of cochineal arriving in Seville each year—the key determinant of cochineal's price—became a matter for international speculation among merchants, bankers, and high-ranking diplomats.

Further proof of cochineal's importance in European markets was the appearance of cartels devoted to cornering the market in the dyestuff. This was worrisome enough on a regional level, but in 1585 two merchant families—the Capponis of Florence and the Maluendas of Burgos—together succeeded in creating a cochineal cartel that spanned most of Europe. Like most maneuvers in the dye trade, their cartel began as a covert operation. Having surreptitiously learned that the annual fleet had left New Spain with an unusually low amount of cochineal, the two firms sent out express couriers ordering their agents in Seville, Italy, France, and Flanders to quietly snap up every ounce of the dyestuff they could find. After these agents had secured most of Europe's existing stock of cochineal, as well as a large proportion of the incoming shipment, the Capponis and Maluendas substantially raised the asking price for the dyestuff. At first artisans and lesser merchants balked at the cost, but those who depended on cochineal for their livelihood—and who had enough money to meet the price—eventually gave in. Until the next harvest of cochineal arrived in 1586, European cloth makers remained at the mercy of the Capponis and Maluendas, who profited greatly from their monopoly.

What made the Capponi-Maluenda cartel so successful was the fact that cochineal had become indispensable to the production of high-quality fabric. As early as 1550, many fashionable Europeans were insisting that their red cloth be made with cochineal. Demand grew rapidly over the next few decades, mak-

ing the dyestuff's conquest unusually swift and complete: by 1580, cochineal had driven the traditional kermes reds to the fringes of the European textile market. The priest's red velvet chasuble, the dandy's red satin sleeves, the nobleman's red silken draperies, and the countess's red brocade skirts—all were now colored with cochineal.

THE INTENSITY OF EUROPE'S RESPONSE TO COCHINEAL is all the more remarkable given the rise of black as a fashionable color in the sixteenth century—a somber trend that owed a great deal to the emperor who claimed the land in which cochineal was produced. On his father's side, Charles V was a Burgundian, and it was in Burgundy that black had first made its appearance as chic court garb. In the fifteenth century, the duke of Burgundy had taken to wearing black in order to set himself apart from his colorful courtiers; to ensure that there was no confusion about his status, he had worn only the finest and most expensive cloth. Inspired by this example, Charles also dressed for most of his reign in fine black garments, which he paired with a stiff white neck ruff. He may also have felt that this costume reflected his grave religious responsibilities as defender of the Catholic faith.

As Europe's greatest monarch, Charles was the man of the hour. Whatever he said or did was worth noting, and once noted, worth imitating. Soon black suits and white ruffs—the "Spanish fashion"—had been adopted not only by Spanish grandees but by trendsetting aristocrats across the Continent. Other neutrals and muted colors also became fashionable, a change that can clearly be traced in the wardrobe accounts of England's Elizabeth I. Daughter of the peacock-bright Henry VIII, she wore red and crimson in her youth, but after she ascended the throne in 1558, she dressed primarily in white, black, and gold, as well as subdued colors such as peach, ash, and tawny.

Yet despite these changes in fashion, the European market for high-quality red dyestuffs remained substantial. This was not only because they were sometimes used, with other dyes, to make the finest grades of black cloth, but because red itself remained extremely popular among the highest echelons of European society. For all its cachet, black and other neutrals were apt to be confused, at least at a distance, with the clothing of the poor and penitential. To avoid such embarrassment, some aristocrats, particularly women, continued to clad their entire persons in scarlet and crimson. Other elites conveyed a sense of majesty by combining their black-and-white garb with a splash of these valuable reds.

Among the many people who enhanced their black with red was Charles V, as a famous 1548 portrait by Titian, the greatest colorist of his age, demonstrates (see fig. 5). In the painting, which commemorated the emperor's victory over the Protestants at Mühlberg, red and black are everywhere evident. Charles's black-and-gold armor is set off by a magnificent red plume, red scarf, and red sash; his dark warhorse is bedecked with a red plume and a red-and-gold saddle cloth; Charles holds the horse in check with red reins. Even today, the medley of red and gold and black conveys the impression of great power and wealth, all the more since the portrait is life-size. Charles liked the painting so much that he paid Titian the princely sum of a thousand gold crowns for his work.

Other monarchs also found red a perfect foil for their black-and-white ensembles. Elizabeth I, for example, sometimes went so far as to dress all her ladies-in-waiting in red, the better to set off her own black-and-white gowns. For similar reasons, she dressed her servants in woolen scarlet livery—a fashion that influenced rulers and would-be rulers for centuries afterward.* Even in the

* Among those who wore scarlet livery was William Shakespeare, who like other royal actors was given "scarlet red cloth: 4 and half yards" to make his official costume for the coronation of Elizabeth's successor, James I.

democratic United States of America, George Washington and other prominent leaders favored scarlet livery for their servants. In Elizabethan England, courtiers who vied for the queen's attention took to wearing red satin and velvet; gentlemen who truly wished to be au courant dyed their beards to match.

Red backgrounds, too, were favored by the great. When Charles's chief rival, Francis I of France, posed for an early royal portrait in a costume of black, white, and gold, an intricately brocaded crimson backdrop enhanced his kingly air. Taking a page from the same book, black-clad noblemen often had themselves painted against scarlet draperies—a code for wealth that can be seen to especially fine advantage in the paintings of Anthony Van Dyck, whose billowing scarlet backdrops sometimes threatened to overwhelm his human subjects. Often the extravagant draperies were an illusion; only the wealthiest gentlemen could afford to be so lavish with such expensive fabrics. But to the relief of men of more straightened means, Van Dyck, like many other painters, kept stock draperies in his studio, which allowed sitters to appear richer than they in fact were.

Aristocrats who could afford luxury in real life surrounded themselves with scarlet and crimson tapestries, curtains, and cushions, which meant that the residences of Renaissance men-in-black were often a riot of color. Sir William Cecil, Queen Elizabeth's secretary of state, for example, may have followed the sober Spanish fashion in his dress, but at home he slept in a Jacobean bed flamboyantly hung with crimson velvet.

Even when traveling, aristocrats often enveloped themselves in red. The prince of Eboli, an influential confidant of Charles's son Philip, rode in a carriage upholstered in glowing cochineal-dyed satin, behind horses said to be the finest in Spain. When the countess of Carlisle, wife of England's ambassador to Russia, entered Moscow in 1663, she did so in a carriage upholstered in crimson velvet, accompanied by trumpeters, drummers, and two hundred sleighs.

If aristocrats liked to wrap themselves in rich red trappings, so too did less exalted individuals, including merchants and lawyers. Among those who succumbed to red's lure was the wily-eyed Venetian art merchant Jacopo Strada (fig. 6). In a portrait painted by Titian in 1568, Strada wears a black doublet with shining rose-colored silk sleeves, a sartorial advertisement of financial success and consequent social advancement. Although cochineal imports had helped make it possible for Strada and other prosperous men of the mercantile class to afford more red cloth than ever before, high-quality red textiles were still far from common, and they conferred prestige on those who wore them.

For some merchants, cochineal-dyed cloth was a means not only of displaying wealth but of acquiring it, too. Most of the trade in cochineal-dyed textiles took place within the boundaries of Europe, but European merchants also exported top-quality cochineal-dyed woolens, in limited quantities, to the Middle East, India, and the Americas. Cochineal-dyed cloth was proba-bly carried to Africa as well, where red fabrics were a prized item of exchange in the slave trade, worth as much as a man's liberty or even his life.

THE BULK OF THE COCHINEAL THAT ARRIVED IN Europe was used as a textile dye, but the dried insects came to be employed for other purposes as well. Like the ancient Mexicans, Europeans saw cosmetic applications for cochineal and made an art of applying it to their faces. In Elizabethan England, the startling contrast of vivid cochineal-stained lips and pallid white cheeks, coated with lead powder, was considered the height of beauty.

Another aesthetic practice that Europeans had in common with the ancient Mexicans was the use of cochineal as an artists' pigment. In Europe, cochineal was usually used as an ingredient

for crimson lake—*lake* being the general term for any pigment made by attaching colorless inorganic compounds to translucent dyes, enabling the dyes to be used in painting.

Red lakes were also made with madder, lac, and various types of kermes. Only recently have museum conservationists discovered reliable ways of distinguishing which dyestuff was used in a given work of art. Although many paintings have yet to be tested, and others have produced equivocal results, early analysis indicates that cochineal was much more slowly adopted by painters than by dyers. Largely ignored for several decades, cochineal lakes finally came into their own in the late 1500s and 1600s, finding a place on the palettes of masters like Tintoretto, Vermeer, Rembrandt, Rubens, and Van Dyck. Velázquez and other Spanish artists are also thought to have used them. In later centuries, cochineal lakes would also appear in the works of, among others, Canaletto, La Tour, Gainsborough, Seurat, and J. M. W. Turner.

To make cochineal lakes, painters sometimes started with shearings from cochineal-dyed textiles, then boiled them in lye and added alum to extract the red coloring. A stronger and clearer red could be obtained by starting with the raw pigment itself. "Buy . . . some good Cochinele, about half an ounce will do," counseled one early art manual, which then advised painters to grind the insects into "fine Pouder, then put to them as many Drops of the Tartar Lye as will just wet it, and make it give forth its Colour." After adding water, the painters were to "take a bit of Allum, and with a Knife scrape very finely a very little of it into the Tincture . . . [to] make it a delicate Crimson." The whole mixture was then strained into a clean pot and used quickly, "for this is a Colour that always looks most Noble when soon made use of, for it will decay if it stand long."

As this last warning suggests, cochineal paints were not nearly as durable as cochineal textile dyes. When made with a sufficient proportion of dye to fixative medium, cochineal lakes were fairly fast in oil paintings, but like all lakes they had a ten-

dency to fade with exposure to light. In high-quality paints, this process could take centuries; in poor-quality ones, the red coloring might fade in a matter of months. Used as a watercolor paint, cochineal was even more transient, with a loss of color evident in a few days or even a few hours. Aware of these limitations, some artists painstakingly sought out the very best lake pigments or more often manufactured them themselves, according to their own exacting standards. Their diligence frequently paid long-term dividends; the cochineal lake that Rembrandt used in *The Jewish Bride*, for example, has given added depth and beauty to the bride's red skirt for over three hundred years (see fig. 7). A less careful artist—Turner is the most famous example—could see his cochineal-streaked sunsets fade before his eyes.

Artists who made their own paints were often advised to procure cochineal from their local "Drugist" or pharmacy, advice that highlights the fact that Europeans also used cochineal as a medicine. This practice, too, was at least partly borrowed from ancient Mexico. Francisco Hernández, a sixteenth-century physician who had traveled to New Spain, recommended in *De materia medica*, his handbook of American medicines, that Europeans use the dyestuff in the Mexican manner: "Dissolved in vinegar and applied in the form of a poultice, it cures wounds, strengthens the heart, head and stomach, and cleans the teeth extraordinarily well."

If Hernández's readers were inclined to follow this Mexican prescription, it was probably because Europeans themselves had a long tradition of using dyes as medicines. In Latin—the indispensable language of Renaissance medical professionals—the word *pigmentum* signified both a pigment and a drug, and many substances were employed in both fashions, including various types of kermes reds. Cochineal thus slotted neatly into the European pharmacopoeia and remained there for centuries.

European medical indications for cochineal were many and varied—and like dyers, most apothecaries had their own secret formulas for its use. In addition to the applications extolled by

Hernández, cochineal was considered an antidepressant: Gerard's
Herball, a widely consulted medical text, claimed in the seventeenth
century that it was "good against melancholy diseases, vaine imag-
inations, sighings, griefe, and sorrow with manifest cause, for that
it purgeth away melancholy humors." Cochineal was also praised
for producing sweat, preventing infection, and cooling fevers,
which may explain why the dyestuff was given to England's Charles
II—along with cinnamon, marshmallow leaves, violets, rock salt,
and antimony—in an enema as he lay on his deathbed in 1680.
Desperate remedies were in fashion; before the king expired, doc-
tors also applied pitch and pigeon dung to his feet.

An eighteenth-century English manual, *The Country
Housewife's Family Companion,* also prescribed cochineal for jaun-
dice. The book directed sufferers to mix the dyestuff with cream of
tartar and Venetian soap, "and take half a dram three times a day"—
a foul-tasting potion, no doubt, but preferable to the alternative,
which was to swallow "nine live lice every morning for a week, in a
little ale." A more palatable cochineal remedy was described by
Lorenzo Da Ponte, the librettist for Mozart's *Le nozze di Figaro,
Don Giovanni,* and *Così fan tutte.* En route to Bologna, his carriage
overturned, and the injured Da Ponte was carried half-dead to a
nearby inn. Tucked into bed by the innkeeper's wife, he was
brought a "drink of excellent Chianti" and "an exquisite cochineal
liqueur of prodigious strength made only in Florence." So powerful
was this liqueur, Da Ponte claimed, that in less than three hours he
was ready to continue his journey.

Cochineal was used in other foods and drinks as well, though
not always for medicinal purposes. In early-nineteenth-century
England, the dyestuff was frequently used by bakers "to make the
apple and the gooseberry outblush the cherry and the plum." Yet
the idea that cochineal had medical properties endured, at least
in some circles. During the same era, cochineal was added to the
meals of mental patients in the United States, ostensibly to calm
them.

• • •

FOR ALL THAT COCHINEAL PROVED A USEFUL ADDI-
tion to European dressing tables, paintboxes, and medicine cabi-
nets, it was primarily the textile industry that fueled trade in the
dyestuff. Eventually, that trade crisscrossed the world. Cochineal
traveled to Constantinople in Venetian galleys; from there, mer-
chants sent it on to Turkey and the Caspian region, where the
dyestuff was greatly admired and used to make intricate textiles and
carpets. Merchants from France, Spain, Holland, and Flanders also
helped funnel cochineal to the East, and as a result of their efforts
artisans in Persia and Cairo began using it. Cochineal became pop-
ular, too, among the people of the Philippines, who received their
cochineal courtesy of the Spanish galleons that had opened up
trade between Acapulco and Manila in the 1570s. From the
Philippines, cochineal eventually found its way to China, where it
became known as *yang hung*, "foreign red."

Year by year, cochineal was sweeping the world, an early
instance of truly global trade. So popular was the dyestuff that in
Candide, Voltaire satirically pointed to cochineal as proof that
humans were living in the best of all possible worlds. When
innocent Candide questions how syphilis could exist in a perfect
world, Dr. Pangloss explains that the dreaded disease ultimately
works toward the greater good. Syphilis, after all, comes from
America, and without America, Pangloss triumphantly con-
cludes, "we should not have chocolate and cochineal."

If few of Voltaire's readers were quite so optimistic as
Pangloss, it was nevertheless true that to most Europeans
cochineal seemed a gift of nature, a perfect commodity that God
had intended them to possess and use to their own advantage. It
never crossed their minds that the dyestuff might actually be a
cultural legacy—the result of the ancient Mexicans' long and suc-
cessful effort to cultivate a strain of cochineal that would produce
a perfect red. Not until the early 1900s did biologists, informed

by evolutionary theory, begin to suspect how great a role the ancient Mexicans had played in the creation of *Dactylopius coccus*.

Renaissance Europeans, who neither knew nor cared about these cultural origins, merely concerned themselves with the fact that cochineal had no equal. Yet whether Europeans acknowledged it or not, cochineal's global triumph owed less to their efforts than to thousands of years of Mexican ingenuity. And as European merchants struggled to meet the world's burgeoning demand for the dyestuff, they soon found themselves relying once again on the initiative of Mexico's indigenous people.

SEVEN

Legacies

 AMONG THE EUROPEANS WHO SAW cochineal as an object of desire was Philip II, Charles V's son and heir. Cochineal, for Philip, meant money in the bank—and money was something that Philip, like his father before him, desperately needed.

Quiet and conscientious, Philip had come to the throne in the shadow of his father's financial disgrace. Although Charles had managed to conceal the extent of his debts for decades, toward the end of his reign his income was mortgaged away a year in advance, and he was regularly confiscating private silver remittances from the New World in order to pay his debts. He ostensibly paid for the silver with government bonds, but his vast military expenditures, financed by bankers' loans that ran to millions of ducats every year, ultimately proved more than his empire could bear. In 1552, when Charles suffered a crushing defeat at the hands of the Protestant princes of Germany, his bankers began to call in their loans. Hard-pressed, Charles

turned to Sevillian merchants for cash, but his obligations were so immense that the city's banking system soon collapsed under the strain. In 1557, the Spanish Crown was forced to declare itself bankrupt.

By then, however, Charles was no longer king. Stung by financial and military failure, crippled by gout, and weary of the burdens of state, Charles had abdicated in favor of his son in 1556. For months afterward, the great monarch's retirement to the rural monastery of San Gerónimo de Yuste was the talk of Europe. That the most powerful man in Europe should become a monk seemed incredible. Rumor had it that he had gone so far as to hold his own funeral, to mark the end of his life as king.

As is often the case, however, rumor had it wrong. It was true that Charles had retired to a monastery to contemplate the life to come, but he did not take vows, and he was in no way dead to the joys of the temporal world. On the contrary, his well-furnished house in the monastery grounds was filled with lavish tapestries and works of art, including paintings by Titian. Fifty people served him there, including brewers, barbers, musicians, watchmakers, and cooks. Special couriers provided him with exotic foods, and he feasted each day on oysters, olives, anchovies, iced beer, and eel pie. Although his doctor frowned upon the consumption of such rich delicacies, Charles continued to enjoy the pleasures of the table until he died of fever in September 1558, at the age of fifty-eight. Philip, meanwhile, was left to fight the good fight in his father's stead—and to pay off his father's debts.

Did Philip resent being pushed into this role? The evidence suggests not. Twenty-eight when his father abdicated, Philip had been groomed for imperial responsibilities from an early age—responsibilities that included stints as his father's regent in Spain and a short, unhappy, and ultimately fruitless marriage to England's Bloody Mary Tudor.

Awed by his larger-than-life father, Philip feared he would never measure up to Charles's golden standard. His trepidation

must have increased when he failed to be elected Holy Roman Emperor in his father's stead; the title, along with the Habsburg lands in central Europe, went instead to Charles's brother Ferdinand. In the territory that remained—Spain, Portugal, the Netherlands, parts of Italy and North Africa, and Spanish America—Philip was determined to prove himself a worthy and illustrious son. Continuing his father's battle against Protestantism, he fought hard to preserve his legacy.

Like his father, Philip found war costly. To provide money for the fight, and to restore a royal treasury devastated by his father's previous campaigns, he taxed his European subjects heavily. As his father's experience had already proved, however, taxing Europeans was a tricky business. It was much easier to obtain money from America, especially after Philip replaced the inefficient transatlantic convoys with a well-organized annual system of treasure fleets in the 1560s. By then, the silver mines of Mexico and Peru, which had barely begun to produce returns in Charles's day, were pouring an average of over 600,000 pesos into the royal coffers every year—an amount that would rise to over two million pesos a year in the 1590s, toward the end of Philip's reign.

These staggering returns were a gift that other European rulers envied, but for Philip they were not enough. "Apart from nearly all my revenues being sold or mortgaged," he wrote in 1565, "I owe very large sums of money and have need of very much more for the maintenance of my realms." Soldiers were expensive, and a month of battles could sometimes cost as much as an entire year's silver remittance.

To increase his returns from America, Philip, like his father, was forced to look to that continent's other exports. Chief among them was cochineal, which by the late 1560s was well on its way to becoming New Spain's most valuable export after silver. As many as 175,000 pounds of dyestuff were harvested annually, most of which seems to have been shipped to Seville. The Sevillian authorities valued cochineal imports at approximately 250,000 pesos a year, and

the Crown, which taxed the dyestuff heavily both in Spain and in Mexico, profited accordingly. Royal taxes—including the *alcabala* (a sales tax), the *avería* (a tax that paid for Philip's fleet system), and the *almojarifazgo* (a duty on imports and exports)—amounted to as much as 25 percent of cochineal's import value, and the Crown collected additional sales taxes each time the dyestuff was resold in Spain.

None of these facts would have escaped Philip, a born bureaucrat who not only insisted on reading all state papers himself but also corrected his secretaries' mistakes in the margins. Impressed by the cochineal figures, and aware that European demand for the dyestuff was still rising, he began to look for ways to boost cochineal production in New Spain. In July 1568, he and his advisers ordered the newly appointed viceroy, Martín Enríquez de Almanza, to gather information on cochineal production and trade, with a view to increasing exports. In particular, they wanted to know "the quantity of cochineal collected in New Spain each year, and the people who collect it, and what price it is worth in that land."

To a man of Philip's regal position, boosting cochineal production may have seemed a simple matter of collecting information and passing decrees. But like his father, he was to discover that it was difficult to dictate to the people of New Spain. Heavily burdened with other responsibilities, Viceroy Enríquez did not deliver any reports on cochineal to Philip II until the 1570s. By then, however, the viceroy had accepted that Spanish colonists had little interest in cultivating the dyestuff.

Although Enríquez did not say so, this continuing lack of interest in cochineal was something of an anomaly. While early Spanish settlers had scorned indigenous crops like cochineal, later colonists usually proved more open to the opportunities that such commodities offered. Cocoa beans—which, like cochineal, were native to America—are a case in point. In the decades immediately after the Conquest, some Spanish settlers adopted the indigenous

custom of using cocoa beans as a medium of exchange, but few were willing to drink the Aztec chocolate made from those beans.* Gradually, however, they developed a taste for the drink, especially when the bitter, spicy brew was sweetened with sugar. They also began to appreciate the importance of cocoa and chocolate in American markets, and to show great interest in growing cocoa for themselves. By the late sixteenth century, Spanish settlers owned numerous cocoa plantations in Mexico and Guatemala, and over the next century they would expand their operations still farther.

If late-sixteenth-century Spaniards were willing to grow cocoa, a crop that was barely known in Europe at the time, why wouldn't they grow cochineal, which was worth far more per pound than chocolate, and which was much desired by merchants around the globe? The answer seems to lie in the fragile biology of the cochineal insect itself. Extremely sensitive to variations in climate and prone to attack by predators and disease, *Dactylopius coccus* was ill suited to the Spanish system of enterprise—a system that promoted the use of forced or low-wage labor on large-scale, capital-intensive projects.

Cocoa trees, though native to America, adapted fairly well to this Spanish system. Grown on huge plantations with cheap indigenous labor, or with the labor of imported African slaves, the trees produced decent profits. But when some settlers, lured by the hope of high profits, tried to raise cochineal the same way, they often met with failure. An unexpected storm or frost could ruin them, and fungal diseases and cochineal pests seemed to spread like wildfire in their large tracts of nopals. Even when they did manage to harvest a sizable crop, there was no telling what its market value might be, since cochineal prices varied wildly from year to year.

Far from showing economies of scale, cochineal seemed to

*One early conquistador described chocolate as appearing like dirty water, or—when mixed with red dye—like a bowl of human blood.

do best when grown on family plots, perhaps because only small-scale growers had the patience and personal incentive to give it the painstaking attention it needed. But wealthy Spaniards were not interested in this kind of farming, and poor Spaniards lacked the detailed understanding of cochineal cultivation that made growing the insect profitable. Instead, it was Indian peasants, cultivating cochineal in thousands of small cactus patches, who produced most of the world's supply of the Mexican dyestuff—not only in the sixteenth century but through the entire period of Spanish rule (see fig. 8).

BASED ON PRECEDENT, THE PEOPLE OF OAXACA AND the Mixteca region ought to have been the first to take advantage of Europe's appetite for cochineal. Wild cochineal had most likely been domesticated in that part of the southern highlands, and farmers there had been leading producers of the dyestuff under the Aztecs. The initial Oaxacan and Mixtecan response to the European cochineal boom, however, was compromised by the Spaniards in their midst.

Many of these Spaniards were Dominican missionaries, who first arrived in the region in the late 1520s. According to two seventeenth-century Spanish accounts, the missionaries actually "taught" the Indians to plant nopals and grow cochineal—a story that no doubt pleased Spanish readers, but which bore no relation to the facts, since sixteenth-century Indians knew far more about cochineal than did the recently arrived friars. Indeed, while some Dominicans may have encouraged indigenous people to grow cochineal—and to contribute some of the profits to the work of evangelization—most friars were convinced that better opportunities were afforded by silkworms, which they introduced to the province in the 1530s. Urged on by the missionaries, thousands of indigenous people chose to devote themselves to silk in

the 1540s and 1550s. Other native Mexicans were forced into the work by Spanish *encomenderos*, who like the Dominicans saw more potential in silk than cochineal. Although Oaxacan and Mixtecan cochineal production did increase during this period, it was overshadowed by the silk boom. Indeed, silk manufacturers may well have absorbed much of the local supply of the dyestuff, as they strove to create outstanding colored fabrics for international markets. In any case, the amount of cochineal exported from this region fell far short of meeting European demand.

Where, then, did Spanish merchants find the bulk of their cochineal? Some, it seems, found suppliers in Michoacán, Jalisco, and Yucatán, but these areas of Mexico never produced large amounts of cochineal. Yucatán, in particular, with its droughts and extreme heat, produced very small yields. For far more impressive supplies of cochineal, knowledgeable merchants turned instead to Puebla, a city more than a hundred miles northwest of Oaxaca. Because Puebla was on the main colonial road that ran between Mexico City and New Spain's official port, Veracruz, merchants who bought cochineal there found it relatively easy to transport the dyestuff to market.

A great deal of the cochineal that passed through Puebla in the 1540s and 1550s was actually grown a bit farther north, in the region of Tlaxcala. A fiercely proud and patriotic people, the Tlaxcalans enjoyed more freedom than any other indigenous people in New Spain—a state of affairs that had its roots in the pre-Conquest era, when Tlaxcala had been the only city-state in central Mexico to remain undefeated by the Aztecs. Montezuma told the Spaniards that he believed he could crush the province, but that he preferred a protracted and inconclusive war instead, to train his soldiers and provide his priests with sacrificial victims, in the form of captured Tlaxcalan warriors. Not surprisingly, Tlaxcala became Spain's greatest ally during the Conquest, supplying thousands of warriors for the assault on the Aztec empire. Without Tlaxcalan aid, Cortés's expedition would almost

certainly have failed. Recognizing his debt, Cortés, acting in the king's name, granted the Tlaxcalans a degree of independence unique in New Spain: they were to be governed by the Crown, as Spaniards themselves were, and not by *encomenderos*. No *encomiendas* were ever granted in their province, and Spaniards were discouraged from settling there.

To be sure, Tlaxcalan independence was far from absolute. Even though Tlaxcalans did not have to provide tribute for *encomenderos*, they were still forced to pay other forms of tribute to the Spanish government, Church, and army. Moreover, Spanish officials ruled the province at the higher levels, and despite discouragement other Spaniards settled there and became ever more influential. But Tlaxcalans were freer than most Mexican peoples, and they made good use of their direct relationship with the Crown, going so far as to send envoys to Spain to obtain personal guarantees of their freedoms from Charles V himself. Accomplished diplomats and astute businessmen, the Tlaxcalan envoys may even have spoken with Spanish merchants about the possibilities presented by cochineal.

It was not the machinations of diplomats, however, that made Tlaxcala so central to the post-Conquest cochineal boom. What made Tlaxcala so important was the relative independence of the Tlaxcalan people themselves. Freed from the demands and directives of Spaniards who had little interest in cochineal cultivation, Tlaxcalans responded quickly and enthusiastically to the first indications of strong European demand for the dyestuff. Having produced cochineal on a small scale in the Aztec era, they expanded production dramatically from the mid-1540s, very soon after European dyers started seriously seeking out the dyestuff. By the early 1550s, the Tlaxcalans were producing large amounts of cochineal for the European market each year.

The rewards were tremendous. In 1554, Spanish merchants in Mexico estimated that the Tlaxcala-Puebla cochineal trade was worth over 100,000 pesos a year to New Spain—considerably less

than annual silver remittances but nevertheless a remarkable sum
for an agricultural product. At the time, a laborer in Spain was
unlikely to earn as much as a single peso a week. With this kind of
wealth in the offing, cochineal merchants prospered at many levels,
with Spanish merchants focusing on the transatlantic end of the
business, and indigenous merchants continuing to play a major role
in local and regional markets.

Cochineal's indigenous producers also found the business
profitable—too profitable, in the opinion of the Tlaxcalan
cabildo, the council of elite Indians that oversaw daily life in the
province. Concerned that the very success of the trade was lead-
ing to social disorder, the council prohibited the cultivation of
cochineal in 1552. Evidently the measure failed, for nine months
later, in March 1553, the council devoted an entire meeting to
the cochineal problem.

To judge from the official minutes taken at the meeting, the
council members regarded the dyestuff as the root of all evil in
Tlaxcala. Like most elite Tlaxcalans, they were fervent Catholic
converts, and they noted with dismay that cochineal growers
"devote themselves to their cochineal on Sundays and holy days; no
longer do they go to church to hear mass as the holy church com-
mands us." Even worse, "they buy *pulque* and then get drunk."* As
far as the council was concerned, the cochineal dealers, too,
behaved outrageously. Not only did they trade on Sunday, but they
encouraged female cochineal sellers to drink to excess, the better to
"commit sins" with them—though for modesty's sake the council
declined to detail the sins in question.

What bothered the council most, however, was that the
Tlaxcalan cochineal growers no longer showed proper deference
to their betters. In the best tradition of nouveaux riches every-
where, the cochineal farmers were growing uppity. "He who

*Made by Mexicans since ancient times, *pulque* is an alcoholic beverage derived
from the sap of the maguey plant.

belonged to someone no longer respects whoever was his lord and master," the council lamented. Cochineal-growing common-ers were dressing above their station, drinking too much, and buying goods that formerly only nobles could afford, including the best Aztec chocolate—"very thick, with plenty of cocoa in it." To demonstrate their new status, some commoners had even started to refuse perfectly good chocolate on the grounds that it was weak and watery. A few of them, the council indignantly noted, went so far as to "pour it on the ground . . . [and] they imagine themselves very grand because of it."

Faced with such rudeness, the council could only conclude that the entire social order of Tlaxcala was on the verge of col-lapse. Not one Tlaxcalan commoner seemed content with his lot. "Everyone does nothing but take care of cochineal cactus," the council noted in its records. "They no longer want to cultivate their fields, but idly neglect them." The consequences, the coun-cil believed, were dire: "Because of this, now many fields are going to grass, and famine truly impends."

The council members' fears were exaggerated—Tlaxcala was not on the brink of starvation, or anywhere near it—but their apocalyptic language reveals the degree to which the cochineal boom had disturbed the Tlaxcalan social order. Yet the council was aware, too, that cochineal had a powerful constituency, not only among commoners but among the many nobles who made money from the dyestuff. It was this constituency that had made the council's previous ban on cochineal cultivation a dead letter. Tacitly acknowledging the impossibility of enforcing another such ban, the council decided to steer a more moderate course: this time around, they merely forbade Tlaxcalans to plant more than ten nopal cacti each.

Nine months later, the council reported that "a very great quantity of cochineal cactus was destroyed" as a result of this rule. Yet market forces could not so easily be denied. In the face of burgeoning European demand for cochineal, the ten-nopal

limit soon proved no more effective than the 1552 prohibition. Proud of their relative independence from Spanish rule, Tlaxcalans were nevertheless eager to take advantage of all that Spanish merchants had to offer, even as their dealings with these merchants tied them ever closer to global markets over which they had no control.

A devil's bargain, perhaps, but Tlaxcalans profited from the deal. For decades to come, Tlaxcalan commoners would continue to wear fancy clothes, drink thick chocolate—and produce tons of cochineal for the European market.

DUE IN NO SMALL PART TO THE EFFORTS OF Tlaxcalans, the amount of cochineal reaching Seville rose spectacularly in the mid-sixteenth century, rising from less than 50,000 pounds of cochineal in 1557 to over 150,000 pounds in 1574. But Tlaxcala did not remain a world center for cochineal production forever. By the late sixteenth century, despite promises to the contrary, the region was being overrun by Spaniards, whose cattle and oxen devastated Tlaxcalan villages and nopalries. Tlaxcalan cochineal growers also faced ever-increasing competition from their Mixtecan and Oaxacan neighbors to the south, who after experiencing severe reversals in the silk industry in the 1570s had returned to producing their traditional dyestuff.

By the early seventeenth century, Oaxaca City, also known by the Spanish name of Antequera, had become the new center for cochineal production. Before the century was out, the province of Oaxaca—which under Spanish rule included not only the Valley of Oaxaca but much of the Mixteca region within its boundaries—enjoyed a virtual monopoly on cochineal production. This state of affairs continued for the rest of the Spanish colonial period.

Oaxaca's dominance in the industry brought tremendous

wealth to its capital city, allowing the construction of gracious homes and lush gardens near the bustling central plaza. The city's many churches were further evidence of its prosperity, especially the magnificent Dominican complex of Santo Domingo, whose soaring church nave glistened with so much gold leaf that crossing its threshold was like entering a vast gilded jewel box. Beside the church, a large Dominican monastery enclosed the clerical brotherhood within its peaceful walls. Friars who walked along the quiet corridors saw breathtaking views through the monastery's wide windows, which framed the high Oaxacan mountains in a manner worthy of a fine Renaissance painting.

Yet if there was ample evidence that Oaxaca City had benefited from having cornered the cochineal trade, there were those who argued—as the council of Tlaxcala had once argued—that cochineal was anything but a good influence on the region's indigenous inhabitants. In an uncanny echo of the Tlaxcalans, a Spanish cleric in Oaxaca wrote in the late 1500s that indigenous people were growing cochineal instead of food, that they were buying their staples from other towns, and that they were getting drunk on their cochineal proceeds. Later, some twentieth-century historians would argue that the cochineal boom had a destructive influence on indigenous life, putting Indians at the mercy of international markets in general and Spanish merchants in particular.

Was cochineal really such a terrible influence? Recent research suggests that, on the contrary, indigenous Oaxacans benefited tremendously from cultivating the dyestuff.

One indication that cochineal cultivation was actually a positive factor in indigenous life is the fact that most Indians appear to have cultivated the dyestuff voluntarily, selling it on their own account to other Indians or to merchants' agents. Although Spanish officials sometimes attempted to increase production through coercion, the efforts rarely enjoyed any sustained success. In the 1570s, for example, Viceroy Enríquez ordered that

Indians raise cochineal in all areas considered suitable to its culti-
vation, but his efforts met with mixed success at best. A similarly
coercive decree was issued in 1597, when Philip II ordered his
administrators in New Spain to "compel the Indians, by all right-
ful and legal means," to cultivate nopals and cochineal. Soon
afterward, Gonzalo Gómez de Cervantes, a provincial governor,
proposed that Indians in cochineal-producing areas be required
to raise twenty-five nopals each. Nothing much, however, came
of these strong-arm approaches. Perennially strapped for cash,
the Crown could not afford to enforce even the lordly dictates of
its king, let alone those of provincial authorities.

What instead proved most effective in boosting cochineal
production were market incentives. Rather than threaten Indians
with the stick of laws and quotas, Spanish merchants offered
them the carrot of credit—an offer many Indians, long accus-
tomed to participating in sophisticated markets, willingly
accepted.

Exactly how and when this cochineal credit system got
started is a mystery. Merchants in Mexico were offering advance
payments for silk by the 1560s, but a credit system for cochineal
appears to have developed even earlier, before 1550. At first it
was much frowned upon by the Spanish authorities, who passed
laws against it, but evidently the system persisted, becoming
commonplace by the 1600s. The linchpins of the system were
local officials, whom the bankrupt Spanish Crown could not
afford to pay. Men of gentle birth but limited income, these offi-
cials often accepted loans from Spanish merchants, with the
understanding that they would use a substantial part of the
money to extend credit to Indian cochineal producers for a
period of six to eight months. Indians later repaid the loans with
cochineal offered at a fixed rate. After the officials had collected
the cochineal, they sold it to the Spanish merchants who had lent
them money in the first place.

Officials who selected borrowers carefully and were forceful

in collecting payment at harvest time could usually repay their debts and make a substantial profit besides. In time, their lucrative posts became some of the most sought-after positions in the Spanish Empire. Merchants, spared from the onerous duty of administering thousands of Indian loans themselves, also profited from the arrangement.

Yet if Spanish officials and merchants enjoyed the greatest advantages from this system, Indians benefited, too. Cochineal loans were one of the few sources of credit available to them, and many used the money to buy high-cost items such as bulls and mules, which they could not have afforded any other way. The contracts' fixed rate for cochineal was usually below market price, but once cochineal growers had paid their debts, they were permitted to sell the remaining dyestuff to anyone they pleased, for as much as the market would bear. That Indians considered these terms reasonable—or at least acceptable—is evident from the alacrity with which they signed cochineal contracts. Although they occasionally protested to Spanish authorities about local officials who pressed too hard for repayment of cochineal loans, they almost never claimed that they had signed those loan contracts unwillingly. Complaints from Indians whose application for credit was denied, or who did not receive as large a loan as they wanted, were far more common.

Indigenous people who participated in the cochineal credit system usually raised cochineal on their own land or on land owned by the village as a whole, often as a sideline to the main business of subsistence agriculture. Produced in this way, cochineal cultivation was an attractive way of generating the small cash income that most indigenous households needed or desired. Unlike most forms of paid labor under the Spaniards, it did not require Indians to part from their villages and families or to suffer the degradation of working directly under the people who had conquered them. Instead, it allowed them to work at home, in the company of their children and extended family (see fig. 9).

By the middle of the sixteenth century, the devastating twin impact of Spanish rule and Old World diseases had fragmented many native communities. Entire cultures were disappearing. But in areas where cochineal was grown—areas where people were able to make a living while remaining close to their kin—communities demonstrated a remarkable ability to withstand such pressures. Many villages that grew cochineal were able to preserve their languages, traditions, and cultures for centuries, which helps explain why Oaxaca, the chief cochineal-producing region, remains today the most culturally and linguistically diverse state in Mexico.

If cochineal satisfied the desire for color in Europe, among Mexicans it met even deeper needs. More than a marvelous dyestuff, cochineal for them was a living legacy from their ancestors, a gift that connected past and present, and a critical source of strength in the battle for personal and cultural survival.

EIGHT

Trade Secrets

 THE ADMINISTRATION OF EMPIRE IS NO easy task. So, at least, the Spanish Crown must have concluded as it attempted to exercise control over its possessions in America. To rule the continent, the Crown relied on an immense bureaucracy of officials, judges, and councils, a bureaucracy whose size and scope amazed many Europeans. Yet even with this mighty corps of officials behind it, the Crown could not always impose its will on Spanish America.

Cochineal was no exception to this rule. When it came to increasing cochineal production, the credit system's incentives had triumphed over the Crown's brute-force directives. In other respects, too, the cochineal trade proved difficult for the Crown to regulate. At the behest of Philip II and his son and successor, Philip III, the officials of New Spain attempted to formulate trade rules, combat market fraud, and establish a royal monopoly on the dyestuff—all in the name of producing more cash for the Spanish treasury. In every case, Crown officials soon discovered

that their success depended on the support of the Crown's subjects, especially the powerful merchants of New Spain.

Of the thousands of people in New Spain trading in cochineal by the late sixteenth century, most were small dealers who auctioned off cochineal in weekly markets, or who roamed from town to town, looking for cochineal on the cheap. Primarily Indians, mestizos, mulattoes, and Africans, they were people of little influence, with whom the Crown could deal harshly without fearing retaliation. And deal harshly it did. In 1580, Viceroy Enríquez banned blacks and mulattoes from trading in cochineal; he allowed Indians to engage in the business only if they were the servants of Spaniards.

The merchants at the top of the network, however, were a different story. With enough capital and nerve to engage in the risky but spectacularly rewarding transatlantic arm of the cochineal trade, these Spanish businessmen had few qualms about going head to head with Spanish officials whenever they deemed that they were being treated unfairly. Apparently, however, Viceroy Enríquez's discriminatory 1580 decree was one ruling that met with their full approval, probably because it cut down on the competition their agents faced. It is possible, too, that some of them believed—mistakenly—that the new laws would cut down on fraud, the most pressing problem of the cochineal trade.

From the time of the Conquest, and probably under the Aztecs as well, tricksters and con artists had been attracted to cochineal because it was such a lucrative commodity. Since tiny quantities of the dyestuff could produce a considerable profit, even small-scale frauds could be worthwhile. Consequently, fraud was common at every level of the trade and at every point of interchange: Indian producers cheated Indian dealers, who cheated Spanish merchants, who cheated European buyers, who cheated European consumers.

The gambits employed were legion. Some sellers attempted to pass off low-grade cochineal as the top-drawer article, a scam that was particularly effective if the customer lacked experience with the dyestuff. Other dealers, taking advantage of the fact that cochineal payments were based on weight, doctored the balances. Counterfeiters went one step farther and doctored the cochineal itself. The simplest way to do this was to mix the grains of cochineal with sand, chalk, or tiny pebbles, but many people used more sophisticated techniques that enveloped the real grains of cochineal in thin coatings of red ochre, flour, lime, and ashes. Some sellers also attempted to add weight to the cochineal by killing the insects in hot water and packing them before they were fully dry; the resulting cochineal rotted before it reached Europe and was worthless to dyers.

These sharp practices led some Europeans to complain about the quality of the cochineal they received. In 1552, for example, a dyer reported to the Venetian senate that "the new Indian kermes" was often adulterated; as a result, he claimed, "the colors fade in a short time, and become bad and horrible to be seen." Whether cochineal was in fact any more likely to be adulterated than the traditional kermes reds is an open question. After all, guilds and governments frequently inspected many kinds of dyestuffs, and it is unlikely they did this without cause. Nevertheless, Indian traders, Spanish merchants, and Spanish officials were worried, for if cochineal came to be seen as an unreliable, low-quality dyestuff, their profits would decline.

Even before the Venetian complaint was filed, Tlaxcala's elite council had appointed special officials to oversee the cochineal trade and to ensure that standard measures were used. Soon afterward, in 1554, four Spanish merchants asked the Mexico City authorities to investigate the phenomenon of cochineal adulteration and to find ways to stop it. The following year, after hearing extensive testimony on the subject, the chief investigator recommended that all cochineal be inspected and sealed by

Crown officials, that adulterated cochineal be confiscated, and that both buyers and sellers of false cochineal be fined. If the buyers or sellers happened to be mestizo, black, or Indian, the investigator further recommended that they be punished with a public whipping of one hundred lashes.

The viceroy of Mexico apparently accepted these recommendations and enacted them into law, but enforcement was weak and piecemeal. At the time, cochineal was not a high priority for the Crown, and not enough officials were assigned to the job. Officials also found it difficult to detect many common frauds, in part because there was legitimate debate about the proper way to kill and dry the cochineal insects. Most people agreed that the best method was to expose them to continuous sunlight; the resulting dyestuff, known as *plateada* or *blanca* for its powdery silver surface, was widely considered the top grade of cochineal. But since sun-drying, done properly, could take up to two weeks, many producers experimented with cheaper techniques. *Jaspeada* (marbled) cochineal was baked; *negra* (black) was killed on a hot plate; *denegrida* (lightened) was boiled in steaming cauldrons. Other types of cochineal were dispatched with vinegar, smoke, or sulfur fumes. The relative value of the cochineal these methods produced was anyone's guess.

As cochineal became increasingly important to royal finances, Crown officials became more aggressive. In September 1572, Viceroy Enríquez made all processing methods except sun-drying illegal. A month later, he created a new Crown position, the *juez de grana*, "the judge of cochineal." Charged with enforcing a new and more rigorous system of inspection, the judge was based in Puebla, which at the time was New Spain's most important cochineal entrepôt. Under the new regime, all cochineal had to be weighed in front of the judge in Puebla's public markets before it could be exported to Spain. The judge also examined the dyestuff for quality and purity. If a sack of cochineal made the grade, it was packed in a wooden box. When the box was full, it

was nailed shut, branded with an official mark, and stored in a public warehouse. At the official port at Veracruz, ship captains were forbidden to accept any cochineal that did not come in a crate marked with the judge's brand. Only certified boxes of cochineal were carried to Spain, along with a copy of all inspection records and receipts, which were checked by merchants and customs officials in Seville.

It was a marvelously thorough system, one that presented serious obstacles to swindlers. But most cochineal merchants opposed it—not necessarily because they were dishonest but because they felt it gave too much power to the Crown. They particularly objected to storing their cochineal in public warehouses after inspection. What they wanted instead was an amendment allowing the judge to inspect cochineal in merchants' homes, after which the merchants would be allowed to store the sealed cochineal in a locked room on their own property.

So powerful were these merchants, and so strong and united their demands, that a bare two months after passing the new regulations Viceroy Enríquez was forced to accede to their wishes. From December 1572, merchants were allowed to store sealed cochineal in their own storehouses for a maximum of four days, after which it had to be shipped to Veracruz. The change opened the door to all kinds of merchant fraud, and consequently Enríquez reinstated the original law in 1580, near the end of his term of office. By then, he had also appointed additional judges for other cochineal entrepôts, an act that did much to improve the quality of cochineal exports, even as it tried the tempers of Spanish merchants.

Long after Enríquez had left office, merchants and Crown officials continued to wrangle over cochineal regulations. To Crown officials, merchants appeared sly double-dealers, bent on cheating the king of his due. To merchants, Crown officials seemed meddling busybodies whose arbitrary rules increased the costs of trade.

What worried the merchants most were the Crown's repeated attempts to create a royal monopoly on cochineal—a monopoly that would cut the merchants out of the business altogether. In Spain, as in much of Europe, it was common for the Crown to claim monopoly rights over a trade, especially if it involved a scarce and highly valuable commodity like cochineal. Royal officials did not always run the monopolies themselves but often auctioned them off; exclusive rights to the Spanish slave trade, for example, were sold to a Portuguese contractor in 1595. Either way, monopolies were an easy way for a ruler to make money, which is why they proved so attractive to the bankrupt Spanish Crown.

From the 1560s to the early 1600s, Crown officials in Spain repeatedly came up with schemes for setting up a royal monopoly on cochineal—the only American agricultural product they ever deemed worthy of such treatment. Again and again, however, these plans were frustrated by logistical problems and merchant opposition. Only in 1618 did the Crown finally establish a partial monopoly on the dyestuff. Under the new law, the merchants of New Spain were required to auction off their cochineal to the king's agents. The profitable transatlantic arm of the trade thus became the province of the Crown, which apparently hoped to net about 100,000 pesos a year from the arrangement.

Rightly perceiving this semi-monopoly as a threat to their livelihood, merchants hid their cochineal, lied to Crown officials about the way the grading system worked, and generally drove auction prices sky high. Conceding, with some bitterness, that the "dealers in cochineal are crafty and far more knowledgeable than we are," Crown officials repealed the law in 1622. In subsequent years, the Spanish government occasionally tried to resurrect the notion of a royal cochineal monopoly, but Mexico's top officials always rejected the idea. In their view, the struggle of 1618–1622 had proved that it was a waste of time to establish a monopoly that the merchant community adamantly opposed.

Yet although the Crown had no success in creating a royal

monopoly on the dyestuff, it did succeed in an even more vital task: maintaining the global monopoly on cochineal production that belonged to the Spanish Empire as a whole. By the early 1600s, Spanish cochineal imports were worth more than 500,000 pesos a year. To keep this lucrative trade in Spanish hands, the Crown had to prevent other Europeans from producing the dyestuff for themselves.

Taking a cue from the Venetians and other major players in the color trade, Spanish officials treated cochineal as if it were a state secret, making it clear that the curious and the indiscreet would be punished. In part, the Crown relied on existing Spanish laws that made it hard for foreigners to get close to the sources of cochineal production. Crown officials, for example, did not allow anyone to travel to America without a permit, which most foreigners found impossible to obtain. Although some people discovered ways to get around the system—chiefly through residence in Spain or a Spanish dominion, marriage to a Spaniard, employment by a Spanish firm, or forged paperwork—any foreigner in New Spain who showed too strong an interest in cochineal was carefully watched and, if necessary, deported.

In addition, Philip II enacted a law that specifically forbade foreigners to trade in the dyestuff—a ruling that deprived foreign merchants not only of a valuable item of commerce but of a reasonable excuse to visit the cochineal nopalries of New Spain. At first foreigners who violated the law were merely threatened with the loss of their goods, but from 1614, when Philip III passed a harsh law against all foreign trade, the punishment was death.

The Spanish Crown had a habit of passing draconian laws that it could not enforce, but when it came to preserving Spain's global monopoly on cochineal, Crown law, for once, proved effective, especially as far as the live insect was concerned. In part this was because Crown officials realized how high the stakes were, and were correspondingly zealous in their prosecution of the relevant statutes. But no doubt it helped that in this battle

the Crown had the full cooperation of Spanish merchants on both sides of the Atlantic. Indeed, no Spaniard wished Spain to lose its monopoly, for the country's possession of the superb dyestuff had become a point of patriotic pride.

Even so, it is somewhat surprising that Spain managed to keep such a firm grip on an animal as small as cochineal. There was, however, another factor working in Spain's favor: cochineal's inability to tolerate all but the most optimum environments. Vulnerable to heat, cold, rain, and other sudden changes, *Dactylopius coccus* was not a natural traveler. Moreover, techniques for collecting botanical and zoological specimens were still quite primitive (and would remain so until the nineteenth century). Most collectors simply sent back pressed plants and stuffed animals or did the best they could to keep living collections alive in trunks and packing cases—a makeshift approach that was ineffective with creatures as delicate as cochineal. Anyone who tried to cram live cochineal into a chest and smuggle it out of the country was likely to find the insects dead before he reached the border.

Yet if royal edicts, Spanish vigilance, and cochineal biology combined to make it almost impossible for foreigners to steal cochineal from Mexico, the fact remained that at some point the processed dyestuff had to be shipped across the Atlantic to Seville. Even the most experienced Spanish captains regarded this voyage with some trepidation, for they knew that their enemies might attack at any moment—"Pirats," as the poet-adventurer John Donne described them, "which doe know / That there come weak ships fraught with Cutchannel, / The men board them."

Bold and cunning, these pirates were determined to smash the Spanish monopoly and seize the transatlantic cochineal trade for themselves.

NINE

Pirates' Prize

 WHEN JOHN DONNE WROTE ABOUT cochineal piracy, he was speaking from firsthand experience. Famous in later life as a metaphysical poet and English divine, he preferred more adventurous pursuits in his youth. In the summer of 1597, at the age of twenty-five, "Jack" Donne, as he was then known, set out with more than a thousand other men on a massive maritime expedition against the Spanish fleet, led by the earl of Essex, Robert Devereux.

It was in many ways an ill-starred voyage. Dashing young Essex, elderly Queen Elizabeth's darling, had hoped to capture the treasure-laden fleet in the Azores, Spain's vital port of call in the mid-Atlantic, but poor weather, poor naval intelligence, and poor judgment defeated him. Donne sketched scenes from the disastrous expedition in verse for a close friend: "Lightning was all our light, and it rain'd more / Than if the Sunne had drunke the sea before." He finished, "Compar'd to these stormes, death is but a qualme, / Hell somewhat lightsome, and the Bermuda calme."

Aside from Donne's poetry, the only bright spot of the entire voyage occurred in late September, when Essex and his men spied three ships from Havana that had fallen far behind the rest of the Spanish fleet. Upon boarding the vessels, the Englishmen discovered holds brimming with cochineal. When Essex brought his prize into Plymouth harbor a month later, the English authorities were first staggered, then jubilant, to learn that he had seized more than twenty-seven tons of the red dyestuff. It was the largest cochineal prize of the century—enough, proclaimed the queen, "to serve this realm for many years."

By the time Essex captured his famous cargo, pirates had been preying on Spain's American empire for nearly a century. Spanish officials attempted to guard against attacks by strengthening their coastal fortifications, patrolling Caribbean waters, and establishing armed convoys for the Spanish treasure fleet. Yet the interlopers only grew bolder over time.

For Spanish galleons, it seemed no place was safe. The Caribbean, riddled with remote islands and hidden coves, was a pirates' paradise, and the waters around the Azores were likewise a draw for all kinds of adventurers. Even the coast of Spain itself was vulnerable to attack: the year before Essex captured his cochineal prize, he had sacked the port of Cádiz, razed its walls, and put the town to the torch.

The viciousness of such assaults was due in part to the fact that many pirates, Essex included, saw themselves as participants in a holy war. For Protestants, Spain was militant Catholicism personified, a danger to dissenters everywhere. "An insollent, cruell and usurping nation," was how Essex described Spain, ". . . a generall enemie to the libertie of Christendome." Aware that American treasure kept Spanish armies in the field, many Protestants argued that piracy was nothing less than a religious duty. Indeed, men like Essex claimed that their attacks were legitimate acts of war rather than theft. They were not pirates, they insisted, but privateers or

corsairs. By this they meant that they had obtained documents from a European nation at war with Spain, officially commissioning their services at sea.

In Essex's case, the commissioning nation was his own country, Elizabethan England, one of Spain's most implacable enemies. For English Protestants, the struggle against Spain was personal: they had known Philip II once before, as consort of their own Bloody Queen Mary. Although Philip had been careful to distance himself from his wife's rabid pursuit of dissenters, the English associated him with Mary's reign of terror, during which three hundred Protestants were burned to death for heresy. After Mary had died and her Protestant sister Elizabeth had succeeded her, Philip continued to regard England as a land ripe for domination. Working in concert with the Vatican, his agents plotted to assassinate Elizabeth and restore England to the Catholic Church.

Even before Philip launched his great Armada against them in 1588, English Protestants feared him as they feared no other ruler. To curtail his powers, they made plans to strike at his American lifeline. "If you touche him in the Indies," the geographer Richard Hakluyt counseled Elizabeth, "you touche the apple of his eye; for take away his treasure . . . [and] his olde bandes of souldiers will soone be dissolved, his purposes defeated, his power and strengthe diminished, his pride abated, and his tyranie utterly suppressed." Hakluyt imagined Philip, cut off from his American treasure, "bare as Aesops proude Crowe." Stripped of his glossy feathers, "he will, in shorte space, become a laughinge stocke for all the worlde"—an image calculated to put heart into English Protestants. Convinced that their nation was the new Israel, many Englishmen assumed that their success against Spain was foreordained.

Wary of Spanish strength, Elizabeth was reluctant to declare open war on Philip II. Nevertheless, she keenly appreciated the threat that Spain represented to her rule, and she gave considerable

encouragement to privateers. Between 1570 and 1577, at least thir-
teen different English raiding parties sailed to the Caribbean.
Succeeding decades saw dozens more follow in their wake.

Whether these adventurers were primarily motivated by
Protestant sympathies is an open question. On one expedition, a
ship's surgeon piously argued, "We could not do God better ser-
vice than to spoil the Spaniard," but greed alone appears to have
inspired many a raider. Whatever they called themselves—
pirates, privateers, corsairs—the rewards of their ventures were
rich indeed. Although some pirates returned from their adven-
tures empty-handed, and others were executed by the Spaniards
or lost at sea, successful adventurers could live for years on the
proceeds taken from a single Spanish prize.

Some prizes, of course, were better than others. If a pirate
crew went to the trouble and danger of capturing a Spanish
galleon, only to discover that it contained European tools and
furniture destined for the Americas, they felt cheated. What they
wanted instead was American treasure in the form of gold, silver,
and jewels—and increasingly, as the sixteenth century wore on,
they wanted cochineal, too.

Unknown and undesired by early-sixteenth-century pirates,
cochineal became a prime target for adventurers as demand for
the dyestuff ballooned in Europe. Among the many freebooters
intrigued by the commodity was the legendary English pirate
Francis Drake, the scourge of New Spain. The son of a cloth
maker, Drake was well aware that textiles were still the biggest
business in Europe, a key source of power, prestige, and profit.
According to plans drawn up in 1577, he had "great hoepe" of
"cochinillo" when he embarked that year in the *Pelican* (later
rechristened the *Golden Hind*) on a voyage around the world.

By Drake's time, procuring cochineal had become a matter of
great importance not only for sea captains, dyers, and merchants
but for statesmen as well. European monarchs and their advisers

had come to see the dyestuff as a vital economic resource, a strategic commodity essential to their nations' prosperity. Without it, a country could no longer hope to defeat its business rivals and climb to the top of the textile ladder. One year, a country's merchants might have so much cochineal that they could afford to reexport it to partners elsewhere; two years later, cochineal might be so scarce that dyers could not obtain it for love or money. Such vicissitudes could have serious consequences even for well-established textile merchants; in countries still struggling to establish themselves in the high end of the market, the effects could be devastating.

To Protestants, in particular, Spain's control of the cochineal supply was a cause for alarm, not least because Spain did not scruple to use the dyestuff as a political weapon in its holy war against them. In 1586, Philip II ordered Spanish merchants to cease trading with Protestant rebels in Holland and Holland's ally, England. This embargo was a blunt weapon that applied to all Spanish goods, but the embargo on cochineal hit especially hard. Both the Dutch and the English were horrified to find their supply of the dyestuff cut off. Ultimately, they were able to secure a fair amount of cochineal from dealers in France, but there was no denying that the embargo made it more difficult, dangerous, and expensive to obtain the dyestuff, underscoring Protestant vulnerability in the face of Spanish power.

For both Dutch and English Protestants, this was galling in the extreme. The Dutch, however, could not exact retribution, for at the time they were engaged in a life-and-death battle with Spain, a struggle for independence that demanded all their resources. The English, on the other hand, were already Spain's most fearsome enemy at sea. While English raiders had considered cochineal a worthwhile prize before 1586, the embargo made them redouble their efforts. If Spain could use cochineal as a weapon, they reasoned, why shouldn't they use their own weapons to secure cochineal?

• • •

FOR ENGLISH PIRATES, WHO OFTEN HAD NO MORE than a light ship or two under their command, the Spanish convoys that carried cochineal to Seville were a formidable target. Highly organized, they crossed the Atlantic at regularly appointed intervals and could include upwards of a dozen large vessels. They were usually escorted by two to eight armed warships: immense fighting galleons, often of 500 tons, that dwarfed most pirate vessels.

Size, however, was not always an advantage. Quicker and more agile than 500-ton galleons, pirate ships could overtake convoy stragglers with ease. Because Spanish captains and seamen knew that their lives would usually be spared if they surrendered peaceably, they did not necessarily fight to the death. Indeed, in some cases English raiders had only to overtake a lagging Spanish ship and fire a token shot or two, and the vessel was theirs.

The organized nature of the convoy system likewise proved a mixed blessing. In an ideal world, the Spanish Crown would have preferred to keep the routes and timing of fleet crossings a secret. But to coordinate a system that could serve all of Spanish America, the convoys had to operate on a fixed schedule, which remained essentially the same from year to year. English pirates soon learned the details of the Spanish route and used the information to plan their attacks.

In the 1580s, for example, the English adventurer John Chilton reported that ships laden with cochineal and other goods departed from Puerto de Caballos in Honduras every April. Chilton then described their route with great precision, outlining how the vessels navigated past Jamaica to Havana, where they rendezvoused with other ships before crossing the ocean to Spain. Other informants reported on the fleet that sailed from Veracruz to Havana, which carried even more cochineal than did the ships from Puerto de Caballos. They also described the

movements of the united fleet that crossed from Havana to Seville.

By 1586, when the Spanish embargo against Holland and England first went into effect, English raiders were lying in wait off the coast of Honduras, hoping to intercept the ships of Puerto de Caballos. Other English privateers—many of them, like Essex, leading men of the realm—concentrated on the Azores and the waters off the Iberian Peninsula, where even richer prizes were to be found. In the spring of 1589, an English fleet captured a Spanish ship that carried 30,000 pounds of cochineal—probably more than 10 percent of the entire year's harvest. Later that year the earl of Cumberland captured a Spanish ship off the coast of Spain, which contained another 600 heavy cases of the dyestuff. The next year the famous captain Sir John Hawkins brought in still more cochineal, as did other English raiders.

For the next decade, the English continued to seize a staggering amount of cochineal from Spanish vessels. In 1591, Robert Flicke reported that he had spied a Spanish ship in the Azores, "and somewhat before night obtayned her, named the Conception, Francisco Spinola being Captaine, which was laden with hides, Cochonillio, and certaine raw silke." The following year English raiders captured another 50,000 pounds of cochineal, part of an Aladdin's cave of treasures on board the 1,600-ton carrack *Madre de Dios*. And in 1597, Essex secured his vast cochineal prize in the Azores: over 55,000 pounds of the dyestuff in all.

Pound for pound, cochineal was one of the most valuable goods a pirate could capture. In the 1580s and 1590s, the dyestuff was worth 26 to 40 shillings a pound in England, depending on quality and market scarcity. Essex's prize was initially valued at more than £80,000, an immense sum at a time when £80 was deemed sufficient to support a Protestant clergyman for a year.

Indeed, cochineal was so valuable that any vessel that carried

it was vulnerable to attack. Not content with stealing the dyestuff from Spain, on occasion English pirates robbed other nations' ships as well. The French, the Dutch, and the Florentines all suffered from English depredations—though most also returned the favor and went after English cochineal cargoes whenever the opportunity presented itself.

Overall, however, Spain remained the primary target of English raiders, providing the bulk of cochineal prizes. To protect their dyestuff, Spaniards were forced to adopt new methods for shipping it overseas. Merchants divided their cases of cochineal among several vessels, in order to increase the odds that at least part of their cargo would make it all the way to Seville. Spanish authorities also allowed them to make use of the *navios de aviso*, the swift messenger ships that crossed the Atlantic at irregular intervals, which were ordinarily prohibited from carrying cargo.

Even so, Spain was reeling from the effects of the English onslaught by 1590. That winter European bankers noted that English raiders had taken several Spanish prizes with "over 20,000 pounds of cochineal on board . . . and gold and silver as well. This is a serious loss for traders, and it is to be feared that Seville will not get through without bankruptcies." The merchants of Mexico were also hard-hit. "God the Lord protect each one of us from harm," the bankers concluded, sobered by the news.

Trained to think in ducats, florins, and pesos, the bankers assessed Spain's losses primarily in financial terms. For many Europeans, however, the struggle over cochineal had a symbolic dimension as well. To possess cochineal was to possess the color of military prowess and imperial glory—a metaphorical triumph that meant everything to Protestant England. Even Thomas Gage, an English-born Catholic priest who lived in Spanish America, could not help bragging about his native country's achievement. The English "single out such ships as from

America carried the rich commodity of cochineal, whereof they make more use than Spain itself to dye their clothes and coats withal," he told a Spanish gentleman in the early 1600s. As a result of their prowess, the English "delighted to go in red, and to be like the sun." Gage exulted that they wore "more scarlet than any nation in the world."

Gage's claims were undoubtedly exaggerated, yet his speech was more than an empty boast. In it, he expressed the feelings of a nation. Among Englishmen, their ability to steal cochineal from Spanish ships—and to make use of it in their own industries—was a point of immense patriotic pride.

CAPTURING A SPANISH VESSEL WAS ONLY HALF THE battle for English raiders. Bringing their cochineal prizes back to England—or to whichever European nation had commissioned them—could also prove complicated. Victorious freebooters frequently attempted to tow the entire prize ship back to base, stationing an English crew on the vessel, along with a handful of the captured sailors and passengers. This was a practical measure: not only were the vessels valuable, but the large cargoes they contained simply could not be carried any other way. Yet prize ships did not always make it back to the home port. Sometimes they were lost to storms and shipwrecks: the earl of Cumberland lost one of his cochineal-laden prizes when it foundered off the Cornish coast in 1589. Sometimes the captives tried to bolt: in 1591, Robert Flicke described the morning after he took a cochineal prize, when the ship "having gotten the winde of us, stood off with all her sayles bearing, so as we were forced to make a new chase of her, and had not the winde enlarged upon us we had lost her." There were times, too, when a prize ship had to be abandoned: after Flicke recaptured his Spanish prize, the ship sprung a leak, and when it became clear that "continuall pumping" would not save the vessel, Flicke "left

her with 11 foote water in holde, and her furniture and 4,700 hides, unto the seas." (He did, however, take care to save "two and forty chestes of Cochonillio and silkes" before he sailed away.)

Captains who managed to conduct their captured ships safely to England faced more complications once they reached port. All captains were expected to declare their prizes to the Admiralty Court, from whom many had already obtained letters of commission in Elizabeth's name. Powerful and corrupt, these court officials had the authority to declare whether or not a cochineal prize was lawful. If lawful, the court was entitled to 10 percent of the takings. Customs officials demanded another 5 percent. The merchants and courtiers who had bankrolled the raiding expedition also expected a handsome return on their money. If the queen was one of the backers—and she often was—the raiders had to be doubly careful to accord her a good profit.

Once they had satisfied their investors, the raiders were usually left with little more than one-third of the total proceeds of their cochineal prize. This often amounted to a considerable sum, but many raiders wanted more. To boost their margin, they sometimes underestimated their profits to the Admiralty Court and smuggled chests of the dyestuff to shore without declaring them. If they were caught in the act, however, the court confiscated all their goods and sometimes sent them to prison. A similar fate awaited raiders who had captured a cochineal-laden vessel without obtaining a commission first, or who had attacked neutral merchants. Often such confiscations had less to do with the actual rights and wrongs of the matter than with the lord admiral's desire to profit from his office. Politics, too, played a role: the lord admiral had every reason to sanction the expeditions he himself had invested in, while condemning as unlawful those backed by his enemies.

In order to avoid awkward questions from the Admiralty Court, as well as English customs duties, some raiders landed their cargoes not in England but along North Africa's Barbary

Coast. Infamous among Europeans as the home of Muslim pirates, the Barbary ports were cosmopolitan places where merchants bought and sold goods without inquiring too closely into their provenance. Cochineal was highly valued there, and a single cargo could find many buyers. Consequently, tracing the path of cochineal through the Barbary ports was a Byzantine task, as legitimate owners who attempted to reclaim their cargo soon discovered. Yet dealing with the Barbary pirates had its risks for the raiders as well: captains could be captured or cheated or kidnapped. For this reason, most English raiders continued to land their cargoes at home, even though it meant facing Admiralty and customs officials.

Although the Admiralty Court was officially the court of last resort for English raiders, from time to time Elizabeth herself stepped in to decide the fate of a cochineal cargo. This happened with the earl of Essex's great prize of 1597. Always capricious, Elizabeth at first showed great displeasure when Essex returned to England; she was furious that he had not captured the entire Spanish fleet. Essex, who could be as mercurial as his sovereign, stomped away from the royal court and sulked in private at his own estate for several weeks. But the queen could not remain angry with her swashbuckling favorite for long. Three months later she granted him an extraordinary privilege: Essex was given £7,000 of the prize "cuccinelloe" outright and allowed to buy the rest for a song. At the time, the going price hovered between 30 and 40 shillings; Essex shelled out a mere 18 shillings a pound. In addition, the queen commanded that no other cochineal could be imported into the kingdom for the next two years, thereby giving Essex a monopoly on the dyestuff.

During this eventful period, Essex—who well understood the importance of pictorial propaganda in Elizabeth's flamboyant court—commissioned a new portrait from Marcus Gheeraerts the Younger, an artist working in a grand Italianate style. The exact date of the painting, which now hangs in the National

Portrait Gallery in London, is unclear; it is possible that it was painted before Essex departed for the Azores, rather than afterward. If so, it was extraordinarily prescient, for in the portrait Essex appears in the red surcoat and purple robes of England's highest chivalric honor, the Most Noble Order of the Garter. The dark robes are thrown back, and Essex stands full length before the viewer, blazing in scarlet splendor.

To his contemporaries, Essex was indeed the scarlet man, the kingpin of the English cochineal market. Yet he proved ungrateful for the queen's favor. Almost three years to the day after she granted him his cochineal bargain, he rose in rebellion against her court. The insurrection was quickly crushed, and Essex was afterward condemned to death for high treason by the scarlet-clad peers of the realm.

Essex went to his execution wearing black, but at the end he followed the example of Mary, Queen of Scots, and used the color red to demonstrate his essential nobility and fighting spirit. After saying his prayers on the straw beside the block, he stripped off his black satin doublet and stood before the assembled crowd in a scarlet waistcoat, a man of courage to the last.

ESSEX'S GREAT PRIZE OF 1597 WAS A HIGH-WATER mark in cochineal piracy. Two years after his execution, Queen Elizabeth died, and her successor, James Stuart, made peace with Spain and frowned upon piracy of any kind. Once raiders no longer enjoyed official support for their escapades, the amount of prize cochineal captured at sea dropped precipitously. Later in the 1600s, when hostilities resumed, English pirates and privateers generally failed to bring in the large cochineal prizes that had been the rule in the late Elizabethan period.

Whether this failure was due to a lack of skill or simply bad luck is hard to say. But few Europeans did better. The Baltic

powers and the Italian principalities were either not willing or not able to pursue the great Spanish fleets. France, which in the early sixteenth century had been Spain's greatest enemy at sea, had lost so much ground during its crippling civil war that it could not mount a truly effective operation; most of its efforts to obtain cochineal involved feeble smuggling schemes centered on the Azores and the Cape Verde Islands.

Only the Dutch were a force to be reckoned with. Having secured their country's independence from Spain, they attacked their former overlords on the high seas throughout much of the seventeenth century. In 1628, they even managed to capture Spain's entire Veracruz fleet off the coast of Cuba, which was undoubtedly laden with a large amount of cochineal. The Dutch Sea-Beggars also proved adept at capturing the dyestuff off the coast of Honduras, once the haunt of English raiders. So successful were they that by 1625, the Spanish merchants in Honduras were forced to start shipping their cochineal along other, less convenient routes. Despite this change in tactics, the Dutch continued to threaten Spanish trade in the dyestuff, not least because they engaged in cochineal smuggling on a large scale.

Yet even the Sea-Beggars were not able to obtain all the cochineal their countrymen needed. During much of the 1620s and 1630s, the dyestuff was so scarce that only high masters like Rembrandt could afford to use brilliant cochineal lakes in their art. Most painters were forced to make do with cheaper and more somber reds. Nor was cochineal the only substance missing from Dutch palettes; the struggle with Spain, and consequent trading difficulties, had also made indigo, logwood, and other exotic dyestuffs extremely expensive. It may have been for this reason that Dutch artists, once renowned for their rich and vivid flower paintings, now began to paint in monochrome. A gray seascape, a still life of pale cheeses, a banquet painted entirely in brown— their art was devoid of all but the blandest colors.

Later that century, as Dutch merchants and seamen grew
ever more powerful, both painters and dyers found it easier to
obtain cochineal. Even so, there was never enough of the dyestuff
to satisfy everyone's desires. Other Europeans, too, chafed at the
fact that cochineal was so scarce.

In England and France, the need for cochineal was especially
acute, for the governments of both countries were engaged in
serious efforts to increase the prestige and prosperity of their tex-
tile industries. The English, in particular, were desperate to
escape their status as underdog, and cochineal became central to
their strategy. Although, as one policy maker put it, England was
famous for producing "the best wool and cloth of the world," its
dyeing left much to be desired; indeed, many cloths left the
country undyed and were finished by more technologically
advanced nations, which claimed most of the profits. To put an
end to this deplorable situation, English merchants and states-
men together established various programs and initiatives aimed
at advancing the art of dyeing in their country. Yet these efforts
were compromised by England's lack of access to top-quality
dyestuffs like cochineal. James I's peace treaty had restored
English commerce with Spain, but throughout the early 1600s
England's highest government councils worried that adequate
cochineal imports were not reaching their island. Similar con-
cerns troubled the French and Dutch as well.

By then, however, it was clear to everyone that piracy alone
was not the answer. Even the largest cochineal prizes disappeared
all too quickly: Essex's massive haul, which was supposed "to
serve this realm for many years," was apparently used up with
remarkable speed. Nor could smuggling or legal trade give these
Europeans what they truly wanted: unfettered access to
cochineal. For that, they would have to look elsewhere.

Their best hope, they concluded, lay in the new colonies they
were establishing in North America and in the Far East—
colonies like New France, New Netherlands, New England,

Virginia, and Batavia. With luck, there they would discover cochineal or other dyestuffs equally as good. English colonists were especially optimistic about their chances: according to a 1609 tract, there was "undoubted hope of finding Cochinell" in Virginia.

Yet despite their sanguine expectations, the searchers faced an immediate problem: they had no clear idea of what cochineal looked like in the field. So jealously had Spain guarded the secrets of the dyestuff that its nature was a complete mystery to most Europeans. What was cochineal, exactly? Did it come from a plant or an animal? How was it produced? For nearly a century these questions had confounded many clever minds. To win cochineal for themselves, Spain's rivals would have to discover the answers.

TEN

Wormberry

FOR EUROPEANS, THE VERY PRESENCE of America—a massive island in a supposedly empty ocean—came as a profound intellectual shock. Neither Ptolemy, nor the other ancients, nor even the Bible itself had ever suggested that such a land might exist. And the shocks continued to come, one after the other, for the discovery of America presented Europeans with a thousand unexplained wonders. The New World's plants, animals, and inhabitants mystified Europeans.

Cochineal was one of the most valuable of these American curiosities; over time, it proved to be one of Europe's most enduring enigmas as well. Unable to observe the growth and harvesting of cochineal for themselves, the sixteenth-century merchants and dyers who first traded in the dyestuff could only guess at its origins. As far as they knew, the rough, dried granules might be anything under the sun.

To better understand the dyestuff, mainland Spaniards and

other Europeans turned at first to the Bible and the classics. Even though these books had failed to mention the existence of America, they nevertheless remained the intellectual bedrock of the Renaissance world. The Bible in particular was beyond question; to doubt it was heresy. And if the writings of the ancients had occasional faults, to most Europeans they still seemed far more trustworthy than any observations made by latter-day, fallible men. In the early sixteenth century it was standard procedure to consult these cherished books about all American phenomena and to try to match each New World curiosity with some ancient equivalent. Thus New World parrots were likened to those mentioned by the great Roman naturalist Pliny, while the life of Hispaniola's native people was compared to Virgil's Golden Age.

In the case of cochineal, finding a match was simple. The works of Pliny and other classical writers had a great deal to say about red dyestuffs in general, particularly the rich red dyestuff they called grain, and Europeans saw no reason why their comments would not apply to the Mexican dyestuff as well. After all, the merchants of Seville and the dyers of Venice had declared that grain and cochineal were virtually identical.

There was, however, one intractable problem: the ancient texts did not agree on the origins of the dyestuff. According to some classical authorities, grain came from animals. According to others, it was derived from plants. To add to the confusion, the most respected classical philosophers—Pliny and the physician Dioscorides, whose first-century writings were much admired in Renaissance Europe—had failed to come to a firm decision either way. Sometimes they described grain as a seed or berry, sometimes as a worm or snail. Indeed Pliny seemed to believe that at least one type of grain might somehow be both things: a berry that turned into a worm, which he called a "wormberry"— a concept that struck most Renaissance Europeans as entirely plausible. Like the ancients, they believed that mud could spontaneously generate worms, and that rotten meat could produce

flies. It was therefore no great leap to believe that a berry could turn into a worm, and vice versa.

Those who turned to the Bible to reconcile the controversy were disappointed. Although the Vulgate used the word *vermil-ion*, or "little worm," to describe the color produced by grain, lending credence to the idea that the dyestuff had animal origins, the Bible made no definite pronouncements either way.

Yet if these ancient books were contradictory, they did at least narrow the field. Having consulted the highest authorities, educated Europeans could be fairly certain that cochineal, like grain, must be one of three things. It might be part of a plant, probably a seed or a berry. It might be an animal, probably a snail or a worm (the latter being a catchall term that included many insects as well as the animals we know as worms today). Or it might be some combination of plant and animal, a wormberry.

Which theory of origin was correct? For centuries, Europeans had been trained to leave such questions to clerics, who attempted to reconcile textual discrepancies by debating the matter endlessly among themselves, according to set rules of logic, with Holy Writ as the ultimate authority. Direct observation and experimentation were, by contrast, discouraged and discounted.

But Europe was changing, albeit slowly. Even before Columbus set sail, Renaissance scholars had been recovering many lost ancient treatises that offered new perspectives on the world. The invention of the printing press had allowed these books to reach a much wider audience. At the same time, the rise of guilds had given Europeans a new respect for hands-on crafts-manship, which in turn helped generate interest in engineering and experimentation among scholars.

The discovery of America accelerated this process of intellec-tual change, for the inadequacies of ancient texts became more apparent with every new American curio that arrived in Seville. America, according to one Spaniard, appeared to be full of "many things . . . that neither Pliny nor Aristotle ever conceived of."

Left in the lurch, some Europeans concluded that the only way to satisfy their curiosity about the temporal world was to observe the facts for themselves.

For these men, acknowledging the evidence of their senses did not generally mean breaking with the Bible or the Church. In some cases, close observation did lead to religious skepticism, but most of the new-style natural philosophers (whom we would later call scientists) firmly believed that their investigations would bring them closer to God. Certainly this was the opinion of the Spaniards who wrote the most accurate sixteenth-century accounts of the New World. Many, in fact, were Spanish priests who hoped that increased understanding of American phenomena would make them more effective missionaries to America's indigenous people. Others—both priests and laymen—simply wished to glorify God by describing the world he had created.

Although these men were reluctant to take issue with the Bible, they had no compunctions about challenging the wisdom of classical philosophers when it conflicted with the evidence of their own senses. Again and again, they emphasized the importance of firsthand observation. "What I have said cannot be learned in Salamanca, nor in Bologna, nor in Paris," wrote Gonzalo Fernández de Oviedo, a soldier of fortune who recorded some of the best early descriptions of New World flora and fauna. For all that he admired Pliny's *Natural History*, Fernández de Oviedo was quick to point out that his own books, unlike Pliny's, were not based on letters and library scholarship but had come to him through the "labors and hardships and perils which for over twenty-two years I have seen and experienced in my own person, serving God and my king in these Indies."

For Fernández de Oviedo, as for many Spanish naturalists, direct observation was more relevant than the most cherished classical texts. Yet describing the New World was no easy task. American flora and fauna seemed to defy categorization, and Spaniards fumbled for words as they struggled to make sense of

the land before them. They were limited, too, by the technology of the time and by the rigors of colonial life. For the most part, Spanish naturalists could document only what they saw with the naked eye; primitive magnifying glasses existed in Europe, but they were expensive and fragile, and rarely if ever used by six-teenth-century Spaniards in the New World. Nor did Spanish naturalists make much use of rulers or scales. Instead they fell back on rough comparisons: animals were said to be "something larger than a rabbit" or "the size of a housecat."

Even the most dedicated naturalists' observations were not always complete or correct. In the case of cochineal, the omis-sions and errors began with Fernández de Oviedo himself. In his *Historia natural* (1526), he presented Europe with its first detailed description of the nopal cactus, but failed to mention cochineal at all. Nine years later, in his more extensive *Historia general* (1535), he described how he had once eaten the nopal's juicy fruit, only to have his urine turn blood-red soon afterward. "I believed without a doubt that all the veins of my body had bro-ken," he wrote. He was greatly relieved when a more experienced friend explained that the fruit was harmless.

Later in the *Historia general*, Fernández de Oviedo wrote about another red dye—"an excellent color, of a very good crim-son"—that was sold in plazas and marketplaces in the form of red cakes. Artists painted pictures with it, and women applied it to their faces. The dye in question was almost certainly cochineal, which was sold and used in this way. Yet perhaps because of his earlier brush with the cactus juice, Fernández de Oviedo con-cluded that the dye-cakes had been made from the fruit of the nopal.

Other Spanish observers were apparently misled by the out-ward appearance of cochineal. In the early 1540s, Toribio de Benavente, a Franciscan friar also known as Motolinía, was aware that Tlaxcala produced "very good cochineal," and he spoke enough Nahuatl to apply the term *nocheztli* to the dyestuff.

He nevertheless seems to have believed that the dye was pro-
duced by trees, and he likened grains of cochineal to "coriander
seeds." Borrowing from Motolinía's work, Francisco López de
Gómara wrote that cochineal came from the "nuchtli fruit" in his
popular history of the Conquest, *Hispania victrix*, published in
the 1550s.

Not for more than thirty years after the Conquest did a
Spaniard suggest in print that cochineal might be an animal,
rather than the fruit of a plant. In 1554, a professor at the
University of Mexico, Francisco Cervantes de Salazar, noted the
existence on the nopal cactus of "some little worm-like creatures,
which, when killed in ashes, are a very fine grain, the best that is
known." His description, however, did not suffice to end the
debate about the true nature of cochineal, for he mistakenly
wrote that the cactus somehow "bred" the worms within its flow-
ers—leaving open the possibility that cochineal was not a true
worm but something more like Pliny's wormberry.

Investigations continued, for by then cochineal had become
one of New Spain's most valuable exports, which whetted
Spanish curiosity. The first Spaniard to correctly describe
cochineal in a manuscript was Bernardino de Sahagún, a
Franciscan friar who spent decades compiling a marvelously
detailed account of ancient Mexican culture with the help of
indigenous elders. By the 1570s, the account included a descrip-
tion of cochineal: "This cochineal is an insect; it is a worm. The
cochineal nopal is the breeding place of this cochineal. It lives, it
hatches on the nopal like a little fly, a little insect." To this,
Sahagún appended elaborate (though not entirely accurate) illus-
trations of the insect, along with portraits of men painting with
cochineal and selling cakes of cochineal dye.

Sahagún's description of cochineal surpassed that of any of
his contemporaries in both accuracy and detail, but few of his
contemporaries ever read it. In 1577, the book was confiscated by
Philip II, who took a dim view of unauthorized accounts of the

New World. While he did not specifically prohibit his subjects from publishing information about cochineal, he preferred that all information about Spain's overseas empire be gathered and monitored by Crown officials. Upon seeing Sahagún's richly illustrated manuscript, Philip evidently concluded that the book was not a threat but an objet d'art. In 1579, he gave the manuscript away as a royal wedding gift. Modern historians consider Sahagún's work the single most important source on Aztec life and culture in existence, but it languished on the shelves, unappreciated and virtually unread, until the nineteenth century. Only then was it finally reproduced in print.

Deprived of Sahagún's book, some sixteenth-century Spaniards continued to insist that cochineal was a seed, a fruit, or some kind of wormberry. In time, however, the power of close observation won out. In *Historia natural y moral de las Indias* (1590), José de Acosta, a great naturalist and Jesuit missionary, stated the case clearly: on the nopal, he wrote, "are born some worms that are fixed to the cactus and covered with a certain thin coating." Soon afterward, the historian Antonio de Herrera declared that "cochineal is a living thing, a kind of round worm [that is] as large as a lentil." He added that once the cochineal "worms" reached their full size, they produced offspring. New worms were "like mites, and they swarm over the whole tree."

These authoritative accounts were soon confirmed by others, and together they settled the debate about the true nature of cochineal—at least as far as most educated Spaniards were concerned. By the early 1600s, they had accepted that the dyestuff was an animal, not a plant. For the rest of Europe, however, the question remained open.

Part of the problem was lack of information. High printing costs, Spanish censorship, and other vagaries of the Renaissance book trade ensured that many accounts of the New World did not circulate widely even in Spanish, let alone in translation. Some manuscripts, like Sahagún's, were not printed for centuries.

Most others that did reach a wide audience during the Renaissance did not mention cochineal at all. Of those that did, at least two—Fernández de Oviedo's *Historia general* and López de Gómara's *Hispania victrix*—implied or stated that cochineal was the product of a plant. The only sixteenth-century "bestseller" that described cochineal as a worm was Acosta's *Historia natural y moral de las Indias*, a work that was rapidly reprinted in Italian, Dutch, French, German, and English after its original publication in Spain in 1590.

Confronted with these contradictory accounts, many Europeans began to wonder if Spain was deliberately fudging the facts in order to preserve its monopoly. Even scholars who managed to consult a wide number of sources, and were therefore aware of the growing Spanish consensus that cochineal was a worm, were not sure what to think. The principles of full disclosure and open communication were starting to become central to scientific endeavor, but secrecy had long been the rule in all matters relating to dyes and the textile business, and centuries of international rivalry had conditioned people to be suspicious of any seemingly valuable information provided by a competitor. To most Europeans it seemed entirely possible—even likely—that the Spanish consensus was actually a Spanish conspiracy, a high-stakes bluff meant to distract and deceive them.

Mistrusting the all-powerful Spaniards, naturalists in other European countries ultimately decided that they must discover the truth about cochineal for themselves. In doing so, they set themselves a Herculean task. Spanish law forbade them to make field observations in Mexico, and existing magnifying glasses were too weak to allow them to determine cochineal's true nature from dried samples of the dyestuff. Out of desperation, English, French, and Dutch naturalists tried to piece together the natural history of cochineal from the tales of their own countries' explorers, merchants, and seamen. Surely their countrymen were more trustworthy than were the despised Spaniards, these naturalists

reasoned; indeed many of them had already provided reliable information about other aspects of Spanish America, such as the departure times of Spanish fleets. Yet however sound these adventurers were on matters of shipping and Spanish policy, their accounts of cochineal were wildly misleading.

The story of Robert Tomson, a merchant who provided one of the earliest non-Spanish reports on cochineal, is instructive in this regard. To Englishmen like Richard Hakluyt, the prominent geographer who published his tale in the late sixteenth century, Tomson seemed the perfect witness. A covert Protestant who evidently relished the role of informant, Tomson had lived and worked in Seville for many years, was married to a Spaniard, and knew a great deal about the Indies trade. Best of all, he had been permitted, as a Hispanicized merchant, to travel to New Spain in 1555, where he had observed the mysteries of America firsthand.

A well-informed man, to be sure—or so it seemed to Hakluyt and his readers. But Tomson had not been permitted to wander about Mexico on his own, nor had he ever had the chance to see live cochineal for himself. Nevertheless, he spoke as an authority on the subject: cochineal, he stated, was "not a worme, or a flye, as some say it is, but a berrie that groweth upon certaine bushes in the wilde fielde, which is gathered in time of the yeere, when it is ripe." Many Europeans—including Hakluyt, who ensured the story circulated widely—accepted this fabrication as truth, simply because it did not come from the mouth of a Spaniard. English colonists were advised to search long and hard for "the berrie of Cochenile," as well as other plants and fruits "fitte for dying," in their New World settlements.

Another man of action who helped promulgate the idea that cochineal was a berry was the French explorer Samuel de Champlain. As a young man, Champlain sailed to Mexico and the Caribbean in 1599. Like Tomson, he did not have much chance to explore New Spain beyond its coastline, but he gave free rein to his imagination. Upon his return from the New

World, Champlain reported to the French king that cochineal "comes from a fruit the size of a walnut which is full of seed within. It is left to come to maturity until these seeds are dry, and then it is cut like corn, and afterward beaten to get the seed, some of which they sow again so as to have more." This preposterous account evidently proved influential among top policy makers in France, for the report met with the king's favor and later passed into the hands of a vice admiral of the French navy.

Thanks to Tomson and Champlain—and to the atmosphere of suspicion that characterized the relationship of Spain and its neighbors—many Europeans became convinced that cochineal was the product of a plant. Yet as more and more Spanish treatises described cochineal as an animal, Europeans who had the opportunity to consult the relevant texts began to wonder if perhaps they were telling the truth. In the 1630s Joannes de Laet, a director of the Dutch West India Company, became one of the first non-Iberians to publicly side with the Spanish naturalists. Familiar with the work of Acosta and Herrera, Laet described cochineal as "an animal, or rather an insect."

Over the next several decades, a number of eminent philosophers came around to Laet's way of thinking. Nevertheless, a great many Europeans remained unshaken in their belief that cochineal was a seed or berry. In 1636, the directors of the Providence Island Company advised English colonists to "grow" cochineal in the Bahamas along with crops such as ginger and rice. In 1694, Pierre Pomet identified cochineal as a cactus seed in his *Histoire générale des drogues*. Indeed, to many people the idea that cochineal was an insect seemed to fly in the face of reason.

"It is impossible, and altogether incredible, that the Drug call'd Cochineel should be . . . Flies, or any sort of Animal endued with Wings, Head or Feet," wrote one Dutch merchant and amateur scientist in 1704. According to his calculations, a single pound of cochineal contained as many as 102,400 grains or particles. "Where can you find Men enough," he asked, "who at

the proper time of the year shall catch these Insects, and dis-
member every individual by pulling off its Head, Legs and
Wings, etc.?" It was obvious, he concluded, that "Cochineel must
needs be a Fruit, or the Excrescence of some kind of Plant."

Other Europeans sought to reconcile the two opposing views
by way of the ever-popular "wormberry." One such man was
Thomas Johnson, the editor of a highly esteemed botanical trea-
tise, who wrote in 1633 that "certain excrescences" grew on the
nopal cactus, "which in continuance of time turn into insects;
and these out-growings are that highly prized *Cochenelle* wher-
with they dye colours in graine."

The English pirate William Dampier offered a more elabo-
rate version of the wormberry argument at the end of the seven-
teenth century. "The Cochineel is an insect," he reported, but
one born of a cactus, the "mother Fruit." To harvest the dyestuff,
Indians spread out a linen cloth under the cactus and shook its
branches, Dampier described, "and so disturb the poor Insects,
that they take wing to be gone, . . . but the heat of the Sun so dis-
orders them, that they presently fall down dead on the Cloth
spread for that purpose, where the Indians let them remain 2 or 3
days longer, till they are thoroughly dry." Wild cochineal—
domesticated cochineal's smaller, less valuable cousin—also came
from a cactus fruit, according to Dampier, but unlike domesti-
cated cochineal it was a seed, which fell from the ripe fruit "with
the least touch or shake."

This creative compromise evidently satisfied Dampier, but it
did nothing to settle the controversy over cochineal's true nature.
Throughout the seventeenth century, the debate over cochineal
raged on. It was one man's word against another's, for in the
absence of any universally verifiable information about the dyestuff,
people sided with Acosta and Herrera—or with Tomson and
Champlain according to their own personal prejudices.

Yet if the debate about cochineal was going nowhere,
progress was being made on other fronts. In the early 1600s,

Europeans made a startling discovery about the dyestuff's chemical properties. Leading the way was a Dutch engineer and alchemist named Cornelis Drebbel.

BORN AROUND 1572 IN ALKMAAR, NORTH HOLLAND, Cornelis Drebbel was a colorful character in more ways than one. An inventor, he built a "perpetual-motion" machine that became the sensation of early-seventeenth-century Europe. Later he built the first submarine. To the great amazement of Londoners who crowded the riverbanks to watch, the leather-covered boat carried a dozen oarsmen and traveled under the Thames for three hours; apparently Drebbel generated an oxygen supply for the crew by burning saltpeter—another first. The Dutch diplomat and amateur scientist Constantijn Huygens the Elder wrote admiringly of Drebbel's "remarkable mechanical instruments." To Robert Boyle, he was "that deservedly famous Mechanician and Chymist," to Baron von Leibniz, "le fameux Drebbel."

Even Drebbel's admirers, however, did not consider him a true natural philosopher. To their minds, natural philosophers were men (and very occasionally women) who were preoccupied with the theoretical side of what we now call science; although they sometimes engaged in hands-on experimentation, they were admired primarily for the ideas they expressed in their lectures and treatises. Drebbel, who spent most of his time building mechanical contraptions and tinkering with them, belonged to an altogether different and less exalted group; he was an "Engeneere," or what Isaac Newton later termed a "Vulgar Mechanick."

The sheer range of Drebbel's efforts provoked scorn from his detractors. Over the course of his life, Drebbel built dozens if not hundreds of new machines, including not only the famous *perpetuum mobile* and submarine but also a self-winding clock, a new kind of chimney, a self-playing spinet, a self-regulating oven, and

an incubator for hatching chickens and ducks. How, his critics wondered, were they supposed to take such a man seriously?

Even worse, Drebbel exhibited an ungentlemanly interest in profiting from his inventions. Having begun as an engraver's apprentice in Holland, he took a time-honored path to upward mobility: he married well, wedding his master's younger sister in 1595. A decade later, he moved his young family to England, where he enjoyed royal favor. But he continued to live from hand to mouth for most of his life—due, some said, to his wife's extravagant tastes. Always on the lookout for extra income, Drebbel created various toys and spectacles for the court of King James I, including firework displays and automated replicas of Roman gods. Needless to say, these frivolities did nothing to increase his standing among intellectuals. When King James died, Drebbel walked in the funeral procession with "Baston le Peer the dauncer" and sundry "Actors and Comedians," rather than with the great men of his day.

Because Drebbel's inventions were his sole source of income, he was reluctant to share his techniques with anyone else. To this day no one knows exactly how his *perpetuum mobile* and submarine worked. Had he been a dyer by trade, this penchant for secrecy would have passed without remark. But because his activities fell within the newly emerging sphere of science, where openness was becoming a hallmark of good practice, he came in for a great deal of criticism. Elite natural philosophers—many of whom were supported not by their inventions but by private fortunes or generous patrons—disapproved of secrecy on principle, and some denounced Drebbel as a charlatan.

It did not help matters that Drebbel was deeply involved in the occult discipline of alchemy, not only publishing an alchemical treatise but at one point accepting an appointment as alchemist to the Bohemian court. Once widely regarded as a respectable discipline, by the seventeenth century alchemy had become a more dubious enterprise. It was true that some serious

intellectuals still manifested an interest in the art: Isaac Newton, for example, devoted decades to the study of alchemy and wrote many papers on the subject. Yet even advocates of alchemy were forced to acknowledge that the field was crowded with tricksters and crackpots. Anyone connected with the enterprise could be tainted by association, which was one reason why many historians of science later sought to suppress evidence of Newton's alchemical interests. No doubt it was Drebbel's connection with alchemy that led some influential contemporaries to accuse him of being a "magician" and a "sorcerer."

True to form, Drebbel left no personal record of his experiments with cochineal, so no one knows exactly how he stumbled onto one of the dyestuff's unusual characteristics: its great affinity for tin. According to one early account, his great discovery was entirely accidental. Soon after his arrival in England, probably in 1606 or 1607, Drebbel boiled a solution of cochineal and water for use in a thermometer; as expected, he ended up with a bowl of dark crimson-purple liquid. To cool the vessel, Drebbel placed it by the window, below a phial of *aqua regia*, a mixture of nitric and hydrochloric acids. The phial somehow broke, spilling acid onto the window frame, where it hissed and bubbled before falling into the bowl of cochineal-dyed water. To Drebbel's astonishment, the dark liquid instantly turned bright scarlet.

Upon further investigation, Drebbel discovered that a piece of the tin window frame had dissolved in the acid, and that it was primarily tin's action upon cochineal, in the presence of an acid, that had caused the color shift. Drebbel then experimented with cloth, using pewter (a tin alloy) and various acids as mordants for the cochineal, with spectacular results. Ordinary recipes for cochineal, most of which employed alum as a mordant, produced a fine scarlet cloth, as vibrant as any Europe had ever seen. But Drebbel's recipe produced an even brighter red, a shade of scarlet cloth so brilliant that no one had ever seen its like before.

Was Drebbel's discovery truly an accident? According to the

eminent chemist Robert Boyle, who knew Drebbel's son-in-law, Drebbel had actually undertaken to experiment with cochineal as a business venture: "some merchants put him upon the advancement of a certain way of dyeing a fine red or rather crimson, that had been a while before casually lighted on in Holland, and proved very gainful to the finders." These merchants hoped that Drebbel would be able to produce a similar red dye; instead, according to Boyle, Drebbel invented one that was even better. Plausible though Boyle's story seems, there is little evidence to support it. Not only is there no record of any Dutch competitors, but no merchants appear to have marketed Drebbel's discovery.

Yet the accident story has drawbacks, too. Aqua regia is a dangerous chemical that must be treated with great caution; would Drebbel really have left it in so precarious a position by his window? Is it possible, instead, that Drebbel was deliberately experimenting with cochineal—as an alchemist?

Tin and aqua regia were commonly used in alchemy. Moreover, according to many ancient alchemical texts, the philosopher's stone—which transmuted base metals into gold and bestowed immortal life, wisdom, and salvation on its maker—was actually a red powder or liquid. One manuscript described it as "the body of red invariable," the most beautiful scarlet on Earth. Consequently, alchemists like Drebbel were greatly interested in red dyes. Given this, it seems entirely possible that Drebbel was dabbling in alchemy the day he made his discovery. When he saw his cochineal solution turn scarlet, he may well have thought he had discovered the philosopher's stone—and all the wealth that went with it.

Wealth, however, continued to elude Drebbel for the rest of his life. He started a dyeworks in 1607 at Stratford-on-Bow, a few miles east of London, but it does not appear to have been a great success; it seems Drebbel had no talent for business. The dyeworks served their purpose, however, for they helped attract two eminently eligible suitors for his daughters: Abraham and

Johannes Sibertus Kuffler, two Dutch brothers who, like Drebbel, had emigrated to England in search of greater opportunity for their scientific talents.

Greatly impressed by Drebbel's many inventions, especially his scarlet dye, Abraham Kuffler married Drebbel's daughter Anne in 1623; Johannes Sibertus married her sister Catherina four years later. Blessed with more business acumen than their father-in-law, they turned his cochineal recipe into a money-maker. By 1627, people were exclaiming over the Kufflers' scarlet cloth, which one observer maintained was "more beautiful and at a better price than the colours now usually made." After Drebbel's death in 1633, the brothers reorganized the dyeworks at Stratford-on-Bow, and the firm soon became quite prosperous. Later, the Kufflers set up another dyeworks in Holland, which also produced scarlet cloth.

The Kufflers went to great lengths to keep Drebbel's technique secret, but dyers everywhere were curious about how the bright scarlet cloth was made. Eventually, the most dedicated dyers figured out that tin was the key ingredient; indeed, a few dyers may have discovered how to make the new scarlet—either independently or through espionage—while Drebbel was still alive. By the 1660s, top dyers across Europe were using tin and cochineal in various formulations to produce the sought-after dye.

Known as Bow-dye, Dutch scarlet, and Kuffler's color, Drebbel's dye took fashionable Europe by storm. Depending on the exact composition of tin, cochineal, and other ingredients, the various recipes yielded a range of luminous scarlets, from a deep cherry red to an eye-popping neon color. The most brilliant reds were "full of fire," according to one observer, "and of a brightness which dazzles the eye." In the eyes of the chemist Robert Boyle, and of many of his contemporaries, Drebbel had succeeded in creating "a perfect Scarlet."

Royal robes, court gowns, military sashes—wherever Drebbel's scarlet appeared, it attracted notice as the finest, brightest color in

the room. Aristocrats and well-to-do Europeans took to the dye with enthusiasm, all the more so since the fashion for Spanish black was fast retreating before the glorious presence of the Sun King, Louis XIV. From his magnificent gold-embossed robes to his red high-heeled slippers, Louis delighted in flamboyant color, and Europeans made haste to follow the powerful monarch's lead.

In England, where the French fashion for color strongly influenced Charles II's riotous Restoration court, Drebbel's scarlet also served another, more serious purpose. It was under Oliver Cromwell, shortly before the Restoration, that English army coats became red, and Cromwell specified that they be made in Gloucestershire, an area that was to become famous for scarlet woolens dyed with cochineal and tin. While lower-ranking red-coats had to settle for less costly dyes like madder, Gloucestershire's cochineal scarlet cloth was used to make many a British officer's uniform over the next two centuries. Drebbel's scarlet therefore appeared on such famous British battlefields as Culloden and Waterloo—and made British officers easy marks for the sharp-shooters of Lexington and Concord in 1775.

Although its brightness could be a liability in backwoods warfare, Drebbel's scarlet was used for other military uniforms, too. The coats of Russia's Imperial Guard were made with it, and so were the kilts of Scots warriors. Various cochineal scarlets appeared in flags as well, including the star-spangled banner that flew over Baltimore's embattled Fort McHenry in 1814, which gave rise to the national anthem of the United States.

Fashioned into blankets and broadcloths, Gloucestershire's tin-and-cochineal woolens also became a vital staple in the fur trade. Native North Americans bartered for them with beaver pelts, which Europeans coveted for their hat industry.

Tapestry makers, too, were eager to employ the new cochineal scarlet in their designs. Among the first to learn the secret of its manufacture was the firm of Gobelins, in Paris. The new scarlet was so striking that some Parisians whispered that it was not a

human invention at all; to acquire the recipe, they said, the dye-masters at Gobelins had dealt with the devil himself.

Occult rumors aside, there was no disputing that Drebbel's discovery had made cochineal more valuable than ever. To the frustration of many Europeans, however, the dyestuff's origins remained a mystery. Fortunately, a remedy for their scientific dilemma had recently appeared on the scene: an innovative machine called the microscope that would cause controversies of its own.

Through the Looking Glass

 IN THE EARLY 1600S, AS EXPLORERS IN North America and Asia sought far and wide for the "berrie of Cochenile," Europeans were startled to hear of a new invention, the microscope, that allowed the viewer to see objects so small that they were invisible to the human eye. It was a device that had been a long time in the making. The action of the lens—the fundamental component of the microscope—had been described by the Arab mathematician Alhazen at the turn of the first millennium, but the first true microscopes emerged only in the 1590s and early 1600s. One early report concerns the astronomer Galileo: ill in bed in 1614, he told a visitor how he had previously fashioned a makeshift microscope from one of his celebrated telescopes, which allowed him to see "flies which look as big as lambs."

These early microscopes were very primitive machines. Galileo's device, which had one convex and one concave lens, was long and awkward and had an extremely limited field of view.

But other inventors—including Cornelis Drebbel—soon discovered that much more compact and powerful microscopes could be made using either a single convex lens (a simple microscope) or convex lenses in combination (a compound microscope). To the astonishment of natural philosophers everywhere, these instruments revealed a whole new world. Under the microscope, fleas appeared as wide and bristled as boars; thyme seeds loomed large as melons. Pure rainwater played host to a zoo of squirming, squiggling, and crawling creatures, the likes of which had never been seen before.

Entranced by this strange miniature world, the English experimentalist Robert Hooke published a book called *Micrographia* in 1665, which featured thirty-eight engravings of everyday phenomena—such as fish scales, mold, and lice—as viewed through a microscope. Like the London architect Christopher Wren, who collaborated with him on the book, Hooke was a superb draftsman. In the *Micrographia*, they did some of their best work; the twenty-one-inch louse, in particular, was a wonder to behold. Both a popular sensation and a scientific success, the *Micrographia* was treasured even by continental scientists who could barely read any of the English text it contained.

Stunning though Hooke's images were, his Dutch contemporary Antoni van Leeuwenhoek soon produced even better ones. Unlike most of the great scientists of the day, Leeuwenhoek was not particularly well educated, and his inadequacies prevented him from fully participating in the learned society of his time. Born in 1632 to artisan parents, he received a childhood education that appears to have been strictly practical. As a young man, he was apprenticed to a draper and trained in the cloth business. Eventually, Leeuwenhoek achieved the status of minor municipal official in Delft, his home city, but he remained, in the words of one acquaintance, "a stranger to letters, master neither of Latin, French or English, or any other of the modern tongues besides his own." Even when he wrote in his

native Low Dutch, his grammar and spelling were sometimes confused. His manners, too, were said to be gauche.

There can be no doubt, however, that Leeuwenhoek was a master when it came to the microscope. No one knows why he took an interest in the invention, but he may have begun by experimenting with the weak magnifying glasses that drapers commonly used to detect flaws in fabric. In a surprisingly short time Leeuwenhoek became an expert lens grinder and glassblower. Although he built only single-lens microscopes, they were superior to all others of the period, including the compound ones that used several lenses to boost their viewing power. Unlike Hooke and Wren, Leeuwenhoek had no talent for drawing, so he was forced to commission artists to record the images he obtained, but no one who saw the results could help but be amazed. For clarity and power, it soon became evident that Leeuwenhoek's microscopes could not be equaled. One Leeuwenhoek lens, now held by the University of Utrecht Museum, was capable of portraying structures only 0.00075 millimeters thick—a feat not equaled until the nineteenth century.*

Fearing that he would lose his tenuous place in the scientific world if he revealed his secrets, Leeuwenhoek refused to share his methods of magnification with anyone; to this day, we do not fully understand all his techniques. His observations, however, were a different matter; he shared them with any number of friends and colleagues. One of those colleagues, a Delft physician, was so struck by Leeuwenhoek's findings that he forwarded them to the Royal Society of London in 1673.

Incorporated only a decade before, the Royal Society was nevertheless one of the most distinguished scientific organizations in Europe. Like the Académie Royale des Sciences in France and Italy's Accademia dei Lincei, it championed essential

*Most lenses were hand-ground, but this lens appears to have been hand-blown into its final shape.

principles of modern science: an experimental approach to knowledge and open communication and collaboration among scientists. Favorably impressed by Leeuwenhoek's work, the Royal Society requested further observations; in 1680, to the Dutch burgher's great joy, they unanimously elected him a member. Year after year, until his death in 1723, Leeuwenhoek enjoyed a regular correspondence with the society's "gentlemen philosophers," including Robert Hooke, who learned Dutch solely so he could translate Leeuwenhoek's letters.

Throughout fifty years of microscope observation, Leeuwenhoek racked up a startling number of firsts. He was the author of the first published descriptions of the structure of red blood cells, spermatozoa, and many types of bacteria, as well as the copulation of fleas, the generation of corn-weevils, and the parthenogenesis of aphids. Fellow scientists praised him for the genius of his work; in revealing the secret lives of small things, he had become, in the eyes of many, "the great man of the century," as Constantijn Huygens the Younger wrote in 1680. Leeuwenhoek did, however, make some mistakes—and one of his greatest mistakes concerned cochineal.

IN THE SUMMER OF 1685, THE ARISTOCRATIC ENGLISH chemist Robert Boyle asked Leeuwenhoek if he would examine cochineal under his fine microscopes. Boyle was a founding member of the Royal Society, which was greatly interested in the cochineal debate. As early as 1668, the society's *Philosophical Transactions* had published a report claiming that cochineal was an insect "engendered" of "a fruit called the Prickle-pear"; the report suggested that similarly valuable insects might be bred from other "Vegetables of Tincture," if only these "Herbs, or Woods, or Berries and other Fruits" were dried, boiled, and allowed to rot under the proper conditions. Other cochineal

reports followed, but nearly twenty years later the society had not yet come to a definite conclusion about the dyestuff. No doubt Boyle hoped that Leeuwenhoek's prowess at the microscope would help settle the debate.

In August 1685, Leeuwenhoek responded to Boyle's request, explaining that he had already examined cochineal several times on his own, but that he had repeated the study once again before replying, to be sure of his observations. "In all cases," he wrote, the results were the same: cochineal was clearly "the fruit of a tree, which carries, or produces, within itself more than 100 very tiny oval seeds, each of which seeds is again enclosed in a membrane." After discussing the appearance of the "seeds" in detail, he concluded, "if we wish to imagine the structure of this cochineal as it is internally, I cannot find a better comparison than with a dried black currant."

How could an expert like Leeuwenhoek have been so mistaken? Over his lifetime he studied more than sixty species of insects, as well as eleven arachnids. He was also very curious about seeds and often examined them under his microscope. Surely he, of all individuals, ought to have been able to place cochineal in the right category.

Perhaps part of the problem lay in the machine itself. Seventeenth-century microscopes were temperamental instruments. When the diarist and dedicated amateur scientist Samuel Pepys purchased one, he was dismayed to discover that at first he could not see anything through it; after much adjustment, he saw only shadowy images that were nothing like the precise figures in Hooke's *Micrographia*. Even Leeuwenhoek's advanced and much-celebrated microscopes were far from infallible. Excellent though his lenses were, like all seventeenth-century glass they were riddled with bubbles, streaks, and other flaws. Most also bore pitted scars from the grinding, which distorted the image in view. Other distortions arose from color dispersion and the spherical nature of the lens itself. In viewing an image, scientists

had to make allowances for all these sources of error: they needed not only to observe but to interpret. Preconceived notions often influenced those interpretations, and perhaps Leeuwenhoek came to his microscope so convinced that cochineal was a seed that he could see nothing else.

It must also be said that cochineal was an unusual subject for Leeuwenhoek. When observing animals, he always preferred live specimens, or at any rate ones that had been freshly obtained. His fleas came from his own maidservant, who also donated her blood; his bacteria came from nearby gutters, from his own mouth, and even from his chamber pot. "I have often endeavored to discover Animalcules in Spittle, but in vain," he once wrote to the Royal Society. "But examining a kind of gritty Matter from between my Teeth, and mixing it sometimes with Rain-water, and sometimes with Spittle . . . I discovered therin with admiration a great number of very small ones moving." Cochineal, being dead and dried, could not produce such lively results as Leeuwenhoek's other "Animalcules." It was also difficult to prepare, since the dried grains first had to be soaked in water or vinegar for several hours to make them larger and more translucent. Moreover, the long journey from Mexico reduced many cochineal insects to fragments, further complicating observation.

Yet although it was difficult to discover the true nature of cochineal under the microscope, it was not impossible. While Leeuwenhoek failed to see anything more than "seeds," his contemporary and compatriot Jan Swammerdam had already seen clearly that cochineal was an animal.

Most microscopists, including Leeuwenhoek, preferred to examine a wide range of life-forms, but Jan Swammerdam devoted much of his life to studying a single class of animals, the insects. At the time, insects were a somewhat ill-defined zoological category, many of whose members were thought to be characterized by a predisposition to spontaneous generation; in the 1600s, the term *insect* encompassed not only flies, grasshoppers, and beetles but also many

other creatures, including worms, slugs, frogs—and, for some scientists, crocodiles. A precise and careful microscopist, Swammerdam helped separate such myths and misconceptions from fact.

Swammerdam's precision is evident in his description of cochineal, which he wrote sometime before 1680. After careful examination, he compared cochineal to the larvae of bees; he also saw the vestiges of legs on their bodies. He did not, however, communicate these findings to the wider world. Haunted by depression, Swammerdam was ill at ease with most people, including his scientific contemporaries; he was also a perfectionist. Rather than write them frequent letters about his results, he saved almost everything—including his observations about cochineal—for his magnum opus, *Biblia naturae*. Unfortunately, Swammerdam died of malaria before the book could be published. Subsequent lawsuits and other misadventures prevented the *Biblia naturae* from reaching the public for nearly sixty years, by which time many of its revelations were common knowledge among scientists.

Unlike Swammerdam, Leeuwenhoek and his colleagues at the Royal Society understood the importance of communicating their results early and often. Communication, as they saw it, was essential to the new-style science: if a scientific discovery was not publicized, it could not be discussed or verified; it was of no use to anyone.

This commitment to openness did have its limits, of course. Anxious to prevent their rivals from stealing their thunder, Royal Society members sometimes recorded accounts of their new discoveries in code or secret handwriting. Other members refused to share every new discovery with the society as a whole, often restricting their discussion instead to a charmed circle of trusted colleagues within the larger group, particularly if the new information concerned chemistry or alchemy. Yet by and large the Royal Society, like its counterparts in France and Italy, helped advance a new ideal of openness that included the frequent exchange of insights and results among scientists. Robert Boyle, for example, was always

eager to receive letters from Leeuwenhoek, and to suggest new avenues for Leeuwenhoek's research—and it was this practice that ultimately helped Leeuwenhoek see cochineal with new eyes.

Soon after receiving Leeuwenhoek's report on cochineal, Boyle reported—via a Dutch correspondent—that he was "very satisfied" with the Delft scientist's conclusion that cochineal was a seed. Nevertheless, Boyle had recently acquired new information that he wished to relay to Leeuwenhoek as soon as possible: a governor of Jamaica had informed him that cochineal "originates in the fruit of a Fig-tree, which, on rotting or putrefying, produce worms, or cocoons, which change into Flies." Since the governor had been so firm in his assertion that "the Cochineal is really the hindmost part or tail of the fly," Boyle wondered if Leeuwenhoek might consider examining the dyestuff again.

Fanciful as the governor's report was, it led to a breakthrough for Leeuwenhoek. Now that he knew what to look for, when he next examined cochineal under the microscope, he saw signs that legs, wings, and head had been detached from each grain, leaving "nothing but the innermost part of the Abdomen." In September 1685, he reported that the evidence was incontrovertible: "each tiny grain is a part of a little animal." Two years later, he wrote that in subsequent examinations of cochineal he had concluded that the grains were in fact "females whose body is full of eggs."

Both of these accounts were published widely, first appearing in Dutch in 1687, and in French and Latin before 1690. Leeuwenhoek did not, however, include any illustrations with either report—a serious oversight that allowed his bitterest rival, Nicolaas Hartsoeker, to upstage him.

BORN IN 1656, NICOLAAS HARTSOEKER WAS MORE than twenty years Leeuwenhoek's junior. The son of a Dutch Calvinist minister, he had demonstrated an interest in science

and microscopes from an early age. At sixteen, he had called on Leeuwenhock and been deeply inspired by the visit. In later years, however, the upwardly mobile Hartsoeker came to consider Leeuwenhoek extremely crass—an opinion that he expressed more and more often as Leeuwenhoek continued to outdo him (and everyone else) in the laboratory. Although Hartsoeker was willing to falsely claim that he, and not Leeuwenhoek, had discovered spermatozoa, he declared himself disgusted by many of the Dutch burgher's other revelations. Hearing that Leeuwenhoek had gone for two weeks without changing his stockings in order to better study the detritus between his toes, Hartsoeker castigated him for making the "most grotesque observations in the world." When Leeuwenhoek examined his own excrement and reported, with delighted wonder, that it contained "animalcules a-moving very prettily," Hartsoeker was simply appalled.

University educated and very ambitious, Hartsoeker preferred to spend his time on more elevated (and more sanitary) pursuits. These included tutoring the rich and famous, including the Elector Palatine and Peter the Great. Later he became an honorary professor of philosophy at the University of Heidelberg. He also published books on lofty subjects such as physics, mathematics, and the nature of light and color. It was in the process of writing about the latter topics that he first examined cochineal under his microscope.

As Hartsoeker was well aware, theories about light had preoccupied European philosophers since medieval times. According to medieval Church doctrine, to understand light was to understand God. To medieval scholars, it seemed self-evident that color was a corruption of pure "white" light, but no one was entirely sure how such corruption occurred. Not until the 1660s did Isaac Newton, the brilliant son of an illiterate Lincolnshire farmer, begin to work out the true relationship between light and color. On leave from Cambridge University, Newton discovered

that ambient light passing through a prism was split into its component parts; the differentially refracted light beams created a rainbow. In subsequent experiments, Newton noted that if the rainbow was then passed through a second prism, rotated through an angle of 180°, it became pure "white" light again. Newton concluded that "white" light was nothing more than, as he put it, "a heterogeneous mixture of differently refrangible rays." That is to say, "white" light was composed of all colors.

Having revolutionized the study of colored light, Newton turned his attention to colored objects. In this venture, however, he was less than entirely successful. He hypothesized that the color of an object depended on the selective absorption and reflection of different parts of the spectrum; that is, an object that absorbed orange light but rejected blue light would appear blue to our eyes. This hypothesis was advanced for its time, but it was only partially correct, and Newton's physical explanation for why such differential absorption and reflection might occur was completely off base.

Not until the nineteenth century did scientists begin to grasp how a range of light effects—such as diffraction, interference, reflection, and dispersive refraction—might combine to create color in objects, and only in relatively modern times have scientists come to understand many of the complicated chemical and atomic factors behind such phenomena. A green leaf, for example, is green because it produces chlorophyll, the molecular structure of which absorbs incoming red and violet rays and reflects the green ones. Many green birds, however, have only yellow pigments in their feathers; we see them as green because the feathers' physical structure produces light effects called thin layer interference and scattering, which add blue to the yellow.

As these examples suggest, the causes of color in objects can be complex. In the seventeenth century, however, most scientists, including Newton, were seeking a single explanation that would cover all cases; what they wanted, in short, was a grand unified theory of color. It was an impossible dream, but they pursued it

with passion, not least because many of them had a penchant for alchemy. Newton, for example, considered himself an alchemical adept and devoted much energy to the art. Perhaps not coincidentally, he was obsessed with the color crimson; his notebooks contain many recipes for red dyes, and his house was decorated throughout with crimson curtains, crimson cushions, crimson bed hangings, and even a crimson settee. Robert Boyle, who, like Newton, was at the forefront of research into colored objects, also practiced alchemy and took a special interest in the color red. It may have been partly for this reason that he evinced such eager interest in Leeuwenhoek's observations about cochineal.

In constructing their theories of color, Newton, Boyle, and many other eminent scientists made use of the idea of corpuscles: all matter, it was believed, could be reduced to these tiny particles, whose nature determined the essential qualities of various objects. Leeuwenhoek, for example, believed that pepper corpuscles were covered with spikes which prickled the tongue, inducing the sensation of spiciness. Similarly, it was thought that the color of an object was also determined by some aspect of its corpuscles. What exactly this aspect was, however, was not clear. Some scientists theorized that corpuscles had surface irregularities, which reflected or modified the light cast on them. Others believed that corpuscles were more like transparent films or plates, or perhaps an "infinity" of colored "convex mirrors."

The man who proposed the mirror theory was Nicolaas Hartsoeker. Like many seventeenth-century scientists, he believed that microscopes would eventually reveal how color worked at a corpuscular level, at which time he was certain his mirror theory would be proved correct. He reluctantly concluded, however, that such a thing would not be possible until, as Robert Hooke wrote, "we very much improve the *Microscope*." In the meantime, Hartsoeker decided to use his microscope to examine another, somewhat larger object that might shed light on the mysteries of color: a grain of cochineal.

To Hartsoeker, cochineal was "the fundamental base" of the color red; the dyestuff was "as tough and durable as the stained glass that one sees in the churches, it can preserve its color for entire centuries, without changing." Under the microscope, he saw clearly that it was an insect. "I have opened many," he reported in his *Essai de dioptrique*, a treatise on light that was published in 1694, "and I have found that the greatest part is full of a very great quantity of little eggs which gave me an extremely red juice when I broke them." Alongside this description, he included an engraving of a magnified cochineal insect: a ribbed oval with two tiny eyes, lying on its back (see fig. 10).

For once, Hartsoeker had gotten the better of Leeuwenhoek: he had published the first illustration of a cochineal insect. Yet Hartsoeker's engraving was simple in the extreme, as was his accompanying description—so simple that they were anything but convincing, especially to the many Europeans who were still wedded to the idea that cochineal was a seed. To Hartsoeker's consternation, however, his microscopes were not capable of any further magnification. It was left to Leeuwenhoek, the rival he despised, to return to the subject once again and examine the matter in greater depth.

In this affair, as with anything to do with Hartsoeker, Leeuwenhoek refused to be intimidated or hurried. It was not until 1704 that he sent a new report about cochineal to the Royal Society. The society, however, lost no time in publishing the report in its *Philosophical Transactions*, for Leeuwenhoek's findings were important.

In his earlier reports, Leeuwenhoek had accepted the Jamaican governor's idea that cochineal insects were "produc'd from worms." In 1704, however, having improved his microscopes and his techniques, Leeuwenhoek could now see inside the cochineal eggs—a breathtaking achievement, since they were only about 0.001 millimeter long. To Leeuwenhoek's astonishment, each egg contained a miniature cochineal insect: an "unborn Animalcula," with legs

"orderly folded up" against its body. He concluded that cochineal insects did not arise from worms, or still less from the putrefaction of cactus flowers, as some adherents of the wormberry theory believed. Instead, he wrote, cochineal insects carried their young within, and "bring forth their own likeness."

To prove his point, Leeuwenhoek sent ten detailed illustrations to the Royal Society (see fig. 11). A single grain of cochineal, massively enlarged, was the centerpiece; the ridged and scalloped trunk of a female insect lay before the viewer, looking like a fantastically carved piece of coral, or a strange shell cast up by the sea. Along one side were detailed drawings of cochineal eggs and the "Ovarium or Egg-Nest." The remaining illustrations were of various "unborn Cochineel," with heads, jointed legs, and even a proboscis, which Leeuwenhoek correctly supposed was "the Instrument wherewith it gets its Nourishment."

Drawn by one of Leeuwenhoek's limners, the figures were nothing short of miraculous. Although the creatures they depicted were prodigiously small, the drawings were exact and accurate. To many, they offered conclusive proof that cochineal was an insect.

Others, however, remained unconvinced. At the time, many sensible people mistrusted microscope evidence on principle. The instruments, after all, were known to have numerous flaws; even in the best hands, they were liable to produce errors. Then, too, microscopists were quarrelsome folk, given to inflating their claims in order to triumph over their rivals. Some, indeed, were said to be out-and-out liars. Hartsoeker, for example, declared in print in 1710 that Leeuwenhoek had not seen one-thousandth of the things he claimed to have done. Leeuwenhoek later returned the favor, noting in a letter to the Royal Society in 1715 that Hartsoeker "presumed to state untruths, and hath great self-conceit."

In point of fact, Leeuwenhoek appears to have been an honest, if stubborn, man; although he sometimes made mistakes, he admitted his errors and corrected them on numerous occasions.

It was Hartsoeker, eaten away by jealousy, who appears to have deliberately lied to inflate his scientific reputation. At the time, however, it was Leeuwenhoek's work that most often received a skeptical reception. Because he was not willing to share his microscope techniques (a fact which itself seemed suspicious), few people could reproduce his results, and his description of miniature creatures seemed pure fantasy to those who had not seen such marvels for themselves.

In the case of cochineal, several scientists could at best see only the simple form described by Hartsoeker; most others saw even less. For them, the very precision of Leeuwenhoek's illustrations was itself suspicious. How could he possibly have obtained such fine results? It was problematic, too, that he was changing his tune. Hadn't he once claimed that cochineal was a berry? How could he be sure he had the truth now? Among nonscientists, Leeuwenhoek's conclusions carried even less weight.

Rather than proving that cochineal was an insect, Leeuwenhoek's 1704 article proved only that most people did not trust microscopes, particularly when it came to settling a highly contentious matter like the cochineal debate. But if microscopes could not be trusted how, then, was the controversy to be resolved?

Not, as it turned out, by a new machine, or indeed by any advances in technology, for microscopes did not substantially improve until the early nineteenth century, when the introduction of new lens-making techniques reduced chromatic aberration. Instead, the matter was settled by a bet—a bet made by a man with the mind of a scientist, the skill of a diplomat, and the nerve of a world-class gambler.

TWELVE
A Curious Gamble

GAMBLING IS AN ACTIVITY AS OLD AS time, but rarely has it exercised such a hold on a culture as it did on Enlightenment Europe. Even as philosophers promulgated the idea of a rational and orderly universe that could be understood through diligent and careful scholarship, in the wider society the chaotic world of high-stakes gaming became a way of life. Europe's first great gaming houses were founded in the seventeenth century; by the eighteenth century, gambling dens were everywhere. Artisans, soldiers, lords, and princes—people from all walks of life hazarded their fortunes on dice, backgammon, and cards.

In France, where Versailles itself was known as *ce tripot* (the gambling den), noblewomen hazarded millions at the card table each night. At fashionable Brooks's Club in London, Horace Walpole claimed that "a thousand meadows and cornfields are staked at every throw, and as many villages lost as in the earthquakes that overwhelmed Herculaneum and Pompeii." Even in

smaller establishments, people sometimes lost their entire inheritances on the turn of a card, a fact that prompted a French father in 1769 to beg his local councillors to "put an end to a game of chance that has long existed in our town. My children are ruining me."

Nor were games of chance the only action open to players. Throughout the eighteenth century, people wagered immense amounts of money on trifles and dares. In 1735, for instance, the count de Buckeburg tried to win a large bet by riding backward on his horse from London to Edinburgh. (Whether he succeeded in this dubious venture is not known.) To win a wager with Marie Antoinette, the comte d'Artois had to construct a palace in just two months. (He hired nine hundred laborers who worked around the clock and built the exquisite Bagatelle in sixty-four days.) "There is nothing, however trivial or ridiculous, which is not capable of producing a bet," declared a London journal in 1754. People could, and did, bet on almost anything: on the outcome of a footrace, on Tuesday's weather, or on the result of a duel. Some even bet on the nature of cochineal, as Melchior de Ruusscher did in 1725.

As perhaps befits a high-stakes gambler, Melchior de Ruusscher is a shadowy figure in the history of cochineal. Almost everything we know about him comes from a book he published in 1729, *Natuerlyke historie van de couchenille*, a natural history of cochineal that describes his bet and its resolution. From the book's introduction, it is clear that Ruusscher was Dutch and most likely a resident of Amsterdam; earlier in his life he had "lived many years in Spain." It is also evident that he was a wealthy man. Unfortunately, the work tells us precious few other details about Ruusscher's life. Whether Ruusscher, like many Europeans, went to Spain as a merchant, or whether he lived there as a gentleman or in some other capacity, is never revealed.

Yet if the *Natuerlyke historie* is short on facts, it is long on character. From the way Ruusscher tells his story, indeed from the fact that he recorded it at all, we know that he was a great

reader and writer, who either owned or had access to a very fine library. It is also evident that he had strong passions, a generous heart, and a gift for friendship. Above all, we learn from his book that he was a man of his age: in true Enlightenment fashion, he believed absolutely in the new scientific ideals of open communication and collaboration. A scholar as well as a gambler, he was determined to expand the boundaries of knowledge, no matter what the cost.

It was while living in Spain that Ruusscher became convinced that cochineal was an animal. He apparently interviewed several "great Navigators" about the dyestuff, all of whom "constantly assured" him that cochineal was a living creature. When he returned to Amsterdam, however, he discovered that there were still many "people of the opposite opinion, who believe that it is a Fruit, or the Seed of some Plant." Wishing to clear up the confusion, Ruusscher brought up the matter with friends who, like him, were scientifically minded. Quickly, however, the friendly discussion turned into a heated argument between Ruusscher and one of the friends, which threatened to spill over into violence. To avoid an unhappy end, the two men agreed to settle the dispute by more civil means: following the fashion of the time, they entered into a wager. Together they appointed four independent arbiters to judge the facts of the matter; to win, Ruusscher needed to produce incontrovertible proof that cochineal was an animal. According to one report, the sum ventured was enormous, amounting to the entire fortune of Ruusscher's friend.

Ruusscher had read Hartsoeker's *Essai de dioptrique*; he also owned a microscope and had viewed cochineal with it. From the start, however, he understood that a microscope alone would not win the day. The evidence it provided was too controversial and too subjective: when Ruusscher looked through the instrument, he saw an insect; when his opponent did the same, he could see only a seed. To win his bet, Ruusscher would have to come up with another strategy for revealing the truth.

Undaunted, Ruusscher turned to a Spanish friend for help: Don Pedro Cristóbal de Reynoso, a knight of the esteemed and influential Order of Santiago. Don Pedro was acquainted with many important people in Oaxaca, which was by then the chief cochineal-exporting region of New Spain; he also had a son, Martín, who was about to embark on a voyage there. Ruusscher wrote to Don Pedro and asked if his son might "have the goodness to take, upon his arrival, the Affidavits necessary to know if Cochineal was a little living Animal." If science could not prove his case, perhaps the law could.

Don Pedro and his son agreed to help Ruusscher, and when young Don Martín arrived in Mexico, he wrote to his father's friends in Oaxaca, soliciting their testimony about cochineal. He was straightforward about his purpose: their affidavits would be shared with foreigners who believed that cochineal came from a plant. Upon receiving the letter, the region's highest Crown authority, Don Juan Bautista Fortuno, the *corregidor*, agreed to testify in the case. So did a dozen other Oaxacans, including several minor Crown officials and an Indian *cacique*, or chief, who lived in a nearby cochineal-growing village.

If Ruusscher had asked for a sample of live cochineal, none of these men—not even his good friend Don Pedro—would have lifted a finger to help him. As Spaniards, they knew that exporting live cochineal was not only illegal but greatly prejudicial to their country's interests. Collecting affidavits and declarations, however, seemed to them an altogether harmless activity, perhaps because they were influenced, as Ruusscher was, by the new scientific ideal of disinterested communication about natural phenomena among men of goodwill. Among the educated classes of the eighteenth century, secrecy was coming to seem a touch medieval, even backward. It was openness that was the hallmark of the thoroughly modern gentleman.

Don Pedro and his friends also believed that there was little risk in providing details about cochineal's true nature. While the

Spanish Crown had never encouraged its subjects to share information about the dyestuff with foreigners, it did not absolutely prohibit such communications, either. Censorship was unnecessary, the *corregidor* Don Juan Bautista testified, because the cochineal monopoly was protected by the very fragility of the insects themselves. If a foreigner ever attempted to smuggle a case of live insects out of Mexico, the insects would die within days—or so the *corregidor* believed. Given these natural protections, the Oaxacans saw no harm in discussing the true nature of cochineal, especially if it would help the friend of a friend win an argument.

Although the process of collecting such testimony entailed a great deal of work, the *corregidor* and other high officials were nevertheless willing to oblige Don Pedro in what they considered an affair of honor. Starting on October 13, 1725, they began to collect affidavits from others and to speak under oath themselves.

The people who testified had considerable experience with cochineal, either as traders, or growers, or bureaucrats. Some of the Spaniards had traded in cochineal for twenty years, and the Indian grower had raised cochineal all his life, as had his ancestors before him. In the presence of Oaxacan officials, the men covered the essential points in their own words: cochineal was made of living animals; they had a "eyes, mouths, feet, and 'claws'"; they bore young like themselves. The witnesses went on to describe in detail how cochineal was raised and harvested, and how wild cochineal differed from the domestic variety. There could be no doubt, they stated, that both types of cochineal were animals. "To doubt that Cochineal is a living animal," the *corregidor* testified, "is the same as saying that the Sun does not shine."

At the end of October, eight affidavits and six supporting certificates were sent to Don Martín, who mailed them to his father in Spain. Don Pedro then forwarded the documents to Ruusscher, who finally received them in the autumn of 1726. Soon afterward, Ruusscher and his friend met with the four independent arbiters for

formal adjudication of their dispute. After Ruusscher and his friend had presented their arguments, the arbiters considered the supplementary proofs presented by both sides.

Ruusscher's friend had prepared a microscope exhibit showing the "small Fruit or Seed" from which cochineal was derived, complete with "its cottony surround." Ruusscher likewise had his own microscope exhibit, designed to prove that cochineal was an insect.

It seems that the judges found Ruusscher's exhibit more convincing, but it was his court evidence from Oaxaca that clinched the case. The sheer number of documents Ruusscher provided was a great point in his favor. By tradition, as Ruusscher himself noted, only two eyewitnesses were needed to establish the truth in a European court of law. Surely, then, there was even more reason to "be convinced of the certitude of a Matter, which one finds affirmed with solemn oaths by eight People, & confirmed again by six others. . . . How could anyone having common Sense imagine that so many different People could be forced to make a false Oath?"

To dispel any lingering doubts about the sincerity of his witnesses, Ruusscher explained how each man was connected by friendship to his own friend Don Pedro. He also made much of the fact that his witnesses were men of high standing in Oaxaca. "Is there the least possibility, that these People of the first rank & quality would give such Certificates, write, sign & confirm them with false oaths?"

In a world where a gentleman's word was his bond, Ruusccher's argument carried great weight. The arbiters unanimously ruled in his favor, declaring in a written judgment that they were now convinced that grains of cochineal had once been "small living Animals." The wager, however, was another matter altogether: they wanted nothing to do with it. "Wishing to cultivate friendship between the Parties & prevent all grounds for a breach," they urged Ruusscher and his opponent to add a clause to their written judgment voiding their bet. Having won his

point, Ruusscher generously agreed to abandon all claim to his friend's fortune—no doubt to his friend's great relief.

At the urging of others, Ruusscher wrote about the case in his *Natuerlyke historie*, which included not only an account of the dispute, complete with names of the arbiters and the witnesses, but also a copy of every document Ruusscher had obtained from Oaxaca. To reach the widest possible audience, he and his publisher issued the book in a trilingual edition: all the documents appeared not only in the original Spanish but also in French and Dutch. Ruusscher hoped that the book would satisfy "Lovers of Truth and of curious Investigations"; he wanted to convince them, as he had convinced the arbiters, of the truth of his argument.

There were, of course, many questions about cochineal biology that the *Natuerlyke historie* did not fully answer. Chief among them was the subject of cochineal procreation, a matter which excited much interest in Europe. Unfortunately, the only Oaxacan witness who addressed the issue was the *corregidor*, who reported that "when [the cochineal] grow large, a small Butterfly passes and re-passes over them"; the *corregidor* added that the Indians believed this "butterfly" was responsible for cochineal conception. Both he and Ruusscher were somewhat skeptical of this theory. To them, it seemed natural that like should mate with like. How, then, could a butterfly breed with cochineal?

The word *butterfly*, however, appears to have been merely a bad Spanish translation. A 1777 document states that the local Mixtec term for the same insect was *Dahua Yitz*, which means "flying husband." Evidently, Indian growers were well acquainted with the truth: male cochineal was a flying insect, which traveled from cactus to cactus copulating with females.

For Europeans, however, the fact that male cochineal differed so substantially from female cochineal proved a great stumbling block. Indeed, many authorities denied that male cochineal existed at all. One Oaxacan scholar, Juan Manuel Mariscal, suggested that an infusion of "divine essence" caused female cochineal insects to

procreate; he even wrote a poem lauding cochineal's eternal virginity. Similar theories were advanced by European microscopists like Leeuwenhoek. Correctly noting that all exported cochineal consisted of female insects, Leeuwenhoek concluded that female cochineals reproduced without the aid of males. He could not, however, elucidate the process by which this might occur. This "Position of mine," he admitted, ". . . may seem very strange, and perhaps not meet with credit by those that maintain there can be no Animal generated without a Copulation of Male and Female."

Just as the mechanics of cochineal reproduction continued to mystify most Europeans until the nineteenth century, so, too, did the question of how cochineal was related to the rest of the animal kingdom. Throughout the eighteenth century, some naturalists maintained that cochineal was "the same which we call the Lady-Bird," or ladybug. The exact relationship between domesticated cochineal and its wild cousins was also hotly debated, and it was only in 1903 that domesticated cochineal finally received the scientific name that it bears today: *Dactylopius coccus*.

Yet if all controversy about cochineal did not cease with the publication of the *Natuerlyke historie*, Ruusscher's achievement was nevertheless profound, for his book dealt the deathblow to the idea that cochineal was the product of a plant. The court testimony from Oaxaca, combined with Ruusscher's own commentary, established for all time that cochineal was a living creature. After the *Natuerlyke historie* was published, European scientists no longer argued that cochineal was a seed.

"It is perhaps the first time," remarked the great French naturalist Réaumur in 1738, "that a question of natural history has been dealt with and decided by the rule of law."

THIRTEEN

A Spy in Oaxaca

 ALTHOUGH RUUSSCHER'S GAMBLE HAD revealed the nature of cochineal to all Europe, the cochineal insect itself remained elusive. For more than a century, explorers from France, Britain, the Netherlands, and other countries had searched the world for the dyestuff, to no avail. The "undoubted hope" of finding cochineal in Virginia had proved illusory, and neither the New Netherlands nor New France had produced better results. "Cochineal is noe where to be had but in Mexico," an Englishman glumly concluded in 1714.

Cochineal substitutes, too, proved thin on the ground, despite occasional glowing reports to the contrary. Sir Walter Raleigh was one of the first to excite European expectations: he claimed to have discovered "divers berries, that die a most perfect crimson and Carnation" in tropical Guiana in the 1590s. Over a century later, similar reports were still coming in, as in the 1750s, when the Swedish consul in Tripoli announced his discovery of a North African beetle that gave "an admirable ink in water, hardly

worse than the best cochineal." Very few of these claims ever panned out, however, and none of the dyestuffs produced anything like a true cochineal red.

Discouraged by their lack of success, eighteenth-century Europeans began to consider a new scheme: stealing cochineal from the Spaniards outright, with a view to replanting the insect in their own lands. Some people even proposed moving cochineal directly into Europe, including an Italian writer who maintained that the perfect breeding ground could be found in Sicily. Yet Venice and other Italian cities were in decline; while they still produced superlative dyes, they lacked the will and resources to put such a scheme into action. Instead, it was the more northerly Europeans—particularly the French and the British—who had the power to plot against Spain to some purpose, and they primarily thought of cochineal in imperial terms. "It would be well worth making attempts to establish it in the American islands," wrote Diderot in his *Encyclopédie* in 1753, noting that Saint-Domingue, Martinique, and the other French possessions in the Caribbean had a climate suited to cochineal cultivation. The British cherished similar ideas with regard to their own tropical and subtropical colonies.

Cochineal, for these imperial powers, was part and parcel of a larger campaign of colonial development. According to conventional mercantilist thought, colonies needed to be made useful—and profitable—through the cultivation of valuable commodities for the mother country. In some cases those commodities were native to the place: northern New England's white pines, for instance, made fine masts for British navy ships. But imperial merchants and colonial entrepreneurs also sought to improve upon nature by introducing lucrative new commodities to their colonial possessions. Seventeenth-century English adventurers, for example, announced their intention of planting Virginia with a host of European and Middle Eastern crops, including "Orenges, Limons, Almonds, Anniseeds, Rice, Cummin, Cotton wool, Carowey

seeds, Ginger," and a "great plentie of Sugar Canes, for which the soyle and clymate is very apt and fit."

As it happened, the Virginian climate was not fit for most of these delicate crops. But colonies in warmer places offered scope for imperial dreamers to translate their grand visions into reality. By the eighteenth century Jamaica and Barbados had become the jewels in the British Crown, producing massive quantities of sugar every year, as well as some indigo, ginger, and cotton. It was the French, however, who truly triumphed: their Caribbean colonies produced the cheapest and most plentiful sugar in the world, as well as fine indigo, cocoa, and coffee. Not content to rest on their laurels, they also secretly obtained cinnamon, pepper, and other spice plants from the East and introduced them to French colonies around the globe.

To imperial entrepreneurs such as these, almost anything seemed possible. They were transforming the world itself, reshaping nature to their own design. Yet even the most optimistic imperial schemers were forced to admit that cochineal presented a formidable challenge to the would-be transplanter. Many European nations had successfully obtained the insect's favorite food, the opuntia, and by 1600 the cactus grew wild in Spain and flourished in botanical gardens in Italy, Germany, the Netherlands, and England. But the cochineal insect itself was a different matter.

Even the most famous botanist in Europe, Carl Linnaeus, found it impossible to obtain live cochineal of any kind. Renowned for creating the binomial system of species classification that we still use today, Linnaeus was also a fervent advocate of self-sufficiency for his homeland, Sweden. Deeply distressed that his countrymen were trading their hard-earned silver for cochineal, tea, tobacco, and other foreign goods, he argued that they should instead make dyes from native plants, smoke Swedish bearberries, and drink tea made from *Linnea borealis,* an evergreen shrub that Linnaeus had discovered in the North. Few

Swedes, however, were keen to accept these substitutes. (Even Linnaeus's own son confessed that the evergreen tea could be "rather repulsive.") As Linnaeus saw it, there was only one alternative: Swedes needed to grow tropical commodities in their own native gardens and greenhouses. He dispatched his students around the world, with instructions to obtain botanical treasures like cochineal for their country.

Although Linnaeus had many disciples, only one ever located any cochineal. In 1755, young Daniel Rolander found what seems to have been a wild variety of the insect in Surinam, a Dutch colony on the northern coast of South America. Creating his own proto-terrarium by keeping the insect-infested cactus in a glass container, Rolander brought it back to Sweden, taking such exceptional care of it that most of the insects survived. When he sent the cactus to Linnaeus's greenhouse, however, the great botanist was not there to meet it. Instead the cactus fell into the hands of one of Linnaeus's gardeners, who knew a grubby and infested plant when he saw one. He decided the cactus must be cleaned immediately.

Only after the gardener had painstakingly removed and killed each insect did Linnaeus arrive on the scene. Realizing at once what had occurred, he was seized by despair; by his own account, the ruin of his hopes gave him a "dreadful fit" of migraine. "About *Coccionella* I do not wish to speak, never wish to think or remember," he later wrote to a colleague. Daniel Rolander fared even worse, for his voyage to Surinam broke his health and his sanity. He raved to all and sundry that he had discovered pearls containing the elixir of life on a Surinam shrub. He never recovered and later died a beggar.

Could anyone hope to secure cochineal from its source and return alive with the prize? Rolander's fate suggested not—and people were understandably reluctant to follow in his footsteps. Enchanted as Europeans were with cochineal, few were so foolhardy as to risk their lives for it.

Aside from Rolander, only the French appear to have made a serious attempt to obtain cochineal during this period. Their effort preceded Rolander's expedition by a generation and was probably instigated by the scientist Réaumur, who proposed that the Crown fund a secret expedition to secure the insect from Mexico in the early eighteenth century. The French spies managed to get their hands on the right kind of cochineal, but to their frustration—and Mexico's relief—the insects died long before they reached French Martinique. After this disaster, it seems the French Crown abandoned the cochineal scheme entirely, preferring to devote its energies to ventures that involved less peril and better odds of success.

It was not until the 1770s that another Frenchman, Nicolas-Joseph Thiery de Menonville, revived the old cochineal dream. Born in 1739 to a family of prominent lawyers and judges in Lorraine, Thiery was forced by his family to study law as his forebears had done, but after he earned his degree, he fled to Paris to pursue his true passion: natural history. Under the direction one of the great Jussieu brothers, the most eminent French botanists of the day, he studied the workings of the natural world. He turned out to have a gift for botany and was much praised by his teachers.

For Thiery, however, praise was not enough. Passionate, patriotic, and more than a little vain, he wanted to cover France—and himself—in glory. No doubt his ambition was strengthened by his awareness that French imperial fortunes were at a low ebb. Humiliated at the hands of Great Britain in the Seven Years' War (known to British-American colonists as the French and Indian War), France had lost many of its colonial territories; the peace treaty signed in 1763 had stripped the country of most of its North American empire and its possessions in India. Since then, Frenchmen had been consumed by the need to make the most of the few colonies that remained to them.

In the 1760s and 1770s, as Thiery was studying botany in

Paris, French scientists and government officials were pursuing schemes for colonial improvement with renewed dedication. The French navy launched an unprecedented number of voyages in the king's name, charged with secretly obtaining rare plants for scattered French possessions in the Caribbean, the Indian Ocean, and Africa. With daring and panache, many of these adventurers succeeded in their missions, to the delight of Frenchmen everywhere.

Although Thiery was more accustomed to the salons and bookstalls of Paris than to ocean crossings and international espionage, these swashbuckling exploits appealed to him. A man of considerable physical courage, he soon set his heart on embarking on a secret mission of his own. Exactly what its object should be, however, at first escaped him. It was while he was in this unsettled state that he read about cochineal in a book by the scholar Abbé Raynal: "Cochineal, whose price is always high," Raynal wrote, "should excite the interest of nations that cultivate the American islands."

Intrigued, Thiery researched cochineal further. Even to a casual observer, let alone to his interested eye, the dyestuff's importance to the French textile industry must have been evident. The wardrobes of noble Parisians—both male and female—were full of scarlet silks and woolens that had been dyed with cochineal (see fig. 12). The Gobelins tapestry works, whose intricate hangings lined aristocratic walls across Europe, were famous for their cochineal reds. Even the cardinals of France, arrayed in ecclesiastical scarlet splendor, attested to the importance of the Mexican dyestuff. If Thiery could establish cochineal in a French colony, not only would he free France forever from its humiliating dependence on Spain for top-quality red dyestuffs, but he would give a great boost to French industry and to the French colonies as well.

To Thiery his life's work seemed clear: he must secure cochineal for his "darling country." That he might lose his life or his sanity in the process did not unduly discourage him. Indeed, the

fact that he was putting his life on the line seems to have appealed to his well-developed sense of drama. When his family and friends tried to dissuade him from what seemed to them a fool's errand, he refused to listen to their advice. Self-important and sometimes arrogant, Thiery was also remarkably stubborn; once he committed himself to a cause there was no turning back. In the end his family gave in and agreed to help pay for the journey.

Finding himself in need of additional funds, Thiery went knocking on the government's door. Employing all his considerable charm, he outlined his plans to the French navy and requested official Crown support—and an official Crown stipend. After some consideration, the navy decided that Thiery's scheme offered substantial benefits to the nation. It gave him its covert backing and promised he would receive six thousand livres for his expenses. He was to collect the money once he arrived in Saint-Domingue, the Caribbean island where he would begin his mission—and the place where he would, if successful, establish France's first cochineal plantation.

THE COLONY OF SAINT-DOMINGUE, LATER KNOWN as Haiti, occupied the western third of the troubled island of Hispaniola, a place that the early conquistadors had likened to paradise. But violence, greed, and disease had destroyed much of the island, and the conquistadors had moved on. By the 1600s, Hispaniola had become a remote backwater, and French buccaneers encountered little resistance when they set up camp on the island's isolated western shores. When Spain officially ceded the occupied portion of the island to France in 1697, Saint-Domingue was still largely wilderness, but under French rule the colony became a textbook example of what could be achieved through an ambitious campaign of transplantation. French settlers planted sugar, coffee, indigo, cocoa, and cotton in the dark,

rich soil, and imported thousands of African slaves to tend the new crops. By the autumn of 1776, when thirty-seven-year-old Thiery sailed for the island, Saint-Domingue was the wealthiest colony in the West Indies. The wealth was shared unequally, however, for nine-tenths of its nearly half million inhabitants were slaves.

For the rich white planters of Saint-Domingue, life was one endless round of luxury. Indolence and self-indulgence were the order of the day. "It is in keeping with the dignity of a rich man," wrote one resident, "to have four times as many slaves as he needs." Yet for all Saint-Domingue's decadence, European visitors found the colony a thoroughly provincial place. Earthquakes and fires regularly raked over its cities, and although a few grand mansions rose gracefully above the rubble, most buildings were rickety one-story wooden affairs that straggled along muddy, unpaved streets. To Thiery, fresh from sophisticated Paris, the city of Port-au-Prince, Saint-Domingue's capital, resembled "nothing better than an assemblage of fishermen's huts."

Uncongenial though the place was, Thiery soon found lodgings. There he recovered from the "tedious and fatiguing" voyage across the Atlantic and pondered the next stage of his journey. How was he to reach New Spain? It was a difficult problem. After 1700, when the inbred Spanish Habsburg line had petered out, the Spanish Crown had passed into the hands of a minor branch of France's Bourbon dynasty; yet while French influence over the Spanish court was now considerable, Spain maintained its independence, and its policy on foreign visitors in its American empire remained essentially unchanged.* Frenchmen like Thiery could enter New Spain only if they managed to

*This accession of a Bourbon heir to the Spanish throne, in the person of Philip V, provoked the War of the Spanish Succession, which ended in 1713. Although Philip remained on the throne, the war took a heavy toll on Spanish territory, resources, and power, and left the country fatally weakened within Europe.

obtain an official passport from the Spanish authorities, which was not often granted. Even with a passport, travel was restricted, and foreigners were closely watched.

Initially, Thiery hoped to subvert the system by surreptitiously crossing Saint-Domingue's border with Hispaniola, the Spanish colony that covered the rest of the island. He then would attempt to find passage to Mexico. As a plan, it was far from foolproof, not least because Thiery spoke very little Spanish. Fortunately, other means of reaching New Spain soon came to light. "I was still wavering in opinion respecting the most prudent plan to adopt, when . . . I was relieved from all perplexity," Thiery later recorded in an account of his adventures. "I learned that a merchant of Port-au-Prince was about to dispatch a brigantine to Havana for the purpose of recovering the cargo of a vessel which had been wrecked in its vicinity." The Spanish authorities specified that the brigantine could enter the harbor only for the purpose of salvaging the lost vessel; no passengers would be allowed to disembark in Havana. Limited though this remit was, Thiery nevertheless scented opportunity. He immediately contacted the colonial authorities and requested the promised money. Short on cash, the Saint-Domingue treasury could offer him only four thousand livres, not six thousand, but it was enough.

When the brigantine *Dauphin* left for Havana on January 21, 1777, Thiery was on board, already plotting his next move. In his luggage he carried "a number of phials, flasks, cases, and boxes of all sizes," as well as a French passport that proclaimed him a botanist and physician. The latter title was something of an exaggeration: Thiery had earned a diploma in medicine, but he had little real experience as a doctor. Yet the paper credential proved crucial to his plans. A fortnight later, when the *Dauphin* anchored off Havana, Thiery developed a sudden, desperate illness, or at least so he claimed. Writing directly to the Cuban governor, he explained that his medical background had enabled

him to diagnose his own ailment: he had a shipboard fever that could be cured only if he were allowed to land. Impressed by his medical knowledge, by his manner, and by the severity of his suffering, the governor permitted him to enter the city.

The young Frenchman—so weak, so well spoken, so dramatic—evidently fascinated the Havana elite. By the time Thiery was restored to full health, he was the toast of Havana society. He dined with the city's aristocrats and attended the opera. He also worked hard to improve his Spanish.

After several weeks of carefully cultivating his new friends, Thiery decided it was time to drop a few delicate hints about his desire to travel to New Spain. In order to avoid suspicion, he played to type: "Pretending to be actuated by that volatility and inconstancy of disposition, oftentimes with so little propriety ascribed to Frenchmen, and which occasionally is so favorable a cover to deep designs, I feigned to be overcome with *ennui* from my long stay in Havana, and the too narrow limits prescribed me as a botanist." The strategy worked to perfection. Concerned about their companion and perhaps somewhat amused by his flighty behavior, Thiery's friends obtained a passport that allowed him to travel from Havana to Veracruz.

The greatest port in New Spain, Veracruz was the golden funnel through which the riches of Mexico reached Europe. Yet for all the glittering treasures in its warehouses, it was essentially a colonial outpost, with little of Havana's glamorous cultural life, as Thiery soon discovered. Although he was received warmly by many of the inhabitants when he arrived in late March, the governor of Veracruz, Don Fernán Palacio, was less welcoming. After giving Thiery permission to reside in the city and study the local plants, Don Fernán—a man of "sour looks" and "rude speech," according to Thiery—took away his passport and refused to return it. He then instructed his soldiers to keep a close watch on the Frenchman.

Stranded in Veracruz, Thiery had no idea where or how he

would procure his cochineal, but he wisely kept silent on the sub-
ject. To allay Don Fernán's suspicions, he feigned an all-absorb-
ing interest in the local flora. "Whether in the fields or in the
streets I constantly had plants in my hand," he wrote, "and either
employed myself in observing them through a magnifying glass,
or in dissecting them with nicest care."

Though intended as a mere cloak for his true purpose, these
investigations nevertheless led to a fortuitous discovery. For
years, Veracruzaños had been importing the roots of the jalap
plant—a strong purgative related to the morning glory—at great
expense from the city of Jalapa, over fifty miles distant. To the
great relief of both their bowels and their purses, Thiery was able
to show them that the plant grew locally. "A discovery like this
rendered me famous throughout the city," Thiery wrote. "I was
looked upon as a most extraordinary character."

Still basking in his local renown, Thiery visited the house of
two local merchants and heard them discussing the relative mer-
its of various varieties of cochineal. The best grade, they agreed,
was obtained from Oaxaca City, nearly three hundred miles
southwest of Veracruz. Thiery quietly made note of the informa-
tion and began plotting how best to secure permission to travel
there. Yet although he was careful not to mention Oaxaca to any-
one, his subsequent attempts to secure a passport to travel into
the Mexican countryside confirmed Don Fernán's worst suspi-
cions. Alarmed, Don Fernán notified the viceroy of New Spain,
the highest Crown authority in the colony. The viceroy ordered
Thiery to leave Mexico on the next ship, which would leave
Veracruz in roughly three weeks' time.

Thiery was careful to show only innocent confusion as the
viceroy's command was read aloud to him, but afterward, alone
in his lodgings, he was overcome by despair. "You fail in an affair
undertaken in contradiction to the advice of your father, your
friends, and everyone; an affair that for four years has subjected
you to nothing but alarms, chagrin, mortification, toil, and dan-

gers of every description," he reproached himself. How could he face the French navy if he returned empty-handed? How could he face his family? With dread, he imagined the kind of homecoming he would receive: "Shame, humiliation, ridicule, contempt will be your lot on every side," he told himself. Recoiling from such a fate, Thiery was seized by a new inspiration: in the three weeks that remained to him, he would attempt to travel secretly to Oaxaca, secure the treasure, and return to Veracruz without being detected.

It was a crazy scheme, and Thiery knew it. The obstacles that stood in his way seemed almost insurmountable. He had to complete a journey of nearly six hundred miles in less than twenty-one days—a journey for which he had no passport and no map. To compound his difficulties, he still spoke Spanish only "indifferently" and knew not one word of the region's indigenous languages. If captured, he would be put to death as a spy.

To Thiery, however, even capture seemed better than the alternative. To "return unsuccessful," he wrote, "was more dreadful than death itself." Quickly he set about making plans for the trip. To cover his tracks, he informed the Veracruzanos that he planned to spend his last three weeks with Doña de Boutilloz, a widow who lived in Medellín de Bravo, a small village some miles south of Veracruz. Because the lady in question enjoyed high regard, and because she had previously shown great affection for Thiery, no objection was raised. Hoping no one would make further inquiries, Thiery climbed over the city walls under cover of darkness and set off down the road to Oaxaca. Not wishing to be weighed down with luggage, he carried only a few possessions: money, a bag, and a rosary. For disguise, he wore the hairnet and broad-brimmed hat that were in vogue among Spanish gentlemen. He trusted he would find food and water along the way.

For the next several days, Thiery covered as much ground as he could, fording rivers, trudging through forests, and crossing

scorched plains under the heat of the sun. At night he grabbed what sleep he could in shepherds' huts and small inns. To account for his poor Spanish, he pretended to be a Catalan physician, born near Spain's border with France, an explanation that appeared to satisfy everyone. Nor was that the end of Thiery's impersonations. Lacking detailed directions to Oaxaca City, he stopped at a monastery fifty miles from Veracruz; there he told the subprior that he was an itinerant doctor making a religious pilgrimage to the church of Nuestra Señora de la Soledad in Oaxaca City. The story, combined with Thiery's air of piety and a generous donation of alms, did the trick. The subprior gave Thiery detailed directions to speed him on his way— "an itinerary so minutely detailed, league by league, and village after village," Thiery exulted, "that the general of an army might have trusted it for a march."

Having already hired a Mexican guide and a horse, Thiery now made swift progress toward Oaxaca, undeterred by the terrible weather or by the vampire bats that attacked his horse. He proved more susceptible, however, to the prospect of amatory adventure. One morning, while eating bread and eggs in an Indian dwelling, Thiery was struck by "the perfect beauty of the mistress of the cottage," who had "nothing on but a furbelowed muslin petticoat, trimmed with a rose-colored cord, and a shift that left her shoulders bare." Overcome by her charms, Thiery pulled out a gold coin, but just as he was about to proposition the lady, he recalled his own perilous position: "In a foreign country, friendless, and without support, surrounded by myriads of dangers still even springing beneath your feet, would you lose yourself? Would you yield to the enervations of voluptuousness? Madman away!" Sighing as he put temptation behind him, Thiery returned to the road.

Several days later, while traveling through a small town called Gallatitlán, Thiery was rewarded by his first sight of cochineal. Spying a garden of nopals, he stopped and pretended

to fiddle with a stirrup, then entered into conversation with the garden's Indian owner. When the Indian mentioned that he grew cochineal, Thiery feigned surprise; "but my surprise was real when he brought it to me," Thiery later reported, "for instead of the red insect I expected, there appeared one covered with a white powder." Shocked by the sight, Thiery wondered if he had made a terrible mistake. Could this powdery creature truly be the source of the dye he coveted? At last he thought to crush the insect on a piece of paper. When it left a purple-red stain, he was "intoxicated with joy and admiration." Certain now that he was on the right trail, he tossed a few coins to the Indian, mounted his horse, and galloped away.

Soon afterward Thiery reached the outskirts of Oaxaca City. Entering the city alone and on foot, he took a room at a miserable inn on the edge of town. In its dirty, crowded kitchen, he encountered dogs, servants, children, a leper, and "eight cats who licked the plates"; he resolved to eat his meals elsewhere. Yet if his lodgings were less than satisfactory, Oaxaca's situation and climate delighted him: the city appeared to enjoy an "everlasting spring-time." What delighted him still more were the nopal plantations, rich in cochineal, that surrounded Oaxaca. But how was he to obtain a supply of nopals and cochineal without arousing suspicion?

Undaunted, Thiery bought baskets from local craftsmen, made friends among the Oaxacan residents, and soon located a nopalry "so thickly loaded with cochineal that not a single leaf could be taken from the nopal without crushing a thousand of the insects." When all his preparations were in order, Thiery went secretly to the nopalry at three in the morning, accompanied by two indigenous servants from the inn. Telling the servants to wait for him at the gate, Thiery strode into the nopalry and woke the elderly black farmer who owned the place. Introducing himself as a physician treating a desperate case of gout, Thiery explained that he needed nopal leaves and cochineal for a remedy, and he offered a good price for them.

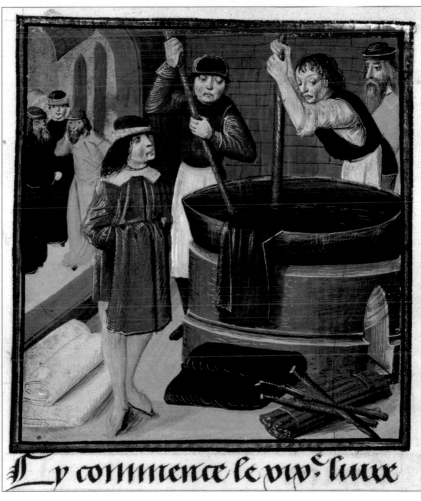

I. In this medieval illumination, watchful dyers stir red cloth
in a dyepot with long poles as a furnace below roars away.

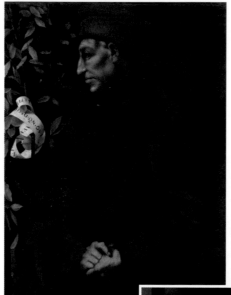

3. The use of red as an emblem of pomp and power can be seen to great effect in this posthumous portrait of Cosimo the Elder, patriarch of the Medici clan. In the early 1540s, Cosimo's namesake, Cosimo the Great, offered protection to the first European dyer known to have experimented with cochineal.

(Erich Lessing/Art Resource, New York)

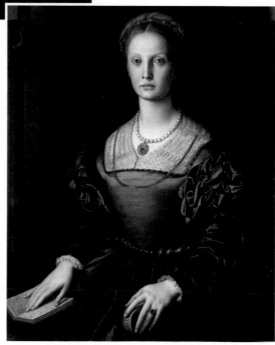

2.Under sumptuary law, Lucrezia Panciatichi, a Florentine woman of the patrician class, was entitled to wear this spectactular Renaissance gown of scarlet and dark crimson silk.

(Scala/Art Resource, New York)

4. For Renaissance merchants and artists, the scarlet turban was an effective form of self-advertisement—exotic proof of success in international markets and of their access to the most coveted red dyes.

(National Gallery, London)

5. Charles V most often dressed in sober Spanish black, but he frequently set it off with red for greater effect, a fashion that became popular throughout Europe. In this painting by Titian, red and black are everywhere evident, a combination that conveys the impression of great power and wealth.

(Erich Lessing/Art Resource, New York)

6. Jacopo Strada, an art and antiquities dealer painted by Titian, shows his wares to clients while dressed in shining rose-colored silk sleeves. Cochineal helped make it possible for prosperous men of the mercantile class to afford more red cloth than ever before.

(Erich Lessing/Art Resource, New York)

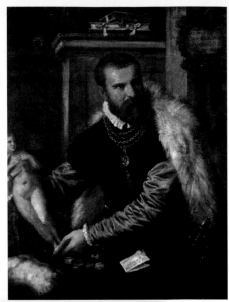

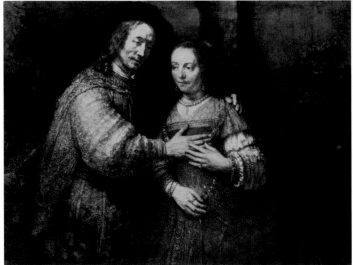

7. In this painting by Rembrandt, cochineal adds depth and beauty to the bride's red dress. Not all artists could afford to work with the dyestuff, but master painters often created their most brilliant reds with cochineal-based pigments.

(Rijksmuseum, Amsterdam/Bridgeman Art Library)

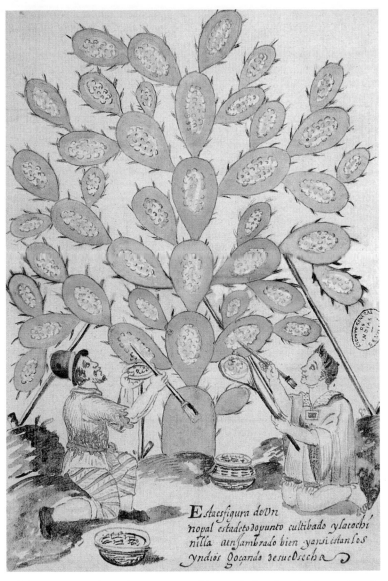

E staesfigura devn
nopal estadetodopunto cultibado ylacochi
nilla aensambrado bien yansiestanlos
yndios goçando desuecosecha

8. Harvesting cochineal was a painstaking task that involved scraping the
insect off the nopal cactus with sticks and brushes. In this seventeenth-
century illustration, the work is shared by a Spaniard and an Indian; in
real life, almost all cochineal was grown and harvested by Indians.

(Archivo General de Indias)

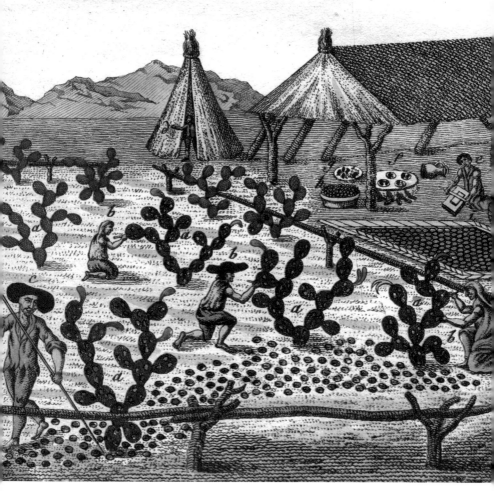

9. The cochineal trade was centered in Oaxaca, Mexico, where indigenous families worked together to produce and process the dyestuff. For them, cochineal was a critical source of strength in the battle for personal and cultural survival.

(From the author's collection)

10. Nicolaas Hartsoeker published the first picture of a magnified cochineal insect in 1694.

(By permission of the British Library, 537.K.19)

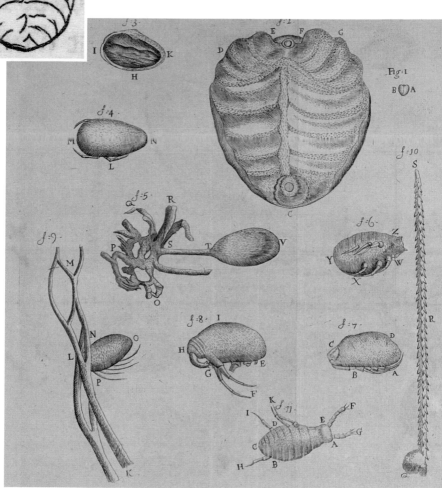

11. In 1704, Leeuwenhoek published the most detailed images of cochineal insects the world had ever seen.

(© The Royal Society)

12. For more than three centuries, Europeans considered cochineal a vital ingredient in the production of luxury red textiles, like the rich French fabric pictured here.

(Victoria and Albert Museum, London/Art Resource, New York)

13. Sir Joseph Banks used his position as unofficial director of the Royal Botanical Gardens at Kew to map out the botanical future of the British Empire, but his secret schemes to introduce cochineal to Australia and India went badly awry.

(Agnew and Sons, London/ Bridgeman Art Library)

The farmer told him to take what he needed. Thiery collected "eight of the handsomest branches, each two feet long, and consisting of seven or eight leaves in length, so perfectly covered in cochineals as to be quite white with them." After placing them in his baskets, he paid the farmer extravagantly in gold. Thiery then lugged the baskets out to the servants, and all three of them left the nopalry "like a bolt of lightning."

"It seemed to me as if I was bearing away the golden fleece, but, at the same time, as if the furious dragon, placed over it as a guard, was following close at my heels," he later wrote. Determined to escape with his prize, Thiery paid the servants well and swore them to secrecy. He then quickly filled the remainder of his baskets with other plants, packed the baskets into eight large wooden cases he had previously purchased in Oaxaca, and set off for Veracruz.

Although the return journey was full of dangers—including local officials who nearly exposed him—Thiery overcame them all. During his travels, he even managed to collect more cochineal-laden nopal leaves for his cases. Swaddled with towels in their baskets, they weathered the trip well, and after twenty long days on the road Thiery ended where he had begun, in his lodgings in Veracruz.

Incredibly, neither his disappearance nor his sudden reappearance—complete with wooden cases—caused comment among the Veracruzanos. The story Thiery had told before he left had provided excellent cover: both his friends and his enemies believed that he had been in Medellín de Bravo with Doña de Boutilloz the entire time, attending the local baths and collecting common plants. There was, however, one ordeal still to come. Before Thiery could board the vessel that would take him to Havana, and then to Saint-Domingue, his baskets and boxes had to be inspected by local customs officials—a prospect he regarded with "some dread."

On the appointed day, Thiery arrived at the docks at dawn. "I calculated that at this hour the idle would be yet asleep, that

the soldiers and officers, tired with the night-guard, would be at rest in their hammocks," he wrote. But if Thiery had hoped to escape unnoticed, he was out of luck. The very size of his collections—he required thirty porters to carry his cases—woke the town from its torpor. Within minutes of his arrival at the docks, "soldiers, sailors, and tradespeople all rushed forwards to see the plants that the French botanist was bearing away."

It seemed the game was up, but Thiery refused to panic. With perfect aplomb, he presented his cases to the searchers—a piece of insouciance that saved him. "The officer of the guard complimented me on my researches and collection of herbs; the searchers admired them in stupid astonishment, but at the same time were so civil as not to sound any of the cases," he later recorded. "The head of the office, satisfied with my readiness to suffer examination, told me I might pass on."

Having bluffed his way through customs, Thiery had only to face the voyage home—but what a voyage it was. Beset by hurricanes and high waves, the vessel was nearly shipwrecked several times. In all, Thiery spent nearly three months at sea, and the unusually long journey had disastrous consequences for his treasured cargo: despite his best efforts, the nopals and the cochineal began to rot in the dank ocean air.

By the time Thiery reached Saint-Domingue on September 4, 1777, much of his cochineal had died. Enough of the insects survived, however, to ensure him a hero's welcome from the people of Port-au-Prince. "The intendant gave me a most kind and gracious reception," Thiery wrote. "He ordered payment of the two thousand livres due to me, . . . and moreover gave me an appointment under himself, with a thousand crowns a year."

To earn this retainer, Thiery labored hard. After recuperating from his Mexican odyssey, he established a royal garden near the governor-general's quarters in Port-au-Prince. There he coddled the nopals and cochineal he had captured from Spain, hoping to increase their numbers and distribute them among Saint-

Domingue's planters. This turned out to be a greater challenge than Thiery had expected, for the heavy Haitian rains threatened to wash the cochineal off the nopals and made the nopals themselves decay. Nor was Haiti free of cochineal predators: voracious ants preyed on the Mexican imports. Even worse, Thiery discovered that Saint-Domingue already possessed a species of wild cochineal, which like other wild varieties had little commercial value. Only constant vigilance could prevent this species from overwhelming the Oaxacan cochineal he had obtained at such cost.

The dull work tested Thiery's character as nothing else—not even the threat of death—had done. Although he was delighted to be given the title of *botaniste du roi* (royal botanist), to his dismay his cochineal stock increased only slowly, through much struggle. "My stay in this colony is each day more distressing," he once wrote. "Added to hard labor are difficulties which daily increase."

Under the daily grind, Thiery's health suffered and his temper frayed. He became infamous in Port-au-Prince for his harsh character and violent rages. What drove him to particular fury was the suggestion that he had "stolen" his cochineal from Spain. Even though Thiery was indisputably what we today would call a biopirate, he maintained that he had behaved justly toward the people of Mexico. Far from stealing anything, he insisted, he had paid Oaxacan farmers very generously for every nopal and insect he had taken. When Spaniards and other enemies continued to call him a thief, he was outraged.

If the Spaniards were objects of Thiery's spleen, so too were the black slaves of Saint-Domingue. Arrogant in his treatment of Indians, Thiery became positively vitriolic when speaking about people of African descent, whom he characterized as "a nation the most perfidious." It is not known whether he worked closely with black slaves in his cochineal garden, but if he did, he surely maligned and underestimated them, for he firmly believed that Africans and their descendants were by nature lazy, vulgar, and

ignorant. Attitudes like this were prevalent among the French elite on Saint-Domingue, and they were part of what led the island's black inhabitants to revolt in 1791 in one of the bloodiest slave uprisings in history. After thirteen years of struggle, they won their independence from France and christened their new nation "Haiti"—an outcome that struck terror into the hearts of slave owners everywhere.

By the time the Haitian Revolution began, however, Thiery was already long gone. In 1780, before his struggles in Saint-Domingue's royal garden had yielded any real reward, he fell sick with a "malignant fever" and died in Port-au-Prince. His successors tried valiantly to continue his work, but their efforts were no match for Thiery's knowledge and zeal. Without his care, the insects began to die. Within a short time, Thiery's garden was in ruins, and no trace remained of the cochineal that had been dearer to him than life itself.

FOURTEEN

Anderson's Incredible Folly

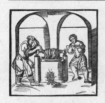WITH THIERY DE MENONVILLE'S demise, the French attempt to obtain cochineal collapsed. Yet Thiery's quixotic quest was not entirely in vain. After his return from Mexico, he had written an account of his travels, and he later compiled a treatise on the care of cochineal, including much hard-won knowledge from his struggle to establish the insect on Saint-Domingue. In 1787, Thiery's colleagues and friends gathered these papers and published them. The resulting book, *Traité de la culture du nopal et de l'éducation de la cochenille*, was soon reprinted in Paris.

No doubt Thiery's colleagues hoped that the book would inspire other Frenchmen to imitate their friend's daring. Events, however, conspired against them. By the time Thiery's *Traité* was published, France was teetering on the brink of a cataclysmic revolution. Imperial wars and French support for American independence had emptied government coffers; not a sou could be spared for another expedition to Mexico. Instead, to the conster-

nation of patriotic Frenchmen everywhere, the first nation to put Thiery's treatise to use was France's archenemy: Great Britain.

In the late eighteenth century, as Old Regime France was crumbling, Great Britain was going from strength to strength. Its capital, London, was home to about 700,000 people, making it the largest city in Europe. Expanding British factories exported textiles, cutlery, and weapons around the globe. The British navy was widely conceded to be the world's best, and the British Crown was well on its way to acquiring the empire upon which the sun famously never set. True, Britain had recently lost thirteen colonies to the American rebels, but its remaining possessions were still substantial. Besides controlling Canada and a fair number of Caribbean islands, the British Crown ruled over parts of India through a dual-control arrangement with the British East India Company. Soon Britain would lay claim to Australia and New Zealand as well.

Having surpassed the French in the sheer extent of their imperial mandate, Britons also intended to outdo them in making use of the fruits of empire. By the 1780s, inspired by French exploits, British scientists, entrepreneurs, and politicians were dreaming up ever more ambitious schemes to obtain commercially valuable plants and establish them in suitable locations throughout their empire.

Of all these dreamers, the most ambitious was Joseph Banks, a gentleman of independent fortune from Lincolnshire (see fig. 13). Born in 1743, he was rich, well connected, and possessed of an energy that few could match. Having been instructed in botany by one of Linnaeus's prize pupils, he traveled as a scientific observer on the HMS *Endeavor*, as part of Captain James Cook's South Seas voyage of 1768–71. Banks returned with a wealth of astonishing finds: he had collected over thirty thousand exotic plant and animal specimens, including representatives of more than a thousand species unknown to European science. These specimens, combined with his dramatic stories of kanga-

roos, shipwrecks, and island romances, made him famous—more famous, many said, than Captain Cook himself.

As a result of his rising reputation, Banks came to the attention of Britain's king, George III, who enjoyed discussing issues of agricultural improvement with him. For Banks, the rewards of this royal friendship were extremely gratifying. In 1773, the king appointed him unofficial director of the Royal Botanic Gardens at Kew. Later he made Banks a baronet—leading an envious contemporary to denounce Banks as a "meer toad eater to the King." Yet Banks evidently had the respect not only of the royal family but of his fellow scientists. His London home at 32 Soho Square, where he installed many of his antipodean treasures, became a meeting place for natural philosophers of every description, and his well-stocked library became a resource for scientists who could afford few books of their own. In 1778, at the relatively young age of thirty-five, he was voted president of the Royal Society, a position that he held until his death more than forty years later.

Following his voyage to the South Seas, Banks had traveled to Iceland in 1772, but by the time he was appointed leader of the Royal Society, his days of global exploration were over. His imagination, however, roamed freely. From his twin cockpits in Kew and Soho Square, Banks dispatched botanists, seeds, cuttings, and manuals to British possessions around the world. He was engineering a new empire, seeking—among other objectives—to introduce nutmegs, cloves, and opium to India, Chinese tea to the Caribbean, and tobacco, cocoa, and coffee to Australia. Most of these schemes failed, sometimes spectacularly so. In 1787, for example, Banks commissioned William Bligh and the *Bounty* to bring breadfruit from Tahiti to the West Indies, so the plant could serve as a cheap food source for slaves on sugar plantations. The mission ended in the most notorious mutiny in the English-speaking world.

Yet although Banks had his failures, he enjoyed many successes as well. His ambition, drive, and charm could not be

ignored, either at home or abroad, and he proved a key man in all kinds of ventures, including the founding of a British colony in Australia. If it was true, as Banks's contemporary Thomas Jefferson wrote, that "the greatest service which can be rendered any country is to add a useful plant to its culture," then Banks rendered Britain service indeed. By the 1780s, the Royal Botanic Gardens at Kew were burgeoning with thousands of new plants, and Banks's passion for promoting British commerce through botany was famous the world over.

One of the great letter writers of the age, Banks advanced many of his schemes through his voluminous correspondence, and it was by means of a letter that James Anderson first came to his notice. A medical officer of the British East India Company, stationed in Fort St. George in Madras, Anderson was also an amateur scientist, and in December 1786 he informed Banks that he had recently "found a Cochineal Insect attached to . . . salt grass, the common food of Horses here." Anderson went on to explain that he had examined the insects with his magnifying glass and had discovered that they produced a good red color in wine and water. Hoping to cultivate the insects "in the Mexican method," he had created a sizable nopalry using a variety of opuntia cactus that had long since been naturalized in India. Inside the letter, Anderson had enclosed a dried sample of the insects for Banks's inspection.

No record remains of Banks's initial response, but almost certainly he was elated by Anderson's discovery. By the late 1700s, British dyers were using about 240,000 pounds of cochineal a year, and although British merchants had become major players in the European cochineal trade, they lacked direct access to Oaxacan producers. Instead, they were forced to pay Spanish merchants nearly £200,000 a year for their cochineal—a sum that could be substantially reduced if a supply of the dyestuff could be had in India.

Anticipating the discomfiture of Spain and great profits for themselves, the directors of the British East India Company were likewise enthusiastic when they heard about Anderson's discovery. Aware of cochineal's importance to the British textile industry in general, and to the making of red army coats in particular, they considered cochineal "an Article of the highest Importance in many of our manufactures, . . . a drug which in point of value stands next in rank to Gold and Silver." Along with Banks, they eagerly awaited professional analysis of Anderson's samples.

Unfortunately for all concerned, Anderson's "Cochineal Insect" turned out to be an imposter. In July 1787, the Court of Directors recorded the dismal results of the analysis: finding that the Indian beetle yielded only "a dirty stain," a range of experts had pronounced it "entirely useless, in the dyeing [of] any colour whatever."

With this verdict in hand, the East India Company reversed course. Far from wishing to encourage Anderson's enterprise, the company directors now worried that he had injured Britain's commercial interests. They ordered Anderson to put an immediate end to his efforts to propagate and domesticate the insect, for fear that his Indian beetle "might be made use of to mix with and adulterate the real Cochineal to the great injury of the Consumer."

Embarrassing as this episode no doubt was to Anderson, it was not the end of his acquaintance with the enterprising Banks. Even though the Indian beetle had proved useless, Banks bore no ill will toward its discoverer. On the contrary, as he wrote to Anderson, the episode had offered him "an opportunity of applying a circumstance which would not probably have presented itself . . . had you not favoured me with your letters." The "circumstance" that Banks had in mind was a new scheme of imperial transplantation. Favorably impressed by Anderson's initiative and drive, and by his vision of India as a cochineal-producing colony, Banks began to conjure up a scheme whereby the Madras doctor would help introduce the Mexican insect to the Indian subcontinent.

• • •

THE IDEA OF ESTABLISHING COCHINEAL IN A BRITISH possession was not an entirely new one for Banks. He was one of the first English scientists to read Thiery de Menonville's treatise, and it may have been Thiery's example that inspired him to try establishing the insect in Australia in 1787. Having heard that nopals and cochineal grew wild in Brazil, he instructed Commodore Arthur Phillip, the commander of Australia's first fleet, to stop there before continuing on to Botany Bay. (Banks was aware that wild cochineal and cultivated cochineal were not exactly the same insect, but he did not fully comprehend the extent of the difference.) In Rio de Janeiro, Phillip collected samples of the plant and the insect, which he ferried to Australia along with "Eight Hundred convicts two Hundred of whom are women."

The fate of Phillip's nopal and cochineal samples are a good illustration of the perils of imperial botany—perils that were not well understood at the time. Introduced into a new environment, exotic species can produce erratic and unpredictable results. Sometimes they perish altogether; sometimes they proliferate wildly. In the case of Banks's Australian experiment, the wild cochineal soon died off, but the nopals thrived, becoming the first of several related opuntia species that eventually overran nearly 100,000 square miles of eastern Australia, rendering the land useless for farming or grazing. Only in the 1920s, with the deliberate introduction of yet another exotic species, the South American moth *Cactoblastis cactorum*, whose larvae fed on the cactus, were the opuntias finally brought under control.* (The moth itself has since become a pest elsewhere. Introduced to the

*In South Africa, where introduced opuntias also became invasive, cochineal itself—a wild species called *Dactylopius opuntiae*—proved the most effective means of biological control.

Caribbean, it has leapfrogged into Florida, where it now threatens to destroy rare native cacti.)

Unaware of the undesirable consequences of his botanical engineering, Banks continued with his cochineal schemes. By early 1788, he was already deeply involved in elaborate plans to introduce cochineal to other parts of the British Empire. At first he considered introducing the insect to the British West Indies, only to decide that "the dearness of Labour" there made such an idea impractical. India, to his mind, was much more suitable, not only because Indian wages were so low but because he could rely on the willing assistance of Dr. Anderson. Banks also knew that the directors of the East India Company were likely to prove receptive to his ideas. That spring, at his urging, the directors passed a resolution backing the plan, and the company's Committee of Secrecy established a fund of £2,000 to set the scheme in motion.

Bureaucracy and the mails being what they were—it sometimes took six months or more for a letter to travel from London to India—Anderson did not learn what the company directors and Sir Joseph had in store for him until the beginning of 1789. By then, at Banks's behest, the East India Company had delivered sealed orders "for procuring the Insect and Plants" to several sea captains. To preserve the secrecy of the mission, the captains had been instructed to open the orders only if they happened to land in South America on their passage out to India. Banks also arranged for two nopals, raised at Kew, to be delivered to Anderson. In addition, he sent the doctor a copy of Thiery de Menonville's treatise on the cultivation of cochineal—for according to Banks's plan, Anderson would be expected to receive and care for any cochineal insects that the sea captains managed to obtain.

Ever the autocrat, Banks decided that Anderson was to be informed of his part in the scheme only if the sea captains managed to bring the insect to India. Until then, his orders, like those of the sea captains, were sealed; as a further protection,

they were delivered not to Anderson himself but to the governor of Madras.

To some, these clandestine methods might have seemed like cloak-and-dagger overkill, but to Banks they seemed essential. As president of the Royal Society, an institution that had done much to promote the free exchange of ideas, Banks had a certain stake in the principle of scientific openness, but his scheme to secure cochineal was not a scientific enterprise; it was a plot against Spain's commercial interests, and as such depended on absolute discretion for success. Only with sealed letters and cryptic commands could Banks hope to hoodwink South American officials and forestall objections from British diplomats who wished to preserve their nation's fragile peace with Spain.

Unfortunately for Banks, the governor of Madras opened the sealed orders and passed them to Anderson long before any cochineal arrived. Unaware that Banks had intended to keep him in the dark, Anderson responded to the scheme with great enthusiasm. (Independently, he had been thinking along much the same lines, though his letter on the subject did not reach Banks until some time after the Committee of Secrecy made its decision. "Could the best coloured Insects be sent here," Anderson had written in March 1788, "I pledge myself in the space of a very few years, to render it impracticable for the Spainiards to transport so much as a single pound of Cochineal from Mexico.") Upon receiving Banks's orders and the nopals from Kew, Anderson immediately set about building a new and even larger nopalry to receive the Mexican cochineal. Burdened by heavy responsibilities as physician-general in Madras, he deputized another doctor in India, Andrew Berry, to oversee the daily details of its construction and management.

Believing that Banks had taken him into his fullest confidence, Anderson returned the favor by writing to him and the East India Company with a frank assessment of the plan— including its weaknesses. Although Banks had instructed the sea

captains to obtain their cochineal in Brazil, as Commodore Phillip had done, Anderson questioned whether the right kind of insect could be found in that country, for he had heard that "the Cochineal cultivated there was esteemed far inferior to the Spanish grain." The forthright Anderson also took issue with Banks's reliance on "secrecy and reserve." Taking the ideal of scientific openness to its logical extreme, Anderson advocated that the scheme make use of the power of advertising. He was certain the Mexican insect could be more easily and quickly obtained if the East India Company openly published a reward for it. Writing to a company official in Calcutta, the doctor advised him to offer "One thousand pounds for Sylvester [wild cochineal] and Ten thousand for Grana Fina [domesticated cochineal], and see if we are not soon supplied here."

So sure was Anderson that publicity would bring success, and so eager was he to inform other scientists about his cochineal investigations, that without seeking permission he independently published his entire correspondence with Banks, complete with a full copy of the East India Company's secret resolution. The resulting series of pamphlets, printed in Madras, were widely circulated in the British Empire and beyond. Anderson even sent a copy to a Spanish botanist in Manila. When Banks learned of Anderson's indiscretion, he was livid. "If the Spaniards take special measures to prevent the insect from being exported from their American dominions," he wrote in 1791, "it will be due to Anderson's incredible folly."

Whether due to Anderson's folly or not, no British sea captain had any luck obtaining cochineal for a considerable time. Discouraged, Banks turned his attention to a myriad of other projects, among them the encouragement of the Australian colony, the cultivation of exotic plants at Kew, and the breeding of sheep for King George III. Not until December 1792 did one of Banks's agents finally manage to collect live samples of the insect from Rio de Janeiro. They arrived in good condition in

London in February 1793, only to perish in Banks's hothouse when the heating system failed.

Like Banks, Anderson also pursued other interests, including the culture of silkworms, which he tried to introduce to Madras. His experiments also led him to suggest that nopal fruits could cure scurvy, the vitamin C deficiency that was the scourge of the British navy. Anderson was far from the first to discover a treatment for this dread condition—the Dutch had carried citrus fruits on long voyages since the sixteenth century, and a British surgeon had proposed a similar cure in 1757—but the nopal fruit nevertheless proved a welcome addition to the British naval diet. According to one sailor, bound for the Cape of Good Hope, "Doctor Anderson's excellent nopal" was "equal to any vegetable I ever ate in soup, famous in curries, and very good boiled."

Gratifying as such compliments might be, Anderson must have been frustrated that his nopalry was not being used for its designated purpose: the cultivation of cochineal. But in 1795, seven years after Banks had launched his original scheme, a shipment of live cochineal finally reached India—not, as it turned out, as a result of Banks's machinations, but as a direct consequence of Anderson's "folly."

The man who obtained the cochineal was a British officer by the name of Neilson, who had read Anderson's pamphlets while his regiment was stationed in Madras. After an assignment elsewhere, he was posted to India once again, and when the ship carrying him there was forced to stop at Rio de Janeiro for rations early in 1795, Neilson realized that he "had a good opportunity," as he later wrote to Anderson, ". . . of making an attempt to bring you what you so much desired." While touring the town's environs under guard, Neilson discovered a variety of cochineal in a local nopalry. Later, returning without an escort, he told the cultivators that he was an amateur student of botany and would like to collect some of their cacti. "I easily procured it without any questions being asked," he reported, because the Brazilians

believed he "wanted it merely out of curiosity." Like Thiery de Menonville before him, Neilson smuggled the plants and the insects on board his ship, only to find that a great many died after they put out to sea. But months later, when Neilson finally reached India in May 1795, the last remaining plants still bore living cochineal.

Neilson had expected to disembark at Madras, but his ship instead brought him much farther north, to Calcutta. Though disappointed at not being able to personally deliver the cochineal to Anderson, Neilson did the next best thing and delivered the insects into the care of Anderson's friend William Roxburgh, the superintendent of Calcutta's botanic garden. Neilson and Roxburgh wanted to send some of the insects to Anderson right away, but the weather and winds were against them, and in any case the stock was so small and the dangers of the journey so great that it seemed better to first establish the cochineal in Calcutta. Having written to Anderson for approval, they placed the insects on various nopals, including the variety that Banks had sent from Kew.

The results were disastrous. At the end of May, a distressed Roxburgh informed Anderson that "unfortunately nine tenths of our Cochineal Insects have died on account of their refusing all the three Plants you have been Cultivating for them." It seemed that Neilson's cochineal was as good as dead.

Roxburgh noticed, however, that some insects had made themselves at home on a cactus known as the Bengal nopal, or Neeg-Penny, which had long ago been introduced from America to India and now grew wild in many districts. Soon these insects began to reproduce at a tremendous rate. In late June, Roxburgh cheerfully reported to Anderson and his assistant Berry, "We cannot have less than some Thousands in a thriving State," and sent two boxes of Bengal nopal leaves "with plenty of the Insects on them" to Madras.

The cochineal arrived safely and prospered on the naturalized

cactus, which abounded in the local hedges. Anderson rejoiced at the prospect of using such a commonplace plant to cultivate the rare insect. It would, he believed, allow the East India Company to convert "the most waste, barren and dry lands . . . to great advantage."

The only disquieting note was raised by Roxburgh, who observed that Neilson's cochineal "took only 30 [days] to go through their various Stages"—a swift breeding cycle that indicated that the insect Neilson had obtained was not domesticated cochineal but one of its wild cousins. Anderson's misgivings about the cochineal of Brazil had been well founded, but he took the blow philosophically. Unencumbered by evolutionary theory, or by the knowledge that the domestication of wild cochineal in Mexico had taken hundreds if not thousands of years, he and Berry believed that proper care and nourishment would quickly effect a great improvement in the stock.

Six months after Neilson's cochineal arrived in Madras, it seemed that Anderson's hopes were being realized. Already, Berry reported, the insect was producing better results than the wild American varieties. After experimenting with its dye on textiles, he estimated that Neilson's cochineal yielded as much as two-thirds the dye of top-quality Mexican insects, substantially more than could be expected from any other wild species. In December 1795, Berry sent samples to the governor of Madras: "It is with the greatest pleasure I now forward pieces of Cassimere cloth and Flannel, dyed with cochineal reared here, which in brightness and colour equal the best scarlets." Back in England, Banks became confident that India's cochineal would soon ruin the Spanish monopoly.

By the spring of 1796, however, Berry and Anderson were forced to admit that they had encountered unforeseen obstacles in cultivating Neilson's cochineal. Far from being poor feeders, the insects had turned out to possess ferocious appetites, and they were busily consuming every Bengal nopal in sight. "The danger is that they will destroy their food and be lost," Berry fret-

ted. By July, according to Anderson, the insects were spreading like wildfire, and "wherever they have gone, the plants [Bengal nopals] are so entirely blighted and destroyed, that the people who have gardens, fearing an attack on their greens and vegetables of different sorts are, I am told, cutting the opuntia out of their hedges, on the same principle as a country is laid waste to prevent the approach of a powerful enemy." This was entirely unnecessary, Anderson noted, since the insects would touch nothing except the Bengal nopal, but he feared that Neilson's cochineal would perish as its food source vanished from Indian gardens.

Even more troubling, as far as Anderson was concerned, was the difficulty he had persuading people to cultivate the insect for profit. Despite the high guaranteed price the East India Company offered for cochineal, British landowners—like the Spanish conquistadors before them—had little desire to cultivate such a strange commodity. The few Britons who did engage to raise the insect were not inclined to do any hard labor themselves. In at least one case a landowner employed "children from 7 to 9 years of age" to do the work for him; "I know it will be pleasing to you to hear that the native youth are so well employed," he wrote to Anderson.

Indian landowners were, if anything, even more reluctant to grow cochineal. Anderson found this particularly disturbing, for he had favored the introduction of the insect in part because he believed it would benefit poor Indian farmers. He had never expected high-caste Brahmins to grow cochineal—they were, he explained, "too genteel and delicate to be employed in any menial office"—but he could not understand why weavers, shopkeepers, carpenters, servants, and barbers were not clamoring to grow cochineal on small family plots. That they were opposed to the idea, however, was indisputable.

"I have not heard of any collection of Cochineal being made here either by Europeans or Natives except a trifle for mere amuse-

ment and Curiosity," confided one of Anderson's correspondents in 1796. Despite the fact that he had done everything in his power "to convince the Natives how valuable an acquisition and source of wealth it will prove to them," no Indian was interested in harvesting it. Elsewhere in India, the situation was much the same. Like the British, most Indians regarded Neilson's cochineal as an unknown commodity, and they preferred not to risk their money and time on it. Moreover, they had no desire to tangle with the thorny local nopal, which was apparently much spinier than the variety most Mexicans used for raising cochineal.

Time proved that the people of India were wise to stick with the tried-and-true. The East India Company shipped over 4,000 pounds of Neilson's cochineal to England in 1797, and nearly 40,000 pounds in 1798, but the commodity was not as profitable as its boosters had hoped. Berry's estimate that the insects contained as much as two-thirds the dye of the best Mexican variety turned out to be wildly optimistic. Later estimates suggested that the actual figure was less than one-third—standard for wild species but devastating to the East India Company's calculations.

Faced with this gap in expectations, the East India Company in 1798 slashed the guaranteed price it offered for Neilson's cochineal. But even at the lower price the company found it hard to sell a commodity that was widely regarded in Europe as "not very abundant in colouring matter, and very inferior to any brought from New Spain." In 1807, the company directors finally accepted that cochineal was a losing proposition, costing more to produce and export than it earned in the marketplace. Cutting their losses, they voted to dispose with price supports altogether, a move that put an end to the market for Neilson's cochineal. Although the insect survived in the wild, commercial production virtually ceased.

This resounding failure did not put an end to British dreams about the red dyestuff. Before his death in 1809, Anderson again suggested to the East India Company that it might prove worth-

while to offer a large public reward for the true Mexican cochineal. Willing at last to resort to open advertisement, Banks, too, had made a similar proposal. Accordingly, the Court of Directors voted to offer £2,000 to anyone who could successfully introduce the valuable insect to their possessions in India.

The reward, however, had yet to be claimed in 1820, when Joseph Banks, still active in scientific and imperial circles at the age of seventy-seven, slowly began to succumb to the gout that had plagued him for years. Despite his best efforts, Britons had never replicated Thiery de Menonville's feat, and cochineal remained securely within the confines of the Spanish Empire.

Yet as Banks lay dying amid his magnificent botanical collections in London's Soho Square, the Spanish Empire was dying, too. After enduring Spanish rule for almost three centuries, Latin Americans had been seized by the dream of independence. In province after province, they had begun to fight for their liberty—and in the chaos of their revolutionary struggle, Spain's cochineal monopoly would be endangered as never before.

FIFTEEN
Red and Revolution

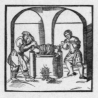IN THE EYES OF MOST EIGHTEENTH-century Europeans, the world's supply of cochineal belonged to Spain. In Mexico, however, the matter was viewed somewhat differently, or so the work of the scientist José Antonio Alzate y Ramírez suggests.

Alzate has sometimes been called Mexico's Benjamin Franklin, and with good reason. Like Franklin, whom he much admired, Alzate had a lifelong interest in the publishing business, an all-consuming curiosity about how the world worked, and an ardent desire to be useful to his country. Born into a wealthy Mexican family in the late 1730s, Alzate was later ordained as a priest, but his chief interest in life was scientific research and writing. Besides his numerous treatises, which earned him membership in Spanish scientific societies and France's Académie Royale des Sciences, he founded three scientific journals, of which the last, the *Gazeta de literatura*, was the most successful.

In the *Gazeta* and in his treatises, Alzate covered any number of diverse topics, from the latest advances in architecture and physics to recent discoveries concerning the migration of parrots, the mechanics of lightning rods, and the treatment of scorpion bites. What interested him most, however, was the botany, agriculture, and industry of his native land, Mexico—or, as it was usually called then, New Spain. Cochineal, which touched on all these matters, was a natural subject for him, and in 1777 he wrote *Memoria sobre la grana*, the most comprehensive survey of cochineal biology and cultivation that had yet been compiled. Later republished in the *Gazeta*, the treatise confirmed Alzate's status not only as a scientist but as a Mexican patriot. He wrote about cochineal, he explained, out of "love towards my Country, and towards my Nation, the sole possessor of such a great treasure." However much Spaniards might believe that cochineal belonged to them, Alzate noted with passion that in fact "this little animal" was one that "Providence had destined solely for New Spain."

For all that he claimed cochineal for Mexico, Alzate was no revolutionary. Unlike Franklin, he did not agitate for independence, and when he died in 1799 his country was still part of the Spanish Empire. Yet like many of his contemporaries, Alzate identified most strongly not with Spain, the seat of empire, but with his American homeland. "Divine Providence willed that I should be born here," he once wrote, and it was with a sense of divine mission that he became the champion of Mexican science, often in the face of Spanish indifference and ridicule. Although Alzate avidly read the work of his European colleagues, he resented their condescension toward Americans, and he was quick to point out errors they made in describing American phenomena. No doubt he enjoyed the uproar that resulted when he criticized the methodology of a Spanish botanical expedition appointed by the king—and lauded the botanical knowledge of ancient Mexicans instead.

If Alzate found Iberian superiority rather tiresome, so too did many of his contemporaries. For the first two centuries of empire, highborn colonials had taken great pride in calling themselves Spaniards, but now that Spain had fallen on hard times, the association no longer gave them such pleasure. Far from being the greatest power in Europe, Spain had become a desolate country. Battered by military defeats, it was fast sinking into poverty and despotism. When the sons of wealthy Mexicans traveled there for education and continental polish, they found few traces of imperial glory. Little wonder, then, that elite Mexicans—and elite colonials throughout the empire—started to call themselves *Americanos* from the mid-1700s onward.

While some of these *Americanos* were content to leave the structure of empire alone, many others contemplated various ways of reforming it. Some patriots wished only for piecemeal changes, such as laws giving local-born traders advantages over those from Spain, or greater representation for Americans among the councils that shaped colonial policy. More radical spirits, influenced by the fervor for independence that was sweeping the Atlantic world in the wake of the American and French Revolutions, suspected that it might be better to break away from Spain completely.

It wasn't until Napoléon Bonaparte invaded Spain, however, that matters came to a head. In 1807, the tiny emperor, who by then had conquered nearly half of Europe, sent his army into Portugal. The following year, he marched into Spain and rapidly secured many of the country's most important cities. Employing persuasion, deception, and outright force, the French invader compelled the weak-willed Spanish king, Charles, and his loutish son, Ferdinand, who had long been at loggerheads, to abdicate, at which point Napoléon proclaimed his brother Joseph king of "Spain and the Indies."

No doubt the brothers Bonaparte were eager to enjoy the fruits of the Spanish Empire. Yet if they had hoped to revel in

cochineal, they were sadly disappointed. The economic depression of the 1780s and the European wars that followed it had taken a heavy toll on all maritime trade, including the cochineal business. As ocean travel became more dangerous and home markets more uncertain, merchants looked for safer investments elsewhere.

Within this gloomy transatlantic context, the cochineal industry had also suffered its own specific setbacks, including the catastrophic Mexican famine of 1785–87, which killed many Indian cochineal farmers and left others too weak to work. In addition, changes in Spanish colonial policy—including the abolition in 1786 of the merchant credit system that funded the production of cochineal and many other goods—hit the industry hard.

Cochineal merchants also faced an unusually difficult market on the other side of the ocean. In the age of the guillotine, scarlet gowns and crimson velvet coats had become distasteful, even dangerous. Instead, plain clothes—dull-colored jackets, buff breeches, and white cambric dresses—were very popular. If people wore any red at all, it was the proletariat red of the *tricolor* and the *bonnet rouge*—a color that could be made with reasonably priced French madder, rather than with expensive foreign cochineal. Although more lavish fabrics staged a comeback when Napoléon rose to power, the cochineal industry was by then a shadow of its former self. In the year that Napoléon marched into Spain, Mexican production amounted to little more than 300,000 pounds a year, a third of what it had been in the 1770s.

Limited though the supply of cochineal was, Napoléon would have been glad to get his hands on it. Having helped to make rich imperial trappings fashionable again, he understood better than most the dyestuff's importance to the French textile industry, yet his enemies were determined to snatch the rich prize from him. The British navy, which had the upper hand at sea, attacked French ships on the Atlantic, ensuring that very little of the dyestuff reached Napoléon. And to the dictator's dismay, Spain itself—

which he had thought would be an easy conquest—was slipping from his grasp. From the first, many Spaniards had steadfastly resisted Joseph's rule, allying themselves with England to drive the imposter out. The war that Napoléon had thought he could win swiftly and cleanly dragged on for six long years, a time of horror and despair depicted by Spain's greatest living painter, Francisco Goya, in an excruciating series of etchings, *Los desastres de la guerra*. Under Napoléon, Spain had turned into a bloodbath for soldiers and civilians alike.

In Spanish America, too, these were tumultuous and terrifying times. When "El Rey Josef" succeeded to the throne, many Spanish Americans refused to recognize him as their legitimate ruler. Most also rejected the authority of the Spanish junta that claimed to speak for King Charles and his son Ferdinand, the exiled royals. Instead, Spanish Americans tried to govern themselves as best they could until order was restored in Europe. In most provinces, this ended in a political free-for-all: conservatives tried to preserve the status quo, liberals demanded ever more drastic reforms, and radicals armed themselves for full-scale revolution.

In Mexico, the revolutionary struggle was led by two charismatic priests. The first, Miguel Hidalgo, was a well-born and eccentric curate who played the violin, read banned books, and liked to gamble. He began his ferocious campaign to free Mexico from Spain in 1810. Encouraging his Indian parishioners to attack not only peninsular Spaniards but white Mexicans in general, he ignited a race war in central Mexico that killed thousands and stopped just short of taking the capital. The Mexican army, controlled by conservatives, captured and executed him in 1811.

Hidalgo's successor, José María Morelos, was a mestizo priest who abhorred the politics of race hatred. Under Morelos, the character of the rebellion changed: it became not only a fight for freedom from European overlords but also a campaign for racial equality. "We are all equal," he said to his followers; there was "no

reason for slavery, since the color of the face does not change the color of the heart or of one's thoughts." Moreover, he believed "that the children of the peasant and the sweeper should have the same education as the children of the rich" and that "every just claimant should have access to a court which listens, protects and defends him against the strong and the arbitrary." This commitment to equality and justice drew many converts to Morelos's side, as did his reputation for courage, humor, and good sense, and by the autumn of 1812 his army controlled much of southern Mexico, including Oaxaca.

As Morelos was well aware, control of Oaxaca effectively gave him control of cochineal, for almost all the Mexican dyestuff was still produced in that region. Within months of his conquest of Oaxaca City, however, trade in the dyestuff collapsed, largely because cochineal merchants—who had strong ties to Spain and were in some cases Spaniards themselves—abandoned the city rather than live under rebel rule. Without merchants there was no way to deliver the dyestuff to world markets and no way to receive payment for it. Production sunk to its lowest level in more than half a century. Starved of cochineal, Europeans fought for the few shiploads that came in, driving the price of the dyestuff sky-high.

Long before matters reached this state, Napoléon had recognized that France was unlikely to receive anything approaching the amount of cochineal it needed. In 1810, the year that Hidalgo began his armed insurrection, the emperor and his minister of the interior, a chemist named Jean-Antoine Chaptal, offered a reward of 20,000 livres to anyone who could create a cochineal substitute from French madder.

Did anyone try to claim the prize? No one knows, but in any case Napoléon and his ministers soon had more pressing concerns on their minds. Although the emperor was at the height of his powers in 1810, the "Spanish ulcer" was even then eating away at his strength. The disastrous decision to attack Russia in

1812 sealed his fate. As the frostbitten remnant of the Grande
Armée struggled back toward France, the duke of Wellington
advanced across Spain backed by British troops and Spanish
guerrillas. By the summer of 1813, the French army was retreat-
ing across the Pyrenees. As Napoléon's enemies continued to
attack from all sides, the empire collapsed, and in 1815 Napoléon
met his final defeat at Waterloo.

By the time the emperor sailed away to his lonely imprison-
ment on the island of Saint Helena, Ferdinand was firmly
ensconced on the Spanish throne. His hapless father remained in
exile, but the people of Spain and Spanish America were satis-
fied, and the empire returned to the royal fold. In Mexico,
Morelos was captured, defrocked, and executed. The insurgency
lived on after his death, but it was much diminished. Elsewhere
in the Spanish Empire, rebellion also died away.

To all intents and purposes it seemed the old order had been
restored. Yet nationalist yearnings and revolutionary passions could
not be stilled so easily. Though many Spanish Americans had been
glad to see the chaos of rebellion end, they chafed at being shackled
again to Spain and to the Bourbons. Perhaps if Ferdinand had been
willing to consider reforms, a compromise could have been bro-
kered. But Ferdinand—whom Napoléon had characterized in dis-
gust as a man who "eats four square meals a day and hasn't an idea
in his empty head"—clung stubbornly to the absolutist ideal. Over
the protests of liberals both at home and in America, he ruled as an
autocrat over Spain and the empire, nullifying all reforms intro-
duced during the Napoleonic years.

It was a situation that could not endure for long. By 1817,
American revolutionaries had found a new leader in Simón Bolívar,
a daring Venezuelan aristocrat who denounced Ferdinand as a
tyrant and launched a new campaign for South American indepen-
dence. His army achieved brilliant victories over imperial Spanish
troops, and Ferdinand watched aghast as country after country
slipped from his grasp.

In Mexico, ironically, it was the loyal conservatives who provided the crucial force necessary to free their nation from Spain. Until 1820, these conservatives were determined to remain under Spanish control, and their army held local revolutionaries at bay. But when Spain itself fell into the hands of anticlerical liberals, who forced a constitutional monarchy on a recalcitrant Ferdinand, the conservatives had second thoughts. Appalled by the prospect of being ruled from afar by godless radicals, the conservatives reversed course and allied themselves with Mexico's revolutionaries. The commander of the Mexican army, Colonel Agustín de Iturbide—a man who had once fought against Morelos and the insurgency— combined his forces with those of Mexico's guerrilla leaders, and together they defeated the Spaniards.

On August 21, 1821, Spain's representative signed the Treaty of Córdoba, formally relinquishing Spanish control of Mexico. Cochineal and all the other glories of New Spain now belonged to Mexicans alone. Or so it seemed. Yet in the case of cochineal, their victory was to be short-lived, for during the chaotic years of the rebellion, the insect had escaped Mexico's borders.

AT FIRST, THE SPREAD OF COCHINEAL DID NOT ALARM most Mexicans, for it began in a small and seemingly harmless way. Sometime between 1811 and 1820, cochineal was introduced to Guatemala, whose people were fighting side by side with Mexicans for freedom from Spain. After independence, Guatemala, like the rest of Central America, chose to become part of Mexico, which meant that cochineal was still an exclusively Mexican commodity. In 1823, however, Guatemala and the other Central American provinces seceded from Mexico. At one stroke, Guatemala's cochineal producers had become Mexico's rivals.

Domesticated cochineal had been introduced to Guatemala before, under the leadership of the conde de la Gómara in the

early 1600s, but locust plagues, heavy rains, and a lack of skilled laborers had caused the insects to fade away within twenty years. No doubt nineteenth-century Mexicans hoped the latter-day transplantation would likewise fail, leaving Guatemala with only the inferior wild cochineal that was common to all Central America. But far from failing, the Guatemalan nopalries survived and slowly expanded. In 1827, Guatemala exported 15,000 pounds of cochineal, rising to 45,000 pounds three years later. Although this paled beside the 450,000 pounds that Oaxaca annually produced during the same period, Mexican cochineal farmers nevertheless watched Guatemala with worried eyes.

What cut Mexicans to the quick, however, was that Spain was producing cochineal, too. Having foreseen the possibility that their country might lose control of Mexico, several Spaniards had taken steps to establish cochineal on the Iberian Peninsula in the early nineteenth century. An early attempt in 1806 ended in failure, but in 1820 a Crown official in Veracruz, a Spaniard from Málaga, sent a shipment of cochineal-covered nopals to Cádiz. There the local chapter of the Sociedad Económica de Amigos del País—a network of citizen-scientists devoted to the rational improvement of Spain and its empire—took charge of the insects. Soon the cochineal had multiplied sufficiently that stocks could be sent to Seville, Málaga, Valencia, and Murcia, and distributed free to anyone who wished to cultivate them.

Though not the instigator of the plan, the Spanish government approved wholeheartedly. Economically and psychologically, Spain was reeling from the loss of its American possessions—a loss the nation, still recovering from the savage depredations of the war against Napoléon, could ill afford. By the end of 1825, their colossal empire, which had stretched from California to Cape Horn, had disintegrated; mere fragments, most of them islands, remained in Spanish control. For Spaniards, introducing cochineal was a way of salvaging something from the wreckage.

Despite much effort, however, cochineal production on the Iberian mainland never prospered. Although the variety of cactus most favored by cochineal had long been established in Spain, this seeming advantage was illusory, because many Spaniards had grown attached to its fruit, and they were unwilling to sacrifice any of the much-valued plants to a parasite like cochineal. The Spanish climate, more extreme than that of Oaxaca, also hampered production. Even the expertise of cochineal farmers who had emigrated from Mexico to Spain did not seem to galvanize the industry. The Spanish dyestuff remained scarce, weak, and expensive. As a cochineal producer, mainland Spain could not compete even with Guatemala, let alone Mexico.

Although Mexicans could take comfort in their overwhelming lead, the existence of a Spanish cochineal industry, however debilitated, was cause for concern. When it came to the spread of cochineal, Spain was now the weak link in the chain. No longer an ocean away, the insects could be found in numerous places along the Spanish Mediterranean coast, within easy reach of the European rivals who had been striving for centuries to capture them. Worse yet, Spain, fatally weakened by the loss of its empire, had neither the strength nor the will to properly safeguard the insects. By 1827 or so, cochineal had spread from Spain to the Mediterranean islands of Sardinia and French Corsica and perhaps even as far as mainland Italy. According to one report, it may even have been introduced to French Senegal at about the same time.

Other countries, too, pursued the scarlet insect, including the new United States. In 1821, two years after Spain formally ceded Florida to the United States, a onetime West Indian planter named Peter Stephen Chazotte was telling Americans that the new territory "promises fair, from the nature of the soil and climate, to produce coffee, cochineal, and cocoa." In fact, neither Florida nor any other area of the continental United States was warm enough for these tropical crops; even in the

warm southern regions, only wild cochineal—which today flour-
ishes in Florida, Arizona, and many other states—was hardy
enough to survive there.* But the dream of a United States
cochineal industry died hard. When Americans seized first Texas
and then most of northern Mexico in the 1830s and 1840s, the
dream was briefly resuscitated, only to expire again in the face of
climatic reality.

Nations whose imperial reach extended to more tropical
climes had better reason to hope for profits. British officials and
explorers continued to make sporadic attempts to introduce
cochineal to India, as well as to Africa and the West Indies. In
the 1830s, the French obtained nopals and cochineal insects from
mainland Spain and brought them to French North Africa.
Fifteen years later, they also introduced the insect to the
Caribbean island of Guadeloupe. The Portuguese, too, were
intent on securing their own supply of the red dyestuff. In the
late 1830s, they established cochineal on Madeira, a Portuguese
island off the coast of Africa, where the weather seemed ideal for
the insect.

The one saving grace, as far as Mexicans were concerned,
was that none of these efforts met with great success. Most,
indeed, were outright failures. But Mexico's luck could not hold
out forever. In the mid-nineteenth century, the production of
cochineal was destined to expand much farther, owing in part to
a Dutch spy, a Guatemalan dictator, and a fungus called *Uncinula
necator*.

*In some of these states, wild cochineal is so abundant that it is considered a
pest.

SIXTEEN

Scarlet Fever

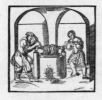 **THE DUTCH HAD POSSESSED ONE OF** the world's great empires since the seventeenth century, but for most of that time their interest in live cochineal had remained academic. They kept an eye out for cochineal when they explored new lands, and were delighted to seize Spanish ships carrying the dyestuff, but they never made elaborate plans to smuggle live cochineal into their dominions so they could raise it themselves. To their mind, dealing in dried cochineal was the best end of the business, and certainly the one most suited to their trading talents. In the 1600s, particularly, Dutch merchants did well from the cochineal trade, excelling in this as in so many other commercial ventures.

In the 1700s, however, the Dutch had second thoughts about their imperial strategy. France and Britain, whose colonies were devoted to plantations as well as trade, had emerged as the most powerful players in the imperial game, far outshining the Netherlands. Hoping to emulate their success, the Dutch worked

hard to establish valuable plants in their far-flung colonies. It was only in the nineteenth century, however, that the Dutch set their sights on cochineal—but having done so, they refused to settle for anything less than success.

The colony where the Dutch wanted to introduce cochineal was Java, an island of lush rain forests and delicate temples that had been the base of Dutch power in the East Indies for two centuries. Following the usual Dutch inclinations, in the 1600s and 1700s the Dutch East India Company had run the colony largely as a trading post; rather than running plantations themselves, company officials contracted with local Javan rulers for delivery of rice, coffee, pepper, and other commodities, which the Dutch East India Company then exported worldwide. But when the company went bankrupt in 1799, control of Java had devolved directly upon the Dutch government, which concluded in the 1820s that Java was a financial drain on the Netherlands. To boost profits, the government encouraged colonial officials to embark on a series of economic reforms, among them the introduction of new crops to the island. At the time, Javanese peasants were already producing some of the world's most desirable exports, including rice, indigo, sugar, pepper, tobacco, cardamom, and cotton. But to improve the colonial bottom line, Dutch officials decided to establish cochineal, among other new crops, on Javanese soil.

The Dutch scheme to procure cochineal insects was an intrigue of truly global proportions, some details of which are still cloaked in mystery. It appears that the scheme was set in motion in the mid-1820s, when the Dutch government dispatched a spy to Cádiz. In all, this spy spent about two years in the Spanish port, eventually finding work in a local nopalry, probably as a hired hand, where he learned everything he could about cochineal cultivation.

In December 1827, the next stage of the scheme was set into motion when Dutch officials sent a warship, the *Leije*, to Cádiz. One dark night, as the warship sat calmly in Cádiz harbor, the spy

and other Dutchmen smuggled seventy-two cochineal-covered nopal plants and more than six hundred nopal cuttings on board. The next morning, when the ship sailed for Java, its passengers included not only the spy but also the head gardener from the Cádiz nopalry, who had decided to collaborate with the Dutch in exchange for a handsome payoff.

Since Europe and the East Indies were halfway around the globe from each other, it took an interminably long time to travel from one to the other during the age of sail, and the *Leije*'s voyage—at the time, the longest ever made with live cochineal—must have killed off a great many insects. But such a vast quantity had been stolen from Spain that when the *Leije* arrived in Java in August 1828 there remained some survivors. These were taken to a special garden in Buitenzorg, in the hill country south of the colonial capital Batavia (now Jakarta), where the head gardener from Cádiz cared for them. In October 1829, he exhibited his first cochineal crop and earned a gold medal from the government.

Soon afterward, colonial officials decided to expand the production of cochineal through the *Kultuurstelsel*, or "Cultivation System"—an innocuous name for the hard-line labor policies that Java's new governor-general, Johannes van den Bosch, enacted in 1830. To make Javanese exports more competitive on world markets, colonial officials forced Javanese farmers to work on new government-run plantations for very low wages, and they encouraged private entrepreneurs to adopt similarly repressive labor practices on privately owned nopalries.

Compared with coffee, rice, and other major crops, cochineal was only a small part of the Cultivation System, and the historical record reveals little information about the specific abuses endured by cochineal workers. It seems likely, however, that they suffered many of the same hardships foisted upon other Cultivation System laborers. Always harsh, the Cultivation System became an exercise in brutality in the 1840s. Many Javanese laborers received such low wages that they could not feed their families, and they were allowed

no time to grow the subsistence crops that were their traditional means of sustenance. By the mid-1840s, hundreds of thousands of Javanese people had succumbed to famine and disease, and the survivors were condemned to continual privation and misery.

As far as most Dutch observers were concerned, however, the Cultivation System was a triumph. Although some colonists, concerned about the soaring Javanese death rate, campaigned to reform the Cultivation System in the late 1840s and early 1850s, few planters and administrative officials were willing to do anything that might compromise Java's newfound prosperity. Meanwhile, the people of the Netherlands remained largely ignorant of what was being done in their name. It was only in 1860, with the publication of the novel *Max Havelaar*, that the abuses of the Cultivation System came to the attention of a shocked public.

Written by Eduard Douwes Dekker, a disaffected colonial official writing under the pseudonym "Multatuli" (based on the Latin for "I have suffered much"), *Max Havelaar* was an uneven story, full of strange turns of plot and phrase, but so fervently did it condemn the corruption in Dutch Java that no one in the Netherlands could ignore it. The dedication alone caused a stir, since in it Dekker addressed King Wilhelm III directly, asking "whether it is your imperial will that . . . yonder Your more than *thirty million* subjects are *maltreated and exploited in Your name?*" The public demanded an explanation, and the Dutch government responded with a series of colonial reforms which culminated in the abolition of the Cultivation System in 1882.

Before the publication of *Max Havelaar*, most people in the Netherlands knew very little about the tragedy unfolding in Java, and those who did know something insisted that the rising Javanese mortality rate had nothing to do with Dutch policy. Instead they focused on the fact that the cost of agricultural production had dropped substantially, enabling both exports and profits to rise to unprecedented levels. "It is impossible to praise too much the man whose genius has created this source of prosperity and wealth for

the motherland," wrote one commentator in the mid-nineteenth century, lauding Governor-General van den Bosch.

Confronted with questions about the welfare of Javanese laborers, Dutch colonial officials and entrepreneurs disparaged the ability of those laborers to make a living in any other way. Typical were the sentiments expressed by H. van Blommestein, a resident of Java who had been instrumental in the expansion of cochineal production on the island. "One might suppose that . . . higher payments would be a stimulus to the Javan," Blommestein wrote, but "anyone who thinks this doesn't know the Javan; he knows no other stimulus to work than orders." A similar philosophy permeated the instructions offered by L. Monod de Froideville, the author of a contemporary Dutch manual for cochineal growers. "The Javan is . . . docile and meek," he wrote in 1847, "but confused and averse to work that demands exertion or is unknown to him." He was quick to assure his readers, however, that with "precise supervision" the Javans could perform the jobs needed to make a cochineal plantation profitable.

To Monod de Froideville, the future for Javanese cochineal seemed bright. Ignoring the high death rates among Cultivation System workers, he turned his attention instead to more cheering statistics. After the uncertain early years of production, cochineal was yielding a net profit for both entrepreneurs and the Dutch government by the 1840s. Noting with pleasure that "the price climbs higher and higher," Monod de Froideville envisioned a day when Java would overtake Mexico as Europe's chief provider of the dyestuff.

Two years after publication of Monod de Froideville's manual, the amount of Javanese forced labor allocated to cochineal continued to increase, and the annual harvest rose to more than 80,000 pounds of the dyestuff, most of which was exported to China and Holland. To the frustration of many Dutch entrepreneurs and colonial officials, however, it was becoming clear that cochineal was not destined to be one of Java's star exports.

As the Spaniards had realized centuries before, the Mexican insect rarely prospered in the hands of forced laborers on big plantations but instead demanded the kind of patience and careful attention most often seen in workers who had small plots and personal incentive to produce the dyestuff. If this was true in Mexico, it was doubly so in Java, where the rainy climate demanded great fortitude from cochineal workers. To protect cochineal from heavy monsoon downpours, the insects had to be reared under cover. Monod de Froideville recommended a complicated bamboo roof structure with adjustable louvers. Other farmers opted for simple straw canopies instead. Neither solution proved entirely adequate to the purpose, and both added to the cost—in time, labor, and materials—of cochineal production on Java.

The island's steamy climate also hurt cochineal producers in other ways. Nopals wasted away in the humidity, and the insects themselves seem to have been stunted by the weather. Like the cochineal produced in mainland Spain, Javanese cochineal was judged inferior to the Mexican variety. Small-grained, it fetched a lower price on the market.

What worried Dutch officials most of all, however, was that year by year the price of the dyestuff was dropping, as they faced ever more competitors in the cochineal market.

EVEN AS THE DUTCH WERE ESTABLISHING COCHINEAL on Java, world cochineal production was rising at a spectacular rate. In Mexico, exports had remained low in the years immediately following independence, but by the 1830s Oaxacan growers were producing the greatest amount of cochineal seen for a generation. At the end of the decade, in the banner year of 1839, they harvested over 900,000 pounds of the dyestuff, the highest total in over half a century.

Mexico's totals, however, were soon surpassed by those of

Guatemala. In the 1820s, Guatemalan officials had promoted cochineal cultivation by offering tax exemptions to growers, but it was under the rule of the charismatic but ruthless dictator Rafael Carrera—a onetime cochineal laborer—that Guatemalan cochineal came into its own. The years after his assumption of power in 1838 saw a renewed government commitment to cochineal, which was by then the country's most important export. The results were dramatic: between 1830 and 1845, Guatemala's cochineal exports increased twentyfold, reaching over one million pounds a year by the end of the period. Most of this cochineal was produced by small farmers and small communities.

Unlike the Javanese variety, Guatemalan cochineal was considered the equal of the Oaxacan dyestuff, and attained the same high prices. Most of it was sold to Britain, which offered tax advantages to the small country's exporters—an arrangement that profited both parties, assuring British factories a reliable supply of the dyestuff and Guatemalan farmers a secure market for their harvest. By 1850, Guatemala was providing three-quarters of all British cochineal imports. One year later it shattered all records by exporting 2 million pounds of the dyestuff, more than twice Mexico's total. In the short space of a single generation, Guatemala had become the world's cochineal powerhouse.

Yet even Guatemala had to watch over its shoulder. On the other side of the Atlantic, Spain was at last gaining ground in the cochineal race. Although mainland production remained poor, Spain's Canary Islands, blessed with rich volcanic soils and a mild, sunny climate, had proved an ideal home for the insect.

Anchored off the coast of what is now Morocco, the Canary Islands had been known to Europeans since ancient times.* In the nineteenth century their main business was the production of

*In Roman times, the islands were named for the wild dogs (in Latin, *canes*) that famously roamed there. Later, the name *canary* was applied to a variety of songbird native to the islands.

world-famous Canary wine, but in the mid-1820s Cádiz's enter-
prising citizen-scientists of the Sociedad Económica sent a
packet of live cochineal to Sabin Berthelot, the director of a
botanical garden on the largest island, Tenerife. Berthelot quickly
bred the insects so that samples could be distributed across the
islands. Meanwhile, the Spanish government, realizing that the
Canaries might help compensate them for the loss of Oaxaca, set
up an additional breeding station elsewhere on Tenerife, to speed
the work along. Due to these efforts, cochineal could easily be
obtained on Tenerife, Gran Canaria, Fuerteventura, Lanzarote,
and Hierro by the early 1830s.

At this point, the enterprise encountered difficulties com-
mon to many other cochineal introductions. Living in a dry land,
the Canary Islanders treasured the nopal for its luscious fruit, and
they were not about to surrender their nopalries to the ravages of
the cochineal insect. Even the tax incentives and price supports
offered by the Spanish government were not enough to tempt
most islanders, who continued to grow grapes for their sweet
wine throughout the 1830s and early 1840s. As a result,
cochineal production in the sunny Canaries lagged well behind
that of rainy Java.

The turning point came in 1853, when the fungus *Uncinula
necator* destroyed the islands' grapevines. No longer able to pro-
duce wine, the islanders turned to cochineal as if to a lifeline. By
1855, annual cochineal exports from the Canaries reached 1 mil-
lion pounds.

Canary Island exports, combined with those of Guatemala,
Mexico, and Java, were like a red sea rising. The world had never
seen so much cochineal. Total production of the dyestuff had
quadrupled between 1830 and 1850, reaching over 2 million
pounds a year, an all-time record—and still it continued to rise.
For consumers, this was wonderful news, but for producers it was
unsettling.

A luxury item with variable harvests, cochineal had been

infamous for its market volatility since the sixteenth century, so producers had weathered periods of weak prices before. Even when cochineal prices hit historic lows in the late 1830s and 1840s, most farmers simply kept their heads down and continued producing the dyestuff. If past performance was any guide, prices would doubtless recover soon.

Unfortunately for the cochineal farmers, new considerations were at play, not only on the supply side of the equation but on the demand side as well. Among the arbiters of fashion, scarlet and crimson were losing their cachet. It is possible that the drop in cochineal prices in the 1830s and 1840s had something to do with the decline, making rich red less exclusive than it once had been. Yet men were already turning against red during the early decades of the nineteenth century, when cochineal was scarce and prices were extremely high. More important, perhaps, was the very exuberance of the color itself. Associated as it was with aristocratic excess, red was not well suited to an age marked by the rise of bourgeois values. Having abandoned their sumptuous red silks and velvets during the French Revolution, men in Europe and the Americas seemed reluctant to return to the color, except in the archaic and ritualized form of an army uniform, a judge's robe, or a peer's mantle.

For a while, the demand for red was sustained by women, who had returned to stronger colors in the late Napoleonic era. But by the late 1830s, red was falling out of favor with females, too. To these early Victorians, all reds were slightly suspect, but it was flaming red—dazzling scarlets of the kind that Drebbel had dyed—that most unnerved them. In their minds, scarlet stood for sin, especially sexual sin, an ancient association that was coming into new and sharp focus during these years, for as red's association with male power had waned, its age-old identification with passion and sexuality came to the fore. Ladies who had no wish to be painted as the scarlet woman took notice. In 1843, a London *Ladies' Handbook* warned that "clouded and neutral

tints" were the only acceptable shades, even in hair and hat ribbons. "Flaming and gaudy colors" were to be "especially avoided."

Gaudiness, of course, was in the eye of the beholder, or so Charlotte Brontë's novel *Villette,* based on her experiences in Brussels in the early 1840s, would suggest. When Paul Emanuel reproves Lucy Snowe for appearing "on one occasion in a scarlet gown," she indignantly corrects him. "It was not scarlet! It was pink, and pale pink, too; and further subdued by black lace." But to Monsieur Paul's enflamed senses, the exact shade of the dress is immaterial. Any color that so much as hints at scarlet is "flaunting, giddy," and entirely unsuitable for a respectable gentlewoman.

The connection between scarlet and sin was further strengthened with the publication of Nathaniel Hawthorne's *The Scarlet Letter* in 1850. In setting the book in seventeenth-century New England, Hawthorne drew on Puritan notions of color symbolism, but he gave them a Victorian twist. Although it was true that Puritan punishments had included the wearing of letters—*A* for Adultery, *B* for Blasphemy, *D* for Drunkenness—by transgressors, the letters were usually made of plain red cloth, or occasionally from other colors instead. Hester Prynne's device, fashioned from rich scarlet cloth and "fantastically embroidered with gold thread," was, in its brilliant coloring and gilded ornateness, a thoroughly Victorian creation. But in Hawthorne's skillful hands, Prynne's scarlet letter—and Dimmesdale's bloody counterpart—became an indelible part of red's iconography, linking scarlet forever with the adulterous affair.

Yet if many Victorians shunned scarlet clothing, there was still reason for cochineal producers to hope that eventually red would make a comeback. After all, ascetics and puritans had tried to suppress the color before, only to find that the human appetite for red could not be quenched.

Sure enough, fashion took a brighter turn in the early 1850s, especially for women. Certain shades of red, it was true, remained forbidden. Although Emily Dickinson's poetry shim-

mered with a "Rush of Cochineal," the dyestuff produced "a tint too Red" for most of her New England neighbors' tastes. In London, fashion manuals denounced "brilliant red" as "vulgar and unsuitable," adding that "no lady with any pretensions to taste should ever wear a dress of crimson, scarlet or any of the *violent* plaids." Yet the same English fashion manuals that condemned scarlet and crimson looked kindly upon the less shocking shades of red. A lady, they agreed, could safely and suitably wear dark reds, brick reds, and maroon, especially if she were married—a sentiment echoed elsewhere in Europe and America. Combined with the rise of the full crinoline skirt, which required vast yards of fabric for a single dress, this vogue for dark reds helped revive cochineal's fortunes in the early 1850s.

Just as women were wearing cochineal reds again, so too were men, though in less obvious fashion. Gentlemen like Jefferson Davis, Confederate president during the American Civil War, slept in cochineal-colored nightshirts. Other men wore red woolen underwear. Similarly, women who would never dream of appearing in public in anything more eye-catching than a dull maroon dress sometimes wore bright red woolen petticoats underneath.

Demand for cochineal was also bolstered by the Victorian mania for rich Gothic Revival colors and ornate household decoration. A plethora of upholstered armchairs, Turkish settees, and divans, covered with plush cochineal-dyed fabrics, cluttered nineteenth-century parlors, replacing the bare chairs of earlier eras. Rich red draperies, valances, table covers, pillows, and mantel trimmings were also extremely fashionable, and they were being manufactured in increasing quantities as the Industrial Revolution took hold. These additional markets for the dyestuff helped keep cochineal prices from falling below profitable levels, despite the incredible rise in supply.

By the early 1850s, the price of cochineal was only a quarter of what it had been in 1820, but that was still enough to make

some people rich. If Oaxacans had reason to lament the end of their lucrative monopoly, elsewhere planters rejoiced in their newfound cochineal profits. In the Canary Islands, in particular, cochineal had introduced a new era of prosperity. According to one nineteenth-century writer, "Extravagant display was the fashion, immense and often useless buildings were begun, . . . and the islanders gave themselves over to a sort of riotous enjoyment of the fortunes that were looming before them." In Guatemala, too, many cochineal cultivators lived well. The prosperity of Amatitlán, one of the country's chief dye-producing districts, so struck one visitor that he described the city as a place surrounded by "broad cactus fields, glistening like silver under their precious coating of cochineal."

So great was the world's demand for red that many cochineal farmers had survived—and even thrived—as the global supply of the dyestuff quadrupled. To most producers, it must have seemed that the trade would go on forever. If the supply could somehow be controlled, or if merchants could find new markets for the dyestuff, there was even hope that prices would one day rise substantially. No one guessed that cochineal was about to receive a blow from which it would never recover, at the hands of an English scientist not yet twenty years old.

SEVENTEEN
A Lump of Coal

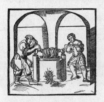 **ALTHOUGH MANY WOULD-BE INVENTORS** toil for decades without results, sometimes inventive genius flowers early. Few inventors, however, have ever achieved success as young as did William Henry Perkin, who was only eighteen when he made a discovery that revolutionized the textile industry.

Born in 1838, Perkin grew up in London's notorious East End, near the disease-ridden Shadwell docks, a district that was the despair of Victorian reformers. Yet not everyone who lived in Shadwell fell victim to Dickensian poverty. Perkin's father ran a successful carpentry business, and as an up-and-coming man he was able to afford both a substantial house and a private education for his son William.

Young William had a talent for drawing and painting, and his father fondly hoped that he would become an architect. But science was also in his blood. Like his grandfather, a Yorkshire leather worker who had dabbled in alchemy, William Perkin was fascinated by chemicals. At twelve, when a friend showed him

some experiments in crystallization, he made his decision. "I saw there was in chemistry something far beyond the other pursuits with which I had previously been occupied," he later recalled. "The possibility also of making new discoveries impressed me very much. My choice was fixed, and I determined if possible to become a chemist, and I immediately commenced to accumulate bottles of chemicals and make experiments."

William's father agreed to fund these scientific studies, but he was deeply disappointed by his son's choice of career. Architecture would have offered William a promising future; chemistry, by contrast, was a no-man's-land, mistrusted by businessmen and academics alike.

Part of the problem was that chemistry's roots were in alchemy. Despite the serious intellectual achievements of Enlightenment chemists like Antoine-Laurent Lavoisier and Joseph Priestley, the field remained tainted by its association with that dubious enterprise well into the nineteenth century.

The other difficulty with chemistry was that it tried to straddle the middle ground between theory and reality, with the predictable result that most people found it wanting. Manufacturers, seeing chemists as dreamers and dabblers, rarely employed them, preferring people with more hands-on training. Academics, on the other hand, considered chemistry's industrial connections degrading. They tolerated chemists' smelly labs and messy experiments only if their research remained resolutely theoretical. Indeed, some universities omitted the laboratory component of chemistry entirely, feeling it lowered the tone of their institutions. Other universities provided only the most limited laboratory facilities, more suited to the amateur alchemy practiced by Perkin's grandfather than to serious scientific inquiry.

William Perkin, however, had the good fortune to live near London's Royal College of Chemistry, one of the few academies in England that offered excellent laboratory training to young chemists. Founded in 1845, the college enjoyed the support of

Albert, Victoria's prince consort, a German who was deeply unpopular with Britons, but whose support and encouragement proved critical to all kinds of technical initiatives in his adopted country. At the time, Germany was at the forefront of university science, and Prince Albert wanted to establish institutes of a similar caliber in Britain. He helped the new Royal College of Chemistry get off the ground, personally intervening with the king of Prussia to secure the eminent German chemist August Hofmann as its director.

By all accounts, Hofmann was an auspicious choice. He was a thrilling teacher, and when Perkin entered the college in 1853, at the age of fifteen, he found himself in an atmosphere that suited him perfectly. Although chemistry was a dangerous discipline—Hofmann's students were sometime blinded or burned, and Hofmann himself suffered injuries—the work was fascinating. Hofmann encouraged his students to break new ground, often by his own example, and every discovery seemed to lead to fresh insights. In later life, Perkin vividly recalled one day when Hofmann added an alkali to a student's distillation and "at once obtained a beautiful scarlet salt." Turning to his students, Hofmann exclaimed, "Gentlemen, new bodies are *floating* in the air."

Modest by nature, Perkin was nevertheless extremely able, and he excelled in this intoxicating milieu. He quickly finished his college course, and at the unusually young age of seventeen he was promoted to the role of research assistant in Hofmann's lab, a plum position. Yet much as Perkin appreciated being able to work at the side of his mentor, the job left him little time to pursue his own independent investigations. To remedy this, Perkin rigged up his own laboratory in the attic of his father's Shadwell home. There, during vacations and off-hours, he undertook a peculiarly Victorian quest: the synthesis of quinine.

In Perkin's day, quinine was the only known remedy for malaria, the mosquito-borne disease of fever and chills that devastated warm, swampy areas on every continent. For Britain,

whose possessions girdled the globe, the need for quinine was particularly acute. In India, it was impossible to continue the work of colonization without it. Quinine, however, was scarce and expensive. The sole source of supply was the cinchona tree, which grew in the remote South American Andes. Desperate for more of the drug, Britons attempted to steal the cinchona tree from South America, but—as with cochineal—they failed to grab the right variety.

According to August Hofmann, however, there was another route to quinine: it could be synthesized in the laboratory from coal tar. A foul-smelling waste product of the burgeoning gaslight industry, coal tar was considered a nuisance by British manufacturers, who gave it away for free to anyone who asked. The black, viscous liquid—a favorite subject of study among Hofmann's students—contained scores of complex chemicals, many of them toxic, including toluene, benzene, and naphthalene.

It was naphthalene that caught Hofmann's attention, because one of its derivatives—naphthalidine—had a chemical formula similar to that of quinine. In 1849, he speculated that one chemical might be converted into the other with relative ease.

In a broad sense, Hofmann was correct: quinine could indeed be synthesized in the lab. But the procedures were far more complicated than he realized, and it would be decades before anyone succeeded in the task. Despite the fact that naphthalidine and quinine were made up of similar atoms, later studies proved that they had quite different molecular structures, which made such conversion impossible. In the mid-nineteenth century, however, when little was known about molecular architecture, Hofmann's theory seemed sound enough to many chemists—including Perkin, who decided to attempt the synthesis of quinine in his attic laboratory during the Easter vacation of 1856.

Perhaps because earlier experiments with naphthalidine had produced disappointing results, Perkin started with toluidine,

another coal-tar derivative that had a chemical formula rather like that of quinine. But his experiment was a failure: instead of the much-desired medicine, he ended up with a useless red-brown powder. Not one to be easily discouraged, Perkin repeated his experiment with still another coal-tar derivative, aniline. This produced an unprepossessing precipitate—what he later described as "a perfectly black product"—that seemed to have no redeeming qualities whatsoever.

At this point, most of Perkin's fellow chemists would have given up in disgust. But instead of pouring the black liquid down the sink, Perkin purified and dried it. For reasons that remain unclear, but which may have had something to do with his early artistic training, he then decided to test the coloring properties of his precipitate. On silk, it produced a shimmering shade of lilac that Perkin called "Tyrian purple," a shade that later became famous as "Perkin's mauve."

Although Perkin's mauve was a new discovery, other synthetic dyes had preceded it. Picric acid, which yielded a bright yellow on silk, had been synthesized from indigo and nitric acid in 1771, and chemists had created several other artificial dyes since then. But before Perkin's mauve, synthetic dyes were generally not manufactured in any quantity and indeed in many cases were too costly or fragile to succeed in retail trade. Partly for this reason, many chemists, Hofmann included, treated color as a curiosity, or at best as an indicator of other, more interesting chemical qualities. It was a sign of Perkin's genius that he grasped that his purple dye could transform the textile industry—if only he could find a way to manufacture it on a commercial scale.

With the help of friends and family, Perkin set up a larger lab in his father's garden to perfect the procedures for making his dye. Later that spring, he sent samples of mauve cloth to a dyeworks in Scotland, asking for their opinion of the dye's commercial possibilities. The reply, from Robert Pullar, the owner of the company, was encouraging: "If your discovery does not make the

goods too expensive," he wrote, "it is decidedly one of the most valuable that has come out for a very long time. This color is one which has been very much wanted in all classes of goods, and could not be obtained fast on silks, and only at great expense on cotton yarns."

On the strength of this response, Perkin decided to withdraw from the Royal College of Chemistry and devote himself full-time to making mauve a success. The move angered Hofmann, who expected his best students to devote themselves to academic chemistry, not industry. In this, he may merely have been reflecting the prejudices of his class, which considered trade degrading. But Hofmann may also have been concerned with the scientific ideal of openness, championed before him by men like Melchior de Ruusscher and James Anderson: as Hofmann saw it, universities and colleges were places where scientists openly shared their results in order to benefit all mankind, whereas commercial chemists kept secrets for private gain. It is likely that Hofmann feared for Perkin's safety, too: not long before, another favorite student had also gone into the business end of chemistry, only to burn to death in an industrial accident. In any case, Perkin reported, "He appeared much annoyed, and spoke in a very discouraging manner, making me feel that perhaps I might be taking a false step which might ruin my future prospects."

Hofmann's reaction caused Perkin real distress, adding fuel to his worst fear: that academic chemistry would disown him forever for going into industry. To a young scientist who loved pure research as much as Perkin did, this was a terrible prospect. But as the son of a self-made man from the East End, Perkin also had a keen sense of what commercial success might mean for himself and his family. Moreover, he had a stubborn streak, and he seems to have been goaded by Hofmann's lack of faith in his dye. Determined to bring his invention to market, Perkin continued investigating mauve's industrial prospects, with his family's full support. Not only did William's older brother interrupt his

studies in architecture to become his business partner, but his
father invested most of his life savings in the venture.

It was an extraordinary amount of faith to place in the dis-
covery of a teenage boy, but in the end Perkin proved worthy of
it. Putting in eighteen-hour days, he rapidly invented a cheaper
way of synthesizing the mauve dye, new technologies for improv-
ing its consistency, and a new mordanting method to bind it to
cotton—innovations that, in the opinion of some later scientists,
were even more noteworthy than the discovery of mauve itself.
Four hundred pounds of coal were needed to produce a single
ounce of the dye, but one drop could color 200 pounds of cotton,
making mauve cost-effective.

At the end of 1857, Perkin's dye was rolling off the factory
lines in London. By happy chance, mauve was the color of the
moment, worn first by the French trendsetter Empress Eugénie
and then by Queen Victoria. Although the royal silk dresses were
colored with natural dyes rather than with Perkin's mauve, the
synthetic dye soon triumphed for precisely the reasons that
Robert Pullar of Scotland had predicted: Perkin's mauve yielded
a more brilliant and durable color, one that could be applied to
many different fabrics. By September 1859, Perkin's mauve was
everywhere. "Purple-striped gowns cram barouches, jam up cabs,
throng steamers, fill railway stations: all flying countryward like
so many migrating birds of purple Paradise," wrote an English
reporter. Misspelling Perkin's name, he concluded, "The
apotheosis of Perkins's purple seems at hand."

Envying Perkin's wild success, other chemists strove to imi-
tate him. The colors they created—including Lyons blue,
Britannia violet, and iodine green—all found enthusiastic buyers.

Painters, it was true, were slow to adopt the new dyes, for
early synthetic formulas often deteriorated rapidly. On canvas,
geranium pink lakes and violet paint turned pale blue and
lavender-white, betraying artists like Vincent van Gogh and
Paul Gauguin.

Applied to cloth, the new dyes could be equally unreliable, but dyers could afford to be less exacting. In the late nineteenth century, a dress was expected to last only a few seasons or so; unlike a painting, it was not meant to endure for centuries. And in other respects, the benefits for dyers were clear. Synthetic colors were easier to apply, required less time to take effect, and produced more consistent results. They also offered color choices that had never been available before. Most important, many were cheaper than natural dyes—a fact which alone prompted cost-conscious dyers to switch.

Assured of customers for their creations, chemists rushed to bring a rainbow of colors to market, including a variety of reds. Oddly enough, the first synthetic red dye may well have been created by the very man who had most adamantly opposed Perkin's mauve enterprise: his old mentor, August Hofmann. In a reversal that Perkin must have found very satisfying, Hofmann had become greatly interested in artificial dyes after mauve's success, and in 1858 he announced in a scientific journal that he had created a "crimson colouring principle."

Although Hofmann showed no interest in developing his crimson commercially, other red dyes went into production soon afterward. In 1859, French chemists created fuchsine, a crimson dye that some christened solferino or magenta, in celebration of the bloody defeat of the Austrian army by Garibaldi's republican forces in Italy. Like mauve, the new color was worn by Empress Eugénie and became extremely popular; her solferino cashmere petticoat and matching "Garibaldi" blouse were considered quite dashing. Perkin, too, created his own magenta dye, as well as a new color called vermillionette.

Praising the vibrancy of these synthetic reds, Hofmann predicted in 1862 that England would soon be sending "tar-distilled crimson to cochineal-producing Mexico." Events would not turn out quite as he envisioned, but it was nevertheless true that cochineal-producing nations had reason to worry. Having domi-

nated the international trade in top-quality red dyestuffs for nearly three centuries, cochineal was about to undergo a cataclysmic reversal of fortune.

BY THE TIME HOFMANN MADE HIS PREDICTION, THE first signs of a cochineal crisis were evident. Between 1858 and 1862, the price of cochineal in England dropped by almost a third to its lowest level ever. In France, where chemists were even more industrious about getting their new dyes to market, the situation was even worse: in the same period, the price of a kilogram of cochineal nearly halved, dropping from fifteen francs to eight francs. After this sudden fall, prices leveled out for a few years, but with cochineal prices at an all-time low, producers found themselves in desperate straits.

The first producer to go under was Dutch Java. Even before critics of the Cultivation System had made much headway in changing government policy, cochineal was a marginal crop, and the drop in price quickly made it uneconomical to produce. By 1860, Javanese cochineal cost nearly three times more to produce than it was worth on world markets. Faced with these devastating figures and with increasing demands for reform of the system for humanitarian reasons, the government agreed to stop supporting cultivation of the dyestuff in 1865, after which cochineal production on the island effectively ceased.

In Mexico, Guatemala, and the Canary Islands, where the cost of cochineal production was much lower, the dyestuff remained profitable, but the drop in price was a cause of great concern. Conspiracy theorists insisted that the reports of new dyes were a clever hoax by speculators who hoped to manipulate cochineal markets. Others accepted the existence of synthetic dyes but argued that prices were bound to improve since no artificial color could ever equal the brilliant red of cochineal. But

when cochineal prices showed no sign of recovering by the mid-1860s, many producers started to panic. In Guatemala, land prices in cochineal-producing areas dropped considerably; lawsuits mounted; people defaulted on their debts. In Oaxaca and the Canary Islands, too, there were increasing signs of decline and hardship. Yet having invested so many years in producing cochineal, most farmers were reluctant—and, in many cases, unable—to switch to new crops. Increasingly hard-pressed, they could not afford to invest in new ventures. Instead, they coped with the situation in the only way they knew how: they kept producing cochineal, and to make up for the low prices, they produced as much of it as they possibly could.

Even as late as 1870, cochineal production in Oaxaca and Guatemala had hardly slackened at all. Oaxaca was harvesting over 500,000 pounds of cochineal annually, while Guatemala exported nearly 1.5 million pounds of the dyestuff each year. It was on the Canary Islands, however, that cochineal farmers really outdid themselves, increasing production by a staggering factor of six between 1855 and the early 1870s. By the end of the period, the islanders' annual harvests often amounted to as many as 5 or 6 million pounds of cochineal—approximately three times the production of the rest of the world put together.

Overproduction on such a grand scale had repercussions of its own. But it was only in the mid-1870s, when a new generation of synthetic reds reached the market, that cochineal producers were at last driven to the wall.

The first of these new red dyes was synthetic alizarin, an exact chemical replica of the active ingredient in the red dyestuff known as madder. The discovery, made simultaneously by Perkin and by chemists working for the German dye firm BASF in 1869, took a few years to reach the market, but when it did it took Europe by storm. Purer, brighter, and less costly than natural madder, synthetic alizarin was the first artificial red dye that was very light- and water-fast. Not only did it completely destroy

the market for madder, but it made inroads on the cochineal market, too. Though alizarin could not produce as rich a color as the insect dyestuff, it was an acceptable substitute to many people, especially as it was so much cheaper.

After alizarin, a new red dye entered production every year or two. Eosine, roccelline, and other synthetic reds were followed in 1878 by Biebrich scarlet, a German dye that was a near-perfect cochineal match when applied to wool. As new red dyes continued to appear—each one seemingly better, richer, cheaper than the last—the bottom dropped out of the cochineal market.

In Guatemala, cochineal exports plummeted from well over a million pounds in the early 1870s to less than 500,000 pounds by 1877. The downward spiral continued, and by 1884 exports had diminished to less than a thousand pounds a year. By 1890, Guatemalan cultivators had virtually ceased production. At the persuasion—and sometimes coercion—of state officials, many cochineal farmers instead became low-wage workers in the burgeoning coffee industry.

In the Canary Islands, where most farmers had nothing else they could produce for export, the economy went into free fall. Mansions and public buildings stood half-finished, a casualty of the islands' sudden descent into poverty. Lacking any other means of support, some islanders continued to produce cochineal throughout the 1880s, but they were barely able to survive on their earnings. Although a few went on producing cochineal into the twentieth century, most gladly switched to growing bananas when a lucrative export market was developed in the 1890s.

In Oaxaca, it proved harder to turn the economy around. Climate was one reason: nopalries flourished in the region's dry season as few other crops did. Culture was another: cochineal had been part of Oaxacan life for so long that to abandon it seemed almost unimaginable. Out of necessity, some Oaxacans found work on railroads or in mines, or tried to grow other commodities like tobacco and cotton, but others refused to turn their

backs on cochineal. Many farmers cultivated the dyestuff through-
out the 1870s and 1880s, and a handful of Oaxacan communities
were still producing and exporting cochineal in the early 1900s.

What sustained these last remaining cochineal exporters
were a few minor markets in textiles, food, cosmetics, medicine,
and art. Despite the fact that scientists had created many daz-
zling shades of red, they had so far failed to find an exact substi-
tute for cochineal, and these markets, for various reasons, could
accept no compromises.

While most consumers quickly switched to textiles made
with synthetic dyes, a small but faithful crowd continued to insist
on fabrics made with old-fashioned dyestuffs like cochineal. For
some, the preference was a matter of state dictate: in 1903, the
government of Persia, wishing to safeguard the traditional craft
and high quality of Persian carpets, forbade the importation and
use of chemical dyes. Elsewhere, some customers sought out
cochineal on their own accord, often because they were aware
that the dyestuff preserved certain advantages over its competi-
tors. Unlike many of the newfangled colors, cochineal was com-
pletely water-fast and even seems to have been somewhat rain-
resistant: on cochineal-dyed cloth, water beaded up on the
surface, rather than immediately soaking through.

Cochineal also posed no health hazards to its wearers, some-
thing that could not be said of many synthetic dyes. As early as the
1860s, people who wore the new dyes next to their skin had com-
plained of rashes and other afflictions, and in the 1870s and 1880s
accounts of such suffering multiplied. Bright reds like fuchsine
were identified as particularly dangerous, and researchers searched
for reasons why they might cause toxic reactions. Most investiga-
tors focused on arsenic acid, which was used in the production of
fuchsine and other synthetic dyes, and which left traces of arsenic
on many finished textiles. A thorough washing usually made these
fabrics safe to wear, but many people omitted this step, since it

tended to fade the new dyes for which they had paid so dearly. Instead, they wore their new garments straight from the shop, and whenever the cloth became damp through rain or perspiration the arsenic leached into their skin.

Whether this leaching was likely to have permanent ill effects was hotly debated in newspapers and medical journals. Most dyers insisted that the amount of arsenic was minuscule and that the colors were essentially harmless. To prove the point, a London chemist fed his rabbits for weeks on oats dyed magenta and other strong colors; no ill effects were reported. Despite this experiment, many other investigators remained convinced that the dyes were hazardous. For proof, they pointed to the fact that two dye factories in France and Switzerland had contaminated the local wells with arsenic; after several poisonings, both had been forced to shut down. With the issue unsettled, cautious people either washed their garments thoroughly or returned to using natural dyestuffs like cochineal.

Poison fears also sustained three other minor cochineal markets. Worried about toxins like arsenic, many people objected to consuming synthetic dyes in medicine, makeup, and food. Cheap and cheerful, the synthetic dyes found their way into these products anyway, but high-quality manufacturers catered to anxious consumers and used cochineal instead. Billed as a slightly more expensive but completely harmless alternative to the nasty synthetic reds, cochineal was commonly found in grocery stores, home kitchens, and children's food. Although few people still believed that cochineal had medicinal properties, it also remained a standard dye in pharmacies for many decades. In 1906, cochineal appeared in Edith Nesbit's *The Railway Children*, the source of the pink in Perks's birthday icing: "You know how it's done, of course? You beat up whites of eggs and mix powdered sugar with them, and put in a few drops of cochineal." As late as 1930, Noël Coward gave it a bit part in *Private Lives*: Elyot

Chase, hearing that his wife, Sibyl, has lost her lipstick, advises her to "send down to the kitchen for some cochineal."

By the time *Private Lives* hit the West End, however, synthetic dyes had long since cleaned up their act. Water-fast and reliable, they no longer contained arsenic, and experts considered them a harmless and affordable substitute for natural dyes. With their fears of poison put to rest, most consumers were no longer willing to pay extra for cochineal-dyed cloth. By 1900, commercial demand for cochineal was so low that almost all textile manufacturers stopped using it. By then, even the famous red coats of the British army were largely produced with synthetic dyes.

Over the next few decades, many high-class food and cosmetic manufacturers, reassured that synthetic dyes were safe, also stopped using cochineal. Even artists deserted the fold: a few continued to paint with cochineal-based pigments, but most took up synthetic colors instead, which were inexpensive, easy to obtain, and less prone to fading than cochineal itself. Among the few remaining customers were physicians and scientists, who bought small amounts of the dyestuff for use as a biological stain and other medical purposes. These were very small markets, however, incapable of supporting more than a smattering of cochineal farmers around the world.

Having once pushed other red dyes to the fringe of the market, cochineal now found itself pushed to the margin, too. An irrelevance in a modern world, it was a commodity fast approaching its vanishing point. Yet cochineal was a renaissance dye in more ways than one, and its final act was not yet over.

EIGHTEEN

Renaissance Dye

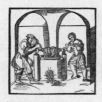With the advent of synthetic dyes, the entire process of creating color had changed. To obtain rich hues, a nation no longer needed to steal a rare insect or tree, nor seek possession of a tropical empire. Scientific ingenuity and a supply of coal or petroleum were the key variables now. With these, brilliant colors could be synthesized in a factory anywhere in the world.

As the terms of the international struggle to control color altered, so, too, did the winners. For centuries, imperial nations like Spain and Britain had dominated the lucrative dye trade, lording it over countries like Germany, a poor and fractured conglomeration of principalities that had never done well in the colonial sweepstakes. Yet in the brave new world of industrial chemistry, Germany had great potential. Rich in coal, it had a reputation for scientific excellence, and it also had leaders willing to invest money and resources in dominating the new field.

The results of the German program of industrial develop-

ment were nothing short of spectacular. In the early 1860s, Germany produced very little synthetic dye, but less than twenty years later its chemists were outdistancing all other European competitors. By 1881, Germany was producing almost half the world's supply of synthetic dye, and its market share was rising. Soon German dominance in the dye industry was almost unassailable, owing in part to the workings of patent law.

Patents had been granted to inventors since Renaissance times, but for centuries weak enforcement had been the rule. Not until the late 1700s and early 1800s did many Western countries finally enact new patent statutes, which—along with general improvements in communication and transport—made it easier to find and prosecute patent violators. By the mid-nineteenth century, patent law had become vital to many industries, including the dye business.

Patent law demanded a certain level of openness from dyers: to qualify for protection, they had to set down enough detail about their secret techniques to convince government officials that they had indeed invented something new and worthwhile. To many dyers, this openness must have seemed counterintuitive. Secrecy, after all, had long been a hallmark of the dyer's art, to the point that medieval dyers' guilds had sought to punish indiscretion with expulsion or even death. But the openness demanded by patent law had its advantages. By confiding their secrets to the patent office, nineteenth-century dyers and dye companies received certain protections that even the most draconian guild statutes had been unable to secure. A patent allowed a dye company to seek legal redress against anyone in the country—including turncoat employees and industrial spies—who tried to copy their registered dye formulas and dyeing techniques. The age of the lawsuit had arrived.

German dye companies were acutely aware of the benefits that patents conferred. Germany's patent laws were the best in the world, striking an excellent balance between encouraging

new inventions and protecting the rights of previous inventors. The German patent process also had a protectionist slant, favoring German patent seekers over foreigners. British and American laws, by contrast, allowed foreigners to take out patents without ever exercising them—a situation that worked to the advantage of many German companies, which filed hundreds of dye patents in Britain and the United States and then refused to work them. Hemmed in by these patents, the British and American dye industries withered away, and British and American textile manufacturers became dependent on German dye imports.

Clever application of patent law, combined with scientific ingenuity and wise use of resources, put Germany far in the lead in the chemical race. By 1900, Germany was producing four-fifths of the world's synthetic dyes. No other rival could touch it. Switzerland accounted for only about a tenth of world production, with the remaining tenth made up by countries like Britain, France, and the United States, which lagged far behind in the chemical race. Moreover, Germany was at the forefront of the most promising developments in dye research—research that was already leading to the creation of whole new classes of products, including coal-tar perfumes, coal-tar pharmaceuticals, and the first coal-tar plastics.

Even William Perkin, the boy genius of the dye industry, was unable to keep up with German developments. Frustrated by the demands of business and by the English patent system, which did not adequately protect his discoveries, Perkin sold the family dyeworks in 1873. Soon afterward, at the remarkably young age of thirty-six, he retired to a wealthy country house. He was not a millionaire, but the fortune he had made through his dyeworks— about £100,000—meant that he no longer needed to work for a living. Although Perkin fitted up a home laboratory and published academic papers, he was no longer at the forefront of the commercial side of the discipline. Nor did this seem to bother him. A strong supporter of temperance and vegetarianism, he

devoted most of his time to his family, his church, and various good works. The brilliant chemist was also a dedicated trombone player and an amateur magician. By his nephew's account, he was "in his element entertaining children at school treats."

Yet if Perkin thoroughly enjoyed his retirement from business, it nevertheless worried him that Britain was losing ground to Germany in the industry he himself had created. Even before he sold his dyeworks, he had seen signs of the shift in power. His old mentor, August Hofmann, had abandoned the Royal College of Chemistry in the 1860s for the chair of chemistry at the University of Berlin. And Hofmann was not alone. Over the next decade other German chemists working in England also began to return home, bringing their expertise with them. By the end of the century, German research institutions were so advanced that two of Perkin's own sons, bent on following him into the field, temporarily left England for Germany to pursue advanced training in chemistry.

That Germany so completely dominated the chemical industry was a matter of some chagrin to many nations, especially Britain, where many sorely regretted the loss of their early lead in the field. But in 1906, when scientists celebrated the fiftieth anniversary of Perkin's discovery at a gala dinner in London, a German chemist named Carl Duisberg assured the guests that they had no reason to worry. As the head of Bayer, Germany's largest chemical company, Duisberg could say with certainty that the chemical industry was safe in German hands. "England has a highly-developed coal and iron industry; her textile industry, both spinning and weaving, is second to none. She has more colonial possessions subservient to her than any other country in the world, and only in the coal-tar color industry . . . must she be satisfied with second-place," Duisberg said. "Why should Germany in this one instance not take a leading position?"

Why not, indeed? The answer soon became apparent with the outbreak of World War I. By then the German grasp on the chem-

ical industry was so complete that the Allied nations were almost wholly dependent on Germany for dyes. When the war began, their textile industries were thrown into crisis. Homegrown dyes were in short supply, and many proved streaky and unreliable—which did nothing for Allied morale. But worse was to come, for dominance in the dye trade also allowed Germany to make rapid progress in manufacturing poison gas.

In 1914, the German army began top-secret research into tear gas, employing the talents of leading academics and dye chemists, including Bayer's Carl Duisberg. When experiments convinced the research group that tear gas was not sufficiently powerful to accomplish war aims, a young professor named Fritz Haber persuaded them to turn to chlorine, a much more danger-ous chemical that was used extensively in the German dye indus-try. In April 1915, after much research by Haber and his associ-ates, the German army released a cloud of yellow-green chlorine gas over Allied lines at Ypres. Lungs burning, Franco-Algerian and Canadian soldiers bore the brunt of the attack. They choked and suffocated in the trenches, the first victims of the horrors of modern-day chemical warfare.

After Ypres, the Allied armies made every effort to catch up with the Germans, and soon they, too, were producing and deploy-ing poison gas on the battlefields of Europe. But Germany's prewar dominance in the dye industry gave it a head start in the production of the toxic compounds. Dye companies like Bayer, Hoechst, and Badische became the kaiser's war machines, churning out poison gas by the ton. They also produced another kind of war matériel closely related to chemicals used in the dye industry: explosives.

Yet despite the best effort of the dye companies, Germany's lead in industrial chemistry was shrinking fast as the war entered its end stages. By then many Allied nations—notably the United States, Britain, France, Japan, Russia, and Italy—had created top-secret chemical warfare units, built labs and factories, and boosted chemical output exponentially. By the time peace was

declared, there was no turning back. The labs and factories were there to stay. Germany, though still a major producer of dyes and other industrial chemicals, now faced stiff competition—especially since the Allies claimed half the remaining German dye stocks and certain rights to prewar German dye patents as reparations in the Treaty of Versailles.

Allied dye manufacturers soon discovered, however, that the patent clauses in the Treaty of Versailles were not quite the giveaway they seemed. Even in the twentieth century, dyeing and secrecy went hand in hand. The openness demanded by patent law was not absolute, and German dyers—like their colleagues elsewhere—had shied away from explaining all the mysteries of their profession to the patent office. Consequently, German dye patents did not always reveal the details a manufacturer needed to know to make a profit. After the war was over, Allied factories sometimes paid licensing and consulting fees to German companies to get the full benefit of their expertise.

Increasingly, however, Allied businessmen relied on the breakthroughs made by their own homegrown research chemists, many of whom had entered the profession to make war matériel, only to turn to the manufacture of dyes after 1918. This time, the Allied businesses were careful to take advantage of patent law, which in some nations was altered to give home industries greater advantages, as German patent law had long done.

Even with the existence of patent law, dyers still worried about industrial espionage, and bitter rivalry remained the rule in the modern color trade. Indeed, the rivalries only intensified as more and more companies went into the dye business in the 1920s. As countless wartime factories turned to the peaceful production of color, synthetic dyes flooded European and North American markets. Intent on keeping prices high during a time of record production, dye companies looked for new customers, not only in the West but in other parts of the world.

Since at least the 1890s, boxes of synthetic dye had appeared

alongside sacks of cochineal and indigo in Middle Eastern souks and Asian bazaars. But unlike Western consumers, people in Asia, Africa, and Latin America still relied heavily on natural dyes in the 1920s. This was partly a matter of supply: the bulk of synthetic dyes were sold in the West, leaving only a limited amount for the rest of the world. Cost was a factor, too: outside the West, additional transport charges made the new dyes less competitive with natural dyes that grew locally. Finally, tradition also played a role: especially in more rural and remote areas, people preferred to do things the old way.

To Western dye companies, these regions seemed ripe for development. Eager for sales and anxious to avoid direct competition, they quickly carved up the world into a series of cartels. French companies, for example, were given the upper hand in Latin America, while German companies had special privileges in the Far East. With these matters profitably settled, the companies started to flood their new markets with a vast wave of synthetic dyes.

Slowly at first, but with increasing speed, these dyes permeated far into the interior of Asia, Africa, and Latin America, at a price that allowed even very poor communities to buy them. Within a few decades the synthetics had swept away all but the last vestiges of the age-old trade in cochineal and other natural dyestuffs. Even in the remote villages of mountainous Oaxaca, the traditional dyer's art was in danger of disappearing forever, swamped by the rising tide of synthetic color.

WELL BEFORE WORLD WAR I, THE COCHINEAL FARMER had become something of an endangered species in Oaxaca. In 1909, a Frenchman named Léon Diguet wrote that he had encountered great difficulty locating active cochineal farmers in the region. "The nopalries have little by little disappeared," he reported, and it was only near the town of Ocotlán, some twenty miles south of

Oaxaca, that he finally managed to find "some miserable nopal plantations that the natives continue to maintain."

In some ways, Diguet was overly pessimistic. Other villages, more remote than the ones he saw, were also producing cochineal in the early 1900s, and another source indicates that small amounts of Oaxacan cochineal were still being exported abroad as late as 1932. But in essence, Diguet was right: the industry was in grave decline. Although a limited market for cochineal still existed, Oaxacans were finding it impossible to compete with producers in other places, particularly the Canaries. Ironically, it was their long experience with the domesticated insect that was proving their downfall. As the homeland of *Dactylopius coccus*, Mexico was also the homeland of a great many cochineal predators—predators that simply did not exist in the Canaries and elsewhere. For Oaxacans, then, raising cochineal was a harder, costlier, and riskier way of making money than it was for other top producers, putting Oaxacans at a disadvantage in the export market.

Over time, even the local market for Oaxacan cochineal dwindled. By the 1880s and 1890s, and possibly even earlier, some Oaxacan dyers and weavers were turning to fuchsine, magenta, and other synthetic dyes for their reds, and the use of synthetics increased as the new dyes flooded into Mexico after World War I. The attraction for Oaxacans appears to have been financial: they had a living to make, and using the new dyes and predyed thread was cheaper and easier than following the old methods. But the conversion, too, had a price, for eventually most Oaxacans lost the skill of dyeing the traditional way.

As late as 1947, an American tourist guide to Mexico noted that even though cochineal had been "supplanted largely by aniline dyes," it was still possible to find a few Oaxacans producing red wool serapes colored with cochineal. But cochineal was fast disappearing. Not long after the tourist guide was published, a Mexican scientific expedition searched for samples of *Dactylopius coccus*, only to be told in village after village that cochineal cultivation had long

since been abandoned. At last the insect was located in a wild cactus patch near tiny San Agustín Amatengo, with the help of Lauro Ramírez, a Zapotec farmer who two years before had been the last in his village to give up raising the dyestuff.

Hoping to save Oaxaca's cochineal industry from obliteration, the Mexican expedition did what Mexico's rivals had once done in Haiti, Madras, and Java: they established a stock of cochineal in a scientific garden, where they could nurse it back from the brink of extinction before reintroducing it to general cultivation. At first, production was very low, and only a few live cochineal offspring were shared with trusted growers. Small samples of the processed dyestuff were also sent to expert Mexican craftspeople, to help keep the art of natural dyeing alive.

By the late 1960s, however, Mexico had hopes of a much greater cochineal revival. Demand for the dyestuff was growing in North America and Europe, as a consequence of the wider vogue for natural foods. Even a New York City outbreak of salmonella that was eventually traced to contaminated cochineal from Peru did not dampen enthusiasm for the dyestuff, in part because synthetic dyes were increasingly being linked with a more dreaded disease: cancer. Scientists believed that the people most severely affected were dye workers, but some studies suggested that consumers might face cancer risks, too, especially from red dyes.

In the early 1970s, public fears reached fever pitch when Russian research indicated that one of these dyes—known as amaranth or Red No. 2 in the United States, and as E123 in Europe—was a carcinogen. Citing evidence that the dye caused malignant tumors in rats, the United States Food and Drug Administration banned its use in foods, pharmaceuticals, and cosmetics in 1976. Critics chided the government for acting too hastily, but uneasiness about synthetic red dyes continued to rise over the next decade, with some researchers and advocacy groups linking them not only to cancer but to asthma, attention deficit disorder, hyperactivity, and a host of other ailments.

With the safety of synthetic red dyes in question, manufacturers sought other, more natural alternatives. Cochineal emerged as a new favorite—a coloring agent that had no known safety issues, blended well with other ingredients, and had a long shelf life. Used alone or mixed with other natural dyes, it could impart a variety of reds, purples, pinks, and oranges to food and cosmetics. By 1990, the cochineal renaissance was in full flower, and world production had reached 1 million pounds.

Since then the figure has soared even higher, with most exports going to the United States, Europe, and Japan, where factories extract carminic acid from the dried insects. Although it is now possible to synthesize carminic acid in the laboratory, the process is too complex to be cost-effective. Cochineal insects are the most economical manufacturers, and they remain the only commercially viable source of the dye.

Sold free of bug parts, in liquid or powdered form, cochineal appears on European labels as additive E120, and elsewhere as cochineal extract, carmine, carminic acid, or simply as "coloring added." It can be found in products as diverse as candy, Popsicles, sausages, yogurt, fruit juice, ice cream, apple sauce, pudding, cheese, cough syrup, rouge, lipstick, eyeshadow, and Campari.

SINCE THE MODERN-DAY COCHINEAL BOOM BEGAN, Mexico has seen a mild resurgence in cochineal production, but so far those hoping for a full-scale revival of the industry there have been disappointed. Competition for markets remains fierce, as farmers in other parts of the world, sensing opportunity, have also raced to satisfy demand for the dyestuff. Today the Canary Islands, Bolivia, Chile, South Africa, and several other countries are all cochineal exporters. The chief beneficiary of the cochineal boom, however, is Peru.

Peruvians have collected wild cochineal since ancient times,

but they began to seriously cultivate the domesticated insect only in the mid-nineteenth century. As late as 1870, overall production was still negligible, and it would not have been surprising if the industry had disappeared altogether in the great cochineal slump of the following decade. Peru, however, emerged a survivor. The country's extraordinarily low wages, combined with its suitable environment and lack of cochineal predators, allowed Peruvians to dominate what little remained of the international cochineal market through the middle decades of the twentieth century. When demand surged in the 1970s, they were well poised to respond.

For some years now, Peru has produced a whopping 80 percent or more of the world's cochineal. Recently annual exports reached nearly 2 million pounds, and the industry is still expanding. Earnings from the dyestuff are believed to support as many as 40,000 rural families, who collect the insects in the Peruvian mountains.

Even in Peru, however, the cochineal business is not without its problems, chief among them the continuing volatility of world cochineal markets. Over the past thirty years, cochineal prices have seesawed wildly, swinging from twelve to over eighty U.S. dollars per kilogram in the 1990s alone. Since then, however, cochineal prices have declined.

In an echo of earlier times, the chief problem of the cochineal industry in the early twenty-first century appears to be one of oversupply, with too many people getting into the cochineal business too quickly. Since the processing end of the business has fewer competitors and more profit—the extracted dye is worth considerably more than the insects themselves—some cochineal-producing countries, including Peru, are now expanding these operations. Many manufacturers in North America and Europe now buy powdered or liquid dye directly from these countries.

There is, however, a growing movement against cochineal in the West, particularly in the United States, where physicians

have discovered that cochineal dyes can cause life-threatening allergic reactions in a few susceptible individuals. As a matter of principle, vegans, vegetarians, and animal-rights groups have also campaigned against the use of the insects, with some advocating the use of beets and red cabbage for coloring instead. Kosher manufacturers, too, have concerns about using the dyestuff. Cochineal prices recently hit the single digits, and it is not clear when they will recover.

This is terrible news for Peru, but the reaction has been muted in Mexico, the ancient cochineal heartland. Despite the best efforts of men like Ignacio del Río Dueñas, a retired engineer who has devoted himself, with infectious enthusiasm, to reviving cultivation of the insect in Oaxaca, modern-day Mexican cochineal exports pale beside those of previous centuries. Although Oaxaca is at the forefront in national production of the dye, the cochineal industry has yet to become a major force in the regional economy.

The local availability of cochineal has, however, helped to breathe new life into Oaxaca's age-old textile arts, allowing them to pass to a new generation. In the 1960s, when the craft of natural dyeing had almost vanished from Oaxaca, a few artisans like Isaac Vásquez, a Zapotec weaver from the small town of Teotitlán del Valle, sought to revive the old techniques. Coloring wool with cochineal, Tehuantepec indigo, and dyes derived from lichens, the acacia tree, and other natural sources, Vásquez became famous for his textiles, which have been sold to buyers around the world. Today Isaac Vásquez still dyes with cochineal in his family workshop.

Some other families in Teotitlán now work with natural dyes, too, among them Fidel Cruz and his wife, María Luisa Mendoza, who live with their small children on the outskirts of town. Cruz, who has won national awards for his textile work, learned how to weave when he was very young, but it was only later, as a newly married man, that he became interested in natu-

ral dyestuffs like cochineal. Lacking teachers, he and his wife were forced to rely on books and family memories to guide them. At first, they say, there were many failures, but gradually they began to unravel the secrets of color.

These days their cochineal comes from several Mexican suppliers, including the del Río Dueñas nopalry in Santa María Coyotepec. Mendoza grinds it to fine powder with her stone mortar, or *metate*, and Cruz throws it into a simmering dyebath heated with a gas-powered flame. To fix, darken, and intensify the deep red, he stirs in alum, acacia fruits, and freshly squeezed limes and their juice. The wool soaks in the steaming dyepot for hours. Every so often, Cruz draws the fibers out, then dunks them back in again, patiently waiting for the color he wants. Like the master dyers of the Renaissance, he relies on instinct and judgment to obtain the shade he desires. Behind him, on a rope that stretches across the hard-packed open courtyard, scarlet skeins of wet wool, dyed earlier, hang dripping. The blazing line splits the dusty horizon, cutting the jagged edge of the Oaxacan mountains in two.

The Cruz family's cochineal-dyed yarns have a depth and richness that modern dyes can rarely match, but for many Oaxacans this richness remains out of reach. Depending on the markets, Mexican cochineal can cost over forty times more than the equivalent amount of synthetic red dye. Cochineal also takes much more time to prepare. Since few textile buyers—importers, tourists, or local merchants—are willing to pay a premium for natural color, most artisans in Oaxaca rely on synthetic dyes to make a living.

Yet the Cruz family and Isaac Vásquez are not alone. A number of Oaxaca's best dyers and weavers have also returned to using locally produced cochineal and other natural colors, despite the great expense. In their intricate woolen rugs and tapestries, the strands of cochineal glow with red fire, a sign of a dying art preserved, and a talisman of glory days gone by.

EPILOGUE
Cheap Color

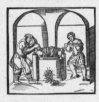 PERKIN'S DISCOVERY OF MAUVE WAS A gateway to modernity, the opening salvo in a chemical revolution that brought us not only dyes but textiles, fertilizers, weapons, and plastics. It changed what we wear, what we eat, how we fight, how we live. It also profoundly altered the way that humans perceive color—a transformation so subtle, yet so all-encompassing, that we have almost completely forgotten that bright color was for centuries a key symbol of majesty and privilege.

This old sense of color was still alive, if somewhat weakened, when factory dyes first painted the world in rainbow hues, and it helped ensure a warm welcome for the new synthetic dyes. Women, especially, were eager customers. Setting aside the ideals of subtlety and restraint that many fashion manuals had advocated in the 1840s and early 1850s, ladies of standing vied to be the most brilliant figure in the room. Throughout the 1860s, parlors and ballrooms glowed with crinolines in emerald green, bright blue, and magenta. In both England and France, the fever

for color burned so brightly that there was even a revival of the fifteenth-century fashion for parti-colored clothes. Sleeves, bodice, and skirt were made with three or four different materials, all the better to display the new dyes.

In a further throwback to Renaissance times, some Parisians even colored their hair with the new dyes; the preferred shade (à la Empress Eugénie) was strawberry blond. Significantly, the English word *colorless*, which had until then only been a synonym for *pale*, took on a new and less flattering meaning during this period: it became a derogatory adjective describing a person or object "without distinctive character, vividness, or picturesqueness."

If the brilliancy of the new fashions had many enthusiasts, it also had its detractors. "To be fancifully dressed, in gaudy colors, is to be very badly dressed," pronounced an American *Hand-book of Etiquette* in 1866; among "people of substantial good breeding," it counseled, more subdued colors prevailed. More emphatic and detailed criticism of the new craze for color came from the French philosopher Hippolyte Taine. On a Sunday stroll in London's Hyde Park in the 1860s, he was startled to see women wearing "ferocious violet, . . . poppy-red silks, grass-green dresses decorated with flowers," and "azure blue scarves"—women who topped off their ensembles with gold laces and "bright purple gloves." That the women in question were respectable, middle-class ladies shocked him all the more. To Taine, such clothing was clearly "that of a woman of easy virtue, or a *parvenue*."

Ignoring Taine and other critics, most fashionable American and European women flamed on through the mid-1870s. The fact that the new colors were expensive gave them confidence, for they knew that only the well-to-do could afford to wear them.

With surprising speed, however, the price of the new dyes fell within reach of consumers for whom bright color had long been an unattainable luxury. By the late 1870s, people on the bottom rungs of the economic ladder were reveling in long-forbidden hues, wear-

ing them whenever and wherever they could. Red, in particular, proved a favorite: "The cheaper magenta and scarlet fabrics are much sought after by the poorer labouring classes for underclothing, stockings and trimmings," noted the *British Medical Journal*. Even though the dyes sometimes ran or left poisons on their skin, the working classes still wanted them. They clamored for more color, and especially more red—the brighter, the better.

If the working poor had a thirst for scarlet, so too did other people who had previously been barred, either by dictate or by cost, from wearing such brilliant colors. This was true not only in Europe and America but in regions far beyond them, such as early-twentieth-century Turkistan, where government soldiers longed to replace their standard-issue blue trousers with brilliant red uniforms, which they associated with military glory. A young pretender to the throne, learning of their desire, raided state storerooms for red cloth and fashioned it into snazzy red trousers. When he distributed the trousers to the troops, he won their loyalty then and there.

In North America, some of the most enthusiastic customers for the new colors were immigrants from southern and eastern Europe, who had started to arrive in the United States in huge numbers just as synthetic dyes became widely available. Many eagerly bought brightly dyed dresses and other clothing, often because it had been associated with high status in their homelands. This affinity, especially on the part of Jewish immigrants, did not escape notice from journalists, who sometimes criticized and sometimes rhapsodized about what, according to them, was a "racial love" for color.

In both Europe and North America, vivid colors also became associated with people of African and Asian descent, and with indigenous peoples on many continents. It is possible that linguistics may in part account for this: in English, for example, the adjective *colored* had been a racial term for nonwhite people from the early 1600s, and the terms *Red Indian* and *yellow race* date

back at least to the early 1800s. But despite the existence of these terms, it seems that Europeans associated bright colors—especially in clothing—far more with wealthy whites than with any other group until the mid-nineteenth century. Only then, as cochineal and other bright dyes became ever cheaper, did vivid clothing, especially in red, acquire other racial connotations.

One of the earliest works to specifically link bright clothing and race was Prosper Mérimée's 1845 novella *Carmen*, which later became the basis for Georges Bizet's opera. Carmen's very name is nearly synonymous with the French word for ·the color that cochineal produces (*carmine*), and from the start it is clear that she is a Gypsy—which to most Europeans of the time meant that she belonged to a separate, darker, and lesser race. ("Their complexion is very swarthy," Mérimée explained in an afterword to the book. "Hence the name of *calé* (blacks) which they so often call themselves. . . . One can only compare their expression to that of a wild animal.") Wild, clever, and passionate, Carmen wears red—in scandalous fashion. When she first appears before the hero, Don José, in Seville, she is dressed in "a red skirt, very short, which displayed her white silk stockings, with more than one hole in them, and tiny shoes of red morocco, fastened with flame-coloured ribbon." Her mode of dress shocks Don José: "In my country, a woman in such a costume would have made every one cross himself." The short red skirt also made a tremendous impression on Mérimée's readers, including Bizet, who insisted that the Carmen in his opera be clothed exactly as Mérimée had described.

In 1857, a French handbook connected red and race in even more explicit fashion, stating that "women with jet-black hair and very dark skin should not wear red clothing, because this color darkens their complexions even more and makes them look like mulatresses." In succeeding decades, as factories churned out ever increasing amounts of synthetic dye, the racialization of bright colors only gathered pace. By the 1880s, "loud" colors were deprecated as "Oriental" in Britain, and said to be unfit "for a human being,

except a Margate nigger." Similar attitudes endured on both sides of the Atlantic well into the twentieth century.

For many European and American commentators, the connection between bright color and race was strengthened by the fact that many people of color found the new dyes especially attractive. This passion for color did not surprise the African American scholar W. E. B. DuBois. "All through the life of colored people and of their children the world makes repeated efforts to surround them with ugliness," he wrote in 1924. "Is it a wonder that they flame in their clothing? That they desire to fill their starved souls with overuse of silk and color?" It was true, he admitted, that they "may fail in their object or overdo it . . . but I do say that New England old maids dressed like formless frumps in dun and drab garments, have no right utterly to suppress and insult these children of the sun."

Yet although DuBois sympathized with the thirst for color, he understood very well that by his day bright clothing had become a social liability. And no doubt he was also aware, despite his rhetoric, that the prejudice against color was not held merely by a few "New England old maids." On the contrary, the revolt against color was a widespread and enduring phenomenon, a process led by the elite classes of Europe and North America— who had turned against color in the late 1870s precisely because it had come within reach of African Americans like DuBois and others outside the privileged classes.

Before the invention of synthetic dyes, there had been periods when the wheel of fashion had not favored bright color. Yet even when color was temporarily eclipsed, it had remained for most people an unquestioned symbol of wealth and power—and sooner or later the elite, tiring of subtlety and simplicity, had always returned to it. But the invention of factory dyes fundamentally altered the equation. They made color *cheap*, in every sense of the word. To many people in the upper classes, color became hopelessly vulgar. Its very ubiquity made it déclassé.

To ensure that they were not confused with the common herd, after 1880 the upper classes wore bright color sparingly, if at all. They even toned down the livery worn by their coachmen, grooms, and footmen. As a British tailor explained in 1894, these uniforms were traditionally very "showy," often involving scarlet and yellow cloth, fancy lace, and bold piping, a fashion that endured into the mid-1800s. By the end of the century, however, the "mark of gentility" was "to have livery dark in color, unobtrusive in style, quietly made."

Although bright dyes continued to be used for upper-class sportswear, and also remained de rigueur in military uniforms, hunt jackets, and other forms of archaic costume, they became relatively rare in formal clothing. Later, when vivid color did appear—as, for example, in Paul Poiret's striking art nouveau dresses and Elsa Schiaparelli's shocking pink—it still attracted notice, but that notice was not necessarily flattering. No longer automatically associated with privilege or wealth, bright color was increasingly seen as risky, suspect, even downright crass.

By 1900, the prejudice against color had permeated all levels of society. People who wanted to appear respectable avoided bright color, whether they were rich or poor, black or white, native or foreign-born. Established American immigrants, having absorbed the idea that colorful dress was not only immodest but the mark of a greenhorn, toned down their plumage and exhorted their fellow immigrants to dress "more like violets and less like sunflowers." Teachers at Indian boarding schools in the United States insisted that Native American children dress in subdued shades of gray, black, chambray blue, and white. Likewise, educational institutions such as the Hampton Institute and Fisk University cautioned African American students against dressing "showily," telling them to "err on the side of too little color rather than too much."

Published in 1928, Nella Larsen's novel *Quicksand* demonstrated that these color taboos continued to apply well into the

twentieth century. Helga Crane, Larsen's African American protagonist, is a teacher who is considered strange, even indecent, for wearing "royal blues, rich greens, deep reds" at her black school; the other faculty and administrators, believing that "bright colors are vulgar," expect her to wear black, brown, and navy blue instead. Unlike earlier rules about African American costume, which were often enforced from without, these dull dress codes—which existed in fact as well as in fiction—were policed from within, by African Americans who were afraid that flamboyance on the part of one person might reflect badly on the morals of all. To earn the respect of others, advised the black fashion writer E. Azalia Hackley in 1916, one needed to exercise "self-control" in the matter of color and style.

In the new era of restraint, the color red, in particular, demanded self-discipline from those who wore it, whatever their ethnicity might be. No other color was quite so treacherous; no other color required so much discretion. Worn in the right shade, at the right time, in the right amount, and by the right people, red could attract favorable comment. But to wear an overly bright red was to court accusations of vulgarity, especially if the material was shoddy or the garment's cut was revealing. For men, this meant being classed as a bounder; for women, it meant being branded as impure, or worse. Class and ethnicity often determined the seriousness of the offense: on an upper-class white woman, a scarlet dress might be judged merely "startling," but if a woman of lesser station wore the same costume, she might well be taken for a streetwalker.

In fiction, the red dress became a fixture, a sure sign that a woman was an adulteress, an adventuress, or a prostitute, or headed in some way for a sexual fall. Although the idea that dangerous women wear red dates back a long way, the trope had an especially strong hold on writers and artists of the late nineteenth and early twentieth centuries. From classics like Edith Wharton's

The Age of Innocence, to popular fiction like *The Diary of a Nobody* and *Dinner at Antoine's*, to the lurid dames on pulp magazine covers in the 1930s and 1940s, the woman in red seemed destined to stir up trouble.

In plays and movies, the red dress became the emblem of the pinup girl and the wanton woman, worn by the likes of Betty Grable, Marilyn Monroe, and Brigitte Bardot. Countless Hollywood films, from *Coney Island* to *Dial M for Murder*, employed the red dress as a symbol of illicit passion, a visual shorthand that hinted at scandal. Among the most famous of these films was *Gone with the Wind*, where Rhett Butler forces Scarlett O'Hara to wear a red dress that marks her out as a hellion and a home wrecker, a woman with a reputation as scarlet as her name. In William Wyler's *Jezebel*, a 1938 Bette Davis vehicle, the entire plot turns on a New Orleans belle's decision to wear a shocking red gown to a society ball. In *A Streetcar Named Desire*, Blanche DuBois's red satin robe lights up the stage, a signal of present instability and a promiscuous past.

Bold and bad, the fictional woman in red often ended up shunned, abandoned, or dead. To avoid her tragic fate, real-life women—especially those whose social standing was less than impeccable—were best advised to leave red alone.

IF RED AND OTHER BRIGHT COLORS WERE DANGEROUS, what did people wear instead?

To be safe, most stuck to subdued hues. Gray, white, and pastels became extremely fashionable in the late nineteenth century, beige in the early twentieth. All continued to be safe bets for years. Even in the psychedelic 1960s—as eye-popping fabrics staged their biggest revival since the early 1870s, and a century of color strictures, both fashionable and political, began to break

down—these muted hues held their own. In our own time, they remain favorites among the upper classes and those who aspire to be like them.

Of all the colors that prospered once red fell into decline, however, blue and black are the clearest winners.

A negligible and unpopular color in the ancient world, blue made rapid strides in the late Middle Ages, when advances in technology and trade led to dramatic improvements in blue stained glass, blue enamels, blue paints, and blue dyes. These new blues caught the elite's eye, and by the 1400s bright blue—the shade of lapis lazuli—was seen as a noble color. Pale blue, meanwhile, remained a color associated with artisans, servants, and laborers.

After the French Revolution, blue soared in popularity. Identified with republicanism, romanticism, melancholy, loyalty, and respectability, the more subdued shades of blue—sky blue, gray blues, and navy—appealed to people in all walks of life. Because they did not attract undue attention, and therefore suited the dictates of Victorian propriety, their popularity increased as the century wore on.

By the early 1900s, the West's preference for blue, in both the abstract and the concrete realms, was an established fact. Opinion polls and scientific studies consistently found that it was the favorite color of European and North American adults. By the middle of the twentieth century, if not before, blue had also become the favorite color in many non-Western nations as well. The color was undeniably popular in clothing, too, as the rise of blue jeans—featured as chic fashion in *Vogue* as early as the 1930s and later worn worldwide—clearly demonstrated.

Even today our love affair with blue continues. Unlike red, it can never be accused of being pushy, and for many people that is part of its appeal. Cool, restrained, and peaceful, blue is not a color that overpowers. Nor does it shock; studies show that even those who do not favor the color are rarely offended by it. It is as close to being neutral as a color can be.

Even in the nineteenth century, however, there were those who found such neutrality boring. For them, black became the preferred antidote. The garb of clerics, sober Protestants, and solid businessmen for centuries, black, like blue, was perceived as a moral color in the West. Unlike blue, however, black had a dramatic and contradictory edge to it, for it was the color of death and frequently of magic, sin, and the devil as well. Even in the era of nineteenth-century scientific rationalism, black retained a whiff of the sinister and diabolical.

Since the days of Philip the Good and Charles V, black had been a force in fashion in Europe. It was only in the nineteenth century, however, that the black suit became a virtual uniform for Western men.

Not everyone approved of the way black stole the show: "The poverty of this costume next to the brilliance, richness, and simplicity of women's dress, becomes more and more shocking," complained *La Génie de la mode,* a French tailors' magazine, in 1862. But shocking or not, men continued to buy black suits, for no other garment so well suited the demands of the era, when both capitalist enterprise and bourgeois mores set a premium on male sobriety and dignity. By dressing in black, men conveyed an essential seriousness that was simply not available to flighty chasers of fashion. The black suit had a certain sexual charge as well, for it exaggerated the differences between men and young women, who generally dressed in white or colored gowns. Indeed, the black suit as a symbol of manhood proved so appealing that in many places the fashion became almost universal. In England, it was worn by men of all stations in life by the 1880s, and not only in the city; according to the novelist and poet Thomas Hardy, even farmers and countrymen had become "as dark as a London crowd."

For the most part, women took to black much more slowly than did men. There were, of course, exceptions. Drab black dresses, inexpensive and unobtrusive, were considered suitable

for female servants. According to ladies' magazines, a simple black gown was also "the stay-by of the woman with a limited income" who could not afford to follow fashion: "it is such a particularly useful garment and can be worn on so very many occasions." And for women of all classes, black was also the color of mourning, which the newly widowed wore for at least a year and a day, and often long afterward.

From time to time, fashionable ladies also wore black simply because it appealed to them. Shunning dull and cheap materials, they dressed with opulence in swathes of rich black velvet, black satin, and black lace, their wasp waists enclosed with long rows of shining black jet buttons. Often they wore their dresses with a touch of white at the throat, as centuries of male courtiers and clerics had done before them. Like elite men who had so quickly adopted the black suit, these women understood that expensive black clothing was dramatic, and that it conferred a certain dignity and power on those who wore it. It set them apart from the pastel crowd yet did not raise eyebrows in the way that bright colors like red were increasingly wont to do.

Yet if black was far more demure and restrained than red, it could nevertheless be erotic, too, even dangerously so, as the case of Madame Virginie Gautreau suggests. The notorious French beauty had her portrait painted by a young John Singer Sargent in 1883. One thin diamante strap held up her low-cut black gown; the other strap fell off her shoulder as she struck a seductive pose. When Sargent exhibited the painting, *Madame X*, at the Paris Salon the following year, viewers were shocked. For them, the combination of black, deep décolletage, and fallen strap was a disturbing depiction of shameless sophistication and sexual immorality. Although the painting became famous worldwide, the scandal ruined what was left of Gautreau's reputation and nearly ended Sargent's promising career.

To avoid such a debacle, most women who favored elegant

black gowns chose to have them cut less sensationally. Yet the eroticism of rich black—however understated—was undeniable and helped make the color popular with the fashionable elite before World War I.

During the war, black for a time became almost universal in Europe; everyone, it seemed, was in mourning for someone. Yet ironically, it was also at this time that the elaborate Victorian code of mourning was pushed to its breaking point. By the end of the war, bereaved women were wearing shorter, simpler mourning dresses. Some refused to wear black at all; others wore black even if they had no specific loss to mourn.

After peace was restored, the connection between black and mourning became even less distinct, and more and more women took to wearing the color just to be chic. The pivotal event was the introduction of the little black dress in the mid-1920s. Popularized by black-and-white movies and by designers like Coco Chanel and Elsa Schiaparelli, the little black dress became, as *Vogue* called it in 1926, a "sort of uniform for all women of taste." In nearly eighty years, it has rarely been out of fashion.

Indeed, black in general has become a fashion staple in the West. Worn by businesspeople, bohemians, and socialites alike, it is enormously popular and accounts for a large proportion of clothing sales each year. A bundle of contradictions, black is both daring and safe, retaining a soupçon of Madame X's dark sensuality even as it protects the wearer from the vagaries of fashion. For wary consumers, and especially for industry professionals, it has become a wardrobe basic—a way of saying that one stands above the fray, too sophisticated to be inveigled into wearing the latest acid pink or pastel green. Black, the ultimate noncolor, has supplanted red as the color of power.

• • •

EVEN AS BLUE AND BLACK HAVE TRIUMPHED, RED HAS
languished. Over two centuries have passed since it last domi-
nated the hierarchy of color. Although red remains extremely
popular in Latin America, its appeal is more limited elsewhere in
the Americas and in Europe, where it usually ranks between
third and fifth place on favorite-color polls. In most of the rest of
the world, red ranks even lower.

Oddly enough, red's modern-day identification with com-
munism and socialism seems to have had little impact on these
rankings. Indeed, conservative and capitalist countries sometimes
regard red more highly than left-leaning and communist ones do.
Perhaps the fact that red is associated with so many other powerful
ideas, groups, and movements explains why the color's popularity
bears no clear relationship to politics.

If politics has not played a large role in red's decline, class
certainly has, at least in the West. Red—especially the bright,
fire-engine variety—still suffers from its demotion at the hands
of the elite nineteenth-century and early-twentieth-century taste-
makers who considered it common and vulgar. Usually consid-
ered acceptable in casual sportswear, bright red continues to have
a bumpy reception in formal settings, where it is often perceived
as provocative and inappropriate. Many women who like scarlet
still think twice before wearing it to a professional meeting. In
formal contexts, men rarely wear the color at all.

Yet if red these days has a checkered reputation, the old sense
of red—red as a symbol of power and prestige—lingers on.
Although red is no longer a luxury, it remains the color of choice
for many powerful people. Many, if not most, of those people are
women, and in this sense the feminization of red has served the
color well: as women have gained power, red's status has risen. In
the United States, in particular, "power red" has seen a real resur-
gence since the early 1980s, when Nancy Reagan became famous
for wearing it. To get President Ronald Reagan's attention,
White House press correspondents took to wearing red dresses

and red ties, and red became a more popular choice for professional women nationwide. Today American women of high status, energy, wealth, and achievement show a strong preference for red. For them, it is a better proof of personal power than black could ever be: only a very strong woman will risk wearing a color that could, if she were less secure, make her look cheap.

In countless other ways, too, red still has a hold on us. In countries as diverse as China, India, the United States, Australia, and Brazil, red reveals a curious universality: again and again, people identify it as the color of passion, energy, heat, and excitement. Whether we like red or not, studies show we react to it. Red lipstick, red lights, red sports cars, red sale signs, red flags: all catch our eye and demand our attention. When we see them, we can't help but respond. Red speeds our heartbeat and quickens our breath—visceral proof that even though the era of cochineal has ended, red remains in our blood.

Notes

PROLOGUE: THE COLOR OF DESIRE

1 *colors seen by human eye*: Burnham et al., 162; Gerritsen, 68, 70.
1 *radical politics, red tape*: *Oxford English Dictionary*, s.v. *red*; Barnhart, 898–99.
2 *human eye*: E. Thompson, 145–46, 160–65.
2 *color terms*: Berlin and Kay, 1–3, 25–28.
2 *ancient cultures and red*: Brunello, 6–12; Williams, 76–79; Chenciner, 290–91; Donkin, "Spanish Red," 5; Brunello, 38–46; J. Gage, *Color and Culture*, 26; Brunello, 23.
2 *"O, my luve's . . ."*: Burns, in Allison et al., 576.
2 *"red in tooth . . ."*: Tennyson, in ibid., 763.
2 *"Friday I tasted . . ."*: Dickinson, *Letters*, vol. 2, 452.
3 *cinnabar*: Gettens et al., 159–68.
3 *shah of Persia, coccinati*: Donkin, "Spanish Red," 5; Brunello, 74.
4 *"a perfect Scarlet"*: Boyle, 4:183.
4 *"the finest and . . ."*: Bemiss, 76.

ONE: THE DYER'S LOT

5 *Lucca*: Edler de Roover, "Beginnings," 2907–8; Meek, 31–34; Scott, 150–52; Green, 53–54; De Francisco, 1031–32; Molà, 42–44.
6 *importance of textile industry*: Spufford, 162–73, 202, Pounds, 400–401; Braudel, 2:312–13; Le Goff, 294; and Molà, appendix B. In medieval times, the term *spice* was a broader category than it is

today, one that included rare dyestuffs and mordants as well as culinary ingredients. In this sense, then, medieval Europe's "spice" trade and its textile industry were inextricably interwoven.

7 *silk*: Edler de Roover, "Manufacturing," 2915–22.

7 *wool*: Ibid.; Gies and Gies, *City*, 98–101, 103; Munro, "Textile Workers," 28–31.

8 *"dyed in the wool"*: Gies and Gies, *City*, 103.

8 *starvation*: Pleij, 100–117.

8 *national rivalries*: Barron and Saul, 12–13; Power, 8–15.

9 *dyes and status*: Chevalier, 2066–67, 2073–75; Gies and Gies, *Village*, 98–99.

9 *sumptuary laws*: Greenfield, 111; Hughes, 69–100; Baldwin, 47–48; Chevalier, 2074; Pastoureau, *Blue*, 86–88.

10 *"coats or dresses"*: J. Gage, *Life*, 196.

10 *"now there is such a confuse . . ."*: Philip Stubbes, in Ashelford, *Elizabeth*, 108.

11 *"graye and russet . . ."*: Geffrey Whitney, in Donkin, "Spanish Red," 6.

11 *colorful aristocrats*: J. Gage, *Life*, 198; Erickson, 228; Scott, 151; Laver, 78–79, 86.

11 *"The dier . . ."*: Geffrey Whitney, in Donkin, "Spanish Red," 6.

11 *hazards of dyeing*: Leix, "Guilds," 14.

12 *mordants*: The chemistry of mordant action is quite complex, since mordants form chemical bonds with both the fabric and the dye. See Baker, 207–27.

12 *"a small sieve . . ."*: Brunello, 157.

12 *value of Tuscan dyeshop*: Ibid.; J. Gage, *Life*, 64.

13 *"a space of . . ."*: Rosetti, 145.

13 *"The finger of a dyer . . ."*: Brunello, 41.

13 *Indian attitude toward dyers*: Ibid., 65.

13 *Greek and Roman dyers*: Sandberg, *Red*, 22; Brunello, 92, 104, 111–14.

14 *dyeing in the Dark Ages*: Leix, "Dyes," 19; Brunello, 122.

14 *medieval dyeing and dyers*: Wescher, 18:219; Brunello, 122–23, 133–40, 146–47; Edler de Roover, "Beginnings," 2907; Le Goff, 59–62; Gies and Gies, *City*, 103; Pastoureau, *Jésus*, 79–80.

15 *Arte di Calimala*: Leix, "Guilds," 11.

16 *dyers' guilds, plain and high dyers*: "Swans," 33; Pastoureau, *Blue*, 69–72; Leix, "Guilds," 14–15; Hills, 186; Brunello, 151–52; Born, 210.

16 *"master-piece"*: Leix, "Guilds," 14.
17 *Lucca's 1255 statutes*: Brunello, 135–40.

TWO: THE COLOR OF THE SUN

18 *execution of Mary, Queen of Scots*: Fraser, 534–39; Ashelford, *Elizabeth*, 32.
19 *ancient Judaism and red*: Genesis, 2:19; Isaiah, 1:18; 2 Samuel, 1:24; Proverbs, 31:21; Jeremiah, 4:30; Nahum, 2:3; Young, s.v. *scarlet*. Ancient Hebrew had different words for different kinds of red, but these words are not always consistently translated in Latin and English Bibles.
19 *"thread of scarlet"*: Song of Solomon, 4:3.
19 *classical culture and red*: Brunello, 38–46, 106–10; J. Gage, *Color and Culture*, 25–26; Pastoureau, *Blue*, 15; Dupont, 123–24; Born, 211; Sandberg, 37.
20 *"most suitable . . ."*: Xenophon, in Santosuosso, 86.
20 *imperial purple*: Munro, "Medieval Scarlet," 13–15; Reinhold, 43–50.
20 *"The official rods . . ."*: Pliny, 3:249.
21 *"for covering . . ."*: Ibid., 3:255.
21 *"the color . . ."*: Ibid.
21 *otherworldly power*: Chenciner, 291–92.
21 *ferocity and courage*: J. Gage, *Color and Culture*, 25–26; Born, 213; Donkin, "Insect Dyes," 855.
22 *Church and red*: J. Gage, *Color and Culture*, 80–89; Chenciner, 291–92; Pastoureau, "Ceci est mon sang," 47–50; Pastoureau, *Blue*, 92–94.
22 *"great red dragon"*: Revelation, 12:3.
22 *"drunken with the blood . . ."*: Ibid., 17:6.
23 *"cardinal purple"*: Jardine, *Worldly Goods*, 120–22; Sandberg, 62; Brunello, 124.
23 *"the most noble . . ."*: Sicile, 33.
23 scarlet *and* crimson: Hills, 176–78; Munro, "Medieval Scarlet," 17–18, 59–60; Rosetti, 5–6, 94; *Oxford English Dictionary*, s.v. *crimson* and *scarlet*.
24 *Charlemagne*: Laver, 52–53.
25 *judges, peers, magistrates, government posts*: Sicile, 34; Roche, 40; Norwich, 94–95; Pastoureau, *Jésus*, 131; Frick, 103–4; Hills, 177–79.
25 *fifteenth-century prices of red cloth*: Munro, "Medieval Scarlet," 61–66.
25 a modo principe: Marin Sanudo, in Hills, 176.

26 *a gentleman can . . .*: Cosimo de' Medici, in Hale, 26. A scarlet robe
 made with "two lengths" of top-quality cloth was the official costume
 of the Florentine council, the Signoria (Frick, 103–4).

26 *aristocrats and red*: McCorquodale, 52–53; Delmarcel, 30–53; "Ruby,"
 Larousse.

26 *"every writer . . ."*: Vespasiano, in Battles, 71.

27 *"gayest scarlet dress . . ."*: Chaucer, 273.

27 *scarlet turbans*: Jardine, *Worldly Goods*, 31.

27 *right to wear red*: Laver, 86.

28 *madder*: Buchanan, 52–53; Liles, 102–15.

28 *"Turkey red"*: Liles, 111.

28 *brazilwood*: Brunello, 25; Wescher, 622; Böhmer, 180–83.

29 *"disceytfull brasell," a "fauls colour"*: Bolton, in Walton, 334.

29 *archil*: Brunello, 96, 133.

29 *lac*: Donkin, "Spanish Red," 11; Böhmer, 208–9; Bemiss, 218.

29 *oak-kermes*: Brunello, 97; Donkin, "Insect Dyes," 859–63; Böhmer,
 205–6; Sandberg, 60.

29 *St. John's blood*: Donkin, "Insect Dyes," 853–58; Brunello, 153.

29 *Armenian red*: Böhmer, 207–8; Donkin, "Insect Dyes," 849–53.

30 *modern chemists*: Böhmer, 212–14; Atasoy, 196.

31 grain, vermilion, kermes: The precise historical meaning of these terms
 is a vexing question for historians. Molà (109–11) argues that *grain*
 referred only to oak-kermes, and that *kermes* applied to Armenian red
 and St. John's blood. This appears to have been true in some cases,
 most notably among many fourteenth- and fifteenth-century Italian
 dyers. But many other Europeans were less precise and used the terms
 interchangeably. See Munro, "Medieval Scarlet," 17–18, 59; Donkin,
 "Insect Dyes," 849–63; Rosetti, 5–6, 94; Cardon, "Les 'vers,'" 1–17.

31 *prices of kermes reds*: Brunello, 164; Staley, 152.

32 *Venetian scarlet, eerie stories*: Hills, 176; McNeil, 50–56; Rosetti, 108;
 Lane, 348–52; Brunello, 183–84.

32 *Venice's supremacy under threat*: Brunello, 195–96.

THREE: AN ANCIENT ART

34 *rumors and myths*: Morison, 99–102, 106 ; Elliott, *Old World*, 19–27.

34 *biology of cochineal*: Flores Flores and Tekelenburg, 169–72; Donkin,
 "Spanish Red," 11, 14; Born, 215–16.

36 *carminic acid*: Donkin, "Spanish Red," 15; Eisner et. al. 1039; de
 Ávila, "El insecto," 32–33.

36 *cochineal dyeing and cultivation*: Wouters and Rosario Chirinos,
 237–55; Donkin, "Spanish Red," 14–15, 33–35; Flores Flores and
 Tekelenburg, 170; de Ávila, "El insecto," 29.

36 *maize, beans, squash*: Piperno and Flannery, 2101–3.

36 *domestication of cochineal*: de Ávila, "El insecto," 29, 35–36; Donkin,
 "Spanish Red," 12, 17, 23; Spores, 80–81; Diamond, 157–75; and de
 Ávila, letter to the author, April 16, 2004.

37 *characteristics of domesticated insect*: Flores Flores and Tekelenburg,
 172, 175; Donkin, "Spanish Red," 14–15; Born, 216.

38 *madres*: Donkin, "Spanish Red," 17.

38 *care of cochineal and cactus*: Ibid., 12–16.

38 *harvest*: Lee, "Cochineal Production," 467; Loera Fernández, 7.
 Donkin, "Spanish Red," 17. A turkey may also have been sacrificed
 at seeding time (see Sánchez Silva, 99).

39 *70,000 dried insects*: Born, 216; Lee, "Cochineal Production," 451.

39 *trade networks*: Markman, 71–75; Gay, 34; Lee, "Cochineal
 Production," 453; Donkin, "Spanish Red," 23.

39 *Aztecs*: Clendinnen 16–19, 216–23; Smith, *Aztecs*, 263–72; Donkin,
 "Spanish Red," 5–7; Wouters and Rosario-Chirinos, 237–55.

40 *"dye feathers . . .”*: Sahagún, 9:88.

40 *"tlapalli”*: Donkin, "Spanish Red," 5.

40 *"blood of the nopal”*: Ibid., 12.

40 *cochineal tribute*: Berdan and Durand-Forest, 30, 39–40; Berdan and
 Anawalt, 102, 106, 108, 110, 112; Dahlgren, *Mixteca*, 228–31;
 Donkin, "Spanish Red," 21. The tribute documents do not always
 agree about the type and timing of cochineal payments. My estimates
 use the figures given in the *Matrícula de Tributos* (130 bags annually),
 which strike a balance between the lowballing of the Codex
 Mendoza (65 bags) and the very high but poorly documented num-
 ber (400 bags) mentioned elsewhere. The weight of the bag (*talega*) is
 not known, but Dahlgren de Jordan argues it was approximately 150
 pounds, the customary weight of bags of *grana* collected after the
 Conquest.

40 *Aztec use of cochineal*: Donkin, "Spanish Red," 21; Castelló Yturbide,
 156–58; Lee, "Cochineal Production," 453; J. E. Thompson, 82;
 Thomas, 291; Donkin, "Spanish Red," 20; Sahagún, 9:87–88;

Haude, 240–70. Ancient Mexicans probably dyed wild silk as well as fur, feathers, and animal hair (de Ávila, "Threads of Diversity," *Unbroken Thread*, 125).

41 *Cortés's expedition to Mexico*: Thomas, 199–204, 669–70; López de Gómara, 1–165; Innes, 38–87; Marks, 19–24, 36–39, 65–67.

42 *"from which Solomon . . ."*: Cortés, 29. Officially, the letter was from the "the Justiciary and Municipal Council of the Muy Rica Villa de la Vera Cruz," but historians believe it was essentially composed by Cortés.

43 *"Cortés and some . . ." / "I took it . . ."*: Díaz, *Historia*, 1:341; Díaz, *True History*, 2:84–85.

43 *marketplaces*: Thomas, 297–98.

43 *"There are many . . ." "They sell . . ."*: Cortés 104.

43 *grana*: Díaz, *Historia*, 1:331.

43 *shipments of plunder, Totonacs*: Thomas, 219–22; 348–49.

44 *conquest of Tenochtitlán*: Ibid., 490, 523–27.

44 *"The houses . . ."*: León-Portilla, 137.

FOUR: THE EMPEROR'S NEW DYE

45 *king and Totonacs*: Thomas, 341, 344–45.

45 *"the bodies . . ."*: Archbishop of Cosenza, in Wagner, 362.

45 *"If ever artists . . ."*: Martyr, 83; Thomas, 348.

46 *"He alone on earth . . ."*: Bishop Ruiz de la Mota, in Thomas, 337.

46 *Juana the Mad*: Habsburg, 26–27.

47 *"Lord, shut your mouth . . ."*: Thomas, 347.

47 *"Habsburg jaw"*: Domínguez Ortiz, 17; Barzun, 96.

47 *gift for music*: Tyler, 21.

48 *accomplished linguist*: Ibid., 20. Another version, recorded much later by England's Lord Chesterfield, has Charles saying, "To God I speak Spanish, to women Italian, to men French, and to my horse—German."

48 *Charles and Spain*: Tyler, 20–21; Brandi, 84–85.

48 *Charles and the Holy Roman Empire*: Tyler, 48; Habsburg, 76; Brandi, 99–112, 130–31.

50 *"try very hard . . ."*: Thomas, 350.

50 *fate of the treasure*: Ibid., 354.

50 *Cortés and Velázquez dispute*: Ibid., 352–54.

50 *"take heed . . ."*: Charles V, in Brandi, 486.

50 *emperor of two worlds*: Elliott, "Old World," 84; Thomas, 441.

50 *maps*: Fernández Alvarez, 71.

50 *Mexican treasure*: Ibid., 73; Parry, *Empire*, 118–19; Herrera, 25; Tyler, 248.

51 *Charles V's debts*: Tyler, 20, 234–36; Domínguez Ortiz, 47.

51 *"However much . . ."*: Charles V, in Brandi, 219.

52 *Spanish textile industry*: Phillips, 202–4.

52 *"a great profit . . ."*: Herrera, 7:24–25.

52 *instructions to royal official*: Chipman, 99–100.

52 *cochineal had reached Spain*: Ibid.; Donkin, "Spanish Red," 23.

FIVE: A PROFITABLE EMPIRE

53 *salaries, booty*: Lockhart and Otte, 39, 43–45; Thomas, 149–50.

53 *gold*: Bernstein, 68 69, 100 11.

54 *"Is this all?"*: Thomas, 527.

54 *200,000 pesos*: Ibid., 547.

54 *less than fifty pesos*: Ibid.

54 *debts*: Lockhart and Otte, 39; Thomas, 545.

55 *"How sad . . ."*: Thomas, 544–45.

55 encomiendas: Ibid., 577; Himmerich y Valencia, 6–7; Parry, *Empire*, 100–101; Simpson, 12–14, 16–24. Legally, the only people who could be treated as property were those whom the natives themselves had enslaved before the arrival of the Spaniards, or who made an unprovoked attack on the Spaniards and were captured as prisoners of war.

56 *minimal changes to* encomiendas: Lemon, 112–14, 162–64.

56 *"3 ⅓ yards . . ."*: Hernando de Castro, in Lockhart and Otte, 37.

57 *Caribbean* encomenderos: Simpson, 18–28; Parry, *West Indies*, 10–11; Las Casas, 24–25.

58 *"Tell me . . ."*: Montesinos, in Hanke, *Justice*, 17.

58 *outlaw* encomienda: Simpson, 54–55.

59 *"to live . . ."*: Charles V, in ibid., 59–60.

59 *"The majority . . ."*: Ibid., 60–61. See also Cortés, 279–80.

59 *Charles accepted the* encomienda *system*: Parry, *Empire*, 180.

59 encomenderos *plundered*: Lemon, 152–53.

60 *quick cash*: Scholes, *Spanish Conqueror*, 19 20; Lemon, 176–80.

60 *canopy, 1529 inventory*: Thomas, 519, 524; Scholes, *Spanish Conqueror*, 11–12.

60 *Cortés and Oaxaca*: Riley, xi, 110; Martínez, 1:435, 437–38.

61 *"I wish to God . . ."*: Baltasar, in Lockhart and Otte, 41.

62 *Cortés's downfall*: Thomas, 596–602.

62 *"Your Sacred . . ."*: Cortés, 159, 280, 337.

62 *expansion of* encomienda *rights*: Simpson 114–15; Parry, *Empire*, 88.

63 *dying by the millions*: Parry, *Empire*, 213–19; Himmerich y Valencia, 135. Scholars continue to dispute the size of the American population at the time of contact, as well as the consequent mortality rate, but all agree that the death toll was staggering.

63 *"The Emperor . . ."*: Vitoria, in Simpson, 127.

63 *"silence these friars"*: Fernández Alvarez, 73.

64 *New Laws*: Parry, *Empire*, 183–84; Simpson 127–38.

64 *tribute receipts, mortality*: Himmerich y Valencia, 71–72.

65 *land*: Semo, 101–3.

65 *acceptable occupations*: Parry, *Empire*, 50, 102–4.

66 *complete mystery*: Donkin, "Spanish Red," 44.

66 *conquistadors preferred to raise sheep, cattle*: Gibson, 150; Zárate, 253–56.

66 *Cortés and cochineal*: "Relación," 184–85; Lee, "Cochineal Production," 456; Scholes, *Spanish Conqueror*, 18–26. Cortés was not alone. A 1536 tribute list shows that only one of the many towns held by the Spanish Crown—"Guaxuapa" (probably Huajapan in Oaxaca, according to Donkin)—had cochineal included as part of its annual tribute assessment. It appears that the cochineal was to be sold along with other tribute goods to provide a salary for the Spanish official in charge of the town. Other Oaxaca towns known to have raised or traded in cochineal in pre-Hispanic times—such as Guaxolotitlán, Macuilsúchil, and Texupa—had their tributes assessed in gold disks and gold dust (Scholes, "Tributos," 201, 204, 209–10; Donkin, "Spanish Red," 53–54).

67 *royal instructions*: Lee, "Cochineal Production," 456.

67 *Indian market*: Records concerning the Indian trade in cochineal are extremely sketchy, but see Sahagún, 10:77; Fernández de Oviedo, *Historia General*, 2:8; and Donkin, "Spanish Red," 18–19.

SIX: COCHINEAL ON TRIAL

69 *official transatlantic port*: Parry, *Empire*, 54–58.

70 *"Quien no ha visto . . ."*: Crow, 69.

70 *"new Babylonia"*: Pike, *Enterprise*, 32.

70 *brotherhood of thieves*: Pike, *Aristocrats*, 193–96.

70 *"in the hands . . ."*: Perry, 14–16.

71 *merchants and cathedral*: Pike, *Enterprise*, 29; Defourneaux, 81–82.

71 *rhythms of Seville's commercial life*: Defourneaux, 75–79.

71 *shipping crisis*: Parry, *Empire*, 121.

72 *Seville's merchants and kermes*: Lorenzo Sanz, 561.

72 *Spanish textile industry and inflation*: Phillips and Phillips, 202–4,
 282–83; Elliott, *Imperial Spain*, 189–91. The literature on the
 Spanish price revolution is extensive; see Elliott, *Imperial Spain*,
 192–99, for an excellent overview.

72 *"mixture or composition . . ."*: Molà, 121.

73 *"kermes and powder of Spain"*: Perugia cotton and silk guild, in Molà,
 121.

73 *da Diranta*: Ibid.

73 *three samples, different names*: Ibid.; Donkin, "Spanish Red," 14.

74 *"grown in the Indies . . ."*: Molà, 122.

74 *guild regulation of new dyes*: Leix, "Guilds," 15–16.

74 *Venetian trial*: Molà, 122–24.

74 *"over the fire"*: Ibid., 123.

75 *characteristics of cochineal v. kermes reds*: Böhmer, 207–12; Molà, 111–12;
 Lee, "American Cochineal," 206; Sandberg, *Red Dyes*, 66; Atasoy, 196.
 The empirical formulas for these acids are $C_{16}H_{10}O_8$ (kermesic acid),
 $C_{16}H_{10}O_7$ (flavokermesic acid), and $C_{22}H_{20}O_{13}$ (carminic acid).

Kermesic Acid

Flavokermesic Acid

Carminic Acid

75 *"This brutal treatment . . .":* Böhmer, 207–8.

76 *top artisans, Genoese dyers adopt cochineal:* Molà, 121–22.

76 *opposition to cochineal:* Lee, "American Cochineal," 215; Molà, 124–30.

76 *most dynamic enterprises:* Lorenzo Sanz, 1:583–88; Lee, "American Cochineal," 208–13.

77 *Capponi and Maluenda cartel:* Lorenzo Sanz, 1:573–75; Ruíz Martín, cxxvii–viii.

77 *cochineal had become indispensable:* Hofenk-De Graaff, 75. Despite a threefold increase in the supply of cochineal from 1557 to 1574, the average real price of the commodity increased, indicating that demand continued to outstrip supply. The real price of cochineal was calculated using Lorenzo Sanz's cochineal price index (1:556–57) and J. Nadal Oller's estimates of inflation during this period (as discussed in Elliott, *Imperial Spain,* 194).

78 *black in Burgundy and Spain:* Hollander, 367; Steele, 20.

78 *neutrals and muted colors:* Arnold, 1–9, 90–91.

79 *Titian:* Brown, *Painting in Spain,* 47; Vasari, 275–76.

79 *ladies-in-waiting, scarlet livery:* Arnold, 5, 56–57; Erickson, 228–29; Baumgarten, 128–30.

79 *Shakespeare:* Wood, 260.

80 *beards dyed to match:* Erickson, 228–29.

80 *Van Dyck:* Jones and Stallybrass, 45–46.

80 *Cecil:* Nicolson, 143.

80 *the finest in Spain:* Boyden, 120.

80 *countess of Carlisle:* Hickman, 138–39.

81 *slave trade:* Foster 57, 66–69.

81 *cosmetic applications:* Hibbert, 36.

82 *lake analysis:* Kirby and White, 56, 66–67, 70–73; Ball, 65–66; Kirby, letter to author, April 26, 2004.

82 *"Buy . . . some good Cochinele . . .":* John Smith, in Harley, 137.

83 *tendency to fade, Rembrandt, Turner:* Kirby et al., 67; van de Wetering, 240–41; Townsend, 67–68; Findlay, 134–35.

83 *"Drugist":* Smith, in Harley, 137.

83 *"Dissolved in vinegar . . .":* Hernández, 1:306–7.

83 pigmentum: Harley, 8.

84 *"good against melancholy diseases . . .":* Gerard, 1343.

84 *sweat, infection, fevers:* Wright, 635.

84 *Charles II:* Shapiro and Shapiro, 22.

84 *"and take . . ." "nine live lice . . .":* Ellis (Web).

84 *"drink of excellent Chianti," "an exquisite cochineal liqueur . . ."*: Da Ponte, 286. *Confectio alchermes* (kermes liqueur) was employed as a medicine by ninth-century Arab physicians and later adopted by European doctors. For centuries it was made with oak-kermes, Armenian red, or St. John's blood, but by the 1600s many physicians and apothecaries appear to have used cochineal instead. See Donkin, "Insect Dyes," 862; Gerard, 1343; Wright, 635.

84 *"to make the apple . . ."*: Blegborough, 2.

84 *mental patients*: Beam, 24.

85 *trade crisscrossed the world*: Donkin, "Spanish Red," 38–39.

85 *yang hung*: Ibid.

85 *"we should not . . ."*: Voltaire, 24.

85 *biologists, informed by evolutionary theory*: Donkin, "Spanish Red," 14.

SEVEN: LEGACIES

87 *Charles V's financial disgrace*: Tyler, 242–58; Elliott, *Imperial Spain*, 206–11, 231.

88 *Charles V's retirement and death*: Tyler, 269–75; Fernández Alvarez, 178–83.

88 *Philip II*: Elliott, *Imperial Spain*, 249–51; Kamen, *Philip II*, 71–72; Parry, *Empire*, 229–30.

89 *silver returns*: Hamilton, 32–35; Elliott, *Imperial Spain*, 184. All figures refer to *pesos ensayados* of 450 *maravedis* each; the figure for cochineal below was calculated using the same units.

89 *"Apart from nearly . . ."*: Philip II, in Kamen, *Philip of Spain*, 87.

89 *entire year's silver remittance*: Parker, 126.

89 *amount and value of cochineal exports*: Parry, *Empire*, 106; Hamnett, *Politics*, 10; Lee, "Cochineal Production," 457–62; Chaunu and Chaunu, 6(2):980; Lorenzo Sanz, 1:550, 556. The value of the cochineal harvest is a matter of some debate, primarily because prices varied widely from year to year and from place to place. The figure quoted—250,000 pesos—comes from a contemporary estimate by a Mexican viceroy, and it dovetails fairly well with the data collected by the Chaunus and Lorenzo Sanz.

90 *royal taxes*: Hoberman, 187–92; Haring, *Trade and Navigation*, 59–95; Lee, "American Cochineal," 219.

90 *corrected his secretaries' mistakes*: Elliott, *Imperial Spain*, 250.

90 *"the quantity of cochineal . . ."*: "Instrucción a Martín Enríquez," in Hanke, *Los Virreyes*, 1:197.

91 *cocoa*: Hoberman, 121–24.

91 *Spanish growers prone to failure*: Donkin, "Spanish Red," 28. The earliest evidence that Spanish growers were trying to cultivate cochineal dates from the 1550s (Lockhart et al., *Actas*, 82).

92 *small-scale growers*: Donkin, "Spanish Red," 28.

92 *Oaxacan and Mixtecan response*: Ibid., 23–25; Lee, "Cochineal Production," 457; Borah, *Silk*, 23–26.

92 *"taught"*: Herrera, 9:154; Burgoa, as cited by Spores, 123.

93 *Michoacán, Jalisco, and Yucatán*: Donkin, "Spanish Red," 22–23; Lee, "Cochineal Production," 464.

93 *Puebla*: Donkin, "Spanish Red," 24.

93 *Tlaxcala*: Ibid., 24–25; Gibson, 14–15, 79, 164–81; Lockhart et. al. *Actas*, 2.

94 *What made Tlaxcala so important*: An early 1530s decree, issued by the second *audiencia* of New Spain, is sometimes credited with launching the Tlaxcalan cochineal boom, and by extension the European cochineal boom as well, but so far no other records have shown evidence of expanded production at such an early date. Europeans had little knowledge of the dye before the early 1540s, and Tlaxcalan council records from 1553 (Lockhart et. al., *Actas*, 83) state that the boom began around 1544 or 1545.

95 *value of Tlaxcala-Puebla cochineal trade*: Lee, "Cochineal Production," 457; Hamilton, 397. See also Gibson, 149.

95 *the council prohibited the cultivation*: Lockhart et al., *Actas*, 79.

95 *"devote themselves . . ."*: Cabildo records, March 3, 1553, in Lockhart et. al., *Actas*, 81.

95 *"they buy pulque . . .,"*: Ibid.

96 *"commit sins"*: Ibid., 82.

96 *"He who belonged . . ."*: Ibid., 81.

96 *"very thick . . ."*: Ibid., 82. Original reads "cacao."

96 *"pour it . . ."*: Ibid.

96 *"Everyone does nothing . . ."*: Ibid., 81.

97 *"a very great quantity . . ."*: Cabildo records, December 18, 1553, in Lockhart et al., *Actas*, 89.

97 *cochineal reaching Seville rose spectacularly*: Lorenzo Sanz, 1: 550–51.

97 *new center in Oaxaca*: Gibson, 152–53; Borah, 29–30; Sánchez Silva, 97; Donkin, "Spanish Red," 25–26.

 98 *cochineal as destructive influence*: Sánchez Silva, 99; Hamnett, 9–23.

 99 *"compel the Indians . . ."*: *Recopilación, lib.* 4, *tit.* 17, *ley* 7. See also Lee, "Cochineal Production," 464; Donkin, "Spanish Red," 24.

 99 *cochineal credit system*: Baskes, 9–38; Hamnett, 9–23. Similar credit systems were also developed for the production of corn, cotton, peppers, and nuts, but the cochineal system offered the most benefits to producers (Baskes, 20–21). Baskes dates the system to the 1580s, but Sarabia Viejo (*Don Luis*, 412–13) notes that Spanish authorities were attempting to forbid advance payments to Indians for cochineal as early as 1550.

100 *Indians benefited*: Baskes, 62–92.

100 *cochineal and indigenous culture*: Ibid., 12–15, 18–20.

Eight: Trade Secrets

103 *1580 Enríquez decree*: Lee, "Cochineal Production," 462.

103 *fraud*: Gibson, 149–50; Gómez, 176–80; Donkin, "Spanish Red," 18.

104 *"the colors fade . . ."*: Molà, 127.

105 *1554 investigation*: Gibson, 150; Lee, "Cochineal Production," 457, 468.

105 *ways to kill and dry cochineal*: Gómez, 174–76; Donkin, "Spanish Red," 17–18.

105 juez de grana: Lee, "Cochineal Production," 468–71.

107 *royal monopoly*: Parry, *Empire*, 240; Hoberman, 126.

107 *1618 partial monopoly*: Lorenzo Sanz, 1:570; Hoberman, 126–27. Lee, "American Cochineal," 219, says that the Crown estimated net profits at 100,000 ducats in 1596. This was equivalent to about 138,000 pesos, or 83,000 *pesos ensayados*.

107 *"dealers in cochineal . . ."*: Hoberman, 127.

108 *500,000 pesos*: Chaunu and Chaunu, 6 (2):980.

108 *foreigners and Spanish laws*: Haring, *Trade and Navigation*, 96–122; *Recopilación, lib.* 9, *tit.* 27, *ley* 6–7.

109 *"Pirats . . ."*: Donne, 238.

Nine: Pirates' Prize

110 *Essex expedition*: Brigden, 340; Monson, 2:28–30; Lacey, 192–93; Lee, "American Cochineal," 212; Donne, 41.

110 *"Lightning was . . ."*: Donne, 252–53.

111 *"to serve . . .":* Calendar of State Papers, Domestic, Elizabeth, 5:18.

111 *Spanish fortifications, convoys:* Parry, *Empire,* 252–57; Andrews, 64–70.

111 *"An insolent . . .":* Essex, in Hammer, 246.

111 *privateers:* Kelsey, 11–12, 217; Lenman, 85.

112 *assassinate Elizabeth:* Erickson, 318–19; Israel, 155–68.

112 *"If you touche him . . .":* Hakluyt, *Original Writings,* 2:249.

113 *English raiding parties:* Lenman, 83; Andrews, 156–57.

113 *"We could not . . .":* Brigden, 278–79.

113 *"great hoepe":* Kelsey, 78.

114 *embargo:* Lorenzo Sanz, 1:587.

115 *convoys:* Parry, *Empire,* 134–35.

115 *token shot:* Lenman, 86.

115 *Chilton:* Chilton, in Hakluyt, *Voyages,* 9:367–68.

116 *prizes, 1589–1590:* Lee, "American Cochineal," 213; Klarwill, 2:190;
 Calendar of State Papers . . . Simancas, 4:562–63; *Calendar of State
 Papers, Domestic, Elizabeth,* 2:695.

116 *"and somewhat . . .":* Flicke, in Hakluyt, *Voyages,* 7:59.

116 Madre de Dios: Williamson, 96–98.

116 *value of cochineal prizes:* Great Britain, Historical Manuscripts
 Commission, *De L'Isle,* 2:311; Lockyer, 111.

117 *English pirates robbed other nations' ships:* Lee, "American Cochineal,"
 214.

117 navios de aviso: Lorenzo Sanz, 1:572–73; Lee, "American Cochineal,"
 214.

117 *"over 20,000 pounds . . .":* Klarwill, 2:201–2.

117 *"single out . . .":* T. Gage, 155.

118 *Cumberland:* Monson, 1:235–36.

118 *"having gotten . . .":* Flicke, in Hakluyt, *Voyages,* 7:59–60.

119 *Admiralty Court, investors:* Quinn, 1:220–21; Lenman, 85.

120 *Barbary Coast:* Great Britain, Historical Manuscripts Commission,
 Sackville, 1:158–60, 344; *Calendar of State Papers, Domestic, Elizabeth
 and James,* Add. (1580–1625):587.

120 *extraordinary privilege:* Calendar of State Papers, Domestic, Elizabeth
 and James, 5:18, 134; Great Britain, Historical Manuscripts
 Commission: *De L'Isle,* 2:311; Harrison, 322, 325.

121 *decline in cochineal piracy:* Lee, "American Cochineal," 213–14.

122 *Dutch attacks:* Parry, *West Indies,* 49–50; Lee, "American Cochineal,"
 214; Sluiter, 165–71.

122 *Dutch palettes*: Israel, *Dutch Republic*, 559–60.
123 *"the best wool . . .*": G. B. Parks, 40–41.
123 *councils worried*: Lee, "American Cochineal," 216–17.
123 *prizes disappeared*: Records do not show exactly what happened to Essex's cochineal, but the desperate state of his finances coupled with the sudden fall in the price of cochineal suggests that he unloaded the dyestuff very quickly. By 1601, cochineal had recovered much of its value, and the price rose rapidly thereafter. (For cochineal prices, see Lee, "American Cochineal," 221.)
124 *"undoubted hope . . .*": R. Johnson, 22. See also Montchrestien, 322–24.

TEN: WORMBERRY

126 *try to match*: Elliott, *Old World*, 41; Grafton, 55.
126 *wormberry*: Pliny, 4: 408–9; 7:8–9. The word Pliny used was *scolecium*, which Rackham translates in the second selection as "worm berry." An influential edition of Gerard's *Herball*, first published in the 1630s, described "Cutchonele" as a form of Pliny's *scolecium*, translated there as "Maggot berrie" (Gerard, 1342–43).
127 *Europe was changing*: Grafton, 116–19; Crombie, 2:122–25
127 *"many things . . .*": Cervantes, 104.
128 *closer to God*: Elliott, *Old World*, 29–31.
128 *"What I have sold . . .*": Fernández de Oviedo, *Historia general*, 1: 39–40.
128 *"labors and . . .*": Ibid., 1:11.
128 *Spaniards fumbled for words*: Elliott, *Old World*, 17–20.
129 *"something larger . . .*": Fernández de Oviedo, *Historia general*, 2:54–55.
129 *"I believed . . .*": Ibid., 1:265–67.
129 *"excellent color . . .*": Ibid., 2:8.
129 *"very good cochineal"*: Motolinía, 218, 248, 280.
130 *"nuchtli fruit"*: López de Gómara 2:144; Thomas 792.
130 *"some little worm-like creatures . . .*": Cervantes, 105; the key passage is *"en las flores . . . cría unos como gusanitos,"* or "in the flowers . . . it [the nopal] breeds some little worm like creatures." The translation cited in Donkin, "Spanish Red," 44, is incorrect.
130 *"This cochineal . . .*": Sahagún, 11:239. On the fate of Sahagún's text, see Browne, 26–35.

131 *some Spaniards continued to insist*: Jiménez (1:9), for example, places cochineal in the section about "trees," rather than in the one about "animals." Hernández (1:306–7) wrote in the 1570s that cochineal was a "worm," but his description suggests that he thought it was generated by the cactus plant.

131 *"are born . . ."*: Acosta, 183.

131 *"cochineal is . . ."*: Herrera, 9:154. At times Herrera uses the word *semilla*, or "seed," to describe the newly hatched cochineal. Used figuratively, the term means simply "descendants," and it was employed in that sense as a term for young cochineal insects as late as the nineteenth century, by people who knew very well that cochineal was an insect. Herrera apparently means it figuratively, too, for he uses *semilla* and *hijuelos* ("little children" or "offspring") interchangeably in his discussion of young cochineal.

133 *Tomson*: Tomson, in Hakluyt, *Voyages*, 9:338–9.

133 *"not a worme . . ."*: Ibid., 9:358.

133 *"the berrie . . ." "fitte for dying"*: Ibid., 7:247.

134 *"comes from a fruit . . ."*: Champlain, 1:43. Some historians have speculated that Champlain never traveled to Mexico, at least not in the manner he claimed to have done. Whether Champlain was really the author of this account (known as the *Brief Discours*) has also been debated.

134 *French navy*: Grant, 3–4; Bishop, 37–38.

134 *"an animal . . ."*: Laet, 229.

134 *eminent philosophers*: Lister, in *Philos. Trans.*, 86:5060; Ray, 2:1465.

134 *Providence Island Company, Pomet*: Calendar of State Papers, Colonial Series (1574–1660), 162, 225; Pomet, 30.

134 *"It is impossible . . ."*: Amsterdam merchant, in *Philos. Trans.*, 292:1614.

135 *"certain excrescences"*: T. Johnson, in Gerard, 1512.

135 *"The Cochineel . . ."*: Dampier, 247–48.

136 *Drebbel's inventions*: Tierie, 37–71; Harris, 3, 149–81.

136 *"remarkable mechanical instruments"*: Hugyens, in Tierie, 28.

136 *"that deservedly famous . . .," "le fameux Drebbel"*: Boyle and von Leibniz, in Harris, 207.

136 *"Engeneere," "Vulgar Mechanick"*: Harris, 194; Newton, in Jardine, *Ingenious Pursuits*, 61.

137 *"Baston . . ."*: Harris, 194. See also Tierie, 4, 89; Harris, 128, 186–87.

138 *alchemy, "magician," "sorcerer"*: Tierie, 27. See also Tierie, 6, 34; Harris, 141–42; Boas, 21.

138 *one early account*: Beckmann, 1:402–3. Jaeger (92–93) claims that
 Drebbel's role in the development of scarlet dye has been overem-
 phasized. Other scholars disagree, noting that Drebbel's contempo-
 raries, including Robert Boyle and Nicolas de Peiresc, gave him full
 credit for the discovery.

139 *"some merchants . . ."*: Boyle, in Tierie, 77.

139 *"the body . . ."*: Roberts, 55. See also Boas, 175; Roberts, 54–55, 99;
 Dobbs, 23–24.

139 *dyeworks*: Tierie, 78; Harris, 192.

140 *Kuffler*: Tierie, 28–29. Abraham and Johannes credited their father-
 in-law with discovering the cochineal-scarlet technique that some
 called "Color Kufflerianus," or Kuffler's color; their only role, they
 agreed, had been to establish the dye commercially (Harris, 193).

140 *"more beautiful . . ."*: Peiresc, in Tierie, 77.

140 *dyers across Europe*: Tierie, 77–82.

140 *"full of fire . . ."*: Bemiss, 186.

141 *"a perfect Scarlet"*: Boyle, 4:183.

141 *Sun King*: Steele, 22–23.

141 *uniforms*: E. H. Edwards, 15–16; Fischer, 122; Chenciner, 65;
 Carman, 40; Mann, 9. English soldiers occasionally wore red coats
 before the mid-seventeeth century, but it was Cromwell's New
 Model Army that established the modern standard.

141 *star-spangled banner*: Taylor, 40. The star-spangled banner's red
 stripes were colored with a combination of tin, cochineal, and madder.

141 *fur trade*: "Wool Trade Cloth" (Web).

141 *Gobelins*: Tierie, 78–79; Beckmann, 1:403.

ELEVEN: THROUGH THE LOOKING GLASS

143 *"flies . . ."*: Giovanni du Pont, "Relazioni dei Viaggi," quoted in Clay
 and Court, 11.

144 Micrographia: Jardine, *Ingenious Pursuits*, 42–45; Ruestow, 22.

144 *Leeuwenhoek's education and inadequacies*: Ruestow, 164–66.

144 *"a stranger . . ."*: Molyneux, in ibid., 164.

145 *magnifying glasses, drapers*: Schierbeek, 24.

145 *0.00075 millimeters*: Ruestow, 14–15, 19.

145 *Royal Society*: Schierbeek, 24–25, 30; Ruestow, 149–54, 163, 169.

146 *"gentlemen philosophers"*: Leeuwenhoek, in Ruestow, 162; Jardine, *Ingenious Pursuits*, 92.

146 *"the great man of the century"*: Huygens, in Schierbeek, 35.

146 *Boyle asked Leeuwenhoek:* Leeuwenhoek, *Letters*, 7:137–38.

146 *"engendered... Prickle-pear..."*: *Philos. Trans.*, 40:796–97.

147 *"In all cases..."*: Leeuwenhoek, *Letters*, 5:273.

147 *sixty species*: Schierbeek, 134, 181.

147 *temperamental instruments*: Jardine, *Ingenious Pursuits*, 42–44; Ruestow, 17–19; Wilson, 220–21.

148 *fleas, bacteria*: Ruestow, 156.

148 *"I have often endeavored..."*: Leeuwenhoek, in *Philos. Trans.*, 197:646.

148 *grains first had to be soaked*: Leeuwenhoek, *Letters*, 5:273.

148 *term* insect: Ruestow, 105–7.

148 *Swammerdam*: Swammerdam, 182; Ruestow, 120–25; Cobb, 125; Leeuwenhoek, *Letters*, 7:155, n. 23.

149 *limits to Royal Society openness*: Jardine, *Ingenious Pursuits*, 316–23.

150 *"very satisfied"*: Leeuwenhoek, *Letters*, 7:142–43.

150 *"nothing but the innermost part..."*: Ibid. 7:145.

150 *"females..."*: Ibid., 7:149–50. See also Leeuwenhoek, *Opera Omnia*.

151 *Hartsoeker's visit to Leeuwenhoek*: Ruestow, 22–23.

151 *spermatozoa*: Schierbeek, 95; Ruestow, 23.

151 *"most grotesque observations..."*: Hartsoeker, in Ruestow, 163.

151 *"animalcules a-moving..."*: Leeuwenhoek, in Schierbeek, 78; Ruestow, 163.

152 *"a heterogeneous mixture..."*: Newton, in Zollinger, 18–19.

152 *Newton only partially correct*: A. E. Shapiro, 98–102.

152 *range of light effects*: Zollinger, 35–38; P. Parks, 160–61.

153 *alchemy*: M. White, 96; Jardine, *Ingenious Pursuits*, 325–31.

153 *corpuscles*: Trusted, 37–53; Jardine, *Ingenious Pursuits*, 94–96; A. E. Shapiro, 100, 130.

153 *"infinity..."*: Hartsoeker, 49–50.

153 *"we very much improve..."*: Hooke, in A.E. Shapiro, 104.

154 *"the fundamental base," "as tough and durable," "I have opened many"* : Hartsoeker, 52.

154 *"unborn Animalcula..."*: Leeuwenhoek, in *Philos. Trans.*, 292:1618–28.

155 *"presumed to state untruths..."*: Leeuwenhoek, in Schierbeek, 38. See also Ruestow, 284–85; Wilson, 220–25.

156 *skeptical reception*: Ruestow, 152–53; Schierbeek, 37–39, 68.

TWELVE: A CURIOUS GAMBLE

157 *ce tripot*: Reith, 65.

157 *"a thousand meadows"*: Walpole, in Porter, *London*, 178.

158 *"put an end . . ."*: Fabre, 3:552.

158 *"There is nothing . . ."*: *The Connoisseur*, in Reith, 63.

158 *"lived many years . . ."*: Ruusscher, 3.

159 *"great Navigators . . ."*: Ibid., 3–5.

159 *entire fortune*: Beckmann, 1:398.

160 *"have the goodness . . ."*: Ruusscher, 5.

161 *die within days*: Ibid., 142–43.

161 *" eyes, mouths . . ."*: Ibid., 19.

161 *"To doubt . . ."*: Ibid., 136–37.

162 *"small Fruit or Seed . . ."*: Ibid., 43.

162 *"be convinced . . ."*: Ibid., 39.

162 *"Is there the least possibility . . ."*: Ibid., 41.

162 *"small living Animals"*: Ibid., 43.

162 *"Wishing to cultivate friendship . . ."*: Ibid. According to Beckmann
 (1:398), Ruusscher deducted the minor expenses incurred in obtain-
 ing the evidence and publishing a record of the case.

163 *"Lovers of Truth . . ."*: Ruusscher, 35.

163 *"when [the cochineal] grow large . . ."*: Ibid., 21.

163 Dahua Yitz: de Ávila, "Alzate," 27. *Dahua Yitz* is a Spanish tran-
 scription of the Mixtec term, which is more accurately transcribed by
 scholars today as *(n)dahua yits(i)*.

164 *"divine essence"*: Ibid., 27–28.

164 *"Position . . .":* Leeuwenhoek, in *Philos. Trans.*, 292:1619–20. See also
 Bell, 22.

164 *"the same . . ."*: *Philos. Trans.*, 193:502; Donkin, "Spanish Red," 45.

164 *"It is perhaps . . ."*: Réaumur, 4:89.

THIRTEEN: A SPY IN OAXACA

165 *"Cochineal is noe where . . ."*: *Calendar of State Papers, Colonial Series,
 American and West Indies* (1714–15), 60. In 1757, South Carolina and
 Georgia were said to be breeding cochineal "in great abundance," but
 this turned out to be a false report (*Transactions*, 6:14).

165 *"divers berries . . ."*: Raleigh, 95.

165 *"an admirable ink . . ."*: Koerner, *Linnaeus*, 135.

166 *Italian writer*: Donkin, 46.

166 *"It would be well worth . . ."*: Diderot, 3:560.

166 *"Orenges, Limons . . ."*: R. Johnson, 22.

167 *French triumph*: Ott, 6; Drayton, 75.

167 *opuntia in Europe*: Donkin, "Spanish Red." 40–42.

168 *"rather repulsive . . ."*: Koerner, *Linnaeus*, 151; Koerner, "Purposes,"
 125–26.

168 *"dreadful fit," "About* Coccionella . . ."*: Linnaeus, in Blunt, 201, and
 Koerner, *Linnaeus*, 150.

168 *Rolander*: Blunt, 183; Koerner, *Linnaeus*, 86–87, 148.

169 *French spies*: Ruusscher, 142–43. See Thiery, *Traité*, civ, for Réaumur's
 interest in cochineal.

169 *Thiery de Menonville*: Thiery, *Traité*, c–ci. Thiery wrote a detailed
 account of his quest for cochineal. Two versions exist, and they differ
 slightly from each other, most probably because Thiery himself made
 emendations as he copied out the manuscript. The first version, sent to
 a French official who had supported Thiery's voyage, can now be found
 in manuscript in the Archives Nationales in France. It has been exten-
 sively excerpted by Ángeles Saraiba Russell in his article "En busqueda
 de la grana cochinilla." (When those excerpts are cited here, they are
 noted as Thiery/Saraiba.) The second version, with additional com-
 mentary from his colleagues on Haiti, was published in 1786 as *Traité
 de la culture du nopal et de l'éducation de la cochenille* (cited henceforth as
 Thiery). The second version was also translated into English in the
 early 1800s by John Pinkerton (modernized and cited here as
 Thiery/Pinkerton).

170 *French navy*: Drayton, 76–77.

170 *"Cochineal, whose price . . ."*: Raynal, in Thiery, ciii; Edelstein,
 "Spanish Red," 1.

170 *French wardrobes*: Roche, 134–37.

170 *"darling country"*: Thiery/Pinkerton, 757, 783.

171 *six thousand livres*: Ibid., 753.

171 *Saint-Domingue*: Moreau, 15; Ott, 3–9.

172 *"It is in keeping . . ."*: Moreau, 22. From the context it is clear that
 Moreau means "slaves," but he calls them "domestics."

172 *"nothing better . . ."*: Thiery/Pinkerton, 756.

172 *"tedious and fatiguing"*: Ibid., 753.

173 *"I was still wavering . . ."*: Ibid.

173 *"a number of phials . . ."*: Ibid.
174 *"Pretending to be actuated. . ."*: Ibid., 766–67.
174 *"sour looks"*: Ibid., 773.
175 *"Whether in the fields . . ."*: Ibid., 775.
175 *"A discovery . . ."*: Ibid.
175 *"You fail . . ."*: Ibid., 788.
176 *"indifferently"*: Ibid., 790.
176 *"return unsuccessful . . ."*: Ibid., 789.
177 *"an itinerary . . ."*: Ibid., 799.
177 *"the perfect beauty . . ."*: Ibid., 801.
177 *Gallatitlán*: Gallatitlán does not appear on any Oaxacan maps. One historian has speculated that Thiery may have been in Jayacatlán, near San Juan del Rey (Saraiba, 26).
178 *"but my surprise . . ."*: Thiery/Pinkerton, 818.
178 *"intoxicated with joy . . ."*: Ibid.
178 *"eight cats . . . ," "everlasting springtime"*: Thiery/Saraiba, 17.
178 *"so thickly loaded . . ."*: Thiery/Pinkerton, 824.
178 *black farmer*: Crown law forbade blacks and mestizos from selling cochineal, and presumably from owning nopalries, but Thiery refers to the farmer as the owner and mentions purchasing more cochineal from another black farmer later during the trip. (See Saraiba, 26.)
179 *"eight of the handsomest branches . . ."*: Thiery/Pinkerton, 826. See also Thiery/Saraiba, 23.
179 *"like a bolt of lightning"*: Thiery/Saraiba, 23.
179 *"It seemed to me . . ."*: Thiery/Pinkerton, 826.
179 *"some dread"*: Ibid., 853.
180 *"I calculated . . ."*: Ibid.
180 *"soldiers, sailors . . ."*: Ibid.
180 *"The officer . . ."*: Ibid.
180 *"The intendant . . ."*: Ibid., 875.
180 *royal garden*: Moreau, 199; Thiery, xx.
181 *"My stay . . ."*: Thiery/Saraiba, 25–26.
181 *"stolen"*: Thiery/Pinkerton, 875.
181 *"a nation"*: Ibid., 797, 845.
182 *"malignant fever"*: Thiery, cxiii.
182 *no trace*: Ibid., lvi, lxxxiv–xcii; Donkin, "Spanish Red," 46.

FOURTEEN: ANDERSON'S INCREDIBLE FOLLY

184 *Britons inspired by French*: Drayton, 80, 109–10.

184 *Banks*: The authoritative biography is H B. Carter's *Sir Joseph Banks*.

185 *"meer toad eater . . ."*: Sir James E. Smith, in Miller, 22.

185 *Bligh*: Drayton, 114, 119.

186 *"the greatest service . . ."*: Jefferson, quoted in MacKay, 49.

186 *"found a Cochineal Insect . . ."*: J. Anderson to J. Banks, December 3, 1786, in Anderson, *Letters* [1788], 1.

186 *240,000 pounds; £200,000*: Bancroft, in Bell, 32–33.

187 *"an Article . . ."*: T. Morton to C. N. White, April 10, 1788, in Anderson, *Letters* (1789), 4–5.

187 *"a dirty stain," "entirely useless . . ."* R. Clerk to Court of Dir., July 31, 1787, in Anderson, *Letters* [1788], 27.

187 *"might be made use of . . ."*: Ibid.

187 *"an opportunity . . ."*: J. Banks to J. Anderson, April 10, 1788, in Anderson, *Letters* (1789), 3.

188 *Commodore Arthur Phillip*: Carter, 232; J. Cox to J. Anderson, November 27, 1787, in Anderson, *Letters* [1788], 28.

188 *"Eight Hundred Convicts . . ."*: J. Cox to J. Anderson, November 27, 1787, in Anderson, *Letters* [1788], 28.

188 *exotic species*: Stiling, 40–43; Brutsch and Zimmerman, 156–57.

189 *"the dearness of Labour"*: J. Banks, in T. Morton to C. N. White, April 10, 1788, in Anderson, *Letters* (1789), 4–5.

189 *resolution, £2,000*: T. Morton to C. N. White, April 10, 1788, in Anderson, *Letters* (1789), 4–5.

189 *"for procuring the Insect and Plants"*: Ibid.

190 *governor of Madras*: Drayton, 120.

190 *"Could the best . . ."*: J. Anderson to J. Banks, March 1, 1788, in Anderson, *Letters* [1788], 28.

191 *"the Cochineal cultivated . . ."*: J. Anderson to C. N. White, February 6, 1789, in Anderson, *Letters* (1789), 19.

191 *"secrecy and reserve," "One thousand pounds . . ."*: J. Anderson to Colonel Kyd, July 10, 1789, in ibid., 31.

191 *Spanish botanist*: Carter, 276.

191 *"If the Spaniards . . ."*: J. Banks to T. Morton, November 17, 1791, in Drayton, 120.

192 *Banks's live samples perish*: Carter, 275–76.

192 *"Doctor Anderson's excellent nopal . . ."*: J. Stevens, November 2, 1795, in Anderson, *Letters* (1796), parts 1, 7.

192 *"had a good opportunity . . ." "easily procured it . . ."*: R. Neilson to J. Anderson, May 8, 1795, in Anderson, *Account*, 1. See also Fontana, 5–7.

193 *"unfortunately nine tenths . . ."*: W. Roxburgh to J. Anderson, May 25, 1795, in Anderson, *Account*, 4.

193 *Bengal nopal*: Ibid.; W. Roxburgh to A. Berry, June 17 1795, in Anderson, *Account*, 7. According to Donkin, "Spanish Red," 49, the species was *Opuntia monacantha*.

193 *"We cannot have less . . ."*: W. Roxburgh to A. Berry, June 20, 1795, and C. Smith to W. Roxburgh, June 20, 1795, in Anderson, *Account*, 8.

194 *"the most waste . . ."*: J. Anderson to Lord Hobart, July 22, 1795, in ibid., 9.

194 *"took only 30 [days] . . ."*: W. Roxburgh to A. Berry, June 20, 1795, in ibid., 8. A later account (Fontana, 9) suggests that forty days was a more accurate figure, which tallies with what we know of the life cycle of wild cochineal in America.

194 *care and nourishment to improve stock*: A. Berry to Lord Hobart, March 23, 1796, in Anderson, *Communications, etc.*, 10–11.

194 *"It is with the greatest pleasure . . ."*: A. Berry to Lord Hobart, December 8, 1795, in Anderson, *Communications from October*, 33.

194 *Banks became confident*: Carter, 276.

195 *"The danger . . ."*: A. Berry to Lord Hobart, March 23, 1796, in Anderson, *Communications, etc.*, 12–13.

195 *"wherever they have gone . . ."*: J. Anderson to Lord Hobart, July 26, 1796, in Anderson, *Letters* (1796), part 1, 10.

195 *"children . . ."*: S. McMorrice to J. Anderson, September 6, 1796, in ibid., 18.

195 *"too genteel . . ."*: J. Anderson to A. Watson, September 14, 1796, in ibid., 21–23.

196 *"I have not heard . . ." "to convince the Natives . . ."*: J. Duncan to J. Anderson, September 23, 1796, in ibid., part 2, 27.

196 *spininess of local nopal*: W. Roxburgh to A. Berry, June 20, 1795, in Anderson, *Account*, 8.

196 *profitability of Neilson's cochineal*: *Transactions*, 6:87–90.

196 *"not very abundant "*: Milburn, in Donkin, "Spanish Red," 49.

196 *price supports*: *Transactions*, 6:89. Supports were phased out over several years.

197 *public reward, £2,000*: *Transactions*, 6:90; Drayton, 301.

FIFTEEN: RED AND REVOLUTION

198 *Alzate*: Cody, 445–48; "Alzate," *DSB*.

199 *"love towards my Country . . ."*: Alzate, *Gazeta* (February 5, 1794), 202.

199 *"Divine Providence willed . . ."*: Alzate, in Cody, 447.

200 Americanos: Parry, *Empire*, 335–41.

200 *Napoléon, Joseph, and Spain*: Schom, 462–66.

201 *specific setbacks*: Hamnett and Contreras Sánchez believe that the chief causes of the industry's decline were the epidemic and famine, the abolition of the credit system (*repartimiento*), and changes in Spanish fiscal policy. Baskes has demonstrated that the decline began before any of these events took place, due to the general depression in Atlantic trade.

201 tricolor, bonnet rouge: Laver, 148–53, 158–59; Ribiero, 211–14; Steele, 34–35, 38–40. The trend toward simplicity in clothing began before the French Revolution, especially among men, but the revolution gave it much greater force.

201 *300,000 pounds*: Baskes, 203–4.

202 *Hidalgo, Morelos*: Krauze, 91–117; Parry, *Empire*, 348–54.

203 *"We are all equal . . ."*: Morelos, in Krauze, 112.

203 *price of cochineal sky-high*: Baskes, 178, 204.

203 *prize of 20,000 livres*: Edelstein, "Historical Notes," 33–34.

204 *"eats four square meals . . ."*: Napoléon, in Schom, 462.

205 *Mexicans defeat the Spaniards*: Parry, *Empire*, 355–58.

205 *cochineal in Guatemala*: R. L. Woodward, 378; MacLeod, 172–73; Donkin, "Spanish Red," 30–31.

206 *cochineal in Spain*: Donkin, "Spanish Red," 42, 46–47; MacKay, "Agents of Empire," 45.

207 *Sardinia, Corsica, Italy, Senegal*: Donkin, "Spanish Red," 47, 49.

207 *"promises fair"*: Chazotte, 7.

208 *Texas*: Brunello, 265–66; Heers, 16.

208 *India, Africa, West Indies*: Donkin, "Spanish Red," 49–50.

208 *North Africa, Guadeloupe*: Blanchard, 53; Heers, 16–21; Donkin, "Spanish Red," 47. The French island of Bourbon (now called Réunion), off Madagascar, also claimed possession of the insect, although these reports were hotly contested. See Bell, *Notices*, 34–42.

208 *Madeira*: Nobrega, 342; Donkin, "Spanish Red," 48.

SIXTEEN: SCARLET FEVER

210 *Dutch botanical stations*: Drayton, 71.

210 *Dutch economic reforms*: Elson, 39, 72–73.

210 *procuring cochineal for Java*: van Deventer, 2:401; Born, 222.

211 *Cultivation System*: Donkin, "Spanish Red," 50; Elson, 42–44, 99–127.

212 *"whether it is your imperial will . . ."*: Dekker, in King, 41. On "Multatuli," see King, 11–12.

212 *reform and abolition of the Cultivation System*: Day, 330–37.

212 *"It is impossible . . ."*: van Hoëvell, in Elson, 100.

213 *"One might suppose . . ."*: Blommestein, in Elson, 439; van Deventer, 2:401.

213 *"The Javan is . . ."*: Monod de Froideville, 281.

213 *"the price climbs . . ."*: Ibid., 208.

213 *80,000 pounds*: Donkin, "Spanish Red," 50–51.

214 *louvers, canopies*: Monod de Froideville, 241–46; Donkin, "Spanish Red," 51.

214 *Javanese cochineal inferior*: Born, 224.

214 *Mexico*: Baskes, 203–5.

215 *Guatemala*: Woodward, 44, 59, 379–80; McCreery, 113–28; Born, 223; Donkin, "Spanish Red," 30–31.

215 *Canary Islands*: Blanchard, 52; Nobrega, 342; Donkin, "Spanish Red," 47; Davies, 359.

217 *red losing cachet*: Perrot, 31–32.

217 *"clouded and neutral . . ."*: Ladies' Hand-book [1843], 36. See also Laver, 168–70; Brontë, 480–81.

218 Villette: Brontë, 480–81.

218 *"fantastically embroidered"*: Hawthorne, *Scarlet Letter*, 52–59. See also Earle, *Punishments*, 86–90. Hawthorne had been contemplating the central motif of *The Scarlet Letter* since at least 1844 (Gale, 441).

219 *"Rush of Cochineal," "a tint too Red"*: Dickinson, *Poems*, 3:1305 (#1489/1463); 2:944 (#1083/1463). The latter poem was composed about 1865, but its metaphor—"If the Tune drip too much/Have a tint too Red/Pardon the Cochineal"—reflects attitudes toward cochineal that were common from at least the 1840s onward. See also Dickinson, *Poems*, 1:150 (#150/60) and 2:738 (#786/748).

219 *"brilliant red," "no lady . . ."*: How to Dress, 6; Science, 18.

219 *vogue for dark reds, crinolines*: How to Dress, 6; Science, 18; Perrot, 101; Laver, 178–88.

219 *Jefferson Davis*: Cooper, 538.

220 *"Extravagant display . . .*": Stone, 1:258.

220 *"broad cactus fields"*: Morelet, in Donkin, "Spanish Red," 31.

SEVENTEEN: A LUMP OF COAL

222 *"I saw there was in chemistry . . .*": Perkin, in Meldola, 65. See also Garfield, 16–19; Read, 6–7.

222 *chemistry mistrusted*: Meldola, 65; Bensaude-Vincent and Stengers, 97–99; Freemantle, 39–43.

222 *Royal College, Hofmann*: Haber, *Nineteenth Century*, 68–69; Kendall, 71; Garfield, 25–27.

223 *"at once obtained . . .*": Perkin, in Kendall, 72. The salt in question was orthonitrophenal.

223 *quinine*: Kendall, 72; Meldola, 65; Drayton, 208–11; Garfield, 33; Morgan, 53.

225 *"a perfectly black product"*: Perkin, in Garfield, 36.

225 *"Tyrian purple"*: Kendall, 74.

225 *synthetic dyes*: Ball, 206–10; Garfield, 44.

225 *"If your discovery . . .*": Pullar, in Kendall, 75.

226 *"He appeared much annoyed . . .*": Perkin, in ibid. See also Meldola, 40, 66.

226 *family's support*: Meldola, 66.

227 *Perkin's innovations*: Gwynant Evans, 62; Kendall, 76; Garfield, 56–59.

227 *"Purple-striped gowns . . .*": Ball, 214.

227 *painters*: Ibid., 228.

228 *"crimson colouring principle"*: Hofmann, in Garfield, 74.

228 *fuchsine, synthetic reds*: Delamare and Guineau, 98–99; Garfield, 74–75; McClellan, 2:283.

228 *"tar-distilled crimson . . .*": Hofmann, in Garfield, 77.

229 *cochineal prices in England, France*: McCreery, 348; Garfield, 81.

229 *Java*: Elson, 134–35, 403.

229 *Mexico, Guatemala, Canary Islands*: McCreery, 128–29; Woodward, 379–81; Davies, 359; Calderón, 40; Donkin, "Spanish Red," 47; Schweppe and Roosen-Runge, 268.

230 *alizarin*: Garfield, 92–97; Ball, 220–21; Brunello, 287.

231 *Biebrich scarlet, new red dyes*: Delamare and Guineau, 102; Brunello, 301.

231 *Guatemala*: Woodward, 379–83; 430–32.

231 *Canary Islands*: Davies, 359–70; Stone, 1:233.

231 *Oaxaca*: Chassen and Martínez, 54–70; Diguet, 89–90; Wright, 636–38; Donkin, "Spanish Red," 31–32.

232 *Persia*: Chenciner, 269. In the long run, laws against the use of synthetic dyes generally proved ineffective.

232 *cochineal water-fast, rain-resistant*: Davies, 359; DuCane, 6.

233 *health hazards, arsenic*: Travis, 343–65; Garfield, 83–84, 100–108.

233 *fear of synthetics in medicine, makeup, food*: Garfield, 103–4, 123.

233 *"You know how . . ."*: Nesbit, 113.

234 *"send down . . ."*: Coward, 15.

234 *harmless*: The ways in which synthetic dyes obtained expert approval varied from country to country. In the United States, for example, laws regulating the use of dangerous dyes in foodstuffs were passed after the Food and Drug Administration was established in 1906. These laws increased safety standards and allayed the public's fears.

234 *red coats*: Schweppe and Roosen-Runge, 280.

Eighteen: Renaissance Dye

235 *rise of Germany, patent law*: Bensaude-Vincent and Stengers, 185; Chemical Society, 14–19; Read, 28; Haber, *Nineteenth Century*, 69, 120, 128, 198–204.

237 *Perkin*: Garfield, 95–97, 119–22.

238 *"in his element . . ."*: "Centenary," 4.

238 *"England has . . ."*: Duisberg, in Meldola, 52–53.

239 *World War I*: Haber, *Cloud*, 24–27, 34–35, 184–98; J. A. Johnson 189–94; Haber, *1900–1930*, 208–10.

239 *Allied factories, reparations, and patents*: Haber, *1900–1930*, 218–20, 248–49. The Treaty of Versailles also demanded other dye concessions from Germany, but these were later mitigated.

241 *markets in Asia, Africa, and Latin America*: Chenciner, 268–69; Haber, *1900–1930*, 275–77; Bensaude-Vincent and Stengers, 196.

241 *"The nopalries . . ."*: Diguet, 89.

242 *Oaxacan producers*: Ibid., 89–90; Wright, 636–37; Donkin, "Spanish Red," 31–32.

242 *Oaxacan artisans*: Wallert, 59–82; de Ávila, "Appendix" to "Threads of Diversity" (ms).

242 *"supplanted largely by aniline dyes"*: Terry, 850.

243 *Mexican scientific expedition*: Wright, "A Thousand Years," 637–38.

243 *cancer fears*: Schweppe and Roosen-Runge, 269; United States, 109–18; González Carrancá, 47–48; Henkel (Web).

243 *asthma, attention deficit disorder*: For a list of articles in reputable journals that link synthetic red dyes with various health problems, consult http://www.feingold.org/research_adhd.html.

244 *cochineal renaissance*: Flores Flores and Tekelenburg, 168; Okie; Seay.

245 *Peru*: Flores Flores and Tekelenburg, 168; Emmett, 94; Donkin, "Spanish Red," 36; Kaste (Web).

245 *cochineal prices, oversupply*: Flores Flores and Tekelenburg, 169; Emmett, 94; Kaste (Web).

246 *allergic reactions*: "Common Food Dye" (Web).

246 *vegetarian, kosher concerns*: Seay.

246 *Ignacio del Río Dueñas*: Sr. del Río, interview with the author, November 29, 2003.

246 *Isaac Vásquez*: A good description of Isaac Vásquez's life and work may be found in Elizabeth Snoddy Cuéllar's "A Natural Dye Innovator."

246 *Cruz family*: Fidel Cruz and María Luisa Mendoza, interview with the author, November 29, 2003. John M. Forcey's *The Colors of Casa Cruz* is the best published guide to their work.

247 *to make a living*: For more on the economics of Oaxaca's textile industry and its human impact in Teotitlán del Valle, see Stephen, 87–155.

EPILOGUE: CHEAP COLOR

248 *1860s fashions*: Price, 135–36; Laver, 190; Nunn, 153–56; Gernsheim, 54–55.

249 colorless: *Oxford English Dictionary*.

249 *"To be fancifully dressed . . ."*: Martine, 49.

249 *"ferocious violet, . . ."*: Taine, in Byrde, 62–63.

250 *"The cheaper magenta . . ."*: *British Medical Journal*, in Garfield, 106.

250 *military glory*: Red's enduring symbolic connection with military valor—and later with communist struggles—may explain why so many countries employ it as a dominant color in their flags.

250 *Turkistan*: I am indebted to Tom Reiss for this story, which he shared from the manuscript of his forthcoming book, *The Orientalist*.

250 *"racial love"*: "Colors for Men," in Joselit, 92.

250 colored, Red Indian, yellow race: *Oxford English Dictionary.*

251 *"Their complexion . . .":* Mérimée, 108.

251 *"a red skirt . . ." "In my country . . .":* Ibid., 42.

251 *"women with jet-black hair . . .":* Auguste Debay, in Perrot, 102.

251 *"loud," "Oriental," "for a human . . .":* Jerome, 60.

252 *similar attitudes:* For one example, see A. Edwards, 58.

252 *"All through the life . . .":* DuBois, 54.

253 *"showy", "mark of gentility", "to have livery . . .":* Holding, 80.

253 *"more like violets":* "What Our Girls Can Do," in Joselit, 183. The statement comes from an 1895 Jewish publication for girls, but the aim was common to many other immigrant groups.

253 *Indian boarding schools:* Lomawaima, 90–91. This account of the Chilocco Indian School in Oklahoma notes that red sweaters were permitted in later years, but one student recalls that some staff would refuse to teach until the students took the sweaters off.

253 *"showily," "err on the side . . .":* Mrs. M. F. Armstrong, in Joselit, 180

254 *"royal blues . . .":* Larsen, 17–18.

254 *"self-control":* E. Azalia Hackley, in Joselit, 40–41.

254 *"startling":* F. White, 60.

255 *pulp magazine covers:* Stewart, 54–59.

256 *blue:* Pastoureau, *Blue,* 51–55, 62–63, 79, 140, 166–70; Burnham, 209–10; Byrne (Web); Sharpe, 51. Pastoureau believes that in France and northern Europe blue achieved supremacy as early as 1600 (*Blue,* 85, and *Jésus,* 110), but his evidence on this point is sketchy. Roche's study of prerevolutionary Parisian wardrobes (129–41) indicates that in the late 1700s red was more popular among the French nobility than blue, although blue was preferred by artisans and shopkeepers.

257 *"The poverty . . .":* La Génie de la mode, in Steele, 95.

257 *nineteenth-century black:* Harvey, 129–223; Steele, 64–66, 81–96; Hollander, 374–83; Laver, 169–70; Edelman, 31, 33; Mendes, 7–10.

257 *"as dark as a London crowd":* Hardy, in Ashelford, *Art of Dress,* 302–3.

258 *"the stay-by . . .":* The Lady's Magazine, in Mendes, 9.

258 Madame X: Mount, 74–91; Davis, 128, 182–88.

259 *"sort of uniform . . .":* Vogue, in Edelman, 14. See also Mendes, 10–11.

260 *red has languished:* Choungourian, 1203–6; Byrne (Web); Pastoureau, *Blue,* 170–74; Komar and Melamid (Web).

260 *communism and socialism:* In a recent random survey of color preferences (see Komar [Web]), Americans selected red at about the same

rate as Russians and Turks; overall, they valued it considerably more highly than the Chinese. It is worth noting that while red is the color of communism, the Chinese government at times has castigated it as a symbol of prerevolutionary decadence, especially in clothing.

260 *Reagan*: Rubenstein, 219.

261 *American women*: "Results" (Web).

261 *curious universality*: Byrne (Web); Osgood et al., 329.

261 *we react to it*: Eiseman, 19–20; Sharpe, 81–85.

Select Bibliography

Acosta, José de. *Historia natural y moral de las Indias* (1590). Edited by Edmundo O'Gorman. Reprint, Mexico, 1962.

Adams, Richard. *Prehistoric Mesoamerica.* Rev. ed. Norman: University of Oklahoma Press, 1991.

Allison, Alexander W. et al., eds. *Norton Anthology of Poetry.* Rev. ed. New York: Norton, 1975.

Alzate y Ramírez, José Antonio. "Memoria sobre la grana" (1777). *Gazeta de literatura.* 1794.

"Alzate y Ramírez, José Antonio." *Dictionary of Scientific Biography.* Edited by Charles Coulston Gillespie. New York: Scribners, 1970.

Anderson, James. *An Account of the Importation of American Cochineal Insects into Hindostan.* Madras, 1795.

———. *Communications, etc.* Madras [1795–96].

———. *Communications from October the 1st, until the 12th of December 1795.* Madras [1796].

———. *Letters.* 2 parts. Madras, 1796.

———. *Letters on Cochineal Continued.* Madras, 1789.

———. *Letters to Sir Joseph Banks . . . on the Subject of Cochineal Insects.* [Madras, 1788].

Andrews, Kenneth R. *The Spanish Caribbean: Trade and Plunder, 1530–1630.* New Haven: Yale University Press, 1978.

Arnold, Janet. *Queen Elizabeth's Wardrobe Unlock'd.* Leeds: Maney, 1988.

Ashelford, Jane. *The Art of Dress: Clothes and Society, 1500–1914.* New York: Abrams, 1996.

————. *Dress in the Age of Elizabeth I*. London: Batsford, 1988.

Atasoy, Nurhan, et al. *Ipek: The Crescent and the Rose: Imperial Ottoman Silks and Velvets*. London: Azimuth, 2001.

Baker, J. R. *Principles of Biological Microtechnique*. New York: Wiley, 1958.

Baldwin, Frances E. *Sumptuary Legislation and Personal Regulation in England*. Baltimore: Johns Hopkins University Press, 1926.

Ball, Philip. *Bright Earth: Art and the Invention of Color*. New York: Farrar, 2001.

Barnhart, Robert K., ed. *Chambers Dictionary of Etymology*. New York: H. H. Wilson, 2000.

Barron, Caroline, and Nigel Saul, eds. *England and the Low Countries in the Late Middle Ages*. New York: St. Martin's, 1995.

Barzun, Jacques. *From Dawn to Decadence: 500 Years of Western Cultural Life*. New York: HarperCollins, 2000.

Baskes, Jeremy Alan. *Indians, Merchants, and Markets: A Reinterpretation of the Repartimiento and Spanish-Indian Economic Relations in Colonial Oaxaca, 1750–1821*. Stanford: Stanford University Press, 2000.

Battles, Matthew. *Library: An Unquiet History*. New York: Norton, 2003.

Baumgarten, Linda. *What Clothes Reveal: The Language of Clothing in Colonial and Federal America*. New Haven: Colonial Williamsburg Foundation/Yale University Press, 2002.

Beam, Alex. *Gracefully Insane: Life and Death inside America's Premier Mental Hospital*. New York: Public Affairs, 2003.

Beckmann, John. *A History of Inventions, Discoveries, and Origins* (1783–1805). 4th ed. Translated by William Johnston. 2 vols. London, 1846.

Bell, John. *Notices of Cochineal, Including a Correspondence which Took Place in the Newspapers, on the Subject, in 1828*. Calçutta, 1838.

Bemiss, Elijah. *The Dyer's Companion* (1815). 3rd ed. New York: Dover, 1973.

Bensaude-Vincent, Bernadette, and Isabelle Stengers. *A History of Chemistry*. Translated by Deborah van Dam. Cambridge, MA: Harvard University Press, 1996.

Berdan, Frances, and Jacqueline de Durand-Forest, eds. *Matrícula de Tributos*. Graz, Austria: Akademische Druck-u Verlagsanstalt, 1980.

Berdan, Frances, and Patricia Rieff Anawalt, eds. *The Essential Codex Mendoza*. Berkeley: University of California Press, 1997.

Berlin, Brent, and Paul Kay. *Basic Color Terms: Their Universality and Evolution*. Berkeley: University of California Press, 1969.

Bernstein, Peter L. *The Power of Gold: The History of an Obsession*. New York: Wiley, 2000.

Bishop, Morris. *Champlain: The Life of Fortitude*. New York: Knopf, 1948.

Blanchard, Émile. "Cochenille." In *Dictionnaire universel d'histoire naturelle*, edited by Dessalines D'Orbigny, 4(2): 49–54 Paris, 1883.

Blegborough, Ralph. *An Address to the Governors of the Surrey Dispensary*. London, 1810.

Blunt, Wilfred. *The Complete Naturalist: A Life of Linnaeus*. New York: Viking, 1971.

Boas, Marie. *The Scientific Renaissance, 1450–1630*. New York: Harper, 1962.

Böhmer, Harald. *Koekboya: Natural Dyes and Textiles*. Translated by Lawrence E. Fogelberg. Germany: REMHÖB-Verlag, 2002.

Borah, Woodrow. *Silk Raising in Colonial Mexico*. Berkeley: University of California Press, 1943.

Born, Wolfgang. "Scarlet." *Ciba Review* 7 (March 1938): 206–27.

Boyden, James M. *The Courtier and the King: Ruy Gòmez de Silva, Philip II, and the Court of Spain*. Berkeley: University of California Press, 1995.

Boyle, Robert. *The Works of Robert Boyle*. Edited by Michael Hunter and Edward B. Davis. 14 vols. London: Pickering and Chatto, 1999–2000.

Brandi, Karl. *The Emperor Charles V: The Growth and Destiny of a Man and of a World-Empire*. Translated by C. V. Wedgwood. New York: Knopf, 1939.

Braudel, Fernand. *Civilization and Capitalism: 15th–18th Century*. Translated by Siân Reynolds. 2 vols. Berkeley: University of California Press, 1992.

Brigden, Susan. *New Worlds, Lost Worlds: The Rule of the Tudors, 1485–1603*. New York: Viking, 2000.

Brontë, Charlotte. *Villette* (1853). Edited by Herbert Rosengarten and Margaret Smith. Oxford: Clarendon Press, 1984.

Brown, Jonathan. *Painting in Spain, 1500–1700*. New Haven: Yale University Press, 1998.

Browne, Walden. *Sahagún and the Transition to Modernity*. Norman: University of Oklahoma Press, 2000.

Brunello, Franco. *The Art of Dyeing in the History of Mankind*. Translated by Bernard Hickey. Vicenza: Neri Pozza Editore, 1973.

Brutsch M. O., and H. G. Zimmermann. "Control and Utilization of Wild Opuntias." In *Agro-Ecology, Cultivation, and Uses of Cactus Pear*, edited by Giuseppe Barbera, Paolo Inglese, and Eulogio Pimienta-Barrios, 155–66. Rome: FAO, United Nations, 1995.

Buchanan, Rita. *A Dyer's Garden*. Loveland, Colo.: Interweave Press, 1995.

Burgoa, Francisco. *Geografica descripción*. 2 vols. Mexico, 1674.

Burnham, Robert W., et al. *Color: A Guide to Basic Facts and Concepts*. New York: Wiley, 1963.

Byrde, Penelope. *Nineteenth-Century Fashion*. London: Batsford, 1992.

Byrne, Marie. "Culture and Communications: Similarities of Color Meaning Among Diverse Cultures." *Journal of Global Issues and Solutions*. http://bwwsociety.org/ journal/html/color.htm (accessed July 31, 2003).

Calderón, Francisco R. *El República Restaurada: La Vida Económica*. Historia Moderna de México. Edited by Daniel Cosío Villegas. Mexico City: Hermes, 1965.

Calendar of State Papers, Colonial Series. Edited by W. Noel Sainsbury, J. W. Fortescue, et al. London, 1860–.

Calendar of State Papers, Domestic Series, of the Reigns of Edward VI, Mary, Elizabeth and James I. Edited by Robert Lemon and Mary A. E. Green. 12 vols. London, 1856–72.

Calendar of State Papers relating to English affairs preserved in . . . the Archives of Simancas. Edited by Martin A. S. Hume. 4 vols. London, 1892–99.

Cardon, Dominique. "Textile Research: An Unsuspected Mine of Information on Some Eighteenth-Century European Textile Products and Colour Fashions around the World." *Textile History* 29 (Spring 1998): 93–102.

———. "Les 'vers' du rouge: insectes tinctoriaux utilisés dans l'Ancien Monde au Moyen Age." *Cahiers d'histoire et de philosophie des sciences* 28 (1990): 1–178.

Carman, W. Y. *A Dictionary of Miltary Uniform.* New York: Scribner, 1977.

Carter, Harold B. *Sir Joseph Banks, 1743–1820.* London: British Museum, 1988.

Castelló Yturbide, Teresa. *Colorantes Naturales de México.* Mexico: Industrias Resistol, 1988.

"The Centenary of a Great Discovery: Sir William H. Perkin's Mauve." Supplement. *Manchester Guardian,* May 7, 1956.

Cervantes de Salazar, Francisco. *México en 1554* (1554). 2nd ed. Mexico City: Ediciones de la Universidad Nacional Autónoma, 1952.

Champlain, Samuel. *Works* (c. 1602–1632). Edited by H. P. Bigger. 6 vols. Toronto: Champlain Society, 1922–36.

Chassen, Francie R., and Héctor G. Martínez. "El desarollo económico de Oaxaca a finales del Porfiriato." In *Lectoras Históricas del Estado de Oaxaca,* edited by María de los Ángeles Romero Frizzi, 4:47–72. Mexico City: Instituto Nacional de Antropología, 1986–90.

Chaucer, Geoffrey. *Canterbury Tales.* Translated by Nevill Coghill. New York: Penguin, 2003.

Chaunu, Huguette, and Pierre Chaunu. *Séville et l'Atlantique.* 8 vols. Paris: SEVPEN, 1955–59.

Chazotte, Peter Stephen. *Facts and Observations on the Culture of Vines, Olives, Capers, Almonds, &c. in the Southern States, and of Coffee, Cocoa and Cochineal, in East Florida.* Philadelphia, 1821.

Chemical Society. *The Life and Work of Professor William Henry Perkin.* London: Chemical Society, 1932.

Chenciner, Robert. *Madder Red: A History of Luxury and Trade: Plant Dyes and Pigments in World Commerce and Art.* Richmond, Surrey: Curzon Press, Caucasus World Series, 2000.

Chevalier, A. "Medieval Dress." *Ciba Review* 57 (June 1947): 10–16.

Chipman, Donald E. *Nuño de Guzmán and the Province of Pánuco in New Spain, 1518–1533.* Glendale, Calif.: Arthur H. Clark, 1967.

Choungourian, A. "Color Preferences and Cultural Variation." *Perception and Motor Skills* 26 (1968): 1203–6.

Clay, Reginald S., and Thomas H. Court. *The History of the Microscope*. London: Griffin, 1932.

Clendinnen, Inga. *Aztecs: An Interpretation*. Cambridge: Cambridge University Press, 1991.

Cobb, Matthew. "Reading and Writing *The Book of Nature*: Jan Swammerdam (1637–1680)." *Endeavour* 24 (2000): 122–28.

Cody, W. F. "An Index to the Periodicals Published by José Antonio Alzate y Ramírez." *Hispanic American Historical Review* 33 (August 1953): 442–75.

"Common Food Dye Can Cause Severe Allergic Reaction." November 3, 1997. University of Michigan News and Information Services, http://www.umich.edu/~newsinfo/Releases/1991/nov97/r110197. html (accessed July 25, 2001).

Contreras Sánchez, Alicia del Carmen. *Capital Comercial y Colorantes en la Nueva España*. Zamora, Michoacán: Universidad Autónoma de Yucatán, 1996.

Cooper, William J. *Jefferson Davis, American*. New York: Knopf, 2000.

Cortés, Hernan. *Letters from Mexico*. Translated by Anthony Pagden. New Haven: Yale University Press, 1986.

Cossío Silva, Luis. "La Agricultura." In *Historia Moderna de Mexico: El Porfiriato: La Vida Económica*, edited by Daniel Cosío Villegas. Mexico: Hermes, 1974.

Coward, Noel. *Private Lives: An Intimate Comedy in Three Acts*. London: Heinemann, 1930.

Crombie, A. C. *Medieval and Early Modern Science*. 2 vols. Garden City, NY: Doubleday, 1959.

Crosby, Alfred W. *Ecological Imperialism: The Biological Expansion of Europe, 900–1900*. Cambridge: Cambridge University Press, 1986.

Crow, John A. *Spain: The Root and the Flower: An Interpretation of Spain and the Spanish People*. 3rd ed. Berkeley: University of California Press, 1985.

Dahlgren de Jordan, Barbro. *La grana cochinilla*. Mexico City: Porrua, 1963.

———. *La Mixteca y su cultura e historica prehispánicas*. Mexico City: Imprenta Universitaria, 1954.

Dampier, William. *A New Voyage round the World*. London, 1697.

Da Ponte, Lorenzo. *Memoirs* (1823–27). Edited by Arthur Livingston. Translated by Elisabeth Abbott. New York: New York Review of Books, 2000.

Davies, P. N. "The British Contribution to the Economic Development of the Canary Islands, with Special Reference to the 19th Century." In *VI Coloquio de Historia Canario Americano*, edited by Francisco Morales Padrón and Vicente Suárez Grimón, 355–70. Las Palmas, 1987.

Davis, Deborah. *Strapless: The Rise of John Singer Sargent and the Fall of Madame X*. New York: Penguin, 2003.

Day, Clive. *The Policy and Administration of the Dutch in Java*. New York: Macmillan, 1904.

de Ávila B., Alejandro. "El insecto humanizado: Biología y mexicanidad en los textos de Alzate y sus contemporáneos acerca de la grana." In José Antonio de Alzate, *Memoria sobre la naturaleza, cultivo y beneficio de la grana* (1777), 19–53. Mexico City: Archivo General de la Nación, 2001.

———. "Threads of Diversity: Oaxacan Textiles in Context." Author's manuscript. Published as "Threads of Diversity" in *The Unbroken Thread: Conserving the Textile Traditions of Oaxaca*, edited by Kathryn Klein, 87–151. Los Angeles: Getty Conservation Institute, 1997.

Defourneaux, Marcelin. *Daily Life in Spain in the Golden Age*. Translated by Newton Branch. Stanford: Stanford University Press, 1979.

De Francisco, Grete. "The Venetian Silk Industry." *Ciba Review* 29 (January 1940): 1027–1035.

Delamare, François, and Bernard Guineau. *Colors: The Story of Dyes and Pigments*. Translated by Sophie Hawkes. New York: Abrams, 2000.

Delmarcel, Guy. *Flemish Tapestry*. Translated by Alastair Weir. New York: Abrams, 1999.

Diamond, Jared. *Guns, Germs, and Steel: The Fates of Human Societies*. New York: Norton, 1997.

Díaz del Castillo, Bernal. *Historia verdadera de la conquista de la Nueva España* (c. 1555). Edited by Miguel León-Portilla. 2 vols. Madrid: Historia 16, 1984.

———. *A True History of the Conquest of New Spain.* Edited by A. P. Maudsley. 5 vols. London, Hakluyt Society, 1908–16.

Dickinson, Emily. *The Letters of Emily Dickinson.* Edited by Thomas H. Johnson. 3 vols. Cambridge, Mass.: Belknap-Harvard University Press, 1958.

———. *The Poems of Emily Dickinson.* Edited by R. W. Franklin. 3 vols. Cambridge, Mass.: Belknap-Harvard University Press, 1998.

Diderot, Denis. *Encyclopédie ou Dictionnaire raisonée des sciences, des artes, et des métiers* (1751–80). 35 vols. Stuttgart: Frommann, 1966.

Diguet, Léon. "Histoire de la cochenille au Mexique." *Journal de la Société des Americanistes de Paris* 3 (1906): 75–99.

Dobbs, Betty Jo Teeter. *Alchemical Death and Resurrection: The Significance of Alchemy in the Age of Newton.* Washington, D.C.: Smithsonian Instititution Libraries, 1990.

Domínguez Ortiz, Antonio. *The Golden Age of Spain, 1516–1659.* Translated by James Casey. New York: Basic Books, 1971.

Donkin, R. A. "The Insect Dyes of Western and West-Central Asia." *Anthropos* 72 (1977): 847–68.

———. "Spanish Red: An Ethnogeographical Study of Cochineal and the Opuntia Cactus." *Transactions of the American Philosophical Society* 67 (September 1977): 3–84.

Donne, John. *The Complete English Poems.* Edited by David Campbell. London: Everyman-Random, 1991.

Drayton, Richard. *Nature's Government: Science, Imperial Britain, and the "Improvement" of the World.* New Haven: Yale University Press, 2000.

DuBois, W. E. B. "Diuturni Silenti." *The Education of Black People: Ten Critiques, 1906–1960.* Edited by Herbert Aptheker. Amherst: University of Massachusetts Press, 1973.

DuCane, Florence. *The Canary Islands.* London, 1911.

Dupont, Florence. *Daily Life in Ancient Rome.* Translated by Christopher Woodall. Oxford: Blackwell, 1993.

Earle, Alice Morse. *Curious Punishments of Bygone Days* (1896). Bedford, Mass.: Applewood Press, 1995.

Edelman, Amy Holman. *The Little Black Dress.* New York: Simon and Schuster, 1997.

Edelstein, S. M. "Historical Notes on the Wet-Processing Industry: I. How Napoléon Aided the Early Dyeing Industry of France." *American Dyestuff Reporter* 43 (1954): 33–34.

———. "Spanish Red: Thiery de Menonville's *Voyage à Guaxaca.*" *American Dyestuff Reporter* 47 (January 1958): 1–8.

Edler de Roover, Florence. "The Beginnings and the Commercial Aspects of the Lucchese Silk Industry." *Ciba Review* 80 (June 1950): 2907–14.

———. "The Manufacturing Process." *Ciba Review* 80 (June 1950): 2915–22.

Edwards, Anne. *The Reagans: Portrait of a Marriage.* New York: St. Martin's, 2003.

Edwards, E. H. "Making the Redcoat: British Army Uniform Manufacture." *Military Illustrated* 81 (February 1995): 15–16.

Eiseman, Leatrice. *Pantone Guide to Communicating with Color.* Sarasota, Fla.: Grafix Press, 2000.

Eisner, Thomas, Stephen Nowicki, Michael Goetz, and Jerrold Meinwald. "Red Cochineal Dye: Its Role in Nature." *Science* 208 (May 30, 1980): 1039–42.

Elliott, J. H. *Imperial Spain, 1469–1716.* New York: Penguin, 1990.

———. *The Old World and the New, 1492–1650.* Cambridge: Cambridge University Press, 1970.

Ellis, William. *The Country Housewife's Family Companion.* London, 1750. http://www.soilandhealth.org/03sor/0302hsted/030205ellis/030205diseases.html (accessed July 2, 2003).

Elson, R. E. *Village Java Under the Cultivation System, 1830–1870.* Sydney: Allen and Unwin, 1994.

Emmett, Suzie. "Price Slump Makes Producers See Red." *Farmers Weekly,* May 3, 2002, 94.

Erickson, Carolly. *The First Elizabeth.* New York: Summit Books, 1983.

Fabre, Daniel. "Families: Privacy versus Custom." In *A History of Private Life,* edited by Philippe Ariès and Georges Duby, 3: 531–69. Cambridge, Mass.: Belknap-Harvard, 1989.

Fernández Alvarez, Manuel. *Charles V: Elected Emperor and Hereditary Ruler.* Translated by J. A. Lalaguna. London: Thames and Hudson, 1975.

Fernández de Oviedo y Valdés, Gonzalo. *De la natural historia de las Indias*. Toledo, 1526.

———. *Historia general y natural de las Indias* (1535). Edited by J. Pérez de Tudela Bueso. Biblioteca de Autores Españoles. 5 vols. Reprint, Madrid, 1950.

Finlay, Victoria. *Color: A Natural History of the Palette*. New York: Ballantine, 2002.

Fischer, David Hackett. *Paul Revere's Ride*. New York: Oxford University Press, 1995.

Flores Flores, V., and A. Tekelenburg. "Dacti Dye Production." In *Agro-Ecology, Cultivation, and Uses of Cactus Pear*, edited by Giuseppe Barbera, Paolo Inglese, and Eulogio Pimienta-Barrios, 167–85. Rome: FAO, United Nations, 1995.

Fontana, Nicola. *Memoir on the Bengal Cochineal*. London, 1779.

Forcey, John M. *The Colors of Casa Cruz*. Oaxaca, Mexico: Impresos Árbol de Vida, 1999.

Foster, Helen Bradley. *New Raiments of Self: African-American Clothing in the Antebellum South*. New York: Berg, 1997.

Fraser, Antonia. *Mary, Queen of Scots*. New York: Delacorte, 1969.

Freemantle, Michael. "Cambridge Marks 300 Years of Chemistry," *Chemical and Engineering News* 80 (August 12, 2002): 39–43.

Frick, Carole Collier. *Dressing Renaissance Florence: Families, Fortunes, and Fine Clothing*. Baltimore: Johns Hopkins University Press, 2002.

Gage, John. *Color and Culture: Practice and Meaning from Antiquity to Abstraction*. Boston: Bulfinch Press, 1993.

———. *Color and Meaning: Art, Science and Symbolism*. Berkeley: University of California Press, 1999.

———. *Life in Italy at the Time of the Medici*. New York: Putnam, 1968.

Gage, Thomas. *The English-American: A New Survey of the West Indies* (1648). Edited by A. P. Newton. London, 1928.

Gale, Robert L. *A Nathaniel Hawthorne Encyclopedia*. New York: Greenwood Press, 1991.

Garfield, Simon. *Mauve: How One Man Invented a Color That Changed the World*. New York: Norton, 2001.

Gay, Josè Antonio. *Historia de Oaxaca* (1881). Mexico City: Editorial Porrúa, 2000.

Gerard, John. *The herball.* Edited by Thomas Johnson. London, 1633.

Gernsheim, Alison. *Victorian and Edwardian Fashion: A Photographic Survey.* New York: Dover, 1963.

Gerritsen, Frans. *Theory and Practice of Color: A Color Theory Based on Laws of Perception.* 2nd ed. Translated by Ruth de Vriendt. New York: Van Nostrand, 1983.

Gettens, Rutherford J., Robert L. Feller, and W. T. Chase. "Vermilion and Cinnabar." In *Artists' Pigments: A Handbook of Their History and Characteristics,* 2:159–82. Washington, D.C.: National Gallery of Art, 1986.

Gibson, Charles. *Tlaxcala in the Sixteenth Century.* New Haven: Yale University Press, 1952.

Gies, Frances, and Joseph Gies. *Life in a Medieval Village.* New York: Harper, 1990.

Gies, Joseph, and Frances Gies. *Life in a Medieval City.* New York: Crowell, 1969.

Gillespie, Charles Coulston, ed. *Dictionary of Scientific Biography.* New York: Scribner's, 1970.

Gómez de Cervantes, Gonzalo. *La vida economica y social de Nueva España al finalizar el siglo XVI* (c. 1599). Edited by Alberto María Carreño. Reprint, Mexico City: José Porrúa, 1944.

González Carrancá, José Antonio. "Pintando ropa para la Unión Europea." *Negocios,* November 2003, 47–48.

Grafton, Anthony. *New Worlds, Ancient Texts: The Power of Tradition and the Shock of Discovery.* Cambridge, Mass: Belknap-Harvard University Press, 1992.

Grant, W. L. *Voyages of Samuel de Champlain, 1604–1618.* Original Narratives of American History. New York: Barnes and Noble, 1952.

Great Britain. Historical Manuscripts Commission. *De L'Isle Manuscripts.* Edited by C. L. Kingsford. London: HMSO, 1925–26.

———. *Sackville Manuscripts.* Edited by A. P. Newton et al. London: HMSO, 1940–66.

Green, Louis. *Castruccio Castracani: A Study on the Origins and Character of a Fourteenth-Century Italian Despotism.* Oxford: Clarendon, 1986.

Greenfield, Kent Roberts. *Sumptuary Law in Nürnberg.* Baltimore: Johns Hopkins University Press, 1918.

Gwynant Evans, John. "The Tinctorial Arts Today." In *Perkin Centenary London: 100 Years of Synthetic Dyestuffs,* 57–82. London: Pergamon Press, 1958.

Haber, L. F. *The Chemical Industry, 1900–1930.* Oxford: Clarendon, 1971.

———. *The Chemical Industry during the Nineteenth Century.* Oxford: Clarendon, 1958.

———. *The Poisonous Cloud: Chemical Warfare in the First World War.* Oxford: Clarendon, 1986.

Habsburg, Otto van. *Charles V.* Translated by Michael Ross. London, Weidenfield, 1970.

Hakluyt, Richard. *The Original Writings & Correspondence of the Two Richard Hakluyts.* Edited by E. G. R. Taylor. 2 vols. London: Hakluyt Society, 1935.

———. *The Principal Navigations, Voyages, Traffiques, and Discoveries of the English Nation.* 12 vols. Glasgow: MacLehose, 1903–1905.

Hale, J. R. *Florence and the Medici.* London: Phoenix, 1977.

Hamilton, Earl J. *American Treasure and the Price Revolution in Spain, 1501–1650.* New York: Octagon Books, 1965.

Hammer, Paul E. J. *The Polarization of Elizabethan Politics: The Political Career of Robert Devereux, 2nd Earl of Essex, 1585–1597.* Cambridge: Cambridge University Press, 1999.

Hamnett, Brian R. *Politics and Trade in Southern Mexico, 1750–1821.* Cambridge: Cambridge University Press, 1971.

Hanke, Lewis. *The Spanish Struggle for Justice in the Conquest of America.* Philadelphia: University of Pennsylvania Press, 1949.

———. *Los Virreyes españoles en América durante el gobierno de la Casa de Austria: México.* Biblioteca de autores españoles. 5 vols. Madrid: Atlas, 1976–.

Haring, C. H. *The Spanish Empire in America.* New York: Oxford University Press, 1947.

———. *Trade and Navigation between Spain and the Indies in the Time of the Hapsburgs* (1918). Reprint, Gloucester, Mass.: Smith, 1964.

Harley, R. D. *Artists' Pigments, c. 1600–1835: A Study in English Documentary Sources.* 2nd ed. London: Butterworth Scientific, 1982.

Harris, L. E. *The Two Netherlanders: Humphrey Bradley and Cornelis Drebbel.* Leiden: Brill, 1961.

Harrison, G. B. *The Life and Death of Robert Devereux, Earl of Essex.* New York: Henry Holt, 1937.

Hartsoeker, Nicolaas. *Essai de dioptrique.* Paris, 1694.

Harvey, John. *Men in Black.* Chicago: University of Chicago Press, 1995.

Haude, Mary Elizabeth. "Identification of Colorants on Maps from the Early Colonial Period of New Spain." *Journal of the American Institute of Conservation* 37 (1998): 240–70.

Hawthorne, Nathaniel. *The Scarlet Letter.* The Centenary Edition of the Works of Nathaniel Hawthorne. Columbus: Ohio State University Press, 1962.

Heers, Jacques. "La búsqueda de colorantes." *Historia Mexicana,* July–September 1961, 1–27.

Henkel, John. "From Shampoo to Cereal: Seeing to the Safety of Color Additives." *FDA Consumer,* December 1993. U.S. Food and Drug Administration. http://vm.cfsan.fda.gov/~dms/cos-221.html (accessed September 9, 2003).

Hernández, Francisco. *De materia medica Novae Hispaniae. cuatro libros sobre la materia médica de Nueva España* (1571–76). Edited by Raquel Álvarez Peláez and Florentino Fernández González. 4 vols. Madrid: Doce Calles, 1998.

Herrera y Tordesillas, Antonio. *Historia general de los hechos de los castellanos en las islas y tierra firme del mar océano.* Edited by Antonio Ballesteros-Beretta and Miguel Gómez del Campillo. 17 vols. Madrid: La Real Academia de la Historia, 1934–57.

Hibbert, Christopher. *The Virgin Queen: Elizabeth I, Genius of the Golden Age.* Reading, Mass.: Addison-Wesley, 1991.

Hickman, Katie. *Daughters of Britannia: The Lives and Times of Diplomatic Wives.* New York: Morrow-HarperCollins, 1999.

Hills, Paul. *Venetian Colour: Marble, Mosaic, Painting, and Glass, 1250–1550.* New Haven: Yale University Press, 1999.

Himmerich y Valencia, Robert. *The Encomenderos of New Spain, 1521–1555.* Austin: University of Texas Press, 1991.

Hoberman, Louisa Schell. *Mexico's Merchant Elite, 1590–1660: Silver, State, and Society.* Durham, N.C.: Duke University Press, 1991.

Hofenk-De Graaff, Judith H. "The Chemistry of Red Dyestuffs in Medieval and Early Modern Europe." *Cloth and Clothing in*

Medieval Europe: Essays in Memory of Professor E. M. Carus-Wilson. Edited by N. B. Harte and K. G. Ponting. London: Heinemann Educational Books, 1983.

Holding, T. H. *Uniforms of British Army, Navy and Court* (1894). Reprint, London: Muller, 1969.

Hollander, Anne. *Seeing through Clothes.* New York: Viking, 1978.

How to Dress with Taste. London: Ward and Lock, 1855.

Hughes, Diane Owen. "Sumptuary Law and Social Relations in Renaissance Italy." In *Disputes and Settlements: Law and Human Relations in the West,* edited by John Bossy, 69–100. Cambridge: Cambridge University Press, 1983.

Innes, Hammond. *The Conquistadors.* New York: Knopf, 1969.

Israel, Jonathan. *The Dutch Republic: Its Rise, Greatness, and Fall, 1477–1806.* New York: Oxford University Press, 1995.

Jaeger, F. M. *Cornelis Drebbel en zijne tijdgenooten.* Groningen, 1922.

Jardine, Lisa. *Ingenious Pursuits: Building the Scientific Revolution.* New York: Doubleday, 1999.

————. *Worldly Goods: A New History of the Renaissance.* New York: Doubleday, 1996.

Jerome, Jerome K. *Three Men in a Boat* (1889). London: Penguin, 1957.

Jiménez de la Espada, Don Marcos. *Descripción universal de las indias.* Bibilioteca de autores españoles. Madrid: Atlas, 1971.

Johnson, Jeffrey Allan. *The Kaiser's Chemists: Science and Modernization in Imperial Germany.* Chapel Hill: University of North Carolina Press, 1990.

Johnson, R. "Nova Britannia" (1609). In *Tracts and Other Papers Relating Principally to the Origin, Settlement, and Progress of the Colonies in North America,* edited by Peter Force, vol. 1. New York: P. Smith, 1947.

Jones, Anne R., and Peter Stallybrass. *Renaissance Clothing and the Materials of Memory.* Cambridge: Cambridge University Press, 2000.

Joselit, Jenna Weissman. *A Perfect Fit: Clothes, Character, and the Promise of America.* New York: Henry Holt, 2001.

Kamen, Henry. *Philip of Spain.* New Haven: Yale University Press, 1997.

Kaste, Martin. "A Big Market for Bug Dye." *All Things Considered,*

June 18, 2003. National Public Radio, http://www.npr.org/display_pages/features/feature_1302796.html (accessed July 31, 2003).

Kelsey, Harry. *Sir Francis Drake: The Queen's Pirate.* New Haven: Yale University Press, 1998.

Kendall, James. *Great Discoveries by Young Chemists.* New York: Crowell, 1953.

King, Peter. *Multatuli.* New York: Twayne, 1972.

Kirby, Jo, David Saunders, and John Cupitt. "Colorants and Colour Change." In *Early Italian Paintings: Techniques and Analysis,* edited by Tonnie Bakkenist, 65–76, Maastricht: Limberg Conservation Institute, 1997.

Kirby, Jo, and Raymond White. "The Identification of Red Lake Pigment Dyestuffs and a Discussion of their Use." *National Gallery Technical Bulletin* 17 (1996): 58–60.

Klarwill, Victor von, ed. *The Fugger News-Letters. 2nd series.* Translated by L. S. R. Byrne. New York: Putnam, 1926.

Koerner, Lisbet. *Linnaeus: Nature and Nation.* Cambridge: Harvard University Press, 1999.

———. "Purposes of Linnaean Travel: A Preliminary Research Report." In *Visions of Empire: Voyages, Botany and Representations of Nature,* edited by David Philip Miller and Peter Hanns Reill, 117–52. Cambridge: Cambridge University Press, 1996.

Komar, Vitaly, and Alex Melamid. "Survey Results." *The Most Wanted Paintings on the Web.* Dia Center for the Arts, http://www.diacenter/km/survey results.html (accessed July 31, 2003).

Krauze, Enrique. *Mexico: Biography of Power: A History of Modern Mexico, 1910–1996.* Translated by Hank Heifetz. New York: HarperCollins, 1997.

Lacey, Robert. *Robert, Earl of Essex.* New York: Atheneum, 1971.

The Ladies' Hand-book of the Toilet. London, 1843.

Laet, Joannes de. *Novus orbis, seu descriptionis Indiae Occidentales.* Leiden, 1633.

Lane, Frederic C. *Venice: A Maritime Republic.* Baltimore: Johns Hopkins University Press, 1973.

Larsen, Nella. *Quicksand* and *Passing.* Edited by Deborah McDowell. New Brunswick, NJ: Rutgers University Press, 1986.

Las Casas, Bartolomé de. *A Short Account of the Destruction of the Indies* (1552). Translated by Nigel Griffin. Reprint, London: Penguin Books, 1992.

Laver, James. *Costume and Fashion: A Concise History*. Rev. ed. World of Art. New York: Thames and Hudson, 1995.

Le Goff, Jacques. *Time, Work, and Culture in the Middle Ages*. Translated by Arthur Goldhammer. Chicago: University of Chicago Press, 1982.

Lee, Raymond L. "American Cochineal in European Commerce, 1526–1625." *Journal of Modern History* 23 (1951): 205–24.

———. "Cochineal Production and Trade in New Spain to 1600." *The Americas* 4 (1947–48): 449–73.

Leeuwenhoek, Antoni van. *The Collected Letters of Antoni van Leeuwenhoek* (*Alle de brieven van Antoni van Leeuwenhoek*). Edited by Gérard van Rijnberk et al. Amsterdam: Swets and Zeitlinger, 1939–.

———. *Opera Omnia, Seu Arcana Naturae*. Leiden, 1719–30.

Leix, Alfred. "Dyeing and Dyers' Guilds in Mediaeval Craftsmanship." *Ciba Review* 1 (September 1937): 10–16.

———. "Dyes of the Middle Ages." *Ciba Review* 1 (September 1937): 19–21.

Lemon, Jason Edward. "The Encomienda in Early New Spain." Ph.D. diss., Emory University, 2000.

Lenman, Bruce P. *England's Colonial Wars, 1550–1688: Conflicts, Empire and National Identity*. New York: Pearson, 2001.

León-Portilla, Miguel, ed. *The Broken Spears: The Aztec Account of the Conquest of Mexico*. Boston: Beacon Press, 1962.

Liles, J. N. *The Art and Craft of Natural Dyeing: Traditional Recipes for Modern Use*. Knoxville: University of Tennessee Press, 1990.

Lockhart, James, Frances Berdan, and Arthur J. O. Anderson, eds. *The Tlaxcalan Actas: A Compendium of the Records of the Cabildo of Tlaxcala*. Salt Lake City: University of Utah Press, 1986.

Lockhart, James, and Enrique Otte. *Letters and People of the Spanish Indies: Sixteenth Century*. Cambridge: Cambridge University Press, 1976.

Lockyer, Roger. *The Early Stuarts: A Political History of England*. New York: Longman, 1989.

Loera Fernández, José Manuel. *¿Qué es la Grana del Carmín? Cochinilla Fina.* Mexico: Tlapanochestli, n.d.

Lomawaima, K. Tsianina. *They Called It Prairie Light: The Story of Chilocco Indian School.* Lincoln: University of Nebraska Press, 1994.

López de Gómara, Francisco. *Historia general de las Indias con la conquista de México y de la Nueva España* (*Hispania victrix*, 1551–52). Edited by P. Guibelalde and E. M. Aguilera. 2 vols. Barcelona: Editora de los Amigos del Círculo del Bibliofilo, 1954.

Lorenzo Sanz, E. *Comercio de España con America en la época de Felipe II.* 2 vols. Valladolid: Servicio de Publicaciones de la Disputación Provincial, 1979–1980.

Mabberley, D. J. *The Plant-Book: A Portable Dictionary of the Vascular Plants.* New York: Cambridge University Press, 1997.

McClellan, Elisabeth. *Historic Dress in America, 1607–1870.* 2 vols. New York: Arno, 1977.

McCorquodale, Charles. *Bronzino.* New York: Harper, 1981.

McCreery, David. *Rural Guatemala, 1760–1840.* Stanford: Stanford University Press, 1994.

Mackay, David. "Agents of Empire: The Banksian Collectors and Evaluation of New Lands." In *Visions of Empire: Voyages, Botany and Representations of Nature,* edited by David Philip Miller and Peter Hanns Reill, 38–57. Cambridge: Cambridge University Press, 1996.

MacLeod, Murdo J. *Spanish Central America: A Socioeconomic History, 1520–1720.* Berkeley: University of California Press, 1973.

McNeil, William H. *Venice: The Hinge of Europe, 1081–1797.* Chicago: University of Chicago Press, 1974.

Mann, J. *The Cloth Industry in the West of England from 1640 to 1880.* Oxford: Clarendon University Press, 1971.

Markman, Charles. *Prehispanic Settlement Dynamics in Central Oaxaca, Mexico: A View from the Miahuatlan Valley.* Nashville: Vanderbilt University Publications in Anthropology, no. 26, 1981.

Marks, Richard Lee. *Cortés: The Great Adventurer and the Fate of Aztec Mexico.* New York: Knopf, 1993.

Martine, Arthur. *Martine's Hand-Book of Etiquette* (1866). Bedford, Mass.: Applewood Books, 1996.

Martínez, José Luis, ed. *Documentos Cortesianos*. 3 vols. Mexico City: Universidad Nacional Autónoma de México, 1990.

Martyr, Peter. *Epítome de Pedro Mártir de las islas recientemente descubiertas bajo el reino de don Carlos y de las costumbres de los habitantes* (1520). Mexico City: Juan Pablos, 1973.

Meek, Christine. *Lucca, 1369–1400: Politics and Society in an Early Renaissance City-State*. Oxford: Oxford University Press, 1978.

Meldola, Raphael, Arthur G. Green, et al., eds. *Jubilee of the Discovery of Mauve and of the Foundation of the Coal-Tar Colour Industry by Sir W. H. Perkin*. London: Perkin Memorial Committee [1906/1907].

Mendes, Valerie. *Black in Fashion*. London: V and A Publications, 1999.

Mérimée, Prosper. *Carmen* (1845). Translated by Edmund H. Garrett. Boston, 1896.

Miller, David Philip. "Joseph Banks, Empire, and Centers of Calculation in Late Hanoversian London." In *Visions of Empire: Voyages, Botany and Representations of Nature*, edited by David Philip Miller and Peter Hanns Reill, 21–37. Cambridge: Cambridge University Press, 1996.

Molà, Luca. *The Silk Industry of Renaissance Venice*. Baltimore: Johns Hopkins University Press, 2000.

Mollon, John. "Seeing Color." In *Colour: Art and Science*, edited by Trevor Lamb and Janine Bourriau, 127–50. Cambridge: Cambridge University Press, 1995.

Monod de Froideville, L. "Bijdragen tot de kennis van de *Nopal*-kultuuren *Cochenille*-teelt op Java." *Tijdschrift voor nederlandsche Indië* 9 (1847): 207–84.

Monson, William. *The Naval Tracts of Sir William Monson*. Edited by Michael Oppenheim. 5 vols. London: Navy Records Society, 1902–14.

Montchrestien, Antoine de. *Traicté de l'oeconomie politique* (1615). Paris: Rivière, 1920.

Moreau de Saint-Méry, Médéric-Louis-Elie. *A Civilization That Perished* (1797–1798). Translated by Ivor D. Spencer. Lanham, Md.: University Press of America, 1985.

Morgan, G. T. *Hofmann Memorial Lecture*. London: Macmillan, 1936.

Morison, Samuel. *The European Discovery of America: The Northern Voyages*. New York: Oxford University Press, 1971.

Motolinía. *Memoriales* (c. 1550). Edited by Edmundo O'Gorman. Mexico City: Universidad Nacional Autónoma de México, 1971.

Mount, Charles Merrill. *John Singer Sargent: A Biography*. New York: Norton, 1955.

Munro, John H. A. "The Medieval Scarlet and the Economics of Sartorial Splendor." In *Textiles, Towns, and Trade: Essays in the Economic History of Late-Medieval England and the Low Countries*, 13–70. Variorum Collected Studies Series: CS 442. Brookfield, Vt.: Variorum, 1994.

———. "Textile Workers in the Middle Ages." In *Textiles, Towns, and Trade: Essays in the Economic History of Late-Medieval England and the Low Countries*, 28–35. Variorum Collected Studies Series: CS 442. Brookfield, Vt.: Variorum, 1994.

Nesbit, Edith. *The Railway Children* (1906). Oxford: Oxford University Press, 1991.

Nicolson, Adam. *God's Secretaries: The Making of the King James Bible*. New York: HarperCollins, 2003.

Nobrega, Gerardo José de. "On the Cultivation of Cochineal." *Pharmaceutical Journal and Transactions* 8 (1848–49): 342–48.

Norwich, John Julius, ed. *Britain's Heritage*. London: Rainbow, 1993.

Nunn, Joan. *Fashion in Costume, 1200–1980*. New York: Schocken, 1984.

Okie, Susan. "Coloring in Food, Makeup Tied to Allergic Attacks." *Washington Post*, December 9, 1997.

Osgood, C. E. et al. *Cross-Cultural Universals of Affective Meaning*. Chicago: University of Illinois Press, 1975.

Ott, Thomas O. *The Haitian Revolution, 1789–1804*. Knoxville: University of Tennessee Press, 1973.

Oxford English Dictionary. 2nd ed. New York: Oxford University Press, 1989.

Parker, Geoffrey. *Philip II*. Boston: Little, Brown, 1978.

Parks, George Bruner. *Richard Hakluyt and the English Voyages*. 2nd ed. New York: Frederick Ungar, 1961.

Parks, Peter. "Colour in Nature." In *Colour: Art and Science*, edited by Trevor Lamb and Janine Bourriau, 151–74. Cambridge: Cambridge University Press, 1995.

Parry, J. H. *The Spanish Seaborne Empire*. Berkeley: University of California Press, 1966.

Parry, J. H., Philip Sherlock, and Anthony Maingot. *A Short History of the West Indies*. 4th ed. New York: St. Martin's, 1987.

Pastoureau, Michel. *Blue: The History of a Color*. Translated by Markus I. Cruse. Princeton: Princeton University Press, 2001.

———. "Ceci est mon sang: le Christianisme médiéval et la couleur rouge." In *Le pressoir mystique*, edited by Daniéle Alexandre-Bidon, 43–56. Paris: Cerf, 1990.

———. *Jésus chez le teinturier*. Paris: Léopard d'Or, 1997.

Perrot, Philippe. *Fashioning the Bourgeoisie: A History of Clothing in the Nineteenth Century*. Translated by Richard Bienvenu. Princeton: Princeton University Press, 1994.

Perry, Mary Elizabeth. *Gender and Disorder in Early Modern Seville*. Princeton: Princeton University Press, 1990.

Phillips, Carla Rahn, and William D. Phillips. *Spain's Golden Fleece: Wool Production and the Wool Trade from the Middle Ages to the Nineteenth Century*. Baltimore: Johns Hopkins University Press, 1997.

Philosophical Transactions of the Royal Society of London. London: Royal Society of London, 1665– .

Pike, Ruth. *Aristocrats and Traders: Sevillian Society in the Sixteenth Century*. Ithaca: Cornell University Press, 1972.

———. *Enterprise and Adventure: The Genoese in Seville and the Opening of the New World*. Ithaca: Cornell University Press, 1966.

Piperno, D. R., and K. V. Flannery. "The Earliest Archaeological Maize (*Zea mays* L.) from Highland Mexico: New Accelerator Mass Spectrometry Dates and Their Implications." *Proceedings of the National Academy of Sciences of the United States of America* 98 (February 13, 2001): 2101–3.

Pleij, Herman. *Dreaming of Cockaigne: Medieval Fantasies of the Perfect Life*. Translated by Diane Webb. New York: Columbia University Press, 2001.

Pliny the Elder. *Natural History*. Translated by H. Rackham. Loeb Classical Library. 9 vols. London: Heinemann, 1949–52.

Pomet, Pierre. *Histoire générale des drogues*. 2 vols. Paris, 1694.

Porter, Roy. *London: A Social History*. Cambridge, MA: Cambridge University Press, 1994.

Pounds, N. J. G. *An Economic History of Medieval Europe*. 2nd ed. London: Longman, 1994.

Power, Eileen. *The Wool Trade in English Medieval History.* Oxford: Oxford University Press, 1941.

Price, Julius M. *Dame Fashion.* London, 1912.

Quinn, David Beers, ed. *The Roanoke Voyages, 1584–1590.* 2 vols. New York: Dover, 1991.

Raleigh, Walter. *The Discoverie of the Large, Rich, and Bewtiful Empyre of Guiana* (1596). New York: Da Capo, 1968.

Ray, John. *Historia Plantarum.* 3 vols. London, 1686–1704.

Read, John. "The Life and Work of Perkin." In *Perkin Centenary London: 100 Years of Synthetic Dyestuffs,* 1–31. London: Pergamon Press, 1958.

Réaumur, René-Antoine Ferchault de. *Mémoires pour servir à l'histoire des insectes.* 6 vols. Paris, 1734–1742.

Recopilación de leyes de los reynos de las Indias (1791). 3 vols. Reprint, Madrid: Gráficas Ultra, 1943.

Reinhold, Meyer. *History of Purple as a Status Symbol in Antiquity.* Brussels: Latomus, 1970.

Reith, Gerda. *The Age of Chance: Gambling in Western Culture.* New York: Routledge, 1999.

"Relaciòn de varios pueblos de la Nueva España que en depósito y encomienda tenía Hernán Cortés" (1537). In *Cartas y Otros Documentos de Hernán Cortés,* edited by Mariano Cuevas, 183–87. Seville, 1915.

"Results of the Roper/Pantone Consumer Color Preference Study" (1995). Pantone, http://www.pantone.com/allaboutcolor/allaboutcolor.asp?ID=34 (accessed May 25, 2001).

Ribeiro, Aileen. *Dress in Eighteenth-Century Europe, 1715–1789.* New Haven: Yale University Press, 2000.

Riley, G. Michael. *Fernando Cortés and the Marquesado in Morelos 1522–1547.* Albuquerque: University of New Mexico Press, 1973.

Roberts, Gareth. *The Mirror of Alchemy: Alchemical Ideas and Images in Manuscripts and Books from Antiquity to the Seventeenth Century.* Toronto: University of Toronto Press, 1994..

Roche, Daniel. *The Culture of Clothing: Dress and Fashion in the Ancien Régime.* Translated by Jean Birrell. Cambridge: Cambridge University Press, 1994.

Rosetti, Gioanventura. *The Plictho of Gioanventura Rosetti: Instructions in the Art of the Dyers Which Teaches the Dyeing of Woolen Cloths,*

Linens, Cottons and Silk by the Great Art As Well As the Common
(1548). Translated by Sidney M. Edelstein and Hector C.
Borghetty. Reprint, Cambridge, Mass.: MIT Press, 1969.

Rubenstein, Ruth P. *Dress Codes: Meanings and Messages in American
Culture.* Boulder: Westview Press, 1995.

"Ruby." *Larousse Dictionary of World Folklore.* Edited by Alison Jones.
New York: Larousse, 1995.

Ruestow, Edward G. *The Microscope in the Dutch Republic: The Shaping
of Discovery.* New York: Cambridge University Press, 1996

Ruíz Martín, F., ed. *Lettres Marchandes échangées entre Florence et
Medina el Campo.* Paris: SEVPEN, 1965.

Ruusscher, Melchior de. *Natuerlyke historie van de couchenille, beweezen
met authentique documenten: Histoire naturelle de la cochenille, justifiée
par des documens authentiques.* Amsterdam: H. Uytwerf, 1729.

Sahagún, Bernardino de. *Florentine Codex: General History of the Things
of New Spain* (c. 1570). Translated by C. E. Dibble and A. J. O.
Anderson. 12 books. Santa Fe: School of American Research,
1950–63.

Sánchez Silva, Carlos. *Indios, comerciantes, y burocracia en la Oaxaca pos-
colonial, 1786–1860.* Oaxaca, Mexico: Instituto Oaxaqueño de las
Culturas, Universidad Autónoma Benito Juárez de Oaxaca, 1998.

Sandberg, Gosta. *The Red Dyes: Cochineal, Madder, and Murex Purple.*
Asheville, N.C.: Lark Books, 1997.

Santosuosso, Antonio. *Soldiers, Citizens, and the Symbols of War: From
Classical Greece to Republican Rome, 500–167 B.C.* New York:
Westview-Harper, 1997.

Sarabia Viejo, María Justina. *La grana y el añil: técnicas tintóreas en
México y América Central.* Seville: Escuela de Estudios Hispano-
Americanos, 1994.

———. *Don Luis de Velasco, Virrey de Neuva España, 1550–1564.*
Seville: Escuela de Estudios Hispano-Americanos, 1978.

Saraiba Russell, Ángeles. "En busqueda de la grana cochinilla: Thiery
de Menonville en Oaxaca, 1777." *Acervos: Boletín de los archivos y
bibliotecas de Oaxaca* 5 (Autumn 2001): 13–26.

Schierbeek, Abraham. *Measuring the Invisible World: The Life and Works
of Antoni van Leeuwenhoek.* New York: Abelard-Schuman, 1959.

Scholes, France V. *The Spanish Conqueror as a Business Man.* Albuquerque: University of New Mexico Press, 1957.

——. "Tributos de los Indios de la Nueva España, 1536." *Boletín del Archivo General de la Nación* 7 (April 1936): 185–226.

Schom, Alan. *Napoleon Bonaparte.* New York: HarperCollins, 1997.

Schweppe, Helmut, and Heinz Roosen-Runge. "Carmine: Cochineal Carmine and Kermes Carmine." *Artists' Pigments: A Handbook of Their History and Characteristics.* Vol. 1. New York: Oxford University Press. 255–83.

The Science of Dress for Ladies and Gentlemen. London: Groombridge, 1857.

Scott, Philippa. *The Book of Silk.* London: Thames and Hudson, 1993.

Seay, Elizabeth. "Why Do They Call Fruit Punch Bug Juice? Here's One Possibility." *Wall Street Journal,* May 15, 1997.

Semo, Enrique. *The History of Capitalism in Mexico: Its Origins, 1521–1763.* Translated by Lidia Lozano. Austin: University of Texas Press, 1993.

Shapiro, Alan E. *Fits, Passions, and Paroxysms: Physics, Method, and Chemistry and Newton's Theories of Colored Bodies and Fits of Easy Reflection.* New York: Cambridge University Press, 1993.

Shapiro, Arthur K., and Elaine Shapiro. *The Powerful Placebo: From Ancient Priest to Modern Physician.* Baltimore: Johns Hopkins University Press, 2001.

Sharpe, Deborah T. *The Psychology of Color and Design.* Totowa, N.J.: Littlefield, 1975.

Sicile. *Le Blason des couleurs* (c. 1400s). Paris, 1860.

Simpson, Lesley Byrd. *The Encomienda in New Spain.* Berkeley: University of California Press, 1966.

Sluiter, Engel. "Dutch-Spanish Rivalry in the Caribbean Area, 1594–1609." *Hispanic American Historical Review* 28 (1948): 165–96.

Smith, Michael E. *The Aztecs.* London: Blackwell, 1996.

Snoddy Cuéllar, Elizabeth. "A Natural Dye Innovator Who's Made a Difference: Isaac Vásquez García." Conference paper, 2002.

Spores, Ronald. *The Mixtecs in Ancient and Colonial Times.* Norman: University of Oklahoma Press, 1984.

Spufford, Peter. "Trade in Fourteenth-Century Europe." In *The New*

Cambridge Medieval History, edited by Michael Jones, 6: 155–208. New York: Cambridge University Press, 1996.

Staley, Edgcumbe. *The Guilds of Florence*. London: Methuen, 1906.

Steele, Valerie. *Paris Fashion: A Cultural History*. Oxford: Oxford University Press, 1988.

Stephen, Lynn. *Zapotec Women*. Austin: University of Texas Press, 1991.

Stewart, Doug. "Guys and Molls." *Smithsonian*, August 2003, 54–59.

Stiling, Peter. "A Worm That Turned." *Natural History* 109 (June 2000): 40–43.

Stone, Olivia M. *Tenerife and Its Six Satellites; or, the Canary Islands Past and Present*. 2 vols. London, 1887.

Swammerdam, Jan. *The Book of Nature* (1737–38). Translated by Thomas Flloyd. London, 1758.

"The Swans of the London Dyers." *Ciba Review* 1 (September 1937): 33.

Taylor, Lonn. *The Star-Spangled Banner: The Flag that Inspired the National Anthem*. New York: Harry Abrams, 2000.

Terry, J. Philip. *Terry's Guide to Mexico*. Rev. ed. Hingham, Mass., 1947.

Thiery de Menonville, Nicolas-Joseph. *Traité de la culture du nopal et de l'éducation de la cochenille dans les colonies Francaises de l'Amérique*. Cap-Français, 1787.

———. "Travels to Guaxaca in 1777." In *A General Collection of the Best and Most Interesting Voyages and Travels*, edited by John Pinkerton, 13: 753–875. London, 1810–14.

Thomas, Hugh. *Conquest: Montezuma, Cortés, and the Fall of Old Mexico*. New York: Simon and Schuster, 1993.

Thompson, Evan. *Color Vision: A Study in Cognitive Science and the Philosophy of Perception*. London: Routledge, 1995.

Thompson, J. Eric. *Mexico before Cortez*. New York: Scribner's, 1933.

Tierie, Gerrit. *Cornelis Drebbel*. Amsterdam: H. J. Paris, 1932.

Timmons, Wilber H. *Morelos of Mexico*. El Paso: Texas Western College Press, 1963.

Townsend, Joyce. *Turner's Painting Techniques*. London: Tate Gallery, 1993.

Transactions of the Agricultural and Horticultural Society of India. Vol. 6. Calcutta, 1839.

Travis, Anthony S. "Poisoned Groundwater and Contaminated Soil: The Tribulations and Trial of the First Major Manufacturer of Aniline Dyes in Basel." *Environmental History* 2 (1997): 343–65.

Trusted, Jennifer. *The Mystery of Matter.* New York: St. Martin's, 1999.

Tyler, Royall. *The Emperor Charles the Fifth.* London: Allen and Unwin, 1956.

United States House of Representatives. Committee on Interstate and Foreign Commerce. *Hearings on Color Additives.* 86th Cong., 2nd sess., H. Rep. 7624 and S. Rep. 2197. Washington, D.C.: GPO, 1960.

van Deventer, S. *Bijdragen tot de kennis van het landelijk stelsel op Java.* 3 vols. Zalt-Bommel, Netherlands, 1865–1866.

van de Wetering, Ernst. *Rembrandt: The Painter at Work.* Berkeley: University of California Press, 2000.

Vasari, Giorgio. *Lives of the Artists: A Selection.* Translated by E. L. Seeley. New York: Noonday-Farrar, 1957.

Voltaire. *Candide* (1758). Introduction by Carl Van Doren. New York: World, 1947.

Wagner, Henry R. "Translation of a Letter from the Archbishop of Cosenza to Petrus de Acosta [March 7, 1520]." *The Hispanic American Historical Review* 9 (April 1929): 361–63.

Wallert, Arie. "The Analysis of Dyestuffs on Historical Textiles from Mexico." In *The Unbroken Thread: Conserving the Textile Traditions of Oaxaca,* edited by Kathryn Klein, 57–85. Los Angeles: Getty Conservation Institute, 1997.

Walton, Penelope. "Textiles." In *English Medieval Industries,* edited by John Blair and Nigel Ramsey, 319–54. London: Hambledon, 1991.

Wescher, H. "Dyeing in France before Colbert." *Ciba Review* 18 (February 1939): 618–25.

White, Florence. *How to Dress Well on a Small Allowance.* London, 1901.

White, Michael. *Isaac Newton: The Last Sorceror.* Reading, Mass.: Addison-Wesley, 1998.

Williams, C. A. S. *Outlines of Chinese Symbolism and Art Motives.* Rutland, Vt.: Tuttle, 1974.

Williamson, G. C. *George, Third Earl of Cumberland.* Cambridge: Cambridge University Press, 1920.

Wilson, Catherine. *The Invisible World: Early Modern Philosophy and the Invention of the Microscope.* Princeton: Princeton University Press, 1995.

Wood, Michael. *Shakespeare.* New York: Perseus, 2003.

Woodward, Jr., Ralph Lee. *Rafael Carrera and the Emergence of the Republic of Guatemala, 1821–1871.* Athens, Ga.: University of Georgia Press, 1993.

"Wool Trade Cloth in the Collection of NMAI—Textile Terminology Glossary." National Museum of the American Indian, http://web8si.edu/wooltrade/glossary.shtml (accessed March 14, 2003).

Wouters, Jan, and Noemi Rosario-Chirinos. "Dye Analysis of Pre-Columbian Peruvian Textiles with High-performance Liquid Chromatography and Diode-Array Detection." *Journal of the American Institute of Conservation* 31 (1992): 237–55.

Wright, N. P. "A Thousand Years of Cochineal: A Lost but Traditional Mexican Industry on Its Way Back." *American Dyestuff Reporter* 52 (1963): 635–39.

Young, Robert. *Analytical Concordance to the Holy Bible.* 8th ed. London: Lutterworth, 1939.

Zárate, Bartolomé de. "Relaciòn descriptiva del Valle del Oaxaca" (1544). In *Cartas y Otros Documentos de Hernán Cortés,* edited by Mariano Cuevas, 253–56. Seville, 1915.

Zollinger, Heinrich. *Color: A Multidisciplinary Approach.* Weinheim: Wiley-VCH, 1999.

Acknowledgments

WHY WRITE A BOOK ABOUT COCHINEAL? IT'S A FAIR question. Both my grandfather and great-grandfather were dyers, so perhaps it's simply that color is in my blood. But I never thought much about cochineal until I was a graduate student at Oxford in the early 1990s, researching a master's thesis on the introduction of chocolate to Europe.

As part of my research, I traveled to Seville to work in the Archive of the Indies—a lucky assignment, because Seville's archive is a magical place. Housed in a Renaissance merchants' exchange, it sits on an elegant square bounded on one side by the crenellated walls of the fairy-tale Reales Alcázares, the royal palaces, and on the other by the city's massive Gothic cathedral, with its Moorish minaret. The archive's shelves hold some eighty million pages of documents pertaining to the Spanish Indies, including letters from Columbus, Cortés, and the Habsburg kings.

In the archive, seated at a wooden desk overlooking the courtyard, I spent several weeks combing through the enormous, black registers of the early-seventeenth-century Spanish fleets, looking for the word *chocolate*. Since chocolate was a relatively uncommon luxury good in that period, the word didn't appear very often. But as I scanned the centuries-old handwriting, other words leaped out at me—especially the word *grana*, which I saw

written again and again, on page after page, shipment after shipment of the dark red dyestuff coming over the Atlantic into Seville. Although I'd learned from academic tomes that cochineal was second only to silver in the exports of New Spain, it was only then that I really started to grasp how vital the dyestuff had been to the Spanish Empire.

At the time I had a thesis to write, with a deadline looming close, so I couldn't afford to think too long about anything that wasn't chocolate. But I knew then that someday I wanted to learn more about cochineal. It was amazing to me that something so precious could have been virtually forgotten by the modern world.

It was in the winter of 2000–2001 that cochineal came back into my mind again. Here in Massachusetts, the ground was covered with snow for months, and every few days the weather forecasters warned that another storm was on the way. One gray day in the midst of that white winter, I found myself staring at the rose-red geraniums on my kitchen windowsill, thinking, "What if that were it? What if that were all the red we had in the world?" And I suddenly understood, at a visceral level, how hungry people could be for a color. I could even imagine why they might risk their lives for it. That got me thinking about cochineal again, and I started digging through research libraries for more details, to see if there might be a story there. And what a story it turned out to be—four centuries and more of desire, rivalry, and empire, with the color red at its heart.

I HAD THE HELP OF MANY PEOPLE IN TELLING THIS story, and I am glad to be able to thank them here. If, despite their aid, I have made mistakes, the responsibility is entirely my own.

I am indebted, first of all, to the historians and other scholars whose work I read while researching this book. Chief among them

are R. A. Donkin, Raymond Lee, and Jeremy Baskes, whose articles and monographs are indispensable for anyone researching the history of cochineal. A historian to whom I owe an especially great debt is Professor Sir John Elliott, who supervised the research that sent me to the Sevillian archives. In taking me on as a graduate student, he opened up new worlds for me. I'm particularly grateful for the careful reading he gave to many chapters of this book, all the more so because his own writing is a model of scholarship and grace. I'd also like to thank Lady Elliott for her kind hospitality.

It was my good fortune to have the help of several Oaxaqueños while working on this book. Dr. Alejandro de Ávila Blomberg, the director of Oaxaca's exquisite Jardín Etnobotánico, helped with this project in myriad ways, not least because he inspired me with his profound commitment to the past, present, and future of Oaxaca. He connected me with other scholars, sent references of useful works, shared his own manuscripts, and commented on a number of my draft chapters. When I visited Oaxaca he was kindness itself, making me feel I was not a stranger but a much-welcomed friend. I also appreciate the help I received from Eric Mindling of Manos de Oaxaca, guide extraordinaire, whose relaxed good humor and love for the region were evident from the moment I first met him. Eric introduced me to Don Ignacio del Río Dueñas, a fellow cochineal enthusiast, who showed me my first live *Dactylopius coccus* and gave me an insider's tour of his nopalry and museum, Tlapanochestli, in Santa María Coyotepec. It was also through Eric that I met Fidel Cruz and María Luisa Mendoza, who welcomed me into their workshop and showed me how they dye with cochineal in Teotitlán del Valle.

I sing the praises of the dedicated staff of the libraries and archives I consulted while working on this book, including the British Library, the Bodleian, the Koninklijke Bibliotheek, the Harvard University libraries (especially Houghton Library, Lamont Library, Widener Library, and the Ernst Mayr Library of the Museum of Comparative Zoology), the libraries of Wellesley

College, Middlebury College, MIT, and Brandeis University, and the Minuteman Library System. Special thanks go to Jodie Randall, librarian at the Jardín Etnobotánico, and to the staff of the Waltham Public Library, especially Tom Jewell, Kate Tranquada, and the indefatigable Marialice Wade, the superwoman of interlibrary loan requests.

A whirlwind of enthusiasm, kindness, perception, and humor, Tina Bennett has been this book's best friend. She coached me through my first book proposal, gave me wise advice as I wrote the book itself, and responded eagerly to every draft I sent her. Her price is above rubies. Thanks are due as well to her terrific assistants, Svetlana Katz and Sara Kriegel, and to the other helpful people at Janklow & Nesbit, especially Cecile Barendsma, Kate Schafer, and Cullen Stanley.

I am deeply grateful to my editors, Terry Karten and Jane Lawson, for their faith in this book and in me. I gained new insights from each of our conversations, and their sensitive comments on the manuscript helped me see the book more clearly. Like all the best editors, they drew more from me than I knew was there. My thanks also go to the many other people at HarperCollins and Transworld/Doubleday who helped bring this book into the world, especially Roberto de Vicq de Cumptich, Nancy Field, David Koral, Danny Mulligan, and Andrew Proctor.

I also wish to thank Robert Ammerlaan, of De Bezige Bij, who believed in the book proposal; Nick Caistor of the BBC, who introduced me to Alejandro; Toby Greenberg, who was an ace picture researcher; Vicki Haire, who copyedited the manuscript with scrupulous care; Dr. Jo Kirby, who kept me up-to-date on recent discoveries on the use of cochineal in painting; Professor Jean Lee, who listened to my thoughts on cochineal and empire and offered good advice; Dr. Jason Lemon, whose Ph.D. thesis refined my understanding of the *encomienda* system; Dr. Sarah Lowengard, with whom I enjoyed spirited virtual conversations on color history; Tom Reiss, who shared a great story about red trousers from his

forthcoming book, *The Orientalist*; Dr. Elizabeth Snoddy Cuéllar, who sent me her conference paper on Isaac Vásquez; Hester Velmans, who translated a Dutch account of the introduction of cochineal to Java; Drs. Robert Sands, Cynthia Slater, Howard Marton, and Carolyn Kreinsen, who looked after my health; the staff and faculty at the Middlebury College Science Center, who allowed me to use their chemistry labs; and the British Marshall Scholarship Commission, which funded the research degree that first took me to Seville.

For responding to various inquiries, I thank David Austin of Abimelech Hainsworth, Mrs. G. Brewer of London's National Army Museum, Sarah Burge of the Society of Dyers and Colorists, Professor J. C. R. Childs of the University of Leeds, Jon Culverhouse of Burghley House, Valeska Hilbig of the Smithsonian's National Museum of American History, and Erika Ingham of London's National Portrait Gallery. For sharing their thoughts on red and fashion, I thank Jenny Xia, Linda McCrerey, and Aimee Fitzgerald. The resourceful members of the Natural Dyes list on Yahoo are a font of wisdom about the practical aspects of dyeing, and they gave me good advice when I experimented with cochineal myself.

I appreciate the help of Nancy Werlin, who read the opening chapters of the book with insight and enthusiasm. Patrice Kindl and Diane Davis gave me encouragement and comments on the prologue. A special thank-you goes to Resa Nelson for her writing advice and companionship, and for reading the entire manuscript at a critical point. Many thanks, too, to the other friends who supported me as I was writing this book, especially Carolyn and Ted Colton, Mary Jo Fernandez, Lisa Firke, Kathi Fisler, Rona Gofstein, Shriram Krishnamurthi, Ben and Linda Labaree, Samantha Scolamiero, and Jenny Turner. Dona Vaughn, who sadly did not live to see the book in print, was also a treasured source of support.

My deepest debt is to my family. Steve Butler sent cheers

from Germany, and Jonathan Butler and Valerie Grabiel offered well-timed travel tips. Stephen and Sarah Greenfield gave me a warm welcome in Britain, while Ruth and Grace Greenfield charmed my socks off. Pat and Bert Greenfield shared family stories about cochineal, helped me with biblical references, and supplied me with tea, meals, and loving care when I was doing research in London.

My parents, Crispin and Barbara Butler, contributed in countless ways, reading chapters, asking wonderful questions, and heartening me with their love and enthusiasm. My dad played alchemist with me, helping me to re-create Drebbel's "accident" in the lab. He was my in-house science consultant, and he located some rare sources that I could not find anywhere else. My mom, who works wonders with fabric, has been teaching me about textiles and color all my life. Watching her lay out the pieces of a quilt, searching for the perfect pattern before piecing it all together—and undoing the stitches if something isn't quite right—has also taught me something about the art and craft of writing.

My greatest pleasure in writing about cochineal has been sharing the adventure with my husband, David Greenfield. In the three years and more that this book was part of our lives, he read every chapter at least three times, accompanied me on research trips, helped with dye experiments, drew chemical diagrams, and participated in many a conversation about cochineal, asking all the right questions and offering wise counsel. He believed in *A Perfect Red* and in me from the beginning, and he is a constant source of strength and joy.

INDEX

Académie Royale des Sciences, 145, 198

Acapulco, 85

Accademia dei Linci, 145

achiote (annatto), 40

Acosta, José de, 131–32, 134–35

Admiralty Court, 119, 120

Africa, 2, 81, 208, 241

African Americans, 252–54

Age of Innocence, The (Wharton), 255

Albert, Prince Consort of England, 223

alchemy, 137–38, 139, 153, 222

Alhazen, 143

alizarin, 230–31

alum, 23, 41

Alzate y Ramírez, José Antonio, 198–200

Anderson, Dr. James, 186–87, 189–97, 226

aniline, 225

Antichrist, 22, 23

Antwerp, 76

apprenticeship of dyers, 15–16

aqua regia, 138, 139

Arab world, 2, 14, 31, 70, 143

Aragon, 49

archil or orchil, 29

aristocrats, 11, 25–26, 79–80, 141, 170

Aristotle, 127

Arizona, 208

Armenia, 30

Armenian red (*Porphyrophora hameli*), 29–31, 38, 75–76

arsenic, 32, 232, 233

Arte di Calimala, 15, 17

artists' pigment, 14, 81–83, 122, 227, 234

Artois, comte d', 158

Asia, 3, 241

Asia Minor, red dyestuff in, 30

Assyrians, 30

Australia, 184, 185, 188

Austria, 49

Azerbaijan, 30

Azores, 110, 111, 116, 122

Aztecs, 3, 39–42, 54, 93

 conquistadors or *encomenderos* and, 41–44, 53–57, 44, 93–94

 Sahagún's treatise on culture of, 131

Badische company, 239

Baltasar, Maestre, 61

Banks, Joseph, 184–92, 194, 197

Barbados, 167

Barbary Coast pirates, 119–120

Bardot, Brigitte, 255

BASF (German dye firm), 230

Batavia (*now* Jakarta), 124, 211

Bautista Fortuno, Don Juan, 160, 161

Bayer company, 238, 239

Benavente, Toribio de (Motolinía), 129–30

Bengal nopal (Neeg-Penny), 193–95

benzene, 224

Berry, Dr. Andrew, 190, 193–95

Berry, duc de, *Très Riches Heures*, 9n

Berthelot, Sabin, 216